ART AMERICA

MARY ANN TIGHE
*Arts Advisor, Office
of the Vice President
of the United States*

ELIZABETH EWING LANG
Northern Virginia Community College

McGRAW-HILL BOOK COMPANY

*New York St. Louis San Francisco Auckland Bogotá Düsseldorf
Johannesburg London Madrid Mexico Montreal New Delhi
Panama Paris São Paulo Singapore Sydney Tokyo Toronto*

84539

This book was set in Palatino by Progressive Typographers.
The editors were Robert G. Manley and Douglas J. Marshall;
the designer was Joan E. O'Connor;
the production supervisor was Robert C. Pedersen.
Von Hoffmann Press, Inc., was printer and binder.

ART AMERICA

1 2 3 4 5 6 7 8 9 0 V H V H 7 8 3 2 1 0 9 8 7

Library of Congress Cataloging in Publication Data

Tighe, Mary Ann.
 Art America.

 Companion Volume to Art America: a resource manual
by P. A. Cecchettini and D. Whittemore, for use with
the video series Art America.
 Bibliography: p.
 1. Art, American. 2. Art America. 3. Art—Study
and teaching—United States. I. Lang, Elizabeth E.,
joint author. II. Cecchettini, Philip Alan. Art
America. III. Title.
N6505.T54 709'.73 77-7125
ISBN 0-07-064601-5 (pbk.)
0-07-064607-4

CONTENTS

PREFACE

This text, along with the *Art America* video series and the re-
source manual, is a component of a learning package that we
hope will have an impact on the teaching and, more impor-
tantly, the learning of art history. All three components were created
in response to a specific need, one which we have experienced first-
hand.

The last decade and a half saw the emergence of community
college systems, continuing education programs, and extended learn-
ing facilities, and from their beginning art history has been inte-
grated into many of these programs. To our amazement and conster-
nation, however, these courses were devoted almost exclusively to
European art and architecture. A 1974 survey of community colleges
throughout the country revealed that students learned about the
Parthenon and Bernini, when only a few miles away museums of
American art stood, their resources untapped.

After introducing a survey of American art to the Virginia com-
munity college system, we began to consider the production of such
a course for a national audience. We knew from our own experience

the limited slide resources of most small colleges, and we saw this as a major stumbling block to the inclusion of an American art course in the curriculum.

Time was another critical factor. Most community colleges are organized on the quarter system, with courses generally 10 weeks in length. A survey of a "specialized" nature, as a course in American art would be considered, would have to be tailored to fit within a 10-week format yet still be flexible enough to allow for expansion.

Finally, we desired a format that would enable this course of study to be available to the widest possible audience. Video has been used extensively in the teaching of the sciences, and its application to the humanities is overdue. Art history in particular benefits from the nature of video, with its emphasis on the visual rather than verbal engagement of the student. Video also eliminates the need for a huge body of slides, since the teacher only needs slides of those works which require more detailed analysis.

The structure of the community college, continuing education, and extended learning systems dictated not only the format of this course of study but the organization and selection of its content as well. It is the nature of these educational systems to emphasize condensation and clarity, to impart basic information in a direct and hopefully engaging fashion. Rather than belittling these values, we have embraced them and thereby made the commitment to train enthusiasts rather than scholars. Thus, *Art America* is not a groundbreaking perspective on the art of the United Sates. The limitation of this educational format is that it offers neither the time nor the forum for the presentation of new ideas. This book, the series, and the resource manual are an introduction to American art in the strictest meaning of that phrase. They provide only a framework on which to build with futher investigation, a means to form a general acquaintance with some of the more cogent issues, events, people, and works in American art.

We have used the designation "American" in its narrowest sense, for *Art America* does not include the art of the Indians, the Canadians, or any other group that might rightly call itself American. This text considers only the art of the continental United States made within the framework of Western European cultural traditions (except in those examples of twentieth century art that demand a broader context). This limitation should not be misread as an indication that the body of art we have chosen to consider is inherently better than work created within a different cultural complex. Rather, it was the dictates of brevity and clarity that determined the scope of this study.

The word "art," however, has been interpreted with greater latitude, for while the principal focus of this text is painting and sculpture, we have also incorporated photography and architecture into the discussion. In addition, *Art America* tries to fill lacunae often found

in other general surveys of American art. The Columbian Exposition, the Armory Show, and the federal art projects each have been given an individual chapter. References to the position of women in the arts of this country have also been included. Current explorations into alternative art forms such as earthworks and conceptual art have been incorporated into the final chapters. An effort has been made to include as many salient aspects of American art as possible, and it is for the teacher and student to pick areas of special interest and expand upon them.

To this end, the bibliographical and biographical supplements have given considerable attention. Once again, their form has been dictated by the needs of students rather than scholars. Therefore, the biographies do not include lists of group and one-man exhibitions, but instead present broader background information that might seem more relevant to the beginning student along with references to further reading on the artist. Similarly, the bibliographical material has been grouped under subject headings that suggest additional areas of study to the student. To the authors, these supplements are as important as the text. They are meant as a self-guide to the complexities of the art produced in this nation. They are intended as road maps, and, if they are successful, they will lead the reader into territory well beyond the limits of this study. It is our hope and intention that *Art America* can encourage and facilitate that journey.

ACKNOWLEDGMENTS

Our appreciation must first be expressed to the three scholars who painstakingly and patiently reviewed and corrected the scripts of the *Art America* television series: the late William Campbell, Curator of American Painting, National Gallery of Art; Dr. Lois Fink, Curator of Research, National Collection of Fine Arts, Smithsonian Institution, and Dr. Joshua Taylor, Director, National Collection of Fine Arts. Dr. Fink in particular deserves our deepest thanks because she remained with this project through the difficult process of transforming the TV material into a text. The strengths of this book are due, in large measure, to her scholarship and teaching ability.

Dr. Judith Zilczer, historian, Hirshhorn Museum and Sculpture Garden, Smithsonian Institution, reviewed the chapter on the Armory Show and Karel Yasko, Counselor for Fine Arts and Historic Preservation, General Services Administration, greatly aided our work on the Federal Arts Project. To both, we are grateful.

We wish to thank Dr. Eltse B. Carter, Chairman, Humanities Division, Northern Virginia Community College, Annandale, for her advice and encouragement through every phase of the *Art America* project. Jan Shauer deserves our deep appreciation for her work in

procuring the illustrations for this book, and we are grateful as well to the institutions and individuals who made these materials available to us. For the research and writing they contributed to the biographies, we wish to thank Lynn Stelmah, Ann Kraft, Lisa Deanna Turner, and, most especially, Cathy Morningstar who saw this tedious task through to its completion. The index was compiled by Ruth Pratt Ewing, and the task of typing the manuscript fell to Peggy Marsh Frazier and Janet Colson Ellis who handled it ably. Robert Manley, our sponsoring editor at McGraw-Hill, pushed us and prodded us to completion in the nicest possible way.

Finally, there are our families and friends whose affection and encouragement sustained us through the writing of this text. In particular we wish to give our thanks and love to Edith and Frank Scarangello, Ruth Pratt, Ruth and Jim Ewing, Aaron Tighe, and Josh and Kristen Lang. Special thanks are due also to David A. Hidalgo, Duncan Tebow, Joan Scarangello, Thomas Scarangello, Bill Ewing, Carol Parsons, Ann Kraft, Eleanor Allen, and Nicolai Cikovsky, Jr.

A NOTE ON THE ILLUSTRATIONS

All illustrations are labeled with the name of the artist, the title of the work as specified by its present owner, and its location and/or owner as of spring, 1977. The date indicated on the caption is the year in which the piece was completed. In the case of photography, this is the year in which the picture was taken, and, with events like happenings, the year in which the piece was performed initially. The medium is not indicated unless possible confusion (due to the inherent limitations of reproducing works of art) was anticipated. For example, all photographs and graphics have been labeled as such to distinguish them immediately from paintings.

Mary Ann Tighe
Elizabeth Ewing Lang

For
Edith and Frank Scarangello and
Ruth Colglazier Pratt

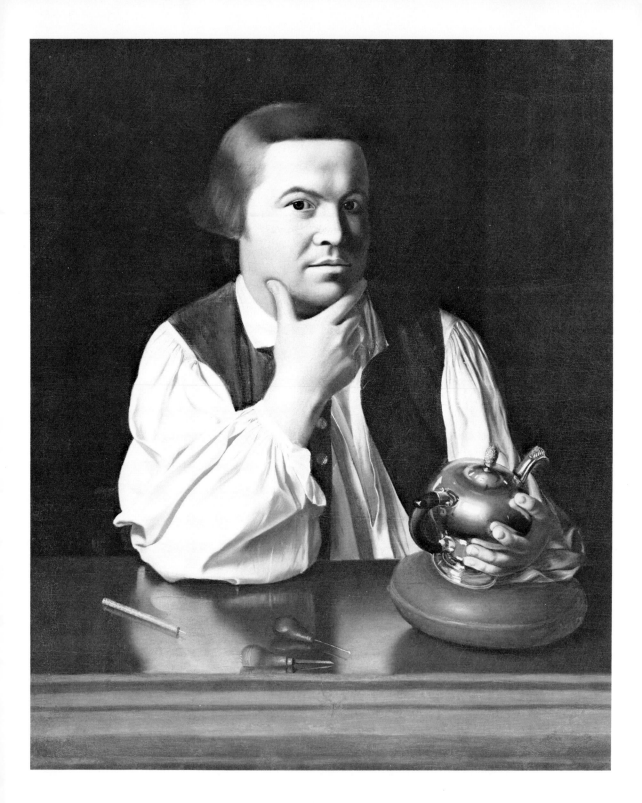

CHAPTER 1

AN INTRODUCTION

FIGURE 1
Copley, John
Singleton, *Paul Revere,*
1765–1770,
Courtesy of
Museum of Fine
Arts, Boston.
Gift of Joseph
W., William B.,
and Edward N.
R. Revere.

W hen did American art begin?
What qualities distinguish a work of art made in America?

What is the relationship of American art to American life?

These are the questions which will guide and shape this study of the history of the visual arts in the United States. From its inception, American art has been the product of a unique set of circumstances that have conspired to make the creation of art in this country a complex, difficult, and exhilarating enterprise. In a sense, the history of American art is a record of a series of challenges—to define a visual tradition; to create an art from native materials that could hold its own by international standards; to overcome the limitations of a young nation lacking the museums, the training, and the patronage available to European artists; and, finally, to establish a viable position for art in American life.

AN AMERICAN SUBJECT MATTER

In the beginning, only one subject seemed suitable for colonial artists to depict—the human face. Portraiture was the staple of the limners, the first professional artists of the New World. To America's earliest painters, it was the only subject for which there was a market, and to our Puritan forebears, it was the only acceptable art. By European standards, however, this was a rather limited role for art.

The aesthetic theories of the eighteenth century did not hold portraiture in high esteem. The European academies of that time taught that art must portray ideal and universal truths, and that the subject matter of a work of art must reflect the artist's commitment to noble values. To eighteenth-century European artists, history painting, the depiction of scenes from history, literature, mythology, or the Bible, was the province of genius, and portraiture was a lucrative but relatively insignificant branch of the fine arts.

Thus, the brilliant American portrait painter John Singleton Co-

FIGURE 2 Greenough, Horatio, *George Washington*, 1833–1841, Courtesy of Museum of History and Technology, Smithsonian Institution.

FIGURE 3 Peale, Charles Willson, *The Artist in His Museum*, 1822, Courtesy of Pennsylvania Academy of the Fine Arts, Joseph and Sarah Harrison Collection.

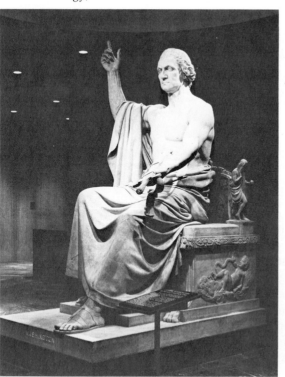

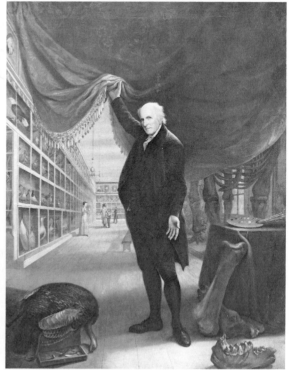

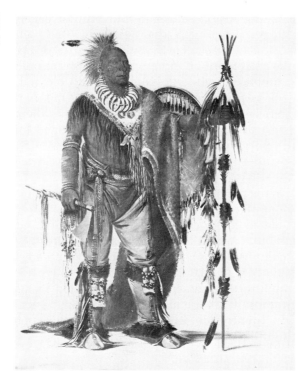

FIGURE 4 Catlin, George, *Ke-o-Kuk, The Running Fox,* 1831, Smithsonian Institution, National Collection of the Fine Arts.

pley yearned to paint loftier subject matter, and eventually abandoned his lucrative New England portrait trade for Europe and a career as a history painter. The climate in America was not suited to the nurturing of a tradition of history painting. The famous battles had yet to be won, and scenes from mythology or biblical subjects carried overtones of the European intolerance from which so many colonists had fled. Yet well into the early nineteenth century the majority of American artists dreamed of transplanting the tradition of history painting from Europe to the United States. They would continue to face frustration and failure, for even after the Revolution the buyers for such paintings were few and the grand style of European history painting seemed unnatural, even undemocratic, to most Americans. When the sculptor Horatio Greenough attempted to follow the highest ideals of the art of his day and portrayed George Washington in classical garb (Fig. 2), it was considered inappropriate and was poorly received by the American public. The popular image became not this grand sculpture but Gilbert Stuart's painted portrait of Washington (Figure 33), straightforward yet dignified.

Other themes seemed natural to American artists. Yankee ingenuity and scientific curiosity found their place in this nation's art early in our history. Charles Willson Peale, for example, joined his zeal for science with his love of painting in a self-portrait in which

his natural history museum and portrait gallery of distinguished Americans are proudly displayed (Fig. 3). Another suitable subject was the land itself. Lacking the centuries of history and hallowed landmarks of Europe, America's glory was found in its untrammeled and promising wilderness by Thomas Cole and the Hudson River School beginning in the 1820s. As Cole himself expressed it: "American associations are not so much of the past as of the present and the future. . . . You see no ruined tower to tell of outrage—no gorgeous temple to speak of ostentation, but freedom's offspring—peace, security, and happiness dwell there, the spirits of the scene."

In the nineteenth century the native inhabitants of the land were acknowledged as an appropriate subject for painting. George Catlin considered his documentation of the Plains Indians to be not art alone but a factual record of what were already considered vanishing cultures (Fig. 4). The early history of photography in this country shared a similar body of subjects. The earliest American photographers, the daguerreotypists, devoted themselves primarily to portraiture, but were also concerned with views of the city and the nearby countryside. Later nineteenth-century photographers turned

FIGURE 5 Homer, Winslow, *Snap the Whip*, 1872, Courtesy of The Butler Institute of American Art.

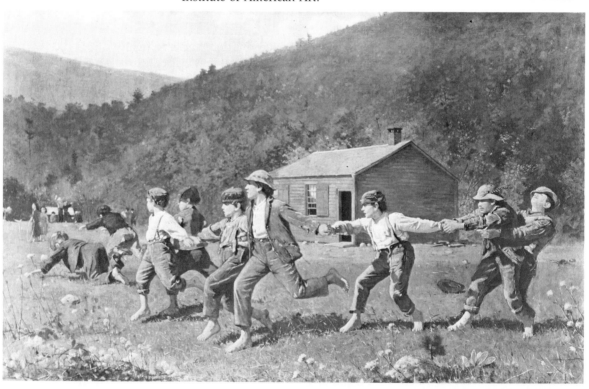

to more distant territories, documenting their virginal appearance for government surveys.

By mid-nineteenth century, another aspect of American life was found suitable for painting and sculpture. The average person at work or play in a picturesque rural setting came to epitomize *the* American subject matter for some artists. Genre painting and sculpture was often anecdotal and frequently sentimental. In the hands of a master like Winslow Homer, however, it could express the freedom, the joy of American country life.

For the fashionable art patrons in the decades following the Civil War, the portrait continued to be in great demand—not the simple, direct likeness of earlier times, but a theatrical, gestural style of painting that presented each sitter in the most favorable light. Typified by the portraits of John Singer Sargent, this approach to painting catered to the aspirations of the nouveaux riches of the "Gilded Age," whose palatial homes also reflected the elegance of the European culture they emulated. American art was dominated by that of Europe because wealthy Americans looked to that continent as the basis for their painting collections, and American expatriate artists established their careers there.

At the beginning of the twentieth century, another side of American life, the urban scene, became the subject of a group of painters who have become known as the Ashcan School. John Sloan, Robert Henri, and George Luks were among the artists who found inspiration in the life of New York's lower classes. Photographers too began to record this aspect of life in America, although Lewis Hine's and Jacob Riis's searing images of immigrants' lives in the city were not as optimistic as the paintings of the Ashcan School (Fig. 6).

Traditions of rural and urban genre persisted well into this century, still part of the quest for an American subject matter. Thomas Hart Benton's paintings often sang the praises of his native Missouri, while Edward Hopper's treated subjects like the melancholy of an all-night cafe.

Even when works became more abstract in style, many American modern artists did not totally abandon representational subject matter. The sleek lines of machinery can be seen in a Charles Sheeler painting or photograph, and Joseph Stella found expressive beauty in the Brooklyn Bridge and Coney Island. In the 1960s popular images from mass culture were transformed in context and meaning by pop artists like Andy Warhol and Claes Oldenburg.

AN AMERICAN STYLE

At the same time American artists were searching for a content expressive of national character and concerns, they were also considering the form of their work. In the beginning, it was enough to adapt

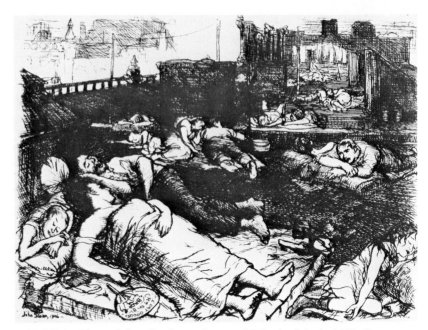

FIGURE 6 Sloan, John, *Rooftops, Summer Night* (etching), 1905, Courtesy of Delaware Art Museum, John Sloan Collection.

the styles of European masters. Gradually, however, certain distinguishing traits seemed to appear again and again in American art. Although intangible and not limited by any one style, they are nonetheless perceptible, and can be seen in many, though certainly not all, works of American art. For example, American artists seem to have a preference for clear, basically simple compositions, emphasizing line and sharply defined shapes rather than looser, more expressive form. American artists have often tended to avoid materials with a strong, sensuous quality, preferring crisp, dry surfaces in their work. Their vision has often taken in expanded vistas, imparting a spaciousness to their paintings which in recent decades has been translated to works of a large scale.

Generalizations such as these can be misleading and treacherous, for any number of American artists—Albert Pinkham Ryder is one outstanding example—have produced works with none of these "typical traits." Nonetheless, many American painters, sculptors, architects, photographers, and craftsmen seem drawn to these qualities.

It could be that the American concern with reality and clarity grew out of a Puritan heritage that demanded direct observation of nature and its faithful reproduction in a work of art. The concern for fact, rather than sensuous beauty, also grew out of a hardheaded Yankee practicality. The breathtaking illusion of Copley's *Paul Re-*

vere (Figure 1) is equaled in a trompe l'oeil still-life of a century later by William Harnett. The same precision and clarity of the work of a folk artist can be found in more sophisticated form in a mid-nineteenth-century luminist's seascape or a photo-realist's contemporary city scene. The passion for large scale can be seen as directly related to the vast territory of the United States and the artists' attempt to grasp and express their response to the open spaces.

American artists often went to extremes to record a scene accurately. Although involvement with verisimilitude is not unique to this country, it has been and is sought here with astonishing zeal. Samuel Morse calculated the perspective of the old House of Representatives (Figure 40) dozens of times in order to render it exactly. Thomas Eakins performed dissections so that he could have total knowledge of his subjects' inner structure. This passion for visual accuracy as well as our continuing national fascination with gadgetry resulted in the immediate and enthusiastic acceptance of photography in America. Eakins, along with a number of other artists, used photos as studies for painting. Eadweard Muybridge employed a battery of cameras to chart the exact progression of human motion. From its inception, the camera's realm was reality. From an Edward Weston artichoke to an Irving Penn cigarette butt (Fig. 7), American photographers haved used their cameras to examine the objects around them with a searching intensity unmatched anywhere in the world.

THE RELATIONSHIP OF AMERICAN ART TO AMERICAN LIFE

The search for an American subject matter and the search for a means to express it are constants in the history of American art. Another constant, one just as difficult to define, is the search for the artist's role in American society, the struggle to relate American art to American life. Generally, American artists have approached this problem in three ways: they have tried to make their art meaningful to everyday life, they have isolated themselves from an uncomprehending public, or they have left the country.

The first American artist to go to Europe for education and for patronage was Benjamin West, the Pennsylvania-born son of Quakers. West settled in London for the rest of his life, and there he welcomed a number of ambitious young American artists—among them, John Singleton Copley, who left his native land because, as he lamented, painting there was considered to be " no more than any other useful trade . . . like that of a carpenter, tailor or shoemaker, not as one of the most noble arts in the world."

The obligatory pilgrimage to study and absorb the art of the Old World continued well into this century. At the end of the nineteenth

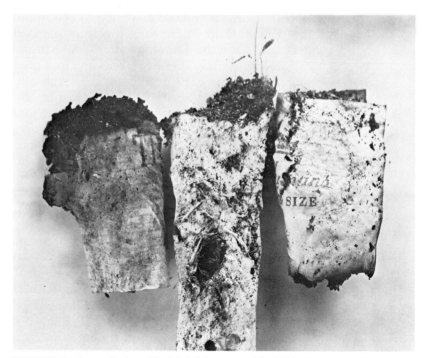

FIGURE 7 Penn, Irving, *Untitled* (photograph), 1974, Courtesy of Museum of Modern Art.

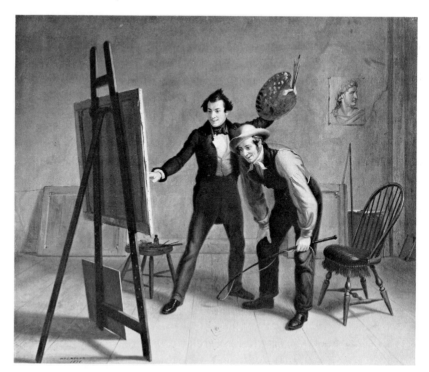

FIGURE 8
Mount, William
Sidney, *The
Painter's
Triumph*, 1838,
Courtesy of
Pennsylvania
Academy of the
Fine Arts. Be-
quest of Henry
C. Carey.

FIGURE 9 Levine, Jack, *The Art Lover*, 1962, Courtesy of National Collection of Fine Arts, Smithsonian Institution.

century, for example, major American talents like Mary Cassatt and James MacNeill Whistler also found their work strengthened by the contacts they made with European artists while living abroad.

Some artists, however, chose to stay at home and establish a relationship with the people and life around them. William Mount's 1838 painting *The Painter's Triumph* pictures this desire succinctly, with the artist dramatically presenting his masterpiece to a friendly farmer, initiating his hard-working neighbor into the joys of the fine arts. In Mount's time, genre painting and sculpture did indeed enjoy popular acceptance. However, artists have not always enjoyed so secure a position in American society. Artists have often been isolated, alienated from their audience, considered different. These differences are due, in part, to a generally held American belief that art is not practical, and to a suspicion that art is not work but play.

Over a century later Jack Levine painted the satiric image of *The Art Lover* precisely because the position of art in American life had changed, and art to many was the province of the sissy, the dandy, the frail aesthete. How, when, or why art received this image is difficult to pinpoint. Perhaps it was because the technological achievements of America always seemed to dominate the life of this nation. The production of artists seemed small and frivolous alongside the wonders of the inventor. Even Oscar Wilde was dazzled by

NOVEMBER 1934

ART FRONT

ARTISTS COMMITTEE OF ACTION

ARTISTS UNION

5¢

FIGURE 10 Cove:
for *Art Front*, 19...,
Courtesy of Ar-
chives of American
Art, Smithsonian
Institution.

American technology when he wrote: "There is no country in the
world . . . where machinery is so lovely as in America." Well into
the twentieth century there seemed to be little in American art to
compare with the integration of function and form, to match the
practical, undisguised American-ness of the Model T Ford or the
Brooklyn Bridge.

American art has always stood in the shadow of science and
technology, and from colonial times art has been treated as a second-
ary aspect of American life. Nevertheless, many American artists
have tried continuously to bring their life and their art into closer
harmony with that of the average citizen. The Ashcan School
painters in the early 1900s sought to relate to everyday life. These art-
ists left their studios to mingle with common people, to observe
them firsthand, and to make them the subject of their art. In addi-
tion, the Ashcan School painter George Luks introduced the "artist
as he-man" image into the art of this century. Luks favored painting
without refinements of technique. His art came straight from his

lusty, uproarious approach to life, an approach which counter-manded any popular stereotype of artistic fragility.

During the Great Depression of the 1930s, many artists stressed their political affinities with the working class. Through organizations like the Artist's Union or publications like *Art Front*, painters and sculptors proclaimed their right to work at wages equal to that of any laborer. When the federal arts projects offered them this opportunity, American artists responded enthusiastically. As workers under government patronage, artists rubbed shoulders with every level of society (Fig. 10).

To combat further the effete image of artists, a number of twentieth-century painters and sculptors, among them Jackson Pollock, David Smith, and most recently and humorously Robert Morris, have cultivated an image of rugged, hard-working, hard-living masculinity. Small wonder that women artists like Linda Benglis have mocked the male chauvinism of this equally inaccurate stereotype of the artist (see Figs. 11, 12, and 13).

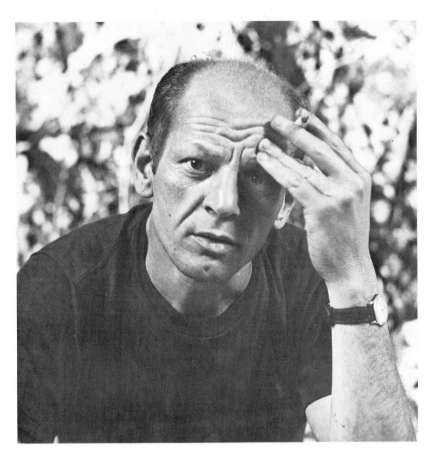

FIGURE 11 Namuth, Hans, *Jackson Pollock.* Courtesy of Hans Namuth.

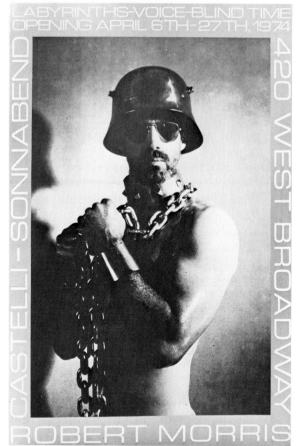

FIGURE 12 Poster for exhibition of the work of Robert Morris, Leo Castelli Gallery, New York.

Throughout American history, other artists, such as Albert Pinkham Ryder, have lived in total isolation from the average, middle-class American life, pursuing their art away from the pressures of society and the unappreciative public. Still others rejected the "uncultured" masses. Alfred Stieglitz, the great photographer and owner of an important art gallery, told the artists he represented, among them Georgia O'Keeffe, Marsden Hartley, and John Marin, that art in America was "for the few, and by the few." Stieglitz deliberately cultivated feelings of elitism among his artist-friends so that they could develop their artistic sensibilities without having to cater to uninformed tastes.

If American artists have been isolated from the general public, they have often felt isolated from one another. Indeed, one reason they settled abroad was to become active members of a respected professional group. With the establishment of artists' societies in the nineteenth century and the organization of events like the Centennial Exposition of 1876, the Columbian Exposition of 1893, and the

Armory Show of 1913, Americans were offered an opportunity to gather together and view one another's work. The federal arts projects of the 1930s and the arrival of the artist-immigrants from Europe before and during World War II increased the sense of an art community in America. Today one example of such a community is the Soho section in New York, where south of Houston Street (the location which supplies its name) artists gather in lofts, bars, and galleries to share ideas and opinions about the contemporary art scene.

To a great extent, the art world is still a closed society. The commercial galleries of New York and around the country are open to the public, but the art within them remains aloof from the understanding of the average person. Ever since Americans first glimpsed avant-garde art in the Armory Show of 1913, there has been a widespread suspicion that modern art, and especially abstraction, is somehow vaguely un-American. If art is to be useful, if it is to have a purpose in this society, so the popular reasoning goes, it must be understood by all. How can it have an effect, if it does not communicate unerringly to the masses? Our Puritan heritage also tends to make us suspect that if a painting or sculpture looks as if it were made without hard labor or was an industrial fabrication, or looks, in fact, as if anyone could have done it, then it must, of course, be worthless. Is art always the result of skilled physical labor? Does art have to relate to everyone? Must art always attempt to reproduce the appearance of objective reality?

If the questions that guide this study are straightforward, the answers remain complex and, at best, tentative. The history of this country's art, like the history of all art, is not a series of neat equations with conclusive products. The issues of national subject matter, style, and popular assimilation remain open, changing, and tantalizingly alive.

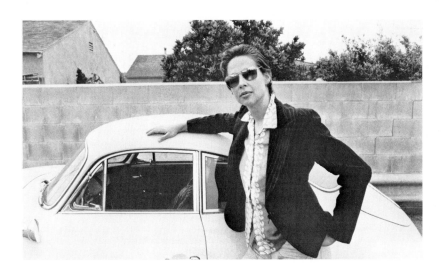

FIGURE 13
Photo of Lynda
Benglis, Paula
Cooper Gallery.

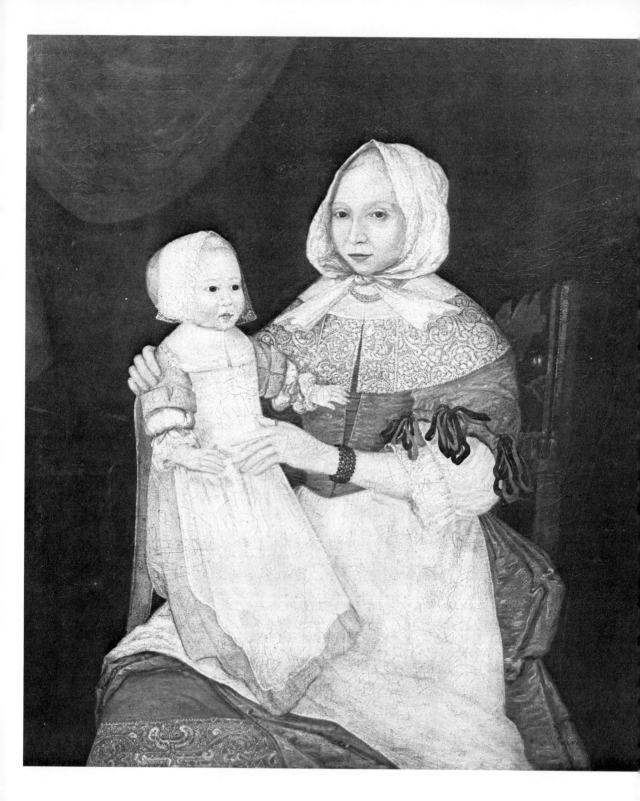

CHAPTER 2

ARTISANS TO ARTISTS

When did American art begin? The search for the origins of American art would naturally lead to the first Americans, the native Indians, and the rich body of crafts and arts of their various cultures. It would also lead to the religious art made for the Spanish settlements in the Southwest. A third source could be traced to the Eastern seaboard of the United States. Here, in the early seventeenth century, as the Colonies were being settled by people of English, Dutch, German, and French origins, a significant tradition of American art was born. Although by no means the only one, this tradition grew with the developing nation and has been the most dominant one during the country's 200-year history.

Rather than being founded by artists trained in Europe, this tradition was founded by artisans, craftsmen who applied their skills to fashioning dwellings and furnishings and painting signboards and decorations. Working to make living in the new land more hospitable, these artisans were also called on to paint the likenesses of members of the community and to carve memorials to lost loved ones. As life became easier, the desire for these luxuries increased,

and artisans catering to the new demands began to improve their skills, developing by the first half of the eighteenth century from artisans to artists.

THE LIMNERS

The Puritans of the Massachusetts Bay Colony and the Pilgrims at Plymouth considered the fine arts frivolous and impractical, smacking of the corruptions of the European society they had fled. But portraits, reminders of loved ones, were always acceptable. Painting, then, originated in the form of portrait likenesses. The earliest portrait painters were self-taught and often itinerant, moving from place to place in search of new commissions. Their identities have for the most part been obscured by time, and today they are recognized by the names of their subjects or the localities in which they worked. These artists have been designated by the name *limner,* a term which was generally used in the sixteenth and seventeenth century in England for manuscript illuminators and painters.

Many of the characteristics of the work of our early limners can be seen in the portrait of *Mrs. Elizabeth Freake and Baby Mary* (Fig. 14), painted about 1674 in the Boston area. The patterns of lace, bows, and embroidery are fastidiously rendered, while the bodies are flat and stiffly posed. Baby Mary seems like a wooden doll propped against her mother, yet her delicately modeled face glows with light. There is a grace and charm to the portrait that overrides its technical limitations. The painting also reflects a sophisticated European source, the Tudor portraits of 100 years earlier. Without access to the latest court portrait paintings in the Flemish and Italian style, the colonial limner recalled this earlier manner of painting. The flat, decorative approach and elegant simplicity of Tudor painting also suited his skills and patrons. These characteristics can be found in many limner paintings. The portraits of the *Mason Children* and *Margaret Gibbs* and her brother *Henry Gibbs,* for example, emphasize the overall two-dimensional design, rather than illusionistic space. The demeanor of each sitter is grave and proper, yet, as the brightly colored and trimmed clothing reveals, our Puritan forebears were not as sober and straitlaced as popular belief would indicate.

Boston was one of three centers for early colonial painting, which included the tidewater area of Virginia and the region of New York settled by people of Dutch and German origins, the patroons. Interesting regional variations resulting from differences in national origin, patronage, and the concentration of artists in a particular area are evident within the limner tradition of the period. Artists in Virginia, for example, tended to follow aristocratic English sources closely. The limner who painted a portrait of *Edward Jacquelin, Jr.,*

son of one of Jamestown's leading families, borrowed the pose and costume from an English court portrait which he had seen in an engraving. In addition, however, he included a native detail—the boy's pet, a Carolina parakeet. A rich tradition of patroon painting was established by the relatively large number of painters working in the Hudson River Valley. Dutch portraiture of the seventeenth century was their most immediate source. One of the most lively and interesting paintings from New York is of young *Magdalena Gansevoort*, who is shown wearing a gaily patterned dress and bright red shoes and standing in an elaborate architectural setting.

Although most seventeenth-century painters remain unidentified, the name of one exceptional artist has not been lost. He was Captain Thomas Smith, a mariner who painted portraits and worked in the Boston area in the 1670s. Not much else is known about the artist, although his self-portrait sheds some light on his personality

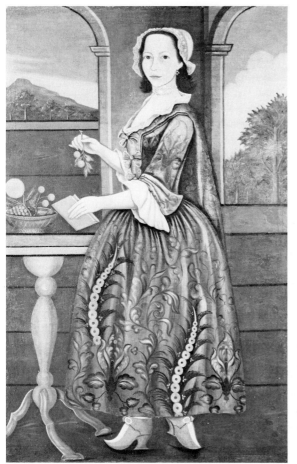

FIGURE 15 Unidentified artist, *Portrait of Magdalena Douw (Gansevoort)*, c. 1729, Courtesy, The Henry Francis du Pont Winterthur Museum.

FIGURE 16 Smith, Thomas, *Self Portrait*, 1670, Courtesy of Worcester Art Museum.

FIGURE 17 Un-identified artist, *Anne Pollard,* 1721, Courtesy of Massachusetts Historical Society.

and convictions. A battle at sea in the background of the painting evidently refers to Smith's career as a ship's captain. Also included in the portrait is a poem relating a note of personal philosophy. The verse proclaims the artist's willingness to face death, not with fear, but with confidence in the crowning glory of salvation. Unlike the limners before him, Smith depicts forms rounded by light and shadow and situated in deep space in the manner of seventeenth-century court portraits in Europe. While Smith may have seen European paintings firsthand during his travels, other colonial painters relied on mezzotint engravings of portraits to keep up-to-date with current developments in painting. As a result of the increased dissemination of these mezzotint engravings in the Colonies by the end of the seventeenth century, limner paintings began to change in format and style.

The artist who painted the portrait of *Elizabeth Paddy Wensley,* for example, included a vase of flowers in the painting and posed her turning slightly, rather than frontally as earlier limners generally would have done. While this more elaborate composition was probably inspired by an engraving of a fashionable English portrait, it does not equal the effects of deep space, rich colors, and sumptuous textures of its source, because the limner was using only a black-and-white print of the painting.

Although limners tended to flatten and dematerialize their subjects' form, they often focused attention on facial features. The most striking aspect of the Elizabeth Wensley portrait is her face—somber, almost petulant, yet compelling. Another early portrait with a fine characterization is that of *Anne Pollard*. Painted in 1721, the portrait convincingly portrays the vigor and vinegar of the 100-year-old matriarch, who claimed she was the first person to land on America's shores with Governor Winthrop's party when she was a small child. The series of sharp angles employed to form her body and head suit the forcefulness of the old dame's personality (Fig. 17).

SEVENTEENTH-CENTURY ARCHITECTURE

Portraits were a luxury in the Colonies; buildings, a necessity. American architecture, like painting, was founded on adaptations of European designs. As quickly as possible, the settlers replaced their rude, temporary dwellings with stronger, more comfortable homes. In the Massachusetts area in the seventeenth century, the most common type of structure was the frame house such as the Fairbanks House in Dedham. The original single-room structure with a loft, chimney, and steep roof was enlarged over the years, growing almost organi-

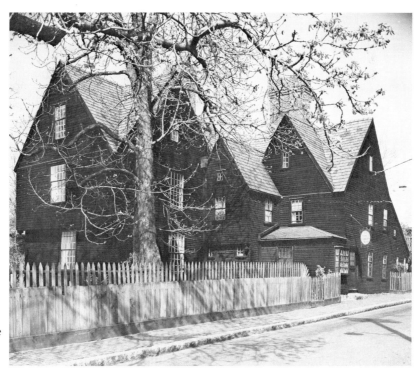

FIGURE 18 *Turner House* (House of the Seven Gables), 1668, Salem, Mass.

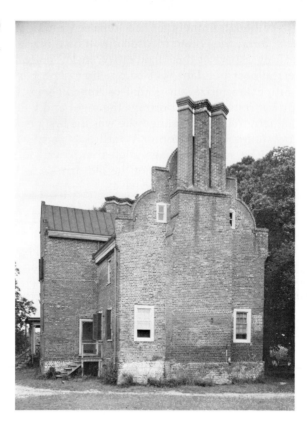

FIGURE 19 *Bacon's Castle* (Arthur Allen House), 1655, Surry County, Va.

cally to meet the needs of its owners. Because of its picturesque additions, the Turner house in Salem acquired its fame as Hawthorne's *House of the Seven Gables* (Fig. 18). Most New England houses of this type were sheathed with wooden clapboards which covered and protected the half-timber and plaster construction derived from rural English architecture. To insulate the house from the bitter New England winters, doorframes and windows were built flush to the clapboards. As a result, the colonial version tends to emphasize plane surfaces and define linear details more sharply than the English original.

Necessity was not the only consideration in colonial architectural design. The Parson Capen house in Topsfield, Massachusetts, is a particularly imposing example of late-seventeenth-century architecture. With its second story overhang and corner decorations called *pendills,* the structure is elegantly simple. A central chimney opens off each room, providing a structural core as well as a social center for the home. The spacious parlor with its low-beamed ceiling, cavernous hearth, and simple, but finely finished, woodwork is fitting for a family of rank in the community.

Although the wooden frame house was the most common type in New England in the seventeenth and early eighteenth centuries, there were some exceptions. The Henry Whitfield house in Guilford, Connecticut, for example, was built of massive stones. Yet because of the scarcity of lime for mortar in New England, wood was the most common building material.

Brick was first used in the Southern colonies, where lime was more plentiful. As early as 1655, houses such as *Bacon's Castle* in Surry County, Virginia, displayed the fine brickwork found in its clustered chimneys and stepped gables. The floor plan for the house, a cruciform one with central entry hall and stairway, was derived from the English manor house rather than from the humbler rural cottage. Because of their closer ties to the upper-class society in Europe, the Southern colonists often aspired to more aristocratic ideals and models than their New England counterparts. Early Anglican churches in Virginia, St. Luke's Old Brick Church in Smithfield, for example, were modeled after rural English Gothic churches with decorative buttresses, pointed arch windows, and simple truss ceilings. In New England, such references to traditional Anglican or Catholic church designs were rare. More common was the simpler meeting house, of which the Old Ship Meeting House in Hingham, Massachusetts, is a fine example. An unadorned square structure with white clapboard walls, a steep-hipped roof, and simple belfry, the house of worship is nevertheless imposing and handsome. The simplicity and strength of the exterior is carried to the interior with its lofty supporting beams, finely crafted wooden pews, and central pulpit.

EARLY SCULPTURE

The same Puritan rejection of traditional religious designs can be found in America's first sculpture—gravestone carvings in New England. Although the use of graven images was considered sinful, religious themes associated with death were acceptable and were dealt with through a rich vocabulary of symbols and designs. In fact, funerals were one of the few Puritan occasions suitable for pomp and ceremony and the display of paintings and carvings. Craftsmen found models for their designs in books, engravings, and even carved wood furniture. The designs are not deeply cut, but have a flat,decorative quality drawn from predominantly two-dimensional models. Symbols developed for the gravestones center on themes of death and rebirth. Floral designs and even female breasts symbolize the more optimistic attitude, while the more sombre images are commonly represented by skull and crossbones, the hour glass of time, or a winged head. Because gravestones also served as public admoni-

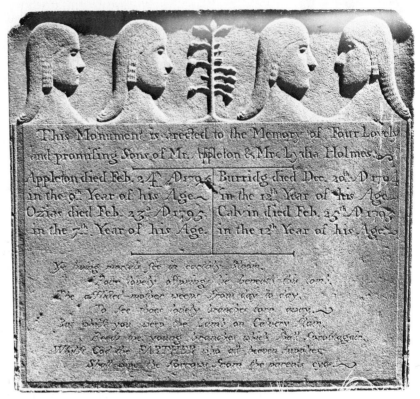

FIGURE 20 *Appleton Holmes Children Gravestone*, 1795, Cemetery, East Glastonbury, Conn.

tions, they often possess a stern or macabre quality, rather than a tender, mournful one.

In the eighteenth century, sculptors began to include portrait likenesses on the stones. Although the carving is shallow and the representation awkward, there are still strong characterizations in many of the portraits of colonists, such as those of Nathaniel Rogers and Thomas Barrett. More generalized profile portraits decorate the melancholy stone for the four young sons of Mr. and Mrs. Appleton Holmes. This gravestone also includes the poignant symbol of the family tree with four branches broken from it.

These gravestones are not just interesting records of our Puritan forebears; until the nineteenth century, they were also among the few sculptural works in America. The artisans who were called to work on them brought traditional skills and ingenuity to the task. In addition, sculpture as craft, for interior decoration, ships' figureheads, weathervanes, and toys, flourished in this early period and continued in the eighteenth and nineteenth centuries.

ARCHITECTURE AND PAINTING
IN THE EIGHTEENTH CENTURY

In the first decades of the eighteenth century as the Colonies pros-
pered and grew, architecture and painting developed rapidly. Ar-
tisans were imported from England to build the colonial capital of
Williamsburg as a planned town, with architecture based on the de-
signs of the great English architect, Sir Christopher Wren. With
architectural details drawn from the classical past and based on the
sixteenth-century designs of the Italian architect Andrea Palladio,
Williamsburg's capitol, palace, and residences are elegant and
restrained versions of the Georgian style.

Southern plantation owners, following architectural model
books, supervised the building of impressive country homes such as
the Lee Mansion in Stratford, Virginia, and Mount Vernon, George
Washington's famous home. In the New England colonies, wealthy
merchants also built in the latest style. The wooden exterior of Isaac
Royall's house in Medford, Massachusetts, like that of Mount
Vernon's, was made to imitate the rusticated stonework of its
English source. Churches, such as Dr. John Kearsley's Christ Church
in Philadelphia with its high steeple, Palladian window, and spa-
cious interior, were also based on English architecture of the eight-
eenth century.

The flourishing economy of the Colonies began to attract profes-
sional portrait painters from Europe. An artist from Germany, Justus
Kuhn, for example, settled in Maryland, where he found a brisk
trade for his portraits among the leading families in Annapolis and
neighboring counties. Although Kuhn, like so many other artists
who came to America, was not among the major painters in his na-
tive land, he was able to introduce colonial painters to the currently
fashionable portrait formulas and a more advanced knowledge of
techniques, valuable lessons for native artists. Each region had its
own imported talent. The English painter Charles Bridges worked in
Virginia in the 1730s painting portraits of members of prominent
families. In Charleston, South Carolina, an Englishwoman named
Henrietta Johnston specialized in pastel portraits, using the medium
of compressed powdered pigment to create delicate likenesses.

One of the most important of the imported European talents was
a Swedish artist named Gustavus Hesselius, who worked in Dela-
ware and Pennsylvania and on the eastern shore of Maryland.
Although his training was in the fashionable European manner,
Hesselius was more concerned with capturing the character and per-
sonality of his subjects than with reproducing sumptuous textures or
creating elegant settings. For the portrait of his wife, Lydia, Hes-
selius used somber colors and a simple, uncontrived pose so that de-

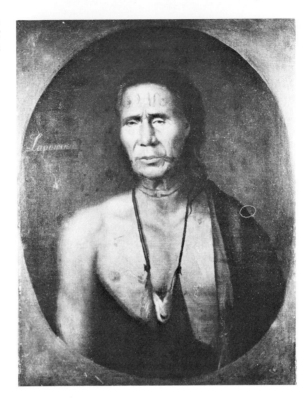

FIGURE 21 Hesselius, Gustavus, *Lapowinsa*, 1735, Courtesy of The Pennsylvania Historical Society.

tails would not detract from her kindly features and apparently pleasant disposition. One of his most impressive portraits is of *Lapowinsa*, chief of a Delaware tribe. The portrait, which was commissioned by an unscrupulous dealer who had tricked the chief out of his tribal lands, sensitively portrays the troubled but dignified leader.

Hesselius was one of the first artists in the Colonies to paint religious and mythological subjects, among them a *Bacchanalian Revel* and *Bacchus and Ariadne*. Based on engravings, the images were circumscribed by propriety and the limits of his skills. Nevertheless, Hesselius's efforts in this direction were a notable addition to colonial art. Hesselius, like many other colonial artists, was not reluctant to apply his talents to less lofty pursuits than portrait painting. He and a partner were employed as wall painters for the state house in Philadelphia—today the famous Independence Hall. This impressive landmark was finished in 1753 and is another colonial adaptation of the classical Palladian revival and Sir Christopher Wren's monuments.

In Boston, the foremost European artist was a Scotsman, John Smibert. Smibert came to New England by chance. His original plan was to join the faculty of a university to be established in Bermuda by Bishop George Berkeley. Lack of funds left Berkeley, his family,

and his faculty stranded en route from England in Newport, Rhode Island, in 1729. The project a failure, Smibert moved on to Boston, where he soon established a studio and began a successful career in the Colonies.

Although Smibert was a competent artist, his career in Europe had not been outstanding. In America, however, he outshown his fellow artists and was received with great acclaim. In 1730, when he held an exhibition in his studio, one awed visitor even called him a "great master." One of the first portraits that Smibert painted in the Colonies was of Bishop Berkeley, his family, and the faculty of his ill-fated university. Known as *The Berkeley Group,* or *The Bermuda Group,* the painting includes eight life-sized figures posed with studied informality. Gestures and glances lead the eye from figure to figure, textures are handsomely rendered, and color and light link the figures with the surrounding space and background.

Smibert's influence on colonial art extended beyond his paintings, for he owned and displayed a small collection of engraved and painted copies of Renaissance and baroque masters' works. A Raphael madonna and a Van Dyck portrait were among them; he also owned casts from ancient sculptures, including the bust of *Homer* and the *Venus de Medici*. In effect, Smibert's studio was the first art gallery in the British-American colonies, providing native artists

FIGURE 22 Smibert, John, *The Bermuda Group: Dean George Berkeley and His Family,* 1729, Yale University Art Gallery. Gift of Isaac Lothrop of Plymouth, Mass. 1808.

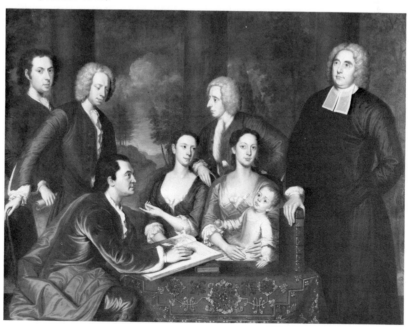

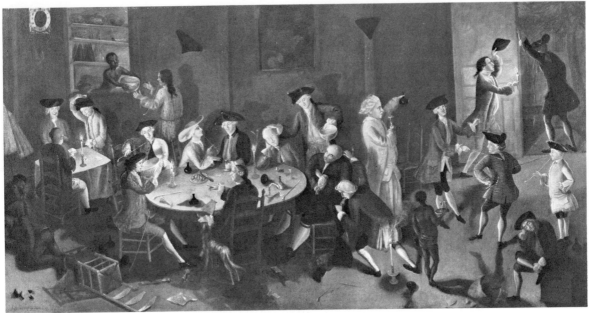

FIGURE 23 Greenwood, John, *American Sea Captains Carousing in Surinam*, 1755, The St. Louis Art Museum.

with samples of the great art of the past. His influence on colonial artists was considerable.

Smibert's *The Berkeley Group* was the model for a group portrait of the Greenwood and Lee families by John Greenwood. Taking up painting after an apprenticeship with an engraver, Greenwood benefited from the example of the more accomplished European artist. His group portrait, however, is but a charming parody of the Smibert painting. The subjects are posed self-consciously, their proportions seem wooden, and their curved arms and gesturing hands lead the viewer awkwardly from person to person. Although Greenwood's skills as a portrait painter were not considerable, he did excel at depicting genre scenes, or subjects taken from everyday life. His mezzotint engraving of *Jersey Nanny* is a forthright and sympathetic portrayal of the character whom he also described in an inscription which reads as follows:

> Nature her various skill displays
> In thousand Shapes, a thousand Ways
> Tho' one Form differs from another
> She's still of all the common Mother;
> Then, Ladies let not Pride resist her,
> But own that NANNY is your sister.

Another Greenwood genre piece, *American Sea Captains Carousing in Surinam* (Fig. 23), was painted in 1775 on bedticking. The raucous assembly at this port of call for Yankee sea merchants on the northeast coast of South America is depicted with satire and rough humor. In this amusing and unusual counterpart of William Hogarth's tavern scenes, specific individuals can be identified. Captain Nicholas Cooke, who later became Governor of Rhode Island, sits at the table with a long pipe talking to one Captain Esek Hopkins; Captain Ambrose Page is using a friend's pocket as a vomit bag while accidentally igniting his coattails; and the queezy artist himself pauses to vomit at the doorway as he leaves the tavern.

The most outstanding native portrait painter of Greenwood's generation was Robert Feke. Active as a painter beginning in 1741, Feke worked in Newport, Boston, and Philadelphia but dropped out of sight in 1750 after a brief 9-year career. Little else is known about his life, but his paintings are vivid proof of his talent. Feke, like Greenwood, was influenced by John Smibert's painting, *The Berkeley*

FIGURE 24 Feke, Robert, *Isaac Royall and Family*, 1741, Harvard Law School Gallery, New Cambridge, Mass., by permission of Fogg Art Museum, Harvard University.

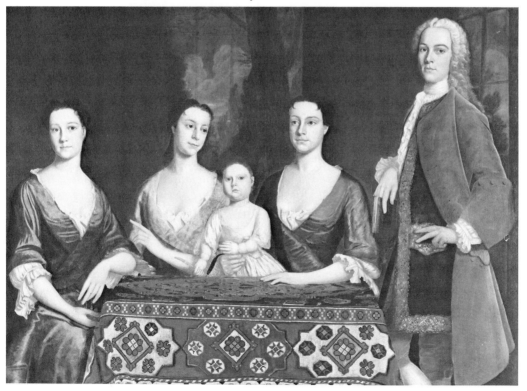

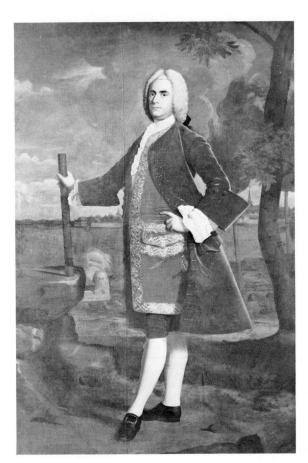

FIGURE 25 Feke, Robert, *General Samuel Waldo*, 1748, Bowdoin College Museum of Art. Bequest of Mrs. Lucy Flucker Thatcher.

Group. In his portrait of *Isaac Royall and Family* (Figure 24) of 1741, Feke followed the format of the earlier work, arranging the figures behind a draped table. Though the similarities are notable, the differences are revealing as well. Despite Feke's ability to simulate textures and his creation of color harmonies, there is still an awkwardness in his handling of the figures and a reliance on surface design. The emphasis on the flat pattern of the Turkey-work rug and separation of the figures from the background are characteristics shared with earlier limner works. Although Feke quickly improved upon his first efforts, underlying his most accomplished portraits are the clarity and simplicity of the emerging native tradition.

The masterpiece of Feke's mature style is his portrait of *Brigadier General Samuel Waldo.* The figure is life-size, standing in a dignified pose with one hand resting on his hip, a long coat pulled back to reveal a brocaded vest, and his free hand holding a spyglass. In the distance, the bombardment of the fort of Louisburg can be seen, a battle

in which General Waldo participated. The portrait is a successful combination of a formal pose, handsomely rendered textures, and a forcefully portrayed figure in a dramatic landscape. Not only had Feke learned from John Smibert but he ultimately surpassed him. In Robert Feke, colonial America found its first distinctive native-born artist. In less than a century, the native tradition had evolved from unsophisticated beginnings to a new self-awareness, from artisans to artists.

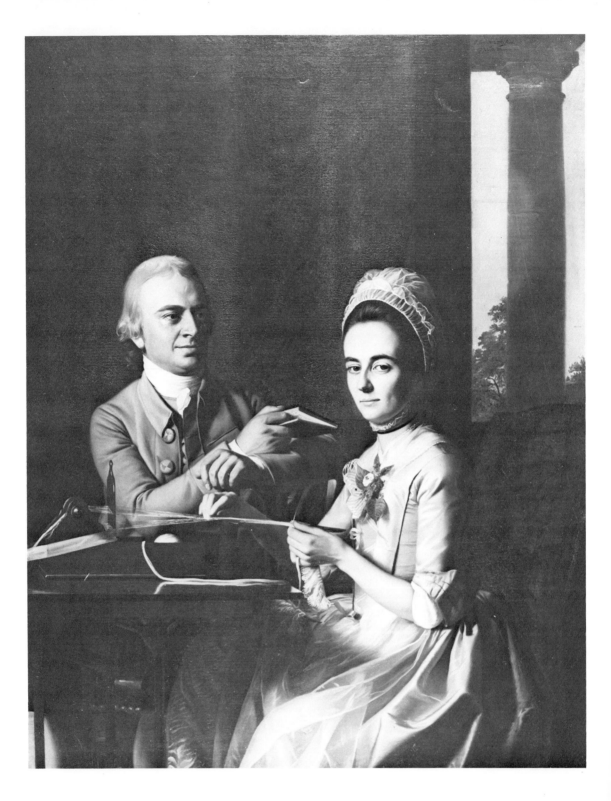

CHAPTER 3

AMERICA'S OLD MASTERS

In the work of Robert Feke, colonial portraiture enjoyed its first flowering, yet American art was still an insignificant species compared with its European counterpart. Colonial artists were handicapped by their distance from the museums, enlightened patronage, and academies of the Old World. If America was not yet ready to establish and sustain artistic communities and institutions, the only solution was for artists to travel to Europe. At a time when the first stirrings for independence were being felt in the Colonies, three artists appeared with sufficient genius and ambition to transcend the talents of their native predecessors. Astonishingly, not only did they achieve preeminence as painters in their own land, but they won the esteem of Europe as well. With the work of these men, John Singleton Copley, Benjamin West, and Gilbert Stuart, American painting emerged as an individual and distinct tradition. Their achievements inspired generations of American artists and earned them the affectionate designation of "old masters."

COPLEY IN THE COLONIES

The greatest of these colonial painters, John Singleton Copley, was born in 1738 in Boston, Massachusetts, one of the centers for early colonial painting. Here John Smibert had opened his studio and exhibited examples of the great art of the past alongside his own portrait paintings. Another English artist and a close associate of Smibert's, Peter Pelham, also worked in Boston. Pelham had preceded Smibert to the Colonies and worked as a mezzotint engraver, depicting such famous figures as Cotton Mather, the Puritan scholar. One of those not uncommon colonial phenomena, a jack-of-all-trades, Pelham offered instruction in "dancing, writing, and painting on glass," as well as his services as an engraver. By a fortuitous coincidence, he married Copley's widowed mother and consequently opened up the world of art to his young stepson.

Although Copley was only 13 when Pelham died, he benefited greatly from the brief 3 years of their relationship, not only learning the craft of engraving but also studying prints of European masterpieces and the books on art that Pelham had brought from England. In 1754, he copied one of these prints, an Italian seventeenth-century engraving of *Galatea*. His translation of the black-and-white print to a color painting was remarkably successful. Although the anatomy and perspective are awkward, the pastel colors are appropriate to the gaiety of the subject and the painting conveys energy and movement. It was quite an ambitious undertaking for an untutored boy of 16, particularly in the Colonies, where painting was, for the most part, limited to portraiture. To improve his skills and lay the groundwork for more than just an engraver's trade, young Copley prepared an anatomy book with carefully drawn studies of muscle and bone structure.

In the 1750s, Copley began his career as a portrait artist in Boston. For a group portrait of *The Brothers and Sisters of Christopher Gore* in 1755 (Fig. 26), he looked to several artists' works for inspiration. John Greenwood's *Family Group* and Robert Feke's *Issac Royall and Family* (Figure 24) provided examples for the poses of the figures, and John Smibert's portraits suggested an approach to painting drapery and faces. Obviously an early effort, with the figures somewhat wooden, the paint application dry, and the drawing tight, the portrait nevertheless demonstrates gracefulness and harmony that hint at future mastery.

After painting *The Gore Children*, Copley was introduced to the more current rococo style of portraiture by Joseph Blackburn, who had arrived from England in 1755. Within the next 3 years, Copley's abilities improved considerably. His adaptation of the new, more elegant manner of portrait painting is readily apparent in his beautiful portrait of the *Daughters of Isaac Royall*, where the stiff poses and

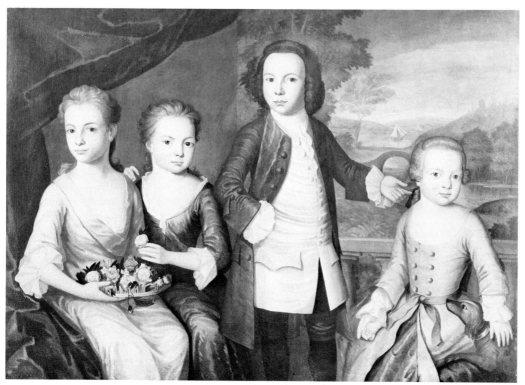

FIGURE 26 Copley, John Singleton, *The Gore Children*, c. 1753, Courtesy, The Henry Francis du Pont Winterthur Museum.

tight drapery of *The Gore Children* are replaced by glowing colors, the representation of luxurious fabric, and the depiction of graceful models placed within deep space. The girls' pet bird and dog add to the casual and youthful mood of this portrait of the richly dressed daughters of the prosperous Boston merchant. Copley's ability involved more than just the dazzling representation of satins, laces, and bows, however, for he skillfully revealed the animation and pleasant dispositions of the two girls as well.

As Copley mastered his craft, his ability to capture the personality of his sitters increased. In the portrait of *Epes Sargent* painted about 1760, the prosperous merchant, shipowner, and Massachusetts assemblyman is depicted as an outgoing, personable man. Sargent is shown leaning against a broken column, a common prop in European portraits. The color scheme is limited to warm greys and browns, and the focus of attention is on the subject's strongly modeled face and gnarled, expressive hand.

During the 1760s Copley began to use pastels for some of his portraits. The best-known colonial artist in the medium was Henrietta Johnston, who had worked earlier in Charleston, South Carolina, but there is little evidence of the medium being used

extensively in New England. Simpler in composition than his paintings and usually confined to the face, Copley's pastel portraits involved the direct approach of drawing in color. Although he found working with pastels easier than the more painstaking and slow process of painting in oil, his works in this medium remained secondary. He chose pastels for an early self-portrait of 1769. By this time, Copley was in his early thirties and his reputation as an outstanding portrait artist was established not only in Boston but along the New England coast.

To suit his prosperous colonial patrons' desire for the sophistication of European works, Copley often used costumes and props found in engravings of fashionable English portraits, a practice that many of his predecessors had followed. Mary Toppan Pickman probably selected the elaborate costume she wears in her portrait from just such a print. Another Copley portrait, of *Mrs. Jerathmael Bowers*, is a direct transcription of an engraving of a portrait of *Lady Caroline Russell* by the celebrated English painter Sir Joshua Reynolds. Even the pet dog in her lap is the same! For Copley, however, a portrait involved more than just a contrived pose and flattering likeness; the character and the physical presence of his subject were even more compelling. Competent English paintings, seen secondhand through engravings, could hardly begin to provide a means to express substance and meaning. For these Copley had to draw on his own intellect and observations.

As Copley's art matured, he began to place his subjects in settings appropriate to their status or vocation and to offer more insight into personality. A judge stands in a classical setting representing the halls of justice; a merchant turns from his desk with pen in hand; a woman looks up from her reading. In his portrait of *Paul Revere* (Figure 1), the famous Revolutionary hero is shown in prewar days with the tools of his silversmith trade. Dressed in his shirtsleeves, and without the fashionable powdered wig, the unpretentious Revere looks up from his beautifully crafted teapot with a forthright gaze. In contrast is Copley's portrait of *Nicholas Boylston*. Another future supporter of the Revolution, Boylston chose to wear an elegant dressing gown and turban on his head, which had been shaved for wearing a wig. Here, too, the character of the shrewd and successful merchant is as important and striking as the luxurious setting. Copley also painted Boylston's mother, depicting her as a bright, richly dressed, but down-to-earth, woman of 70. Equally appealing and frank is his portrait of *Mrs. Ezekiel Goldthwaite*. Copley has emphasized the personality of his sitter by representing her with a distinctive and individual gesture—here reaching for a peach that she has grown in her own garden, a peach as round and appealing as the woman herself. Copley here again used a favorite device, a polished table in the foreground in order to establish the figure in space (Fig. 27, p. 30).

The double portrait of visitors from Philadelphia, *Mr. and Mrs.*

Thomas Mifflin, is one of his most outstanding works. As if interrupted during a quiet afternoon at home, Mrs. Mifflin looks up from her lace making and Thomas Mifflin pauses in his reading. Shadows are deep, and the figures emerge in the sharply focused light. The couple seems to be frozen in a moment of time, caught in the clarity of Copley's space and imbued with the quiet dignity that he imparts to them. Truly Copley's gifts as a painter were extraordinary.

Although prosperous and famous, Copley was not content. Being the best artist in New England wasn't enough; John Singleton Copley wanted to compete with the best artists in the world, with European artists. Accordingly, with some trepidation, he sent a portrait of his stepbrother, Henry Pelham, to England for exhibition at the Society of Artists in London in 1766. Entitled *Boy with a Squirrel,* the painting was taken to England by Copley's friend, Captain R. G. Bruce, who sought the opinion of no less a person than Sir Joshua Reynolds, the president of the Royal Academy. In the painting, young Henry Pelham looks up from playing with his pet squirrel, which is nibbling on a nut. The gleaming table and glass of water look breathtakingly real. Besides these surface effects, however, Copley successfully captured the look and manner of an adolescent boy. To his gratification, the work was well received; the American was elected a member of the Society of Artists. Captain Bruce reported that Reynolds found the painting "a very wonderful performance. . . . If you are capable of producing such a Piece by the mere Efforts of your own genius, with the advantages of the Example and Instruction which you could have in Europe, you would be . . . one of the First Painters of the World." Reynolds also had some criticism, finding "a little hardness in the Drawing, coldness in the shades, an over-minuteness." But these flaws, he added, "could be corrected if he would but journey to Europe" before it was too late. In the meantime, Copley sought to correct the faults by painting another work, *Young Lady with a Bird and Dog,* which he then sent to the Society the following year. However, his second effort brought only disappointment and further criticism.

Although Reynolds had referred to Copley working in his "little way" in Boston, his achievements and fortunes continued to accumulate there. In 1769, he married the daughter of a rich merchant, purchased a home on Beacon Hill, and soon had a growing family and obligations. These practical considerations delayed Copley's move to London by nearly 10 years.

BENJAMIN WEST

Copley's contemporary, Benjamin West, had already taken this major step. He was just beginning his career in London when Copley's *Boy with a Squirrel* was exhibited. Their early development as

artists in the Colonies was strikingly parallel. West, the son of a Quaker innkeeper, was born in the same year as Copley in Chester, Pennsylvania. Like Copley, he learned from the works of the local artists who preceded him: the Swedish painter Gustavus Hesselius, John Wollaston who arrived from England in 1749, and William Williams, whose portraits were painted in the rococo manner of the mid-eighteenth century. As Peter Pelham had helped Copley, William Williams introduced young West to prints of European masterpieces and books on art.

West began his career in Philadelphia, painting portraits such as that of the young *Thomas Mifflin*, but he lacked Copley's natural aptitude for portraiture. Moreover, he held a higher ambition, inspired not only by his discussions with Williams and his study of engravings of masterpieces but also by seeing an original European painting firsthand—a Spanish eighteenth-century work in the Governor's house. West wanted to be a history painter, to work in what was considered to be the highest form of art, far superior to portraiture. As this time, great art was measured by content and meaning, and subjects from history, mythology, and literature provided the painter with content of greatest significance.

Because America offered neither exposure to history paintings nor patrons to commission them, Europe, the source for the tradition of history painting, beckoned to West. In 1760, at the age of 21, he was able to travel to Italy through the financial assistance of several merchants. As one of them explained, "It is a pity such a genius should be cramped for the want of a little cash."

Almost immediately, West's career took a fortuitous turn when in Rome he was welcomed into the circle of Johann Winckelmann, the great German archeologist and scholar. Inspired by the recent discoveries at Pompeii and Herculaneum, Winckelmann was a leading proponent of a classical revival in the arts, promoting not only the use of the antique in paintings and sculpture but also the incorporation of the classical ideals of "noble simplicity and calm grandeur." Winckelmann's belief that morality should be restored to art, replacing the excesses and frivolity of the eighteenth-century court style, was a sentiment that appealed to the sober Quaker.

After 3 years in Italy, West journeyed to London. One of his first efforts there at history painting, *Agrippina Landing at Brundisium with the Ashes of Germanicus* (Fig. 28), was based on writings of the Roman historian Tacitus, and was painted in the spirit of the art theories he had learned in Italy. Meant to be both edifying and classically restrained, the solemn subject depicts the noble widow of an assassinated Roman general who defied imperial order by bringing her husband's ashes home for a hero's burial. West carefully balanced the composition, placing the key figures in the center and painting them in a smooth, sculptural manner like a classical frieze. Mon-

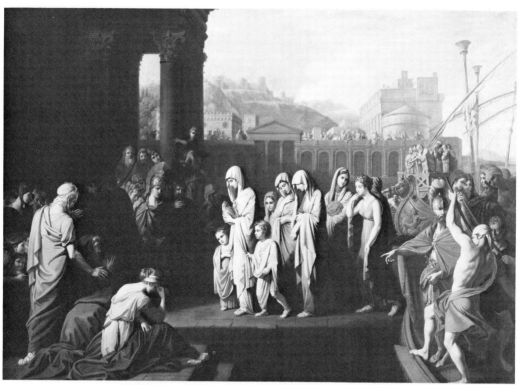

FIGURE 28 West, Benjamin, *Agrippina Landing at Brundisium with the Ashes of Germanicus,* 1768, Yale University Art Gallery. Gift of Louis M. Rabinowitz.

umental architecture derived from antiquity provided an appropriate setting. The young American was breaking ground with this work: first, by dealing with what was considered the most elevated form of art, history painting, and the second, by being among the first to embrace the classical revival which would reach its peak at the turn of the century.

With this painting, West soon established himself as a painter of rank and had the good fortune to receive royal patronage. By 1772 he was appointed History Painter to King George II, with whom, in fact, West developed a remarkably close friendship. No longer limited to portraiture, West was able to draw from a wealth of literary and historical sources. Even when he dealt with lighthearted subjects drawn from Greek mythology, such as *Cupid Stung by a Bee,* West included a moral or didactic theme. In this painting, Venus comforts her child, Cupid, but also reminds him that his love arrows cause even greater pain. Because of the popularity of paintings such as this, West earned a reputation as the "American Raphael."

West's approach to classicism was not limited to scenes of antiquity. For this Quaker from Pennsylvania, recent history was equally

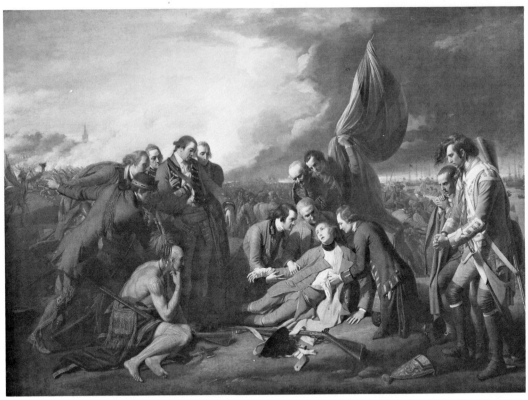

FIGURE 29 West, Benjamin, *The Death of General Wolfe,* 1770, The National Gallery of Canada, Ottawa. Gift of the Duke of Westminster, 1918.

suited to uplifting themes and restrained presentation. In demonstration of this conviction, in 1770 he painted an incident from the French and Indian War. This work, *The Death of General Wolfe,* was to prove to be one of his most controversial and significant accomplishments. The artist's depiction of the English general who died at the moment of his troops' victory over the French at Quebec in 1758 combines heroic drama with factual detail. A powerful and stirring painting, it enjoyed enormous popular acclaim, and excited much controversy. Sir Joshua Reynolds, the respected president of the Royal Academy, had strong criticism for the work, protesting that the figures were represented in contemporary dress rather than antique, as was the conventional practice. According to the taste of the day, classical references elevated history painting to the level of universal meaning and to depict an event in terms of everyday life was thereby to deprive it of more glorious associations. Although West was himself a proponent of classicism, he defended his use of factual detail by arguing, "If instead of the facts of the transaction, I represent classical fictions, how shall I be understood by posterity?" His strong convictions and insistence upon handling of the subject

in his own way assured the success of the painting despite Reynold's criticism. He had done more than record the facts of the event; he had transformed them into an inspirational and moving scene.

Although he broke a canon of history painting by using contemporary costumes, Benjamin West remained within that tradition in other ways. He skillfully made reference to well-known earlier works by basing his figure groups on great masterpieces of the past, depicting Wolfe, for example, in a pose reminiscent of Renaissance scenes of the lamentation for the dead Christ. The other figures express a range of emotions clearly conveyed through gestures and poses drawn from earlier paintings. While Wolfe's officers express both grief over his death and elation over the impending victory, one figure, an Indian scout, remains apart, watching from the shadows. It was a particularly fitting and successful touch for the colonial painter to include an Indian in the scene, for during his studies in Italy he had impressed his scholarly mentors by comparing the *Apollo Belvedere*, a greatly admired ancient Greek statue, to a Mohawk warrior.[1] The noble Indian again appears in West's portrait of *Colonel Guy Johnson*, this time as a silent and faithful companion standing in the shadow of the British Superintendent of Indian Affairs.

Although West made his residence in England and succeeded Reynolds as president of the Royal Academy, he did not forget the land of his birth and proudly looked to it for subjects for his paintings. In *William Penn's Treaty with the Indians*, he depicted the famous Quaker's conquest of the New World by peaceful means. In this work West again sought to depict the facts of the event, studying clothing from the period and using his relatives as models for the Quaker settlers. Painted on the eve of the American Revolution, the picture seems to have been a subtle message to King George to deal with the rebellious colonists in a peaceful way just as William Penn had successfully done with the Indians.

THE GRAPHIC ARTS

In the Colonies, the crisis of the growing conflict stimulated the development of the graphic arts. The earliest prints made in America were woodcuts. A portrait of *Richard Mather* by John Foster in 1670 is believed to have been the first woodcut produced in the Colonies. Baptismal certificates, crests, mottos, and passages from the Scriptures were also printed by this method. By the second quarter of the eighteenth century, in Peter Pelham's day, the mezzotint engraving

[1] West's observation delighted his European hosts because they held the popular eighteenth-century belief in the "noble savage," or uncorrupted man of nature. To compare an Indian to an ideal Greek statue seemed very appropriate.

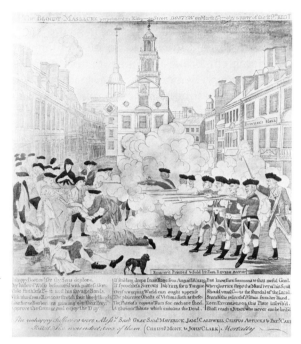

FIGURE 30 Revere, Paul, *The Boston Massacre,* (engraving) 1770, Courtesy of American Antiquarian Society, Worcester, Mass.

had replaced the woodcut for recording portrait likenesses. Both European prints and colonial works were reproduced by this technique and widely circulated. Engravings were also used for topographical scenes such as William Burgis's engraving of *Boston Harbor* in 1722.

The struggle for independence stimulated a more topical use of engravings, especially in illustrations for handbills, broadsides, and magazines. Paul Revere's print of *The Boston Massacre* with its inflammatory text served to arouse the sympathies of the colonists. The graphic arts also became a medium for documentary reporting. Famous battles, sea conflicts, and major events became the subjects of engravings. Although secondary to paintings, engraved prints served as a means to distribute news of events as well as to provide copies of works of art. By the middle of the next century, printmaking would flourish as an art form in its own right in America.

COPLEY IN ENGLAND

Tensions in the Colonies were escalating when John Singleton Copley finally departed for Europe in 1774. Although he had many friends among the Sons of Liberty and had painted the portraits of famous patriots such as Paul Revere, John Hancock, and Samuel Adams, Copley's loyalties were divided. His wife, Sukey, was the

daughter of a Tory merchant, Richard Clarke, one of the consignees of the tea that was destroyed at the Boston Tea Party. Copley's departure at this time was possibly precipitated by the growing uncertainties of life in the Colonies. After stopping in London, he set off for a tour of the Continent, visiting France and then Italy, where he avidly studied works by Renaissance and baroque masters. While he was in Italy, war finally broke out, and Copley hurried to London to meet his wife and children who had fled Boston.

On the threshold of a promising new career in London, Copley painted a family portrait in 1776–1777 (Color Plate I). A greater artistic sophistication, gained from the study of European art, is already apparent in the *Copley Family.* The six figures, linked through varied gestures and psychological grouping, are skillfully composed. Copley stands behind his father-in-law, Clarke, and looks out with the confidence of a successful artist and a proud father. The specifics of the scene, such as the charming still-life of the doll and plumed hat on the left, and the rich textures and colors are unified through highlights, shadows, and composition. Even more delightful than the pictorial effects is Copley's warm and loving portrayal of his wife and children.

Copley's long-held ambition to be a history painter was at last fulfilled in 1778, when he exhibited *Watson and the Shark* at the Royal Academy. Six years after West had painted *The Death of General Wolfe,* Copley scored a success with a painting of recent history. His

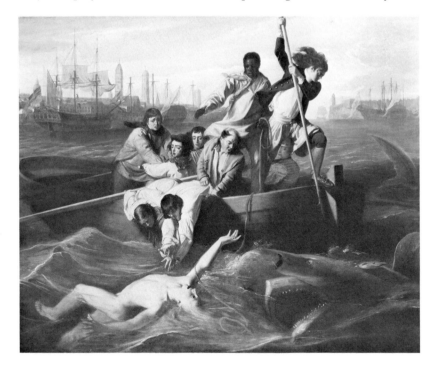

FIGURE 31 Copley, John Singleton, *Watson and the Shark,* 1773, National Gallery of Art, Ferdinand Lammount Bellin Fund, 1963.

subject was not actually an event of historical consequence, however, but an incident from the life of a prosperous London merchant, Brook Watson. At the age of 14, Watson, who was then a cabin boy, was attacked by a shark while swimming in Havana harbor. Before he could be rescued, he had lost his foot. To depict the terrible event, Copley chose the moment of greatest suspense, when the shark emerges from ominous shadow to lunge for the third time at the helpless Watson, just before his rescue. The action takes place in a pyramid design, a stabilizing device derived from Renaissance paintings, which is enlivened by the diagonal thrusts of oars and harpoons. Copley based the setting on charts of Havana harbor and used life sketches for his characters. Watson, however, is not shown as a 14-year-old boy, but rather as a grown man, whose heroic proportions were taken from a classical statue, the *Borghese Gladiator*. In this way, Copley imparted greater significance to the event. With a brilliant combination of fact and dramatic illustration, Copley created a work that transcends the meaning of personal anecdote to convey the universal struggle of man against nature. With this painting of convincing drama and expressive power, Copley enhanced his reputation as a painter of outstanding ability.

Other history paintings followed. In the *Death of Major Peirson*, painted in 1783, Copley chose an incident from the French invasion

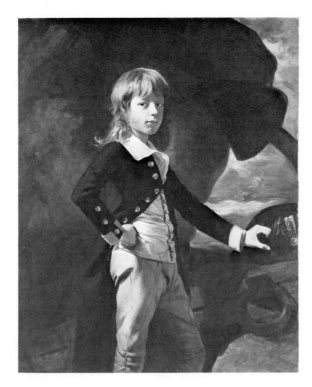

FIGURE 32 Copley, John Singleton, *Midshipman Augustus Brine*, 1782, The Metropolitan Museum of Art.

of the island of Jersey. Peirson, a junior officer who was left with the command, rallied the British troops and was mortally wounded as the invasion was finally crushed. In contrast to West's static and staged depiction of General Wolfe's death, Copley recorded the ebb and flow of street fighting. With vivid color, a dynamic surge of figures, a variety of action, and an accurate setting, the historic moment is convincingly re-created.

Although Copley earned some success as a history painter, he continued to depend on portrait painting for his livelihood. The portraits dating from his London career are distinguished from his American ones by the use of more extravagant props and backgrounds and by brilliant brushwork and color. His portrait of *Midshipman Augustus Brine* (Fig. 32), for example, displays youthful arrogance and sophistication, while *The Three Youngest Daughters of King George III* is filled with fanciful detail and sugary frills. Although beautifully painted, they lack the directness and insight into character of his American works. They were not fresh, original expressions, but conformed more to the fashion of the day. Most likely, however, Copley would not have been patronized in London if his portraits had retained that American directness. Nevertheless, the accomplishments of this transplanted colonist truly equaled, and at times surpassed, the works of his famous English contemporaries.

THE QUESTION OF NATIONALITY

Although Copley and West never returned to America, both were sympathetic to the cause of the new nation. On the eve of the Revolution, Copley wrote, "Poor America. . . . Yet certain I am She will finally emerge from her present calamity and become a mighty empire. And it is a pleasing reflection that I shall stand amongst the first of the artists that shall have led the country to the knowledge and cultivation of the fine arts." Benjamin West cheered America's successes on the battlefield and conference table. To mark the Preliminary Conference of the Treaty of Peace, he began a painting which includes the American commissioners, Benjamin Franklin, John Adams, John Jay, Temple Franklin, and Henry Laurens. Since the English commissioners absented themselves, the painting was never finished.

West also opened his doors to American artists seeking training in London. The list of artists who benefited from West's generosity includes most of the next generation of important American painters, among them John Trumbull, Samuel F. B. Morse, Ralph Earl, Charles Willson Peale, and Washington Allston. One of the American painters, Matthew Pratt, commemorated the gatherings at West's studio in a work called *The American School*, in which West is shown

helping Pratt and several other young artists with their drawings.

Many of the Americans who studied with Benjamin West returned home hoping to establish a tradition of history painting in America. Most met with difficulties and their efforts with neglect. In the years following the Revolutionary War, portraits continued to be the chief form of painting supported in America. One artist, Gilbert Stuart, benefited from this situation and used his talent to become one of the most accomplished American portrait painters in the late eighteenth and early nineteenth century.

GILBERT STUART

Stuart was born in Rhode Island, but lived intermittently in Europe for over 20 years. He first traveled to Scotland with his art teacher, Cosmo Alexander, but returned to Newport, his fortunes at low ebb. In 1775, he traveled abroad again, this time to London, where he became an assistant to Benjamin West and finally a master in his own right. Unlike Copley, whose portrait he painted in London, Stuart was content to devote his career to portraiture. The painting that assured his reputation in London was of a gentleman named William Grant. In this unusual full-length portrait, popularly known as *The Skater*, Grant is shown on ice skates, gracefully gliding across a frozen pond. Stuart, an adroit skater himself, succeeded in conveying elegance and dignity with this informal pose. For a time, *The Skater* was mistakenly attributed to the outstanding English painter Thomas Gainsborough.

Despite lucrative commissions, Stuart's spendthrift nature forced him to flee to Ireland and later America to escape his many creditors. Arriving in New York in 1792, he soon established a thriving new portrait trade there and in Philadelphia, where he was welcomed into the most fashionable circles. A particularly fine portrait from this period is that of *Mrs. Richard Yates* (Color Plate II). Stuart's use of fluid brushwork, shimmering highlights, and a color scheme of greys, brown, and rose set off the face of the lady, who pauses a moment from her sewing to glance up at the viewer. Although he never quite mastered the placement of a figure within a defined environment and avoided full-length poses, Stuart's facility at building up the contours of the head and conveying the animation of the face with a few strokes of color more than made up for his deficiencies.

Stuart is best known for his portraits of George Washington, President, victorious general of the armies, and revered father of the country. With a letter of introduction from John Jay, Stuart persuaded the President to pose in 1794. Washington was notorious for his aversion to posing, and stories abound about Stuart's difficulty in coaxing the President to smile or to even look animated for the

FIGURE 33 Stuart, Gilbert, *George Washington,* Athenaeum version, 1796, Courtesy, Museum of Fine Arts, Boston. On deposit from the Boston Athenaeum.

painting sessions. Instead, Stuart resorted to using Washington's stoney countenance to best advantage. The image of the popular hero became a profitable potboiler for Stuart as he dashed off over 100 versions based on three initial sittings. The first, called the *Vaughan* type, shows the right side of Washington's face; the second, called the *Landsdowne,* is full-length; and the third and most famous,is called the *Athenaeum Washington,* (see Figure 33, above). Stuart was so pleased with the Athenaeum version, which was commissioned by Martha Washington, that he never finished it, using it instead as the model for most of his copies. Many other painters depicted the first President, but Stuart's Athenaeum portrait has remained the most memorable, not because it particularly captures his likeness, but just because it best suggests the qualities of a national hero. More than just the man, the portrait captures the legend.

Although Stuart, Copley, and West traveled to Europe for training, patronage, and inspiration, their work continued to reflect the attitudes, tastes, and experience of their native land. Their achievements, recognized in England as well as at home, set the standard for American art for years to come. The new generation of artists who began working in the last years of the eighteenth century were faced with many of the same problems and options as their illustrious predecessors. Art patronage in America was still essentially limited to portraiture, and Europe and the grand tradition of history painting still beckoned. The achievements of West, Copley, and Stuart would serve as a source of both inspiration and frustration for the men returning from their studies in Europe to face the task of creating an art suited to the aspirations and needs of the growing nation and young Republic.

CHAPTER 4

THE YOUNG REPUBLIC

The war was over, and the Revolution had been won. The Articles of Confederation gave way to the Constitution. The new government was beginning to stabilize, and by the beginning of the nineteenth century, the young nation was prospering. As the country began to adjust to complete self-management, the artists of the young Republic began to search for their place in American life. How could the fine arts contribute to the growth of the new nation? What part in American life should the fine arts play? How could the arts reflect the noble ideals of the fledgling democracy?

THE FEDERAL STYLE IN ARCHITECTURE

FIGURE 34
Jefferson,
Thomas,
Monticello,
1768–1803,
Charlottesville,
Va.

Architects were the first group of artists to have the opportunity of setting a course for art in the new nation, and, appropriately, Thomas Jefferson was the first architect to formulate the direction that course would take. Jefferson's home near Charlottesville, Virginia, called Monticello and based entirely on his own design,

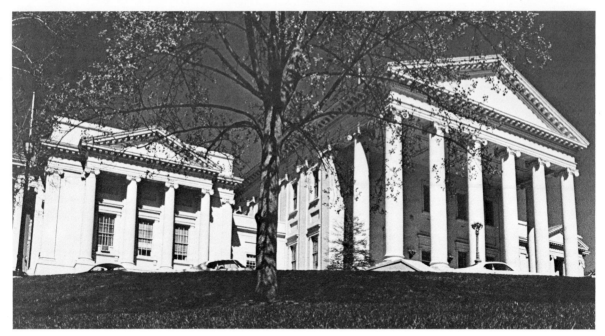

FIGURE 35 Jefferson, Thomas, *State Capitol*, Richmond, Virginia.

was directed and inspired by classical models. Monticello offers a clear idea not only of the variety of architecture that would replace the colonial Georgian but of the sources and ideals which would form the new nation's art. Inspired by ancient temples and the Villa Rotunda, Andrea Palladio's sixteenth-century adaptation of classical designs, Monticello exhibits a pervasive neoclassical influence in the central dome, the use of classical orders on the capitols of the columns, the perfect symmetry of the wings, the colonnaded porch, and the triangular pediments which crown it. These features typify the mode of architecture that emerged in these years, often called the Federal style.

Jefferson elaborated on the design concepts of Monticello in his other architectural projects. For the state capitol at Richmond, he adapted the design from an ancient Roman temple, the Maison Carrée, at Nîmes, France. However, if the Maison Carrée is compared with Jefferson's design for the capitol, differences emerge. The Richmond capitol, for example, has two stories of windows, brightening the interior considerably and making it more suitable for its function, the business of government.

The University of Virginia is Jefferson's most complete statement of his architectural concepts. The main building is modeled after the Pantheon in Rome, with a colonnaded porch, a device first used by Jefferson at Monticello. The proportions of the struc-

ture are longer, thinner, and more elegant than its massive classical model. While the windows of the first story are topped with pediments, the upper windows are unadorned. The symmetry and order of this building are reflected in the organization of the university as a whole: gardens and buildings are placed in a logical, ordered relationship. Jefferson's establishment of this university, its campus, and its tradition of state-sponsored education was the enduring pride of his life. Not only does the epitaph that he chose for his tombstone chronicle his two terms as President of the United States but it also includes his part in the foundation of the University of Virginia at Charlottesville.

ARCHITECTURE FOR THE FEDERAL CITY

Admiration for Greek and Roman architecture, represented by the Federal style, was the result of more than a taste for good design. It was also an attempt to make a deliberate and carefully chosen analogy between the great republics of antiquity, with their ideals of freedom and equality, and the new American Republic. The nation's capital city everywhere evinced this comparison. In 1791, Major Pierre L'Enfant, a French engineer who had come to America with

FIGURE 36 Jefferson, Thomas, *Rotunda of the University of Virginia,* 1822–1826, Charlottesville, Va.

FIGURE 37 *United States Capitol, East Front,* Washington, D.C.

Lafayette during the Revolutionary War, began to design a city to serve as the capital of the United States. He conceived a city of grandeur and grace, one whose organization represented, by its balance and order, the prevailing belief in rationalism. Competition for the design of the Capitol building was won by Dr. William Thornton, who erected a domed Georgian structure. However, in 1814, Thornton's structure was destroyed by the fires of the invading British army, and when the Capitol was begun again, the commission went to President Jefferson's favorite architect, Benjamin Latrobe. The building Latrobe envisioned in the Federal style is basically the building that stands today. His design, with colonnaded porch, pediments, and dome, is clearly classical and, by association, Jeffersonian in spirit. The great wings for the Senate and the House symmetrically flank the Rotunda, and the pediments are filled with sculptures attempting to turn American history into myth. A celebrated Latrobe touch is the capitals of the columns in the Senate wing, where American produce such as corn and tobacco have been substituted for the traditional Greek acanthus leaves. The architects who followed Latrobe—Charles Bulfinch and Thomas Walter—made some modifications and additions to the Federal plan. Recently, some radical additions to the west façade have been debated. In the end, however, the Capitol remains a temple of government, a shrine to the classical taste for harmony, order, and grandeur.

HISTORY PAINTING

The events of the Revolutionary War provided painters and sculptors with subjects worthy of glorification. In keeping with the international visual language of that day, the artists of the new Republic created their work within the neoclassical tradition. According to this approach, great art is based on important subjects, and the most important subjects were events from history or themes from religion, literature, and mythology. Portraiture, that staple of the colonial and Revolutionary period in American art, was considered to be a minor art form, while genre and still-life subjects were even farther down the scale of importance. In the eighteenth century, there had been virtually no market for history painting. The Colonies had lacked the place or historic occasion for this monumental art, and it was left to a new generation of artists to adapt this tradition to the rationalism, the harmony, and the aspirations of the young Republic.

John Trumbull, more than any other painter of this time, capitalized on the themes suggested by the Revolution. The son of the Governor of Connecticut, Trumbull graduated from Harvard and served in the Continental Army. Trumbull did not depict the grim facts of war in his paintings but, in tune with the taste of his time, glorified the heroic and patriotic deeds of famous men. His most famous works, murals in the Rotunda of the Capitol, reflect these ideals, and were actually based on four earlier paintings by the artist. Jefferson supported the selection of Trumbull for the prestigious task of dec-

FIGURE 38 Trumbull, John, *The Declaration of Independence,* Yale University Art Gallery.

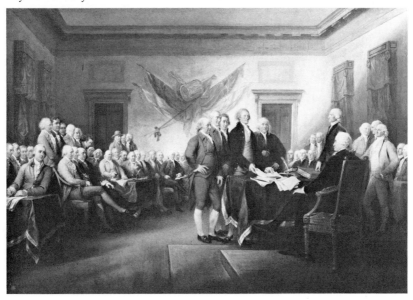

orating the Rotunda, saying that these paintings were "monuments of the tastes as well as the great revolutionary scenes of our country." One of these paintings, *The Declaration of Independence*, is filled with the faces that the young Republic loved—Benjamin Franklin, Thomas Jefferson, John Adams, and, above all, George Washington. Although the great deeds and men of the Revolutionary War provided suitable subject matter for history painting, the demand for this type of monumental art was still limited in America. Major commissions for public buildings, such as the murals for the United States Capitol, were highly sought and difficult to obtain. As enthusiastic young artists returned from their studies abroad fired by the ambition to establish history painting in America, they faced an unenthusiastic public and a virtually nonexistent market for their art. One artist whose fate typifies this dilemma was John Vanderlyn. In 1815, after studying at the French Academy and in Rome (thanks to the sponsorship of Aaron Burr), Vanderlyn returned home, his reputation as a history painter already established with works such as *Ariadne Asleep on the Island of Naxos*. This outstanding American contribution to the neoclassical tradition of the ideal nude won him many honors. In the United States, however, there was simply little interest or demand for painting in the grand mode. For the next 20 years, Vanderlyn's career was marked by disappointments and un-

FIGURE 39 Vanderlyn, John, *Ariadne Asleep on the Island of Naxos,* 1809–1814, Courtesy of Pennsylvania Academy of the Fine Arts, Joseph and Sarah Harrison Collection.

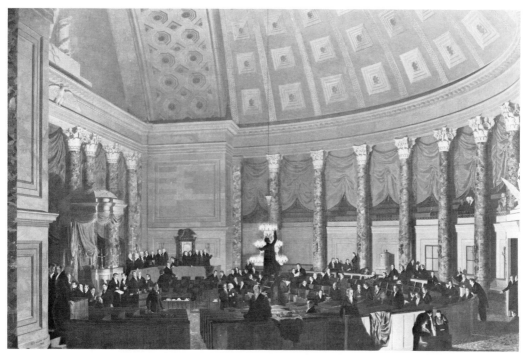

FIGURE 40 Morse, Samuel F. B., *Congress Hall* (*The Old House of Representatives*), 1822, in the Collection of The Corcoran Gallery of Art.

successful financial schemes. In 1837, Vanderlyn received a major commission to paint *The Landing of Columbus*, a companion mural for Trumbull's work in the Rotunda of the United States Capitol. Sadly, the long-awaited commission came too late, for Vanderlyn was in his sixties, his promising career and self-confidence had turned sour, and as a result the finished mural is of no particular merit.

Another artist who faced similar disappointments was Samuel F. B. Morse. Like Vanderlyn, Morse studied and traveled abroad before launching his career in the United States. With his friend, Washington Allston, Morse studied with Benjamin West in London and even received a gold medal from the British Academy in 1812. Back home he too found it difficult to establish himself as a history painter, so he resorted to portraiture for his livelihood. In 1821, in a bid for wider recognition, Morse attempted an encyclopedic documentation of the *Congress Hall, Old House of Representatives.* The painting contains eighty-five portraits of members of Congress and of the Supreme Court. Morse hoped that the government would purchase this work as a valuable historical record, but he was disappointed in this hope.[1] Many years later it was found abandoned in a New York

[1] Morse's painting was of great assistance in the recent restoration of the Old House chambers in the Capitol building. Its accurate detail provided a blueprint for the restoration.

FIGURE 41 Morse, Samuel F. B., *Exhibition Gallery of the Louvre,*
1832–33, Courtesy of Syracuse University Collection.

warehouse, though today it is a notable part of the collection of the
Corcoran Gallery of Art in Washington, D.C.

Just over 10 years later, Morse attempted an equally detailed and
comprehensive work, the *Gallery of the Louvre* of 1832–1833. This
painting depicts the main salon of the Louvre, reproducing in perfect
detail thirty-seven major works by old masters. Rubens, Raphael,
and Titian are represented by works on the walls, while Morse him-
self is shown leaning over a chair to offer some suggestions to a
female copyist. To complete this tour de force, Morse includes the
long gallery leading away from the main salon, all 1400 feet of it visi-
ble. Morse saw this work as a valuable instructional tool for his com-
patriots, because it not only documents the manner in which Euro-
peans exhibited art but reproduces the art as well. The *Gallery of the
Louvre* is a manual of European art history as well as a work of con-
siderable technical accomplishment.

After this project was greeted without enthusiasm, Morse
turned away from art to devote himself to science. Ironically, Samuel
Morse is today celebrated in every American history book as the in-
ventor of the telegraph but is little recognized for his contribution to

the fine arts, which included not only his paintings but also his role in the establishment of the National Academy of Design, the first art institution in the United States governed for and by artists.

PORTRAITURE AND THE PEALE FAMILY

Although there was only limited demand for history paintings dealing with the young nation's past, there was a great one for portraits of the heroes of the Revolutionary War. In fact, an obsession of the fine arts during the early years of the Republic was the image of George Washington.

Although the most famous portrait of Washington is Gilbert Stuart's Athenaeum portrait (Figure 33), several members of the Peale family also painted well-known images of the first President of the United States. Charles Willson Peale was the patriarch of this large and very talented family. In a portrait of his family, painted in 1809, Peale depicts himself leaning over to comment on a drawing by his brother. Like so many of the artists of this time, Peale was expert at more than painting: he was a scientist, an inventor, an author, and an educator. Another self-portrait, painted when he was 81 (Figure 3), portrays the artist pulling back a curtain to reveal his museum,

FIGURE 42 Peale, Charles Willson, *Peale Family Group,* 1809, Courtesy of The New York Historical Society, New York City.

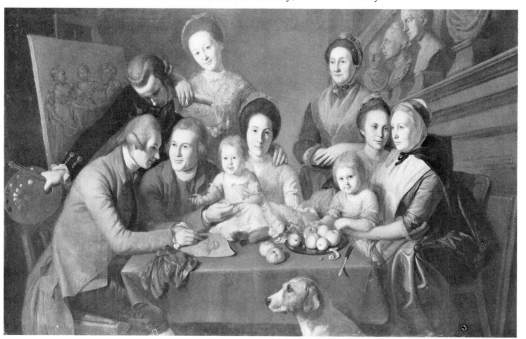

FIGURE 43 Peale, Rembrandt, *Porthole Portrait of George Washington*, 1823, Courtesy of North Carolina Museum of Art. Gift of Mrs. Charles Lee Smith, Sr., William Oliver Smith, Charles Lee Smith, and Mrs. Joseph H. Hardison in memory of Dr. Charles Lee Smith.

which was located in Independence Hall, Philadelphia, and was the first of its kind in the nation. Peale here displays the objects that caught his fancy, and his fancy spread far and wide: stuffed animals, portraits painted and carved, samples of American flora and fossils (including the bones of a mastadon which Peale had helped to excavate in 1801) were all on exhibit in the Peale museum.

Like many artists in the early history of this country, Peale saw no conflict between art, business, and science, and was able to integrate the three happily and successfully into his life. His approach to the portraits of Washington reflect this integration of disciplines. The image of Washington was a marketable commodity in the early part of the nineteenth century, and Peale, his two sons, and his brother produced a number of Washington portraits. In 1795, Charles Willson Peale was granted three sittings with the first President, a rare honor, since Washington detested sitting for his portrait. In order to make the most of the occasion, Peale brought along two of his sons, Rembrandt and Raphaelle, and his brother James.

Several of the women in the Peale family were artists too. Four of James's daughters—Maria, Anna, Margaretta, and Sarah—were celebrated for their still-life painting. Sarah Miriam Peale, who also painted portraits, is often designated the first professional woman artist in our history.

TROMPE L'OEIL PAINTING

The contributions of the Peale family to American painting did not end here. They were also involved in one of the more ingenious art forms popularized in nineteenth-century America—*trompe l'oeil* painting, or painting that tricks the eye. Charles Willson Peale's *The Staircase Group* is a vividly realistic depiction of two of his sons climbing a flight of stairs. A detail that increases the illusion of this work is Peale's addition of an actual step to the bottom of the painting.

Peale's son Raphaelle, named (like several of Charles Willson's children) after a great artist, painted a celebrated trompe l'oeil painting—*After the Bath* of 1823. The work is both technically clever and humorous. It depicts a large, crisp, white sheet strung up to conceal the body of a nude young woman who has just emerged from her bath. Though most of her body is concealed by the sheet, her bare feet and arms are visible. The sheet is rendered in painstaking detail, and its credibility as a real object seems, at first glance, incontestable. So convincing is the image that a fictitious story developed about the painting, to the effect that Raphaelle's wife tried to pull the sheet from the painting in order to discover the identity of her husband's nude model.

FIGURE 44 Peale, Raphaelle, *After the Bath*, 1823, Collection of William Rockhill Nelson Gallery of Art, Atkins Museum of Fine Arts. Nelson Fund.

Trompe l'oeil painting has a special appeal because of its exacting, precise technique, and the magic of its illusionism attracts most audiences. In the last quarter of the nineteenth century, this type of work reached its zenith in the paintings of artists like William Harnett and John Frederick Peto. At the present time, American artists like John Clem Clarke produce startlingly realistic works that are the offspring of this tradition.

NEOCLASSICAL SCULPTURE

Sculptors during this period shared many preoccupations with painters. The image of George Washington, for example, was as popular in three dimensions as it was in two. One of the finest sculptures of Washington is the French sculptor Jean-Antoine Houdon's portrayal of Washington as a soldier and gentleman-farmer. Dressed in his uniform, Washington rests against a bundle of thirteen sticks or fasces, an ancient symbol of Rome, which here reflects the unity of the Colonies. Though in official attire, the President's manner is re-

FIGURE 45 Houdon, Jean-Antoine, *George Washington,* 1788–1792, Metropolitan Richmond Chamber of Commerce, State Capitol, Richmond, Va.

laxed and thoughtful. It was considered innovative for a sculptor of that time to portray a hero in contemporary clothing rather than ancient costume. Houdon's image of Washington succeeds in combining dignity with naturalness, a naturalness which becomes especially apparent when compared with American sculptor Horatio Greenough's heroic-size sculpture of Washington (Figure 2). Greenough was commissioned in 1832 to make this sculpture for the Rotunda of the Capitol. Working in Italy and much affected by classical prototypes, the sculptor decided to create an Olympian work, 10½ feet high, based on the fifth-century statue of the Greek god Zeus by Phidias. Greenough conceived of his version of Washington as a timeless, god-like image. However, the idealized body combined with a human, specific face and the dramatic gesture did not appeal to the citizens of the young democracy. Shortly after being placed in the Capitol Rotunda, the sculpture was moved outside to the lawn, and eventually, it was sent to the Smithsonian for lack of a suitable place. Today it is located in the main hall of the Museum of History and Technology, Smithsonian Institution.

From colonial times on, sculptors in America have had special problems, for the training that was necessary for sculptors was almost totally unavailable in this country. Hiram Powers's development as an artist is typical of the history of so many American sculptors. He began his career in Cincinnati as a mechanic and then made a series of wax human figures writhing in a Dantesque hell. These figures were so horrifyingly real that Powers impressed his local audience and acquired some patrons who financed his move to the East coast. There the young sculptor turned from making wax figures to fashioning marble portrait busts of historic and contemporary notables such as Benjamin Franklin, Thomas Jefferson, Andrew Jackson, and Henry Wadsworth Longfellow. In 1837 Powers settled in Florence, where he had the advantages of the best marble cutters of his day, abundant materials, and the congenial company of other American and European artists. There he created the nude figure that secured his international success. What is so surprising about the popularity of *The Greek Slave* is that it did not offend the prudish morality of the nineteenth century, even though other American depictions of the nude, both before and after Powers's work, were rejected for this very reason.

The Greek Slave (Fig. 46) was so popular that the sculptor created several full-size replicas as well as three-quarter and half-size versions. A system which utilized a pointing machine to transfer measurements made this multiple production possible, and was used widely by sculptors of this time. After first modeling the figure in clay (though sometimes the sculpture was worked directly in plaster), a plaster cast was made of the clay original. Pins were placed at strategic spots on the plaster form. The pointing machine was then

FIGURE 46
Powers, Hiram,
The Greek Slave,
1846, in the Collec-
tion of The Cor-
coran Gallery of
Art.

placed over the plaster model, and a system of adjustable rods and wires attached to the pins reproduced these points of measurement for a stonecutter, who could then carve a block of marble to the shape and dimensions of the plaster. The pins were thus the points at which the sculpture was measured in order to ensure as exact a copy of dimensions as possible. The marble cutters could make half-size and three-quarter versions of the plaster original by dividing the inches between the pins. After the stonecutters were finished with their generalized carving, the marble sculptures would be worked on by the sculptor, who would add the fine details. All this explains the manner in which multiples of the sculpture were made, but not the demand. Why did the American public accept the nudity of *The Greek Slave* when other such works scandalized them?

The answer can be found in the intended meaning of *The Greek Slave* and in Powers's considerable genius for publicity. *The Greek Slave* is based on the *Aphrodite of the Knidos* by Praxiteles, just as

Phidias's Olympian *Zeus* was the inspiration for Greenough's *Washington* (Figure 2). While this classical credential did not save Greenough's work from popular criticism, it did make a good beginning for Powers's advertising campaign. In addition, the title was very important. Citizens of the United States were sympathetic with the Greeks, then struggling for their independence from the Turks. Thus, on one level, *The Greek Slave* represented the democratic ideal enslaved by tyranny. Concomitantly, the sculpture's prominently displayed cross indicated that the figure also represented Christianity violated by paganism. Powers stressed these points in a pamphlet written to accompany the exhibition of the sculpture. In this pamphlet, Powers made his main point when he wrote: "It is not her person but her spirit that stands exposed." Thus, the public, the clergy, and even Elizabeth Barrett Browning who wrote a sonnet about the sculpture, believed that this lady was clothed in virtue, if not clothes. Powers's sculpture was the first of many symbolic nudes, and as such it represents an important development in American art.

The young Republic was a time of invention and variety for American art. If it was a time when artists' aspirations sometimes conflicted with the reality of public opinion, it was also a time when architects, painters, and sculptors learned to know their public. The next generation of American artists were to turn from the grandiose subjects of history to the American scene, especially to genre and landscape.

CHAPTER 5

PRESERVING THE LANDSCAPE

One day in 1825 John Trumbull, the American history painter, saw three paintings in the window of a framer's shop in New York City. Despite his own accomplishments as an artist, Trumbull looked at these paintings and exclaimed, "This young man has done what all my life I have attempted in vain!" The young man Trumbull referred to was Thomas Cole, and the paintings which astonished him were landscapes of the Catskill Mountain region of the Hudson River Valley. What Trumbull saw in these works was a native subject—the wilderness—painted dramatically, with a feeling for the character of the scene. In Trumbull's opinion, the 24-year-old Cole had succeeded in creating an American equivalent to the European tradition of history painting, which so many artists of the young Republic had sought in vain to establish.

With the support of the influential Trumbull, Cole soon became successful and inspired a number of followers. These landscape painters formed America's first indigenous school or group of artists and became known as the Hudson River School. Their paintings, which enjoyed enormous popularity for over four decades, appealed

to a new public, the prosperous middle class, self-made men who wanted art that would grace their homes and express their pride in the nation. By the second half of the nineteenth century, this love of nature and pride in the land took the form of landscape architecture, park planning, and conservation, as well as painting.

WASHINGTON ALLSTON AND EARLY LANDSCAPE PAINTING

Before the success of the Hudson River School, landscape as a subject played a minor role in American art. In the eighteenth century, landscape painting in the Colonies was limited for the most part to topographical views of cities and farms and, occasionally, decorative panels of imaginary views. The wilderness lands of America were still unknown and intimidating, not the sort of subject matter that appealed to colonial patrons. In the second half of the century, native artists began traveling abroad to receive their training, and they returned home with the goal of painting historical subjects, rather than landscapes, for these were considered a less significant form of art. Their hopes were disappointed, however, because of a lack of patronage for history painting; artists such as Samuel Morse and John Vanderlyn were forced to rely on portraiture and an occasional landscape commission for their livelihood. They painted American locations, however, by following the model of the classical landscape tradition based on the work of the seventeenth-century painter Claude Lorrain. Typical of this mode was the depiction of a quiet pastoral scene with trees framing gently rolling hills and a meandering stream leading to the distant horizon bathed in an amber glow. Nature was rearranged to compose a tranquil, lyrical scene.

In the first half of the nineteenth century, landscape became an important subject for European painters, and Americans shared their enthusiasm for the new emotional interpretation of nature associated with the emergence of romantic art. One of the first Americans to do so, Washington Allston, returned from studying in Europe to introduce romantic painting to the United States with both historical subjects of high drama and more intimate, lyrical landscapes. His landscapes such as *Elijah in the Desert* were the most influential, because of the poetic significance he imparted to nature. Rather than topographical views or compositions in the Italianate mode, Allston created landscapes which equalled the dramatic force and poetic meaning of history paintings dealing with men's actions. In *Elijah in the Desert* (Fig. 47), for example, the protagonist is not the biblical hero who is a very small, almost insignificant figure in the scene, but rather, nature, rugged and forbidding, expressing the difficult struggle of the prophet. Craggy cliffs, jagged trees, and a darkened

FIGURE 47 Allston, Washington, *Elijah in the Desert,* 1818, Courtesy, Museum of Fine Arts, Boston. Gift of Mrs. Samuel Hooper and Miss Alice Hooper.

sky heighten the mood of desolation. An evocation of such emotional intensity not only followed the new interest in nature's forces but also appealed to nineteenth-century viewers as an aesthetic experience of the "sublime."[1] Although Allston's career was somewhat marred by an unsuccessful attempt at history painting, his works in landscape helped to prepare the way for the new native approach in paintings of the Hudson River School.[2]

THOMAS COLE AND THE HUDSON RIVER SCHOOL

Thomas Cole, like Washington Allston, viewed nature with a romantic's eye for drama and meaning. What distinguishes his landscapes from Allston's, however, is the representation of a specific American location, not idealized or imaginary, but wild and rugged, close to its actual appearance. In paintings such as *Schroon Mountain* (Figure 48), Cole abandoned traditional formulas for composing a serene and classically balanced landscape for devices which empha-

[1] One of the important theories of the late eighteenth and early nineteenth centuries, the idea of the sublime was most clearly presented in *Philosophical Enquiry into the Origins of the Sublime and Beautiful* by Edmund Burke, first published in 1757.

[2] Allston labored for years without success on a commission for a large history painting of *Belshazzar's Feast.* The unfinished project was a source of deep disappointment for the artist.

FIGURE 48 Cole, Thomas, *Schroon Mountain, Adirondacks*, 1883, Courtesy of Cleveland Museum of Art.

size the power of nature—jagged tree trunks blasted by lightning, a wild tangle of underbrush, and an uninterrupted sweep across the middle ground to the distant landmark, the majestic mountain ringed in storm clouds. This painting inspired sublime feelings of awe and wonder, not through the depiction of a biblical event but solely through the forms of nature, specifically, the terrain of New York State.

Thomas Cole's painting appealed not only to the romantic response to nature but also to the growing feeling of national pride in the land. As new territories were explored, the frontier opened to the Pacific, and the wilderness became less intimidating, the land became identified as a key to the nation's destiny of expansion, prosperity, and progress. The beauty of miles of virgin forest symbolized the greatness of the young country, untainted by centuries of corrupting civilization which marked the nations of Europe. A growing interest in natural history and the romantic love of unspoiled nature contributed to this attitude that the American wilderness was primitive, and hence more pure than the lands of Europe marked by the deeds and misdeeds of human beings. Expressing this attitude, Wil-

liam Cullen Bryant praised Thomas Cole's paintings for "the appearance of a forest never deformed by culture." A native literary tradition also developed from the legends and folklore of the wilderness area of the Hudson River Valley and the Catskills in the work of James Fenimore Cooper and Washington Irving. For these writers and for Thomas Cole, the experience of the American land became the basis for the expression of the American spirit in literature and art.

Cole, the founder of the first native school of landscape painting, was not himself born in America but in the industrial district of Lancaster, England. He settled with his family in Ohio as a teenager and began a career as an itinerant portrait painter, making his way to the East coast. The rugged beauty of the Catskill Mountains awakened his talent, and he furthered his skill with the study of works by Thomas Birch and Thomas Doughty, native scene painters.

To paint a landscape, Cole would walk the mountain paths, contemplating the beauty he found there and making pencil sketches and notes about his feelings and on specific visual points, such as colors. He would then return to his studio to reflect further and finally compose the oil painting. Although nature, not art, was his model, Cole employed a number of artistic conventions in the studio. For example, rather than following a single vantage point, he combined several points of view. Although the overall composition was not an exact transcription, the specifics of the scene were meticulously rendered with details of leaves and bark, rocks and branches emphasized with thick, textured paint. Instead of focusing on the transitory effects of light and atmosphere, Cole used light and shadow to define forms and create dramatic contrasts. Jagged and twisted trees took on an almost anthropomorphic expression, and the transformed scene became a dramatic statement of the artist's emotional response and moral interpretation.

In 1829, Cole, now an established artist, journeyed to Europe. He traveled in England and on the Continent, not to seek training at the academies as an art student, but mainly to visit historic landmarks and galleries to enrich his experience. Although a success in America as a landscape painter, he was not without some apprehension about his reception in Europe and his own response to the art he would see there. His friend William Cullen Bryant warned him to avoid the temptations of European art and its conventions. In a sonnet for the artist entitled, "To Cole the Painter, Departing for Europe," Bryant urged the painter to remain true to the American vision, "to keep that earlier wilder image bright."

Despite Bryant's eloquent admonition and the sincerity of his own convictions, the artist was moved by what he found in Europe. Current landscape painting did not impress him, but the countryside itself, particularly in Italy, did. The associations of the crumbling

ruins of past civilizations with the decay of nature sparked his imagination. Upon his return to America, Cole began to interpret nature in terms of specific historical implications. A narrative tendency had appeared in his work early in his career, when he had painted a dramatic biblical scene of the expulsion of Adam and Eve; but after the trip to Europe, he turned more seriously to this type of expression. To incorporate historical references with a moral lesson or a dramatic scene, Cole began to create paintings related as a series. Nature continued to be the focal point, serving as protagonist by acting out, through the cycles of the changing seasons, time of day, and weather conditions, themes such as the rise and fall of civilization and the changing fortunes of a medieval knight. The artist often wrote lengthy descriptive texts to accompany these works. In a four-part allegory, *The Voyage of Life,* a figure representing "everyman" is followed from childhood through old age. The central motif is that of a boat carrying man on his earthly journey through life—expressed in a landscape that changes from the lush river banks identified with childhood to the threatening, bleak skies of manhood and old age.

The imaginary quality and emphasis on didactic themes in

FIGURE 49 Cole, Thomas, *Youth from the Voyage of Life,* 1842, National Gallery of Art, Alisa Mellon Bruce Fund.

Cole's serial works indicate that the artist was torn between the established standards of narrative painting and the new self-sufficiency of landscape as a subject in painting. The moralizing works appealed to popular taste, however, and 1600 engraved copies of *Youth* from the *Voyage of Life* were distributed by the American Art-Union, an association which promoted the fine arts in America by purchasing works directly from artists. Engravings were annually distributed to subscribers to the organization, and original paintings and sculptures were awarded to the winners of each year's lottery. Cole's original version of the *Voyage of Life* was purchased by the American Art-Union in 1848, increasing their membership to its highest number because of the popularity of the work.

Although Cole's series were popular in engravings, collectors preferred his paintings based on actual American views. In 1836 after completing three parts of the five-part allegorial series called *The Course of Empire,* Cole returned to a natural scene, a view of the Massachusett's landmark, *The Oxbow.* In this work, one of his best landscapes, Cole renewed his contact with nature. In fact, the artist included himself in the scene with his sketch box and umbrella, enjoying the magnificent view of the Connecticut Valley just washed by storm clouds which now darken the adjacent hills. Colors are clean and fresh, the composition is enlivened by the juxtaposition of the darkened foreground with the sunny valley below, and the painter's own delight in the view is aptly conveyed.

Asher B. Durand

When Thomas Cole died in 1848 at the age of 47, his untimely loss was mourned by many. William Cullen Bryant, whose poems of nature were the counterparts to the paintings of the Hudson River School, was appropriately selected to deliver the funeral oration for his friend. He remarked in his address that Thomas Cole was, "not only a great artist, but a great teacher, and that the contemplation of his works made men better." A painted tribute to Cole was made by Asher B. Durand, Cole's successor as leader of the Hudson River School. Called *Kindred Spirits,* the painting depicts Cole standing on a rocky overhang, sharing the beauty of a lush mountain ravine with William Cullen Bryant. The work is not only a fine tribute to Cole and Bryant but also a good example of Durand's abilities as a landscape painter (see Figure 50, p. 62).

Asher B. Durand had accompanied Trumbull on that fateful day when Cole's paintings were discovered in the framer's shop, and partly as a result of that experience, Durand gave up a successful engraving trade for landscape painting. Subsequently, Durand and Cole became friends, and on several occasions they sketched

together in the Catskills. Although Durand was known during Cole's life as a "painter second only to Cole," he was by no means his imitator. While Cole relied on notes about color as a supplement to his pencil sketches, Durand actually used paint and color for his outdoor sketches. His approach involved a more naturalistic representation of the landscape and was not encumbered by leanings toward historical themes. Durand had considerable influence on the second generation of landscape painters not only by the example of his paintings but also in his capacity as head of the National Academy of Design after Samuel Morse. In his "Letters on Landscape Painting" published in the art magazine, *The Crayon,* Durand instructed young artists to go first to nature and learn to imitate her, and then study pictures. In other words, nature, not the art of the past, was to be their primary teacher.

The artists who became known as members of the Hudson River School sketched in the Catskills during the summer, returning to New York City to complete their paintings in their studios. Certain ideas were shared, including an almost pantheistic reverence for nature's spiritual meaning and a dedication to depicting the native land in a distinctly American way. There was, however, a variety of styles and approaches to landscape painting within the Hudson River School over the next three decades. Jasper Cropsey, for example, specialized in autumn scenery. Certain of his works, such as *Autumn on the Hudson River,* were received with great acclaim in London, particularly because European autumns did not approach the intensity of color of the American season as represented by Cropsey. Other members of the Hudson River School, including Robert Duncanson and Worthington Whittredge, expanded the range of landscape painting to include not only the spectacular panorama but also the more quiet and intimate views. Many painters began to look beyond the Catskill Mountains to other areas of the country for their subject matter. Lake George, the Adirondacks, Maine, and even South and Central America became haunts of the second-generation painters. New directions in style began to be explored as well.

THE LUMINIST PAINTERS OF LANDSCAPE

Some painters began to concentrate on depicting the effects of light and atmosphere, and although working independently, arrived at very similar statements. Because of the quality of light in their works, they are sometimes distinguished by the name of *luminists.*

John Kensett pursued his studies of light and atmospheric conditions on locations where their presence is most dramatic—along the shores of lakes and the sea where water, sky, and land meet. In his paintings foreground details are sharply defined, a large expanse

FIGURE 51 Lane, Fitz Hugh, *Owl's Head, Penobscot Bay,* 1862, Courtesy, Museum of Fine Arts, Boston, M & M Karolik Collection.

of water reflects light, and a shimmering, atmospheric haze veils the distant shoreline and low-lying horizon.

Fitz Hugh Lane, working miles away from Kensett along the Maine coast, painted landscapes with remarkably similar characteristics. In his painting of *Owl's Head Penobscott Bay* of 1862, for example, there is a low-lying horizon, a glassy light reflecting water in the middle ground, and a detailed closeup view of land in the foreground, unified by a luminous pervading atmosphere. Kensett and Lane were trained as printmakers, and they continued to work with subtle gradations of value to show depth in their paintings. Lane's study of photographs to more accurately render the details of ships in his marine paintings would have further trained his eye to perceive tonal gradations of light and shadow. The stop-action effect of photography also seems to have influenced the clarity and stillness of luminist scenes. In Kensett's 1869 *Coast Scene with Figures,* (Figure 52) the wave curls, but will never crash upon the shore: it is stopped forever at its crest. In a luminist painting, brushwork is virtually denied by the smooth finish, thus hiding the artist's presence, the action of the artist's hand. By minimizing the artist's expressive involvement, the painting involves the viewer more directly in a subjective response to the scene rather than the work of art itself. A striking parallel has been made by art historian Barbara Novak between luminist painting and the mid-century philosophy of transcendentalism. Ralph Waldo Emerson, spokesman for the latter, equated light with the reappearance of the original soul. In describing his response to nature, Emerson created a memorable phrase: "Standing

FIGURE 52 Kensett, John Frederick, *Coast Scene with Figures*, 1869, Courtesy Wadsworth Atheneum, Hartford, Ella Gallup Sumner and Mary Catlin Sumner Collection.

FIGURE 53 Gifford, Sanford, *Ruins of the Parthenon*, 1868, in the Collection of The Corcoran Gallery of Art.

on the bare ground—my head bathed by the blithe air and uplifted into infinite space—all mean egotism vanishes. I become a transparent eyeball; I am nothing; I see all: the currents of the Universal Being circulate through me: I am part or parcel of God."[3]

The luminists, like Emerson in a sense, became the transparent eyeball through which the land and the sea reveal the mystical light of understanding.

By eliminating dramatic interpretation, luminist painters avoided historical themes and theatrical effects. Sanford Gifford, for example, painted the *Ruins of the Parthenon* not as a theatrical comment on the passage of time or the fall of civilizations but as a nostalgic record of the beauty of the structure and its setting. The atmospheric effects of the brilliant Aegean sun enveloping the bay and distant shore in shimmering light perfectly capture the effect of, as Gifford put it, the "picture of a day."

Another luminist, Martin J. Heade, also depicted nature at dramatic moments, but in his works the drama is evocative of sensations of weather, light, and atmosphere. In the 1860s and 1870s, Heade traveled to South America and the Caribbean Islands to concentrate on a very small and lovely aspect of nature—the tropical hummingbird—collaborating with an amateur naturalist to produce a book on this beautiful creature. Although the book was never published, the illustrations which Heade made for it, such as *Two Fighting Hummingbirds with Two Orchids* (Fig. 54), are among his finest paintings. The hummingbirds, their wings absolutely still, are poised near tropical flowers with the lush, steaming, tropical jungle of a distant valley beyond. The sudden change in distance from the magnified detail of the foreground to the distant misty background heightens the effect of exotic beauty.

FREDERIC EDWIN CHURCH AND THE SECOND-GENERATION HUDSON RIVER SCHOOL

Heade shared a studio on 10th Street in New York with the most popular and successful second-generation Hudson River School painter, Frederic Edwin Church. Like Heade, Church traveled to South and Central America, and he, too, was a keen observer of the effects of atmosphere and light. However, Church's work was much closer in spirit to the works of the founder of the Hudson River School, Thomas Cole, than to luminist painting. Like Cole, Church thought of the landscape in terms of the significance of history painting. Church, however, did not rely on historical references or allegorical figures to convey meaning in his landscapes. Their drama is inherent in the land itself, a South American volcano, a rainbow

[3] Ralph Waldo Emerson, *Nature*, 1836.

FIGURE 54 Heade, Martin J., *Two Fighting Hummingbirds with Two Orchids*, 1875, Collection of Whitney Museum of American Art. Gift of Henry Schnakenberg in memory of Juliana Force.

FIGURE 55 Church, Frederic Edwin, *Niagara Falls*, 1857, in the Collection of The Corcoran Gallery of Art.

arched across a tropical mountain range, a thundering waterfall. In his painting of *Niagara Falls* Church chose the most thrilling prospect, the wide expanse of water seen from the Canadian side. No land is included in the foreground, so that the viewer is suspended directly over the falls and plunged into the power of its surging water and green depths (Fig. 55).

Nature's significance as painted by Church did not refer to literature or religion, but rather related to the interest in science and natural history popular at that time. The German naturalist Alexander von Humboldt, who in his 1849 book *Cosmos* had described the Andes as "an inexhaustible treasure . . . still unopened to landscape painters," inspired Church to visit South America and influenced his response to the scenery he found there. His painting of *Morning in the Tropics*, for example, is an awesome, primeval scene, which evokes the dawn of the earth as both a natural and a metaphysical wonder in the spirit of Humboldt's theories. His huge panoramic paintings met with great enthusiasm and, through special exhibitions where large crowds paid admission to view them, proved to be financial successes. Church was a master of capturing the details, textures, and atmospheric conditions of a scene without detracting from the breadth and overall impact. To display his paint-

FIGURE 56 Church, Frederic Edwin, *Morning in the Tropics,* 1866, National Gallery of Art, Gift of the Avalon Foundation.

FIGURE 57 Vaux, Calvert, *Olana*, 1870, Hudson, N.Y.

ings, the exhibition room was filled with potted tropical plants and lighted by gas lamps; the spectators were provided with a tin tube through which they could pan across the painted landscape as if they were actually in Ecuador on an expedition. Fascinated by science and the new frontiers for exploration like so many of his contemporaries, Church was drawn to other exotic locations including the Arctic, the Holy Land, Persia, and South America.

Olana

In the 1870s, with the wealth amassed from painting sales and exhibitions, Church began to devote his energies to building a home and showplace for the artifacts which he had collected during his extensive travels. The house, built under Church's direction by the architect Calvert Vaux, overlooks the Hudson River and has a view of the Catskill Mountains much enjoyed by the painter. Its eclectic style incorporates Moorish decoration in a Victorian architectural design. Church called his home *Olana*, Arabic for the "center of the world." Olana's exotic name, eclectic architectural style, and landscape setting typified certain aspects of the spirit of the United States in the last quarter of the nineteenth century and was expressive of Church's own personality and interests. Secure in prosperity and progress, America now looked beyond its borders to other lands, confident that it could become the center of the world.

Before working with Church on Olana, Calvert Vaux was the associate of the esteemed landscape architect, Andrew Jackson Downing. Vaux and Downing were widely acclaimed for their innovative designs for family dwellings suited to comfort, convenience, and landscape setting (concerns that were to reappear in the work of the great twentieth-century architect, Frank Lloyd Wright). Downing, who was an admirer of Hudson River School paintings, sought picturesque settings for his homes and attempted to preserve the natural features of the land. Aware that the wilderness glorified by painters earlier in the century was rapidly being replaced by civilization, farsighted men such as Downing and Vaux attempted to preserve as much of the natural landscape as possible. Downing, Vaux, and a gentleman-farmer by the name of Frederick Law Olmsted were responsible for several important public projects in the middle decades of the century. In 1840, Downing was called to Washington to landscape the Capitol grounds. His plans were carried out by Olmsted in 1874, and the layout of terraces, winding paths, and circular drives remain today much as they were 100 years ago.

The most ambitious and celebrated project begun by Andrew Jackson Downing and completed by Vaux and Olmsted was the planning of New York's Central Park. The project was first conceived and promoted in the 1850s by Downing and William Cullen Bryant. Realizing that the sprawling city would soon engulf all available land, they advocated setting aside an area for a public park. It was their aim, as Vaux put it, to "translate democratic ideas into trees and dirt." Completed in 1878 under the direction of Olmsted, the park filled 843 acres, laid out in a pleasant, informal manner. The plans included accommodations for pedestrian footpaths and bridle paths, as well as sunken crosstown streets for vehicles. Parks in urban areas throughout the country were built with this layout as a model.

These people were America's first environmentalists, determined to preserve a part of the wilderness that landscape painters commemorated in paint. Interest in the land as well as its native inhabitants continued in the second half of the century, taking new directions in the work of photographers in addition to landscape architects and painters, but stemming initially from the important contribution of America's first group of landscape painters, the Hudson River School.

CHAPTER 6

THE CREATION OF A SELF-IMAGE

The Presidency of Andrew Jackson brought a new quality to American life, characterized in the fine arts by the attempt of American artists to portray the life around them. In part, it was the optimism and populism of Jacksonian America that turned many American artists away from the tradition of European-inspired history painting and portraiture. For many artists, the energetic life of the average citizen came to represent the true America, a vision that differed in content and, ultimately, in form from the heroic outlook of Benjamin West or John Trumbull. Portraiture no longer dominated American art, and though sculptors generally continued to depict elevated subjects, painters tended to select landscapes or scenes of life from the town or countryside as the subjects for their work.

GENRE PAINTING

At the same time that the painters known as the Hudson River School were creating an American landscape tradition, artists like John Quidor, William Sidney Mount, and George Caleb Bingham were developing American genre painting.

Genre painting is devoted to vignettes from everyday life, glimpses, often sentimental and frequently humorous, of the average person at work or play. Until the late 1820s, genre as a subject for works of art had been looked upon with disdain, and relegated to the decoration of fire screens, commercial signs, or banknotes. However, part of the deep belief in democracy in the years from 1830 until just before the Civil War was the conviction of many artists that a major statement could be made through genre painting. By the second quarter of the nineteenth century, genre emerged as an important subject matter for American art.

John Quidor

One of the first painters of American genre scenes was John Quidor. Little known as an artist in his own lifetime, Quidor made his living in his native New York State by decorating the panels of fire engines and designing banners. Frequently his works were based on the local characters and folktales of the region of the Catskills where he lived. Often, American literature created by local writers like Washington Irving inspired Quidor's work, as in his depiction of Rip Van

FIGURE 58 Quidor, John, *The Return of Rip Van Winkle,* 1829, National Gallery of Art, Andrew W. Mellon Collection, 1942.

Winkle. It is especially fitting that Quidor's vision of American life should grow out of the native school of literature, for the increased circulation of illustrated newspapers, periodicals, and novels in nineteenth-century America goes hand in hand with the interest in genre painting. Quidor's style, however, goes beyond mere illustration. His choice of colors, for example, reflected his emotional response to the scene, rather than mere depiction of the physical reality of the situation. The artist's use of acid greens and yellows alongside deeper earth tones often gave his work a startling, fantastic quality. Quidor's line is equally expressive, with a fluidity and eccentricity that helped to underscore the dramatic qualities of a situation, as well as impart a rough and tumble vitality to the work. Often Quidor's style approached caricature; in general, it reflected a very personal approach to the subject. Although he exhibited his work at the National Academy of Design, Quidor was not widely known as an artist during his lifetime. As a result of this and his subjective approach to painting, Quidor had no followers. It remained for a younger artist, William Sidney Mount, to popularize genre painting with other painters as well as with the American public.

William Sidney Mount

When Mount's work was first seen in the 1830s, the public and the critics alike thought the subjects of his paintings to be vulgar. It is difficult for us to imagine that Mount's graceful, gentle scenes could be viewed as anything but charming by their audience, for the artist's view of life on his native Long Island, New York, is pleasant and anecdotal, without a trace of the exaggeration that typified Quidor's work. Mount had an egalitarian spirit; his belief that an artist should "Never paint for the few, but for the many" is expressed in a work like *The Painter's Triumph* of 1838 (Figure 8), which suggests the relationship of the American artist to the public. Unlike his twentieth-century counterpart, the nineteenth-century artist is more elegantly dressed than his rustic visitor. The artist strikes a pose that Mount borrowed from ancient sculpture, and, with pride and enthusiasm, he presents his latest painting to his visitor. Mount is, perhaps, portraying the American artist's desire to make his work universally accessible, available for appreciation even to the average working person, a sentiment which was alien to the neoclassical tradition from which earlier American art had derived. Artists of that period tended to believe that an artist should paint only noble subjects—subjects that raised the mind of the viewer above his or her mundane, daily experience. Mount was, of course, aware of this tradition, since he had been one of the first students of drawing at the National Academy of Design in New York. Indeed, this painting

FIGURE 60 Mount, William Sidney, *Power of Music*, 1847. Courtesy of the Century Association, New York.

specifically refers to neoclassical ideals. The drawing of the *Apollo Belvedere* in the upper right hand corner of the painting acknowledges a classic prototype, and humorously, Apollo turns away in disgust from the democratic scene before him.

In recent scholarship, the egalitarian reputation of the art of this period has been reexamined, and a painting like *The Power of Music* illustrates this changing attitude in our own time. Mount was among the first American painters to present a sympathetic, dignified image of black men and women; a painting like this has traditionally been seen as an indication of the democratic outlook of Jacksonian America.

Art historian Patricia Hills sees it differently, however. In a discussion of this work she has written: "The painting becomes a nineteenth century visualization of the 'separate but equal' philosophy of race relations. In other words, although the black man is outside and not allowed to participate in white society, the appreciation of music is universal."[1]

Whatever our interpretation of this painting, or Mount's outlook

[1] Patricia Hills, *The Painters' America: Rural and Urban Life, 1810–1910*, Praeger, New York, 1974, p. 26.

on race relations in general, it has been generally acknowledged that music was an important element in Mount's life and art. Writing tunes for the fiddle was a favorite pastime of the artist, who even patented several structural changes on the violin. Mount said: "I often ask someone to play while I am sketching for it livens the subject's face." People playing, listening, or dancing to music was a favorite theme of the artist and, incidentally, showed the average person from a positive viewpoint.

The desire for a realistic statement is basic to Mount's art. The painter was so concerned with accuracy that in the 1860s, in order to better observe the people and the scenes which formed his subjects, he traveled the countryside in a horse-drawn studio. Nevertheless, it was a selective reality on which Mount chose to focus. His subjects are scarcely the average people that their setting and costume implies. Clean, healthy, bright, they and the world they inhabit present a consistently affectionate, optimistic image of America at mid-century. (See Figure 59, p. 78.)

Mount's optimism apparently extended to his outlook on this country. He never felt the need to study abroad, or, at least, never went abroad, perhaps feeling that all the resources for his paintings were in Long Island. He set an example for American genre painting

FIGURE 61 Mount, William Sidney, *Bargaining for a Horse*, 1835, Courtesy of the New York Historical Society, New York City.

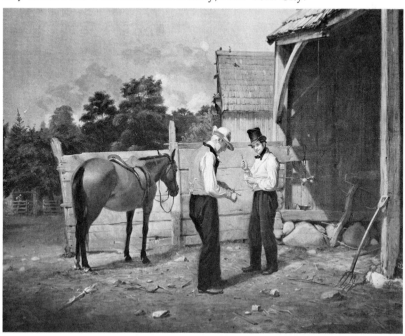

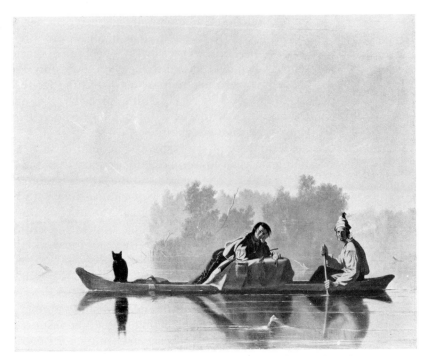

FIGURE 62 Bingham, George Caleb, *Fur Traders Descending the Missouri,* c. 1845, The Metropolitan Museum of Art. Morris K. Jesup Fund, 1933.

by choosing subjects that reflected a spirit of nationalism, subjects peculiar to American life. Farm rituals such as haying, bargaining for horses, and cider making are the basis of much of his art. This subject matter, life in idealized rural America, is the core of Mount's art. His paintings helped to establish a market for genre painting.

George Caleb Bingham

The Western counterpart of Mount's Eastern genre painting is the work of George Caleb Bingham. Bingham grew up in Missouri, and like Mount, took an affectionate view of his surroundings—an environment very different from Mount's Long Island, with the sight of flatboatmen carrying furs down the Missouri River to St. Louis as common as that of a truck driver is today. What Bingham saw was in some ways typical of American life on the frontier, but it was also unique to that time and place. In this sense, Bingham's art grows out of the same spirit of nationalism, the same interest in the local scene, as Mount's.

A politician as well as a painter, George Caleb Bingham served several terms in the state legislature, and, in addition, lost a few elec-

tions as well. His series on county election practices are among the most amusing and revealing genre paintings of the nineteenth century. With the extension of the vote to men without property, the character of American elections changed. The artist views the expanded franchise with honesty and good humor. His paintings catalog the diverse elements of popular participation in government —the honest voter, the drunkard being led to the polls—the playful and the serious side of politics.

Although Bingham did not travel abroad until 1856 when he went to study in Düsseldorf, Germany, European influences can be found in his work even before this date. As a young artist, he trained himself in a manner that was common among American artists up to the mid-nineteenth century. Bingham copied engravings of old master paintings and made sketches of plaster casts of classical sculpture. As a result, individual figures in his work sometimes recall these prototypes; for example, the Greek *Spear Bearer* (*Doryphorus*) was the basis for the pose of Daniel Boone in Bingham's 1851 painting of the frontiersman (Fig. 64). The only variation Bingham made from the pose of the classical Greek sculpture was reversing the position of Boone's legs. In contrast to his homespun subject matter, Bingham's visual organization was complex and sophisticated. His compositions employ groups organized into tight, geometric structures. His color is inventive, creating a thin, smoky atmosphere for

FIGURE 63 Bingham, George Caleb, *The County Election,* 1852, The St. Louis Art Museum.

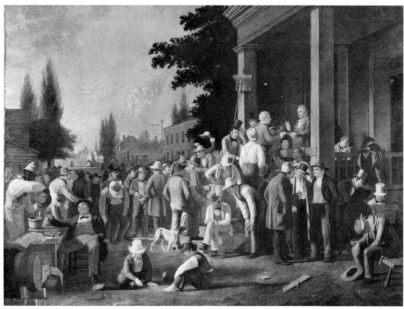

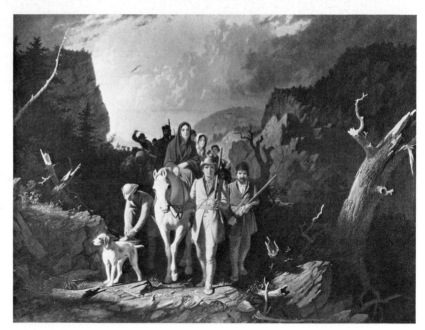

FIGURE 64 Bingham, George Caleb, *Daniel Boone Escorting Settlers through the Cumberland Gap,* 1851–1852, Collection, Washington University, St. Louis.

his scenes. George Caleb Bingham attempted to wed the European artistic tradition to the subjects of the frontier, and he succeeded amazingly well.

GENRE SCULPTURE

Genre sculpture was not as widespread a phenomenon as genre painting, for most mid-nineteenth-century American sculptors continued to work with grander, less colloquial content. However, an unusual nineteenth-century sculptor, John Rogers, created a three-dimensional counterpart to the work of Bingham and Mount.

Even though he had studied in France and met many of the great sculptors of the day, Rogers knew his strength lay in the realistic observation of the life around him. By placing ads in newspapers and periodicals, he sold more than 80,000 small-scale sculptures between 1860 and 1892. In a sense, Rogers wed art to the Industrial Revolution. In his studio, a staff of twenty men made copies of his clay models for mass sale. For only $15, a work like *Checkers up at the Farm* could be purchased. Filled with narrative detail, it is a pleasant presentation of rural American life.

Rogers did not shy away from social commentary. His sculptures at the time of the Civil War, with themes such as *Wounded to the Rear*

or *The Slave Auction*, reflect his Northern sympathies and his abhorrence of slavery.

GENRE AFTER THE CIVIL WAR

The Civil War marks important changes in American genre art, as in so many aspects of our history. The natural optimism that was true of the Jacksonian era was replaced by a more studied nostalgia and sentimentality. Eastman Johnson is a major figure in American genre painting after the Civil War. Long after the war and the Industrial Revolution had changed the focus of American life from rural areas to urban centers, Johnson continued to paint sweet evocations of the American countryside. The subject matter of these paintings was old-fashioned, even for that time. Johnson's *Old Kentucky Home* is the most celebrated of these works. Considerable controversy surrounds the interpretation of this painting with some declaring it racist, others declaring it an attractive physical presentation of the black American (Fig. 66).

It was also in the second half of the nineteenth century that the popular lithography shop of Currier and Ives came to prominence.

FIGURE 65
Rogers, John, *The Slave Auction*, 1859, Courtesy of the New York Historical Society, New York City.

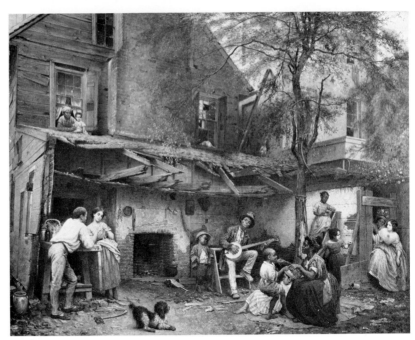

FIGURE 66 Johnson, Eastman, *Old Kentucky Home,* 1859, Courtesy of the New York Historical Society, New York City.

Nathaniel Currier opened a lithography shop in New York in 1835, one of many such establishments in existence at that time. By 1857, 7 years after J. Merritt Ives became his partner, the firm was the most successful in the country, distributing prints which bore the name of Currier and Ives and could be purchased for as little as 25 cents.

In the typical Currier and Ives print, commonplace or well-known subjects were presented in a straightforward, easily understood manner. Currier and Ives usually employed painters to compose the design for their prints, and then technical assistants would transfer the artist's design to the lithographer's stone. Some artists, among them Fanny Palmer, made both the original painting and the lithograph. A formula for both content and design was rigorously enforced, and few important artists worked for Currier and Ives since the firm edited the work so heavily.

THE DAGUERREOTYPE

At the same time that genre painting and lithographic prints were flourishing, portrait painting began to receive strong competition from photography. In 1837, the Frenchman Louis Jacques Mandé Daguerre modified Nicéphore Niépce's invention and created the

daguerreotype, a process whereby an image could be recorded on a copper plate in a matter of minutes.

Samuel F. B. Morse was one of the first Americans to use Daguerre's invention for portraiture. Many followed, as the camera intrigued American painters and lithographers. By 1840, studios had opened along the East coast for the purpose of making daguerreotypes at the cost to the sitter of $2 to $5 each. Kept in cases to avoid exposure to light, daguerreotypes were very fragile. In addition, a sitter would have to hold perfectly still for at least 30 seconds because of the need for long exposure time. This condition lent some vexing and amusing aspects to the daguerreotypist's task:

[A sitter] who is naturally ugly, and finding herself still uglier in the doleful expression of the daguerreotype, insists that it is a failure, and goes out without taking it.

After her comes a man with a tic, who constantly twitches the corner of his mouth, and in spite of it, wants to be daguerreotyped; then another who blinks her eyes rapidly, then an old lady who everlastingly shakes her head. All these people cannot understand that they will never have a portrait by this process.[2]

Despite these difficulties, two men emerged as masters of this medium—Albert Sands Southworth and Josiah Johnson Hawes.

[2] *La Grande Ville* (1842) quoted in Beaumont Newhall's *The History of Photography from 1839 to the Present Day,* Museum of Modern Art, New York, 1964, p. 22.

FIGURE 67 Currier and Ives, Fanny Palmer, *American Farm Scenes #1* (lithograph), 1853, Courtesy of Museum of the City of New York.

FIGURE 68 South-worth, Albert, and Josiah Hawes, *Lemuel Shaw, Chief Justice,* nineteenth century, The Metropolitan Museum of Art. Gift of I. N. Phelps Stokes, Edward S. Hawes, Alice Mary Hawes, Marion A. Hawes, 1938 (daguerreotype).

Their Boston studio specialized in natural poses and expressions, and they extended their subject matter to include landscapes and medical operations as well as portraiture (Fig. 68).

New techniques rapidly challenged the daguerreotype. The calotype, the tintype, and other variations of the daguerreotype made photo portraits cheaper and cheaper. By 1888, George Eastman, inventor of the Kodak, was selling his cameras for $10 each. Everyone became a portraitist, at prices even the middle class could afford.

AMERICAN QUILTS

If photography was a major and dramatic innovation in nineteenth-century America, quilting already had a long-established tradition. The earliest quilts arrived in this country with the first colonists. Soon, however, these wore out, and without a source for new material, the colonists were forced to make quilts from the bits and pieces of fabric that they could gather. Probably, then, the first American quilts were "crazy" quilts, odd patches of fabric stitched together in a free-form fashion.

The earliest sizable body of American quilts dates from the time of Bingham and Mount, the middle of the nineteenth century. These quilts already contained most of the techniques and motifs that

would distinguish American quilts from those of any other country, for in America the utilitarian act of making a quilt had been raised to the level of an art form. The women who made these nineteenth-century quilts, however, did not regard themselves as artists. They were housewives in a period when that occupation involved long hours of heavy life-supporting labor. Yet the skillful designs and exquisite needlework of these quilts have little to do with their function as household items. Given the proscriptions on female education and occupations in the nineteenth century, the quilt was, perhaps, a principal creative outlet for many American women, who invented a vocabulary of design motifs. Often, these motifs were abstract stylizations based on events the women had observed, read about, or experienced. The stylized patterns were named for their sources and designated by titles like "Log Cabin" or "Bursting Star."

Today, perhaps because of the twentieth century's familiarity with abstract design and its nostalgic taste for the craftsmanship of quieter times, the beauty of these quilts is highly esteemed. Quilting is one of the few American art forms that enjoys a virtually unbroken line from its inauguration in colonial times to the present day. In a number of ways, it can be seen as a peculiarly American art form. It combines the American respect for economy and usefulness with precise, linear design and an exacting technique. It is a major contribution of American women to our artistic heritage.

An important aspect of American art from 1830 through the 1870s is the popularization of the visual image. Americans bought American paintings, sculptures, prints, and photographs. Their life was reflected in these works; an American identity was being created. If American art is never again to enjoy such friendly relations with its public, it may be because its public will never again enjoy such positive, promising times.

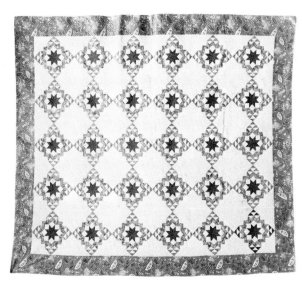

FIGURE 69
Pieced-work quilt by Jane Winter Price, Second quarter, nineteenth century, Courtesy of Division of Textiles, Smithsonian Institution.

CHAPTER 7

EXPLORING THE WILDERNESS

FIGURE 70
Saint-Mémin,
Charles, *Osage
Warrior*, c. 1804,
Courtesy the
Henry Francis
du Pont Win-
terthur Museum.

The American tradition of landscape painting launched in the second quarter of the nineteenth century by the Hudson River School was based on the representation of scenes in the eastern United States. As the frontier to the West opened, new subjects beckoned to painters—not only the land with its varied topography and breathtaking natural wonders but also the native inhabitants, the American Indians. Long before cattlemen and pioneers made their way West to settle the new territories, artists accompanied explorers and fur trappers on expeditions, braving hardships and dangers to record the wonders of the land and folkways of the Indians. By the end of the century, when the "Wild West" was just a romantic memory, artists continued to recount its legends and to record its rugged beauty.

In 1804, Meriwether Lewis and William Clark were sent by President Thomas Jefferson on their historic expedition to chart the Louisiana Purchase land beyond the Mississippi River. Although no artists accompanied them and the only pictorial records of the trip were maps and a few sketches in Clark's journal, the trip indirectly resulted in the first portrait paintings of the Indian natives from the Western plains. Lewis and Clark had been instructed by Jefferson to extend an invitation to the leaders of the various tribes they encountered to travel to Washington to be officially received, and by 1805, the first delegations of Indians had arrived.

During their tour of the larger Eastern cities, several members of the Osage tribe sat for portraits by the French-born artist Charles

FIGURE 71 King, Charles Bird, *Young Omaha, War Eagle, Little Missouri and Pawnees,* 1821, Courtesy of National Collection of Fine Arts, Smithsonian Institution.

Saint-Mémin. Using a mechanical device called the physiognotrace for tracing the outline of the sitter's profile, Saint-Mémin achieved a life-sized, accurate silhouette, and then proceeded to model the contours of the face and define the features with black and white crayon or watercolor paint. While not executed entirely free-hand, the portraits are finely modeled and impressively support Jefferson's appraisal of the Osage Indians as "the finest men we have ever seen" (Fig. 70, p. 92).

For Jefferson and his compatriots in the early nineteenth century, the Indian was both admired and feared. Less than a century before, the Indians of the eastern United States had been considered enemies, native primitives to be exploited or wild barbarians who threatened life and property. In keeping with this attitude, John Vanderlyn painted the grisly story of *The Death of Jane McCrea*, dramatizing the murder of a young woman by ferocious savages. Horatio Greenough depicted a similar incident in a sculptural group for the U.S. Capitol steps called *The Rescue*, in which the superiority of the white man saving a mother and child from an attacking Indian is suggested in a rather blatant way.

On the other hand, the Indian as Jefferson and Saint-Mémin described him was a man of character—the noble savage, an uncorrupted child of nature. Such a romantic notion had prompted the American painter Benjamin West to compare an ancient Greek statue, the *Apollo Belvedere*, to a Mohawk warrior and the writer Washington Irving to describe an Osage tribesman as a young man with "fine Roman countenance, who would have furnished a model for statuary." In this spirit, Thomas Crawford included an Indian as part of the pediment of the Senate wing of the capitol building, representing primitive, but uncorrupted man lamenting the encroachment of civilization. By the time of Thomas Jefferson's Presidency, the Indians were no longer an immediate threat, and curiosity about their customs and ways, particularly those of the Plains Indians who were from the unknown Western Territory, prompted more systematic and objective study.

In 1824 the government established a National Indian Portrait Gallery and commissioned several artists to preserve the likenesses of the tribal representatives visiting Washington and St. Louis. Unfortunately, most of the original collection was destroyed by a fire at the Smithsonian Institution in 1865, though a few portraits by the artist Charles Bird King remain. As his sensitive group portrait of *Young Omaha, War Eagle, Little Missouri, and Pawnees,* (Figure 71) reveals, King was responsive to the noble appearance and natural beauty of his native subjects. Although these portraits are valuable records of the Plains Indians, they are limited to likeness alone, and do not reveal the Indians' natural surroundings or tell of their customs and folkways. It remained for artists willing to follow the arduous course of trekking into the wilderness to provide a more complete picture of the Indians and their way of life.

FIGURE 72
Bodmer, Carl,
*Dance Leader of the
Hidatsa Dog Society*,
1834, Courtesy of
Rare Book Division,
The New York
Public Library.
Astor, Lenox and
Tilden Foundations.

EXPEDITIONARY ARTISTS

One of the first artists to accompany a government expedition was Titian Ramsay Peale, the 19-year-old son of Charles Willson Peale. Titian Peale was hired as a naturalist and scientific illustrator for the Long expedition of 1819. Because his instructions were to accurately depict the wildlife and flora, Peale did not contribute substantially to the pictorial record of the Indians of the region.

Other expeditions followed, and the picture of the American West began to take shape in the work of many other artists, among them, John Mix Stanley, Charles Wimar, and Seth Eastman. Eastman painted scenes of life among the Sioux while he was an army officer stationed at Fort Snelling, Minnesota.

Foreign adventurers were also attracted to the American West. The Swiss painter Karl Bodmer was hired by the prince of a small German state, Maximillian of Nieu-Wied, to accompany his expedition in 1833. After 2 years in the field, they returned to Europe with Bodmer's watercolor sketches, which were copied for 82 copperplate

engravings and published in Maximillian's book documenting the expedition. Although Bodmer never returned to America, his richly detailed studies, such as *Dance Leader of the Hidatsa Dog Society*, are valuable examples of the art inspired by the Plains Indians (Fig. 72).

A Scottish adventurer, William Drummond Stewart, hired an artist he first met in New Orleans, Alfred Jacob Miller, to accompany him to the annual meeting of fur trappers in the Rockies. Miller's pen-and-ink sketches and watercolors became the basis for large mural paintings created for Stewart's manor house in Scotland. Although his watercolor sketches are freely executed, fresh impressions, his finished oil paintings are interpretations flavored more by fancy than fact. Miller, no doubt taking his cue from his patron's boyish enthusiasm, depicted the saga of the West in romantic, idealized terms. Both Indian and trapper were ennobled and given heroic proportions. In his sentimental painting, *The Trapper's Bride*, even the notoriously rough and wily fur trapper has a cultured, gentlemanly demeanor.

Among the early artist-explorers of the nineteenth century, one man stands out not only as a painter with an eye for the character and essence of the land and its people but also as an objective reporter of the Indian and life on the plains. After seeing a delegation of Indians passing through Philadelphia in 1821, George Catlin vowed to dedicate his career to being the pictorial historian of these people, whom he described as "surely the most beautiful model of the painter." There was urgency in his declaration to "snatch from hasty oblivion . . . a lofty and truly noble race.[1]

Setting out from St. Louis in 1830, Catlin traveled over 2000 miles, visiting outposts as far west as Leavenworth, Kansas, and Fort Union, South Dakota, at the mouth of the Yellowstone River. While living among the Indians for 6 years, he witnessed and enthusiastically recorded buffalo hunts, sacred ceremonies, and even an Indian version of the sauna bath. Hundreds of portraits, genre scenes, and landscapes, as well as written accounts, resulted from his experiences with the Kansa, Mandan, Sioux, Blackfoot, Piegan, and Assiniboine tribes.

Using a limited palette of previously prepared colors for easy portability, and thinly applying color so that the painting would dry quickly and not crack when rolled for carrying, Catlin sketched on the spot, filling in the essentials with a quick outline and then completing the work later back at camp. To maintain the spontaneity of his first impressions, Catlin did not extensively rework his original paintings, but left them as oil studies. Years later, because of financial difficulties, he copied some of his early works in more detailed, finished form to sell commercially. (See Fig. 73.)

[1] See Catlin's *Episodes from Life Among the Indians*, University of Oklahoma Press, Normal, 1959, and *Letters and Notes on the North American Indians*, Potter, New York, 1975.

FIGURE 73 Catlin, George, *Buffalo Chase with Bows and Lances*, 1830–1839, Courtesy of National Collection of Fine Arts, Smithsonian Institution.

Although his earliest works are thinly painted and sketchy, they capture with a few sure strokes of color the pageant of village life or the proud stance of a warrior or the character in a handsome face. The admiration for his subjects that is so evident in his portraits is also apparent in his written descriptions, such as his evaluation of Kee-O-Kuk, chief of the Sauk and Foxes, as a "dignified and proud man with a good share of talent and vanity enough to force into action all the wit and judgment he possesses, in order to command the attention and respect of the world" (Fig. 4).

Catlin's landscapes, though simple and almost schematic, are equally expressive, conveying the character of the terrain with the plains rolling and swelling like an ocean of grass and people and animals racing across it, leaning with the wind and curving horizon.

Civilization was already beginning to take its toll while Catlin was living among the Indians, and he captured with sad irony some of the changes being wrought. In his portrait of *Wi-Jun-Jon,* a young Assiniboine brave is shown on his way to Washington wearing his ceremonial costume and returning home in awkward looking clothes that had been presented to him by the government. The contrast between the grace and pride of the former and the degradation of the

latter is painfully apparent. As early as 1841, Catlin began actively promoting the establishment of a national park to preserve the Plains Indians' way of life, but his lobbying efforts did not meet with success. His dream of assembling an Indian portrait gallery was fulfilled, however, but not in the form of a national museum as he had initially hoped, but in the form of a traveling show that was exhibited in numerous cities in the United States as well as in Europe. Many years after his death, a large portion of the original collection was purchased and given to the Smithsonian Institution's National Collection of Fine Arts in Washington, D.C. (then called the National Gallery). Here, at least, in his paintings as well as in the many sketches, prints, travel notes, and books that resulted from his life on the Plains, Catlin succeeded in preserving the image and culture of the American Indian for posterity.

WILD WEST ILLUSTRATORS AT THE TURN OF THE CENTURY

Half a century later in the 1890s, the Wild West was merely the location of folktales of cowboys and Indians, and yet its exciting past continued to be re-created in American art, just as it would be popularized in films and on television a few decades later. Magazines like

FIGURE 74 Catlin, George, *Pigeon's Egg Head (Wi-Jun-Jon) Going to and Returning from Washington,* 1832, Courtesy of Museum of Natural History, Smithsonian Institution.

FIGURE 75 Remington, Frederic, *Flight for the Waterhole*, 1901, The Museum of Fine Arts, Houston, The Hogg Brothers Collection.

Harper's Weekly and *Colliers* thrilled their subscribers with stories and illustrations of life on the range and the bygone days of the Indians and Western exploration. Two of the most popular artists to contribute illustrations to these periodicals were Frederic Remington and Charles Russell. Russell was a self-taught artist who lived among the Indians in Canada for a time and worked as a cowboy until the open ranges were fenced in. Remington was educated at Yale and studied art before venturing West to spend several summers on a Montana ranch and to travel for a time with the Army in the Southwestern desert. (See Fig. 75.)

Remington and Russell have often been dismissed as mere illustrators rather than artists, because most of their paintings are narrative or anecdotal. It is true that both often employed fanciful details and fast action for their "shoot 'em up" dramas and that their art was not always historically accurate. Yet, at their best, the quality of their representations makes the stories convincing and the action entertaining.

Remington followed the not uncommon practice for artists in the late nineteenth century of studying photographs for his paintings. The sequential still-photographs by Eadweard Muybridge, an early experimenter in photographing motion, enabled Remington to paint strikingly energetic and accurate representations of galloping horses. Late in his career, he also took up sculpture, modeling vigorous small-scale figures of horses and cowboys caught in mid-action. The

Bronco Buster, typical of Remington's bronze pieces, is notably expressive and dynamic when compared with the academic formalism of most late-century sculpture.[2] The popularity of Remington and Russell has not diminished over the years, and, if anything, the artists have become as legendary as their art. Perhaps the lasting quality of their work can be explained by Remington's declaration, "I paint for boys . . . boys from ten to seventy."

THE ROCKY MOUNTAIN PAINTERS

Landscape painters were not as quick to venture West to commemorate the magnificent scenery of the Southwestern desert and the Rockies as the students of the Plains Indians were. The Hudson River School painters were content to record the wilderness of the Catskills and White Mountains. It was not until the last third of the century that landscape painters began to specialize in painting the Rockies, the Redwoods of California, and the natural wonders of Yellowstone. By this time, the lofty mountains and rugged desert terrain challenged not only painters but photographers as well. Two painters, Albert Bierstadt and Thomas Moran, established their careers meeting this challenge.

Bierstadt was born in Germany but raised in the United States. After traveling to Düsseldorf to study painting at the Academy, Bierstadt returned to New Bedford, Massachusetts, to begin his career. Achieving a moderate degree of success locally, he decided to strike out on a more adventuresome path in 1859 and joined a federal expedition surveying a new northern wagon route to the Pacific. A photographer friend went along, and together they documented the journey with photographs and with pencil and oil sketches. Some of Bierstadt's sketches of the trip were reproduced in *Harper's* magazine by a correspondent they met en route.

Inspired by the spectacular scenery that he had seen, Bierstadt began painting large-scale landscapes upon his return. Like the famous Hudson River School painter Frederic Church, Bierstadt exhibited his paintings for an admission fee. When great crowds flocked to see *The Rocky Mountains* (Fig. 76), his success and popularity were assured. Bierstadt's enormous panoramas can be compared to Church's in other ways. They shared large scale, a feel for the details of the terrain, dramatic subject matter, and they were crowd pleasers. Because of his training in Düsseldorf, Bierstadt's approach to painting was different from Church's, however. He employed more virtuoso effects: brilliant color, exaggerated dimensions, and emphasis on picturesque details. He was also less

[2] For a discussion of late-nineteenth-century sculpture, see Chapter 11.

FIGURE 76 Bierstadt, Albert, *The Rocky Mountains,* 1863, The Metropolitan Museum of Art. Rogers Fund, 1907.

concerned with capturing the unique American qualities of the land. He even compared the Rockies to European scenery, observing in a letter to the art magazine *The Crayon* that they "resemble very much the Bernese Alps."

After a highly successful career of over 30 years, Bierstadt's reputation began to decline. The final blow came in 1889 when a New York committee rejected as a United States entry for the Paris Exposition his painting *The Last of the Buffalo.* More than anything else, the rejection can be attributed to the fact that this type of painting—a grandiose panoramic landscape derived from the Hudson River style—was outmoded and old-fashioned. Despite the criticism of Bierstadt's paintings (in some cases justified), it cannot be denied that Bierstadt's works were among the most popular and inspirational representations of the scenery of the Rocky Mountains in the nineteenth century and that their popular appeal continues today.

Thomas Moran, like Bierstadt, was born in Europe but raised in America. After working as a wood engraver and illustrator, Moran journeyed to his native England at the age of 25, where he was introduced to the work of the early-nineteenth-century landscape painter J. M. W. Turner. Inspired to take up landscape painting, Moran was influenced by Turner's sensitivity to nature's moods and his use of vibrant color and misty atmospheric effects. Like Turner, Moran also worked with the medium of watercolor as well as with oil. Quickly

achieving fluency with the medium, Moran worked with a light touch, using thin color washes, a minimum of detail, and leaving areas of white paper untouched to enhance the effects of light. The opportunity to put his talent to exciting use came in 1871, when he accompanied as a guest artist Dr. Ferdinand V. Hayden's government geological team surveying the Yellowstone River and Rocky Mountain territory.

Armed with many fine drawings and watercolor sketches of geysers, cascades, and dramatic rock formations, Moran began working on several large oil paintings after his first trip and subsequent ones to Utah, Arizona, and Colorado. Admitting to avoiding "literal transcripts from Nature," Moran sought to capture the essence of a location by using brilliant colors, vigorous brushwork, and emphasizing the breadth and scope of the area. Individual details and textures were carefully rendered, but not allowed to dominate or intrude upon the overall effect. His huge painting, *The Grand Canyon of the Yellowstone River*, measuring over 15 by 7 feet, was purchased by the government and is now displayed in the National Collection of Fine Arts in Washington, D.C. Moran's paintings not only gained him personal success but also were instrumental in per-

FIGURE 77 Moran, Thomas, *The Grand Canyon of the Yellowstone River*, 1893–1901, Courtesy of National Collection of Fine Arts, Smithsonian Institution.

suading Congress to establish the first national park at Yellowstone. Photographs made by William Henry Jackson during the Hayden expedition were also persuasive evidence for the establishment of the park.

LANDSCAPE PHOTOGRAPHY

Since the 1840s, shortly after photography had been invented in France, Americans began working with the process. Used chiefly for portraits in its early years, photography took on a new role—that of documenting events—during the Civil War. Under the direction of Mathew Brady (Fig. 105), many photographers received their train-

FIGURE 78 Watkins, Carleton, *Pi-Iwy-Ac* (*Vernal Falls, California*), c. 1865, International Museum of Photography at George Eastman House, Rochester, N.Y.

ing in the field, capturing the grim images of our war-torn country. After the Civil War, many photographers, seeking equally significant subject matter, joined expeditions and survey teams to record the Western landscape. The task of these pioneer photographers was a difficult one. The photographic process was still relatively crude and inefficient, requiring a great deal of bulky equipment which had to be carried by pack mule and wagon. At that time, a large camera was necessary to photograph the wide expanse of a landscape, because the negative plate could not be enlarged in the positive print. As a practical measure, if a photograph wasn't a success, the fragile glass negative plate was always wiped clean and reused. The outstanding quality of the photographs produced by Jackson and other early landscape photographers, including Timothy O'Sullivan, William Bell, Frances Frith, and Carleton Watkins, is particularly impressive in light of the hardships they withstood in order to take them and the limitations of equipment and procedures.

Photography not only had aesthetic value, but it served a number of practical purposes, as well. Carleton Watkins, for example, carefully recorded the proper botanical name of each example of the flora of the Southwest that he photographed, providing accurate scientific documentation of his expeditions. Many painters like Frederic Remington began to use photographs as preparatory studies for their work. The detailed representation of an Indian encampment in the foreground of Bierstadt's *The Rocky Mountains* was based on photographs (Fig. 76).

While its impact on painting in the last quarter of the nineteenth century was significant, photography would never replace painting, nor rival it, because of its separate and distinct nature as an art form. A striking comparison of the difference between photography and painting can be seen in a Jackson photograph of the Mountain of the Holy Cross in Colorado and a painting by Thomas Moran of the same landmark. Moran was able to use brilliant color and to shift the elevation of the mountain to include a closeup of woods and a mountain stream. Jackson's photograph reveals the sweeping panorama from a single vantage point during a few moments of time. Black, white, and shades of grey define the mass of land and shifts in atmosphere and light. The beauty of photography is equal, yet very different, from that of the artist's interpretation in paint.

A distinguished modern photographer, Ansel Adams, has renewed and extended the tradition of the pioneer landscape photographers in the twentieth century by returning to many of the same locations. His first visit to Yosemite Valley at the age of 14 left an indelible impression which Adams described as "a culmination of experience so intense as to be almost painful. Since that day in 1916, my life has been colored and modulated by the great earth gesture of the Sierra." From his first photographs of the Sierra made with a

FIGURE 79 Adams, Ansel, *Mount Williamson, Sierra Nevada, from Manzanar,* c. 1944, International Museum of Photography, Collection of Newhall, Rochester, N.Y.

Brownie box camera, Adams continued to refine his craft and to study the changing faces of nature seen in different light conditions.

Ansel Adams's work as a photo-muralist for the United States Department of the Interior in the 1940s continued the tradition begun a century earlier by George Catlin and his fellow artists who sought to commemorate and preserve the beauty and unique quality of the land and native peoples of America. Their pictorial record of a century of American life—of the wilderness landscape, the native Indian, the fur trappers, the explorers, the cowboys, and the pioneers—is today a special part of the legacy of painters and photographers of the nineteenth century.

CHAPTER 8

CHAPTER 8

THE VISIONARIES

Some artists look to the world around them for inspiration; others look inward to the realm of the imagination and dreams. In the nineteenth century, visionary or mystical expression was a significant part of the American artistic tradition. Just as writers such as Edgar Allen Poe and Herman Melville probed the dark, mysterious sides of man and nature, so too, painters and sculptors gave form to their inner visions and emotions. The common ground for the visionary artists Albert Pinkham Ryder, Ralph Blakelock, Elihu Vedder, William Rimmer, and George Inness was not their choice of subject matter or their manner of working, but rather the evocative nature of their themes and imagery. The premise of their art, as George Inness described it, was the belief that "a work of art does not appeal to the intellect. It does not appeal to the moral sense. Its aim is not to instruct, not to edify, but to awaken the emotion."

GEORGE INNESS

George Inness was one of the most popular and successful landscape painters in America in the second half of the nineteenth century. Although he was a contemporary of the famous Hudson River School painter, Frederic Church, Inness followed a considerably different course during his career. (See Chapter 5, Figure 56.) While Church painted huge panoramic views of magnificent natural wonders meant to uplift, edify, and instruct, Inness painted smaller, more intimate landscapes drawn from the mind and aimed at the emotions. Inness also experimented with a variety of approaches and was open to a number of influences before arriving at his mature style. Although he had received little formal training, Inness studied copies of seventeenth-century European landscapes when he began painting in the 1840s. He was also influenced by the popular Hudson River School and shared their preference for native subject matter. He did not share, however, their preoccupation with the expressive power of the rugged wilderness lands of America. In his painting of the *Delaware Water Gap*, for example, the natural beauty of the river flowing through gently rolling hills and a fertile valley is touched by the mark of man and civilization. Cows graze near the waters edge, busy barges transport goods on the river, and a locomotive steams across the countryside.

In the *Lackawanna Valley*, a painting commissioned in 1855 by

FIGURE 80 Inness, George, *The Lackawanna Valley*, 1855, National Gallery of Art, Washington, D.C. Andrew W. Mellon Collection. Gift of Mrs. Huttleston Rogers 1945.

FIGURE 81 Inness, George, *The Monk*, 1873, Addison Gallery of American Art, Phillips Academy, Andover.

the Delaware, Lackawanna, and Western Railroad, a round house, departing train, and the growing community of Scranton, Pennsylvania, occupy the lush green valley bathed in bright sunshine.

After several trips to Europe, Inness began painting more informal, pastoral scenes, in which the effects of light and atmosphere helped to create mood. He began to eliminate details and to work with broader areas of color and form to convey mood and meaning in his landscapes. One of the most dramatic examples of Inness's use of nature as a vehicle for personal expression is *Peace and Plenty,* which he painted in 1865 to celebrate the end of the Civil War. For Inness, who was a dedicated abolitionist and Union supporter, the quiet splendor of the sunset across a fruitful land signified the end of hostilities and the promise of a new era of peace and prosperity. The scene was not of a specific location, but a combination of several views. By rearranging nature and emphasizing contrasts of light and shadow, Inness orchestrated a personal declaration of victory and hope.

Inness's desire for expression was closely linked to his design sensibility, and indeed the two were often interdependent. The arrangement of forms, as well as color and brushwork, helped create the mood and sense of mystery in paintings such as *The Monk,* a work painted while he was living in Rome. Here a solitary figure meditates in the lush confines of a garden underneath the splendor of a sunset sky and majestic umbrella pines. The emphatic horizontal

FIGURE 82 Inness, George, *The Clouded Sun*, 1891, Courtesy of Museum of Art, Carnegie Institute.

line of trees repeated in the walled garden creates a stable composition, while pinks, vermilion, gold, and blue light up the evening sky and resonate with the cool darkness of the garden. The elegance and stability of the composition enhances the sense of calm and mystery.

Inness worked at a feverish pace, and his production was prolific, but, as one acquaintance put it, "the flame of genius burned in too slight a temple." Inness is believed to have been an epileptic—his chronic illness described by a friend as a "sensitive nervous state." He pursued spiritual fulfillment in religion and theology with as much determination as he sought spiritual expression in his paintings. A philosophy congenial to his belief that "the goal of art was to first cultivate the artist's own spiritual nature" was found in the writings of the eighteenth-century scientist and mystic, Emmanuel Swedenborg. Toward the end of his life, Inness increasingly sought to create the artistic equivalent for his religious philosophy and emotional state and began to work improvisationally, beginning a landscape in his studio without preparatory sketches. Starting with a few strokes of color on a blank canvas, he would develop an image intuitively. His works dating from the 1880s and 1890s do not describe a particular location, or atmospheric condition, or theme. Compositions are simple, and colors are low in key. Brushwork does not define details or textures, but instead creates enveloping hazes and vague forms, which are punctuated by bright accents of color. Though they did not always satisfy him, Inness said of

his works that "behind all is the man and his vision, freely given and expressed." (See Fig. 82.)

ELIHU VEDDER

A contemporary and friend of George Inness, Elihu Vedder, was also a visionary artist inspired by the inner world of emotions and the imagination, but in a very different way from the landscape painter. In one of his most famous works, *The Lair of the Sea Serpent*, an enormous, coiled sea monster is warming itself on a sand dune. By placing a strange and exotic creature in a plausible context, Vedder transformed the ordinary into the extraordinary. Unlike Inness, who relied on the evocative qualities of nature, Vedder was a storyteller who illustrated the mysterious, the fantastic, and the unexpected, much to the delight of his nineteenth-century audience.

Vedder began his career inauspiciously, doing illustration work in New York, such as drawing comic valentines and illustrating exercises for physical-training manuals. The art market during these years was at a low ebb because of the Civil War, so Vedder traveled to Europe in search of better fortune. Although he continued to maintain his American ties and friendships, Rome became his home for the remainder of his life.

FIGURE 83 Vedder, Elihu, *The Lair of the Sea Serpent*, 1864, Courtesy, Museum of Fine Arts, Boston. Bequest of Thomas G. Appleton.

Although as an expatriate artist Vedder painted many sensitive landscape studies of the Italian countryside, works such as *The Questioner of the Sphinx,* which illustrated exotic or mysterious themes, are more characteristic of his oeuvre.

Vedder also sought to give allegorical form to abstract themes such as "the Soul Between Dawn and Faith" and the "Soul in Bondage." His choice of imagery was at times melodramatic. When he represented mental illness as a troubled woman wandering through a barren and forbidding landscape in *The Lost Mind,* his artist friends jokingly referred to the woman as the "Idiot in a Bath Towel." At his best, though, Vedder could be a provocative and masterful storyteller. His black-and-white illustrations for Edward Fitzgerald's translation of the *Rubaiyat of Omar Khayyam* evoke the rhythmic poetry of the verses in a sensuous and highly effective way.

In the 1890s, along with other noted painters, Vedder was commissioned to paint murals for the Library of Congress in Washington, D.C. His particular subjects were good and bad government. Vedder expressed these themes in the conventional visual language

FIGURE 84 Vedder, Elihu, *The Questioner of the Sphinx,* 1863, Courtesy, Museum of Fine Arts, Boston. Bequest of Mrs. Martin Brimmer.

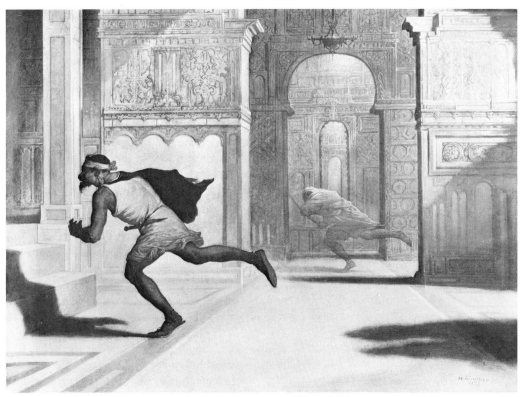

FIGURE 85 Rimmer, William, *Flight and Pursuit,* 1872, Courtesy, Museum of Fine Arts, Boston. Bequest of Miss Edith Nichols.

of the day, utilizing allegory, symbol, and personification. The solid architectural foundation of "Government" becomes a broken ruin in "Anarchy", for example. The female figure holding aloft the scales of justice and representing "Good Administration" contrasts with the figure in "Corrupt Legislation" being swayed by graft. As was common with a number of his contemporaries, both in Europe and America, Vedder was an admirer of antiquity and depicted his allegorical figures as classical maidens garbed in flowing togas— but with the sentimental, fashionable look of nineteenth-century women. In works such as these, Vedder was not solely guided by an inner vision, but was instead dealing with more conventional themes and motifs in accordance with the tastes of his day. In referring to these different types of approaches to his works, he noted: "I am not a mystic, . . . I take short flights or wade out into the sea of mystery which surrounds us, but soon, getting beyond my depth, return, I must confess with a sense of relief, to the solid ground of common sense."[1] His best works, whether of the mys-

[1] Vedder wrote two autobiographical books, *The Digressions of V. Written for His Own Fun and That of His Friends,* Boston and New York, 1910, and *Doubt and Other Things,* Boston, 1922.

tic type or not, were popular in their time, and the power of his images is still potent today.

WILLIAM RIMMER

William Rimmer did not enjoy fame or lucrative commissions, nor did he possess Vedder's ability to retreat from the depths of mysticism to "the solid ground of common sense." He was self-taught and struggled to develop his art while supporting his family at a succession of jobs: sign painter, typesetter, cobbler, physician, and anatomist. Although encouraged by a sympathetic patron, he received only limited critical notice by the artistic community for his commissioned sculptures, and not until after his death were his modeled clay and plaster pieces cast in bronze. The recognition that he achieved during his lifetime was as a drawing instructor and anatomist, not as a sculptor or painter.

As a boy of 14, Rimmer made his first sculpture, a male figure deep in melancholy thought titled *Despair*. The work was inspired by his father, a troubled, eccentric man, who believed himself to be the lost French Dauphin, son of Marie Antoinette and Louis XVI, in exile and hiding from assassins. There was possibly some basis for his contention because he was raised in Europe and well educated in music, literature, and the arts. His father's frustration and bitterness led to alcoholism and poverty and to a life of seclusion for his family. Rimmer's difficult childhood turned the brilliant, sensitive boy inward and onto his solitary creative path.

A painting called *Flight and Pursuit* (Fig. 85, 1872) is typical of the imaginative nature of Rimmer's paintings and drawings and of the dark fantasy that colors them. As an armed messenger races down the mirrored corridors of an Arabian palace, a sinister companion echoes his steps in an adjacent passageway. Is this shadowy figure the pursuer, or is there yet another whose presence is revealed by a dark, looming shadow? The ambiguity of the situation, as well as the setting of endlessly mirrored halls, heightens the mood of terror and tension.

Anxiety and violence were even more emphatically stated in Rimmer's sculptures, in which physical struggle expresses emotional turmoil. His small *Fighting Lions* is a powerfully intense and compact sculpture of two beasts locked in mortal combat. In another work, vigorous surface and strained, muscular forms capture the agony of a *Dying Centaur*. By leaving off the arms of the piece, Rimmer not only recalled the fragmented statues of antiquity but also reinforced the inner coherence and expressive energy of the form. His most impressive, full-length figure, *The Dying Gladiator* (Fig. 86, p. 108), was also based on a classical subject. Rather than making it into a neo-

classical adaptation of an antique work, Rimmer created a unique interpretation of the theme of the heroic athlete. The instability of the pose, thrusting backward into space yet tensely stabilized, expresses through anatomy a deeper psychological struggle. Relying on his knowledge of anatomy rather than any traditional training as a sculptor, Rimmer avoided his contemporaries' dependence on academic formulas. Unlike popular American sculptors such as Hiram Powers, who depicted idealized female figures, Rimmer preferred the male nude and admonished his students to "Draw men, not women, You will weaken your artistic power if you do otherwise."[2]

Although Rimmer was in many ways a tragic figure as an artist, he was not totally isolated from the mainstream of nineteenth-century art. His anatomy and drawing classes attracted a number of admirers, and the list of his students and friends is an impressive one which includes the painters William Morris Hunt and John La Farge, the philosopher, Ralph Waldo Emerson, and the sculptor Daniel Chester French. French, who became one of the most famous sculptors in the last third of the nineteenth century, was responsible for having a number of Rimmer's works cast in bronze. William Rimmer's reputation has increased over the years, and today he is finally acknowledged as a unique and important nineteenth-century artist, whose visionary works are a considerable contribution to American sculpture.

RALPH BLAKELOCK

It seems to have been the fate of several of the visionary artists to be touched by tragic circumstances and unappreciated in their own lifetimes. While struggling to support a wife and nine children, the landscape painter Ralph Blakelock was victimized by unscrupulous dealers, who paid pitifully small sums for his paintings but sold them for a high profit. By the 1890s, when his paintings were widely known and selling for good prices, Blakelock was in a mental asylum suffering from a severe nervous disorder.

Blakelock was self-taught and worked from memory, and like George Inness, used nature for lyrical expression. His peaceful landscapes do not betray the inner anguish of the artist who created them. In paintings such as *Moonlight* (Fig. 87), he worked instinctively, building up the surface of his canvas with thick, impasto paint and then grinding it down with pumice. The composition was pulled together by a final, delicate glaze, or thin wash of oil paint. Darkness obscures detail, and moonlight creates patterns and textures in these evocative landscapes. The image of an Indian encampment, which

[2] Rimmer also wrote and illustrated two texts on anatomy, *Elementary Design*, Boston, 1864, and *Art Anatomy*, Boston, 1877.

FIGURE 87 Blakelock, Ralph A., *Moonlight*, 1885, Collections of The Brooklyn Museum. In memory of Dick S. Ramsay.

appears in many of his works, was inspired by a memorable scene which he had witnessed while traveling out West as a young man. Unlike other artists who were fascinated by the American Indians, Blakelock did not record their customs or portraits; instead, they became for him an inseparable part of the magic of the land and the mystery of the wilderness.

ALBERT PINKHAM RYDER

Another artist, a solitary figure who steadfastly reached out to give form to his visions, was Albert Pinkham Ryder. His paintings were not based on traditional techniques or styles. Their emotional power stems from an expressive pictorial language which was created by going beyond the conventional, the ordinary. As Ryder explained, the path he chose was not an easy one: "Have you ever seen an inch worm crawl up a leaf or a twig, and then clinging to the very end, revolve in the air, feeling for something to reach something? That's like

me. I am trying to find something out there beyond the place on which I have a footing."

Born in the whaling town of New Bedford, Massachusetts, Ryder never forgot the moods of the sea or lost the independence of a New Englander. In 1870, at the age of 21, he moved to New York City, and though he had little formal instruction, he began to pursue his lifelong vocation as a painter. His first works were landscapes based on recollections of the Massachusetts countryside. These small pastoral studies usually include farm animals and are set in the late hours of the day when light is fading and forms are bathed by a soft glow. Rather than literal representations, they are images drawn from within, and simplified by memory and time. At first Ryder was frustrated in his attempts to copy nature. As he described years later:

In my desire to be accurate, I became lost in a maze of detail. Try as I would, my colors were not those of nature. My leaves were infinitely below the standard of a leaf, my finest strokes were coarse and crude. The old scene presented itself one day before my eyes framed in an opening between two trees. It stood out like a painted canvas. . . . There was no detail to vex the eye. Three solid masses of form and color—sky, foliage, and earth—the whole bathed in an atmosphere of golden luminosity. I threw my brushes aside: they were too big for the work in hand. I squeezed out big chunks of pure, moist, color, and taking my palette knife, I laid on blue, green, white and brown in great sweeping strokes. As I worked, I saw that it was good and clean and strong.[3]

Ryder had discovered that he did not want to copy nature, but to seek its equivalent in art. As he said, "It was better than nature, for it was vibrating with the thrill of a new creation."

As he worked, Ryder stripped away details, painting with broad areas of color, and created rhythmical patterns of forms and light. To develop an image, he would sometimes spend years on a single work, painting and repainting. As paint layers were built up, colored forms became darker and areas of light glowed through veils of colored glazes. In paintings such as *Moonlit Cove,* with its strong shapes set against a clouded and luminous sky, Ryder succeeded in creating a mood through color and design alone. The spirit, not the specifics, of nature was the source for his painting. As Ryder explained, "What avails a storm cloud accurate in form and color if the storm is not therein?"

In his singleminded effort to bring his images to life, Ryder often ignored the proper, time-consuming methods for painting, and used instead the most immediately available means at hand. He

[3] From an interview with Ryder which appeared in *Broadway Magazine* in 1905 in an article entitled, "Paragraphs from a Studio of a Recluse."

FIGURE 88 Ryder, Albert Pinkham, *Dead Bird,* 1890–1900, Courtesy of The Phillips Collection, Washington.

would often mix unstable media such as wax, candle grease, and even alcohol with his pigments. Ryder also painted wet into wet and varnished without allowing layers of paint to dry. As a result, most of his works have cracked and become darker with age.

Although he was not concerned with traditional craftmanship, Ryder made many truly beautiful paintings. In *Dead Bird*, for example, the effect of an enameled low relief was achieved by applying thick paint with a palette knife. Ryder thought of his works as living things, saying that he "pondered over them with prayer and fasting, letting them ripen under the sunlight of the years that come and go."

The artist's love of the sea, nurtured during his childhood in New Bedford, grew during his life and became a recurring motif in his paintings. Often drawn to the waterfront district of New York, Ryder spent many evenings absorbed in the passing pageant of clouds, water, and boats. From these sessions of what he called "soaking in the moonlight," Ryder shaped the mental pictures that were later given form in his paintings. In his seascapes such as *Moonlight Marine* and *Toilers of the Sea*, the rhythmical relationships of light and forms bring to mind the cadences of American seafaring literature and poetry.

In many of these paintings, the underlying theme of the mystery and power of the sea was derived from the artist's own imagination. In other works, literature of the sea provided the inspiration. The biblical tale of Jonah and the whale, for example, served as the motif in Ryder's painting depicting the theme of man at the mercy of nature. As Jonah is flung from his boat into a turbulent sea, the

shining, powerful figure of God looks down from the heavens. The swell of a monumental wave seems to literally bend the boat, and Jonah seems but an insignificant actor in the drama of the violent ocean and God's will.

Music was also a source for a number of Ryder's paintings. *The Flying Dutchman,* for example, was based on the Richard Wagner opera. Instead of illustrating a specific scene from the opera, Ryder's painting evokes the tragic meaning of the story of a phantom ship captained by a lost soul. In *Siegfried and the Rhine Maidens,* another painting inspired by a Wagner opera, the ominously swaying trees, cloud-filled night sky, and sinuous shapes echo the emotional tur-

FIGURE 89 Ryder, Albert Pinkham, *Toilers of the Sea,* 1884, The Metropolitan Museum of Art. George A. Hearn Fund, 1915.

moil of the hero as he is being tempted by the seductive river nymphs to return the stolen ring.

Ryder's sources were at times rather unusual. *The Race Track*, for example, was inspired by the suicide of an acquaintance who had lost his life savings betting on horse races. Ryder depicted the cause of the man's death with sinister irony, showing a ghostly rider racing around a track while an evil serpent, presumably Satan, looks on with eyes glowing like diamonds.

Ryder never married; he spent his days in New York in a room

FIGURE 90 Ryder, Albert Pinkham, *Siegfried and the Rhine Maidens,* 1888–1891, National Gallery of Art, Washington, D.C. Andrew W. Mellon Collection 1946.

piled high with papers, paint, old food, and clothing—every inch was covered with debris, with only a narrow path from his bed to his stove and easel. Although he lived as a recluse, and was known as an eccentric for whom money and fame meant nothing, Ryder was not completely out of touch with his contemporaries. He maintained several close friendships with artists and exhibited in the 1870s at the National Academy of Design and later with the Society of American Artists, of which he was a founding member. By the turn of the century, his paintings were in great demand, and in 1913 six were included in the historic Armory Show, the first major exhibition of avant-garde European and American art on this side of the Atlantic. He was recognized not only as a great visionary painter of the nineteenth century but as a man ahead of his time, who created a personal language for his art that foreshadowed the subjective vision of much painting in the twentieth century.

Ryder, Blakelock, Rimmer, Vedder, and Inness were very different artists. They were not bound together by a single style or theory. Each followed his own individual course. If their contemporaries Thomas Eakins and Winslow Homer gave epic form to the realities of American art, these artists, whether they are called mystics, visionaries, or dreamers, celebrated a more hidden side of the American experience. They reached into the inner world of the imagination and the emotions for their inspiration. The results are an intriguing and unusual portion of the legacy of nineteenth-century American art.

CHAPTER 9

THE
EXPATRIATES

FIGURE 92
Kitagawa
Utamaro, untitled
woodcut,
nineteenth
century,
Courtesy of Freer
Gallery of Art,
Smithsonian
Institution.

From the time that the first colonial limners produced their first portraits, European art has been an important resource for American artists—at times even intimidating, with its long tradition of master works. In the years following the Civil War, this feeling was intensified. The war had destroyed an earlier, naïve faith in the imperviousness of democratic ideals. In addition, the postwar years were a time of growing prosperity. In the "Gilded Age" of overnight millionaires and industrial czars like Morgan and Rockefeller, what better way for the nouveaux riches to acquire polish and sophistication than to add to their proverbially rough American exterior a touch of European culture? The Centennial Exposition in Philadelphia in 1876 had shown the United States' citizenry the latest in German, French, and English art and promoted a taste for European design in architecture, furnishings, paintings, and sculpture. Luxurious chateaux and Italian palazzos sprang up in Newport, Rhode Island, and Asheville, North Carolina, with architects like French-trained Richard Morris Hunt translating European grandeur into an American version of opulence. *The Breakers*, for example, was

FIGURE 91 Hunt, Richard Morris, *The Breakers*, 1892–1895 Newport, R. I. Courtesy of The Preservation Society of Newport County, Newport, R.I.

built in the "chateauesque" style and incorporated authentic or accurate elements, details from European architecture of the past. When the Metropolitan Museum of Art in New York City and the Museum of Fine Arts in Boston opened in 1870, their collections were founded on European master works.

Many American artists of the past had gone to Europe to establish contact with the Western tradition. West, Copley, Greenough, Powers, Cole, and so many others had traveled abroad in order to acquire the technical polish and the heightened sensibility that could be obtained abroad. By the last quarter of the nineteenth century, railroads and steamships simplified the effort and lowered the cost of a European jaunt. A number of American artists and writers of this period abandoned the United States for permanent residence in Europe. Often called the "expatriates," the best-known artists in this group include James McNeill Whistler, Mary Cassatt, and John Singer Sargent. Like many American and European artists of these decades, their art tends to be concerned less with subject matter than with style and manner of painting; that is, the way in which a subject is depicted, how it is interpreted is a major concern. Anecdotal or

narrative subject matter is less important during this period than it was for American artists at the middle of the nineteenth century. Unlike the artists of the Hudson River School, the studio and painting in its own right, rather than nature, is at the center of their art. Finally, the art of the expatriates did not aspire to broad, popular appeal. Their work reflected the taste of an elite core of nineteenth-century society.

JAMES McNEILL WHISTLER

Among the first American artists of the last quarter of the nineteenth century to take up permanent residence abroad was James McNeill Whistler. His bohemian appearance, flamboyant personality, and taste for Oriental art and porcelains are in marked contrast to such American contemporaries as Winslow Homer and Thomas Eakins.

Born in the United States, Whistler spent part of his childhood in czarist Russia, where he learned to speak fluent French. Following in his father's footsteps, he studied at West Point. Unlike his father, Major George Washington Whistler, the artist never managed to graduate from the military academy. In 1854, he was dismissed from West Point for having accummulated 218 demerits, 18 more than permissible.

After a short but important stay in the Washington, D.C., area, where he learned to etch while at the U.S. Coast and Geodetic Survey, Whistler fulfilled his dream and went to Paris. Though he received some traditional academic training, Whistler found his friends and direction among the bohemians of French society. His work of the 1860s reveals two major influences: the poetry and artistic theories of Charles Baudelaire and the spatial concepts of Japanese woodcuts. The painting *The White Girl (Symphony in White, No. 1)* shocked nineteenth-century audiences, precisely because of its interpretation of these two influences. Along with radical French painters like Edward Manet, Whistler was unable to exhibit his painting at the official annual salon and participated instead, in a show of the rejected works, the controversial Salon des Refusés of 1863. Like Baudelaire, who believed that "Poetry has no other end but itself," Whistler committed himself to pure painting, painting without a story to tell or a moral to teach. The woman in the painting was Whistler's model and mistress Joanna Hiffernan. Her face, however, betrays no emotion, no hint of the relationship to the artist but rather the steady passivity of the experienced model. Color, the "symphony" created by the counterpoint of different shades of white, is this canvas's reason for being. Whistler did not want to paint the object but the effect which it produced, and he is the first American artist to deny vigorously that he was

FIGURE 93
Whistler, James
McNeill, *The White
Girl (Symphony in
White, No. 1)*, 1862,
National Gallery of
Art, Harris Whitte-
more Collection.
Washington, D.C.

interested in subject matter. While this denial was not totally accu-
rate—Whistler's subjects generally were those with which he had
strong personal associations—it is notable that he attempted to sup-
press content in favor of style.

There is little sense of deep space in *The White Girl*. The floor
is strangely up-ended, and there is no stress on the three-
dimensionality of Joanna's body. Rather than following the tradi-
tional Renaissance approach to perspective, Whistler looked to the
handling of space in Japanese woodblock prints. Prints by masters

such as Utamaro were popular and widely circulated in nine-teenth-century Europe, and Whistler found their use of oblique angles, overlapping forms, and emphasis on flat, two-dimensional design intriguing and refreshing (See Fig. 92, p. 124.)

Whistler not only was interested in Oriental prints but he also admired Japanese fans and Chinese costumes and blue-and-white porcelains. Paintings like *The Golden Screen* and *Rose and Silver: La Princesse du Pays de la Porcelaine*, in which models are dressed in Oriental costumes and surrounded by exotic trinkets, reflect these interests. *La Princesse* was commissioned by Frederick R. Leyland for the dining room of his London home, and this placement resulted in the transformation of the entire room. In mid-1876 Whistler decided on his own to redesign the room, to paint its antique leather-covered walls and shutters with deep blue and gold peacocks. The room was transformed into a perfect setting for the painting and for Leyland's

FIGURE 94 Whistler, James McNeill, *Peacock Room,* north view, including *Rose and Silver: La Princesse du Pays de la Porcelaine,* 1864, Courtesy of Freer Galley of Art, Smithsonian Institution.

FIGURE 95 Whistler, James McNeill, *Nocturne in Black and Gold: The Falling Rocket,* 1874, The Detroit Institute of Arts, Purchase, The Dexter M. Ferry, Jr. Fund.

priceless collection of Chinese porcelains. Today, the Peacock Room, intact except for the porcelain collection which is missing from its shelves, is in the Freer Gallery of Art, part of the Smithsonian Institution in Washington, D.C. It is the only surviving example of Whistler's work as an interior decorator.

In the early 1870s, Whistler painted the two works most frequently identified with him: *Arrangement in Grey and Black, No. 1: Portrait of the Artist's Mother* and *Arrangement in Grey and Black,*

No. 2, the portrait of the Scottish philosopher Thomas Carlyle.

At the same time, the artist was working on a group of "nocturnes," a mode or motif which explores Whistler's fascination with foggy or misty effects—the memory of the river in the dark of night with distant lights shining from a boat. The atmosphere, the mysterious space in which distances are deceptive, the mood, the subtle tones of evening's color attracted the painter. Musical titles became increasingly important at this time too. Whistler referred to his art as nocturnes, symphonies, and harmonies.

It was one of these nocturnes that caused the famous lawsuit between Whistler and the celebrated English art critic John Ruskin. When Ruskin saw Whistler's *Nocturne in Black and Gold: The Falling Rocket,* the painting inspired him to indignantly write, "I never expected to hear a coxcomb ask 200 guineas for flinging a pot of paint in the public's face." Whistler promptly sued him for libel. The artist's defense was art for art's sake. Whistler believed that "art should be independent of all claptrap" and "should appeal to the artistic sense of eye or ear." He won his suit, but received exactly 1 farthing in damages. Because British law required the winner of a lawsuit to pay court costs, the legal battle with Ruskin ruined Whistler financially as well as drained him emotionally.

Whistler went to Venice to recover, and the twelve etchings he produced there in 1880, called the *Venice Set,* are outstanding examples of printmaking. Printed with brown ink on fine old paper, the etchings are subtle and lyrical impressions.

MARY CASSATT

Born in Pennsylvania in 1844, Mary Cassatt chose a very different direction for her artistic career than that taken by a fellow student at The Pennsylvania Academy of the Fine Arts, Thomas Eakins. She went to Europe where she remained. Her most important influence and closest artist-friend was the great French painter Edgar Degas, who in 1877 invited her to exhibit with the group of artists later called the impressionists. Thus, she became the only American artist to show with that famous group. So concerned was the French master with her painting that part of the background of the *Little Girl in a Blue Armchair,* an early Cassatt work, was done by Degas himself.

By 1879, Cassatt's unique, personal style had begun to emerge. Like Degas, Whistler, and many other painters of the time, she was influenced by Japanese prints and owned several woodcuts by Japanese masters. From these artists and from Degas, she learned to view a scene from an unusual angle—from above, for example, or in such a way that part of the subject matter is cut off by the edge of the canvas. Her love of dark, flat silhouettes is also part of this dual influence, as is her taste for a strong linear quality. Individual shapes in a painting by Cassatt—as in works by Degas—hold together with

FIG. 96

FIG. 97

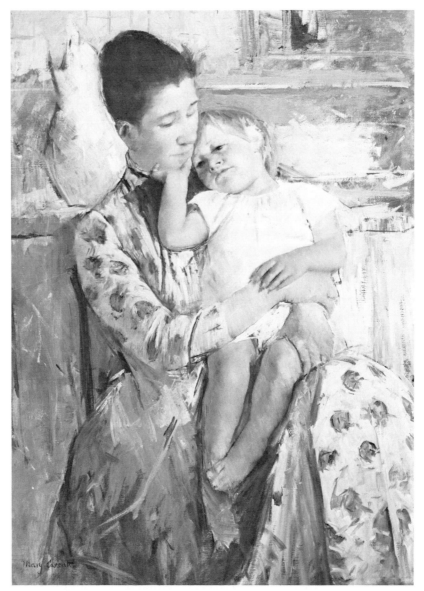

FIGURE 98 Cassatt, Mary, *Mother and Child,* c. 1890, Courtesy of Witchita Art Museum.

FIGURE 96 Cassatt, Mary, *Little Girl in a Blue Armchair,* 1878, National Gallery of Art, Washington, D.C. Collection of Mr. and Mrs. Paul Mellon.

FIGURE 97 Cassatt, Mary, *The Boating Party,* 1893–1894, National Gallery of Art, Washington, D.C. Chester Dale Collection.

greater clarity and have more individual integrity than the more diffused shapes in contemporary works by Monet or Renoir.

Cassatt's individuality, however, can be seen in her taste for strong, intense color and for rich, flesh tones, so different from Degas's palette.

In addition, her subject matter is different. Mary Cassatt is known as a painter of women and children. Unmarried and childless, Cassatt used her sisters, her friends, her nieces and nephews as her models, in other words, the people and life she knew best. At the Columbian Exposition in Chicago in 1893, a mural was needed for the Women's Pavilion. Its subject was "Woman's World," and Cassatt painted it. Since it was destroyed when the Women's Pavilion was torn down, there are but few indications of what the mural looked like. Knowing Cassatt's other work, one thing is certain: the mural must have depicted women with grace and charm but without trite sentimentality. Too often Cassatt has been dismissed on the basis of her subject matter—just a woman painting other women. Cassatt, however, was interested primarily in *how* a subject was depicted. She was an experimenter. Her series of ten color prints done in the 1890s illustrate this perfectly. Their subject matter is traditional, but their division of space is frankly indebted to Oriental prints, more specifically, prints by Utamaro. Cassatt's graphic technique, a combination of drypoint, soft-ground etching, and aquatint, is nothing short of revolutionary.

Not only were Cassatt's paintings and prints important to the history of American art but her taste in art was also highly influential. Louisine Waldron Havemeyer was the wife of the industrialist H. O. Havemeyer and Mary Cassatt's friend, and her magnificent collection, now part of the Metropolitan Museum of Art in New York City, included works by El Greco, Courbet, Manet, Renoir, and Cézanne. The collection reflects the eye and the aesthetic judgement of Mary Cassatt, who advised Mrs. Havemeyer on her purchases. One reason this country is so rich in impressionist painting is because, from the beginning, Mary Cassatt urged her wealthy American friends to buy the work of these struggling but gifted French artists. Independently wealthy herself, Cassatt sold few of her own works. At an 1895 exhibition of her paintings in New York, the lack of response was notable. Yet she continued to proselytize, not for herself, but for her European friends.

JOHN SINGER SARGENT

John Singer Sargent did not suffer from lack of recognition during his lifetime. In fact, his brilliant portraits of late Victorian and Edwardian society set the standard for the portraiture of his time. Sargent's stylish sophistication transformed every sitter into an aristocrat.

FIGURE 99 Sargent, John Singer, *Daughters of Edward Darley Boit,*
1882, Courtesy, Museum of Fine Arts, Boston. Gift of the daughters
of Edward Boit in memory of their father.

Whether his subject was elegantly turned out or in tennis attire,
Sargent's bravura brushwork, his dramatic use of light, his elonga-
tion of forms glamorized and dramatized his models.

Sargent has often been dismissed by artists and critics as
nothing more than a high-priced society portrait painter. He himself
mocked his natural facility for portraits, defining a portrait as a
painting "with a little something wrong about the mouth." At his
best, however, as in the painting of the *Daughters of Edward Darley
Boit,* Sargent could be inventive as well as flattering. The entire
painting is built with blocks of light and dark, scattered across the
huge canvas. Each girl is placed directly within or just to the edge of
a rectangle of light. Light unifies them, yet each girl is separated by
space, space that separates psychologically as well as physically. The
girls are seen as individuals caught up in their own personal reflec-
tions. The enormous blue-and-white vases were a stroke of genius.

FIGURE 100
Sargent, John
Singer, *Madame X*,
1884, The Metro-
politan Museum
of Art. Arthur M.
Hearn Fund,
1916.

They emphasize the femininity, the diminutive nature of the girls, and add a touch of rich color to this primarily black-and-white painting.

Sargent's most famous portrait—infamous might be a better word—is his portrait of Madam Pierre Gautreau, better known as *Madame X*. Shown in the Paris Salon in 1885, this work scandalized French society. Scandalized them so much, in fact, that no Parisian dared risk having a portrait done by Sargent and the artist was compelled to move to London in order to find work. Madame Gautreau's life-style was a favorite source of gossip, but this portrait, with the long V-neck of her dress, her lavender makeup, and her haughty pose, was regarded as too frank. The sitter refused to accept the portrait—hence it came to be referred to as *Madame X*. Sargent's achievement is brilliant, nonetheless. His exaggerations and distortions, such as the incredible curve into which he contorted her right arm, alter reality in order to interpret the personality of the sitter and enhance the force of the painting.

Forceful painting is evident not only in Sargent's portraits but in his genre painting as well. It was no secret that Sargent vastly preferred this kind of painting to portraiture. He once futiley said: "No more paughtraits! I abhor and abjure them, and hope never to do another, especially of the upper classes."

FIGURE 101 Sargent, John Singer, *El Jaleo*, 1882, view in the Spanish Cloister, Courtesy of Isabella Stewart Gardner Museum, Boston.

A painting like *El Jaleo* was a labor of love. Picturesque and theatrical, its life-size Andalusian dancer resulted from Sargent's travels in Spain in 1879 and his study of the work of Velásquez. Today Sargent's painting can be found in the Spanish Cloister of the Isabella Stewart Gardner Museum in Boston, still in the room which Mrs. Gardner had specially constructed for it. It is in a stagelike setting framed by a Moorish arch and lit from below so that the direction of the electric light follows that of the painted shadows (Fig. 101).

Mrs. Gardner was an important patron of Sargent's. His first portrait of her, done when she was 48, is frontal, formal. A later study of her, done in watercolor when she was 82, is very different—more vulnerable and intense. It also displays Sargent's brilliant manipulation of watercolor. The color is luminous, with the white of the paper gleaming through the thin washes.

Although Sargent lived abroad, he made frequent visits to Boston, where he received a number of important commissions not only for portraits and fanciful pieces like *El Jaleo* but also for a series of murals for the Boston Public Library, designed by McKim, Mead, and White. Although Sargent worked on the murals over a 26-year period and they are an important example of the range of his art, today they are in poor condition and many are hidden by bookshelves. Their subject is the development of religious thought, and Sargent traveled to Europe and Africa to study the styles of painting in which religious thought was expressed. As the religious philosophy changes, Sargent changes his style to reflect the art most closely associated with a particular religious outlook. The bravura brushwork characteristic of his portraits is absent from these works. Replacing it is a Renaissance sense of order and solemnity, which Sargent felt was better suited to his subject.

CHASE AND DUVENECK

There were many other artists who followed the expatriates to Europe at the end of the nineteenth century but returned to the United States to work and teach. William Merritt Chase studied in Munich, rather than Paris, and his rapid brushwork, thickly textured paint, and unified color tonality are characteristic of the school of art that flourished there. Chase brought his ideas on art back to New York, where he could be seen strolling toward his 10th Street studio with his Munich student's cap on his head and his wolfhound at his side. His studio was a great gathering place for artistic society at the end of the nineteenth century. It was a gallery, a recital hall, and a classroom simultaneously. Chase was also a noted teacher, whose classes at The Art Students League were very popular. Despite the excitement of his life in New York, Chase still valued the European experience. As a young artist, he remarked: "My God, I'd rather go to Europe than to heaven."

FIGURE 102 Chase, William Merritt, *In the Studio*, c. 1880, Courtesy of The Brooklyn Museum. Gift of Mrs. Carll H. De Silver.

Chase and his fellow student at the Munich School, Frank Duveneck, were important influences on a new generation of American artists. In their paintings, sketchy brushwork is used to capture an impression of a person or scene. Speed and spontaneity were important to them. Rapid application of paint enabled them to take down only the essentials, and added, they thought, to the freshness of the work. In an age when most artists spent days and weeks painting their canvases, Chase told his students: "Take plenty of time for your picture. Take two hours if you need it." This approach to painting, so different from the meticulousness typical of most American art, brought a refreshing new impulse to painting at the turn of the century.

THE TEN

Another group of American artists at the end of the century believed in emphasizing the manner of execution over the subject matter. Known as "The Ten" after exhibiting together in 1898, they painted landscapes and city scenes in a manner that is referred to as American impressionism. Childe Hassam, John Twachtman, and J. Alden

FIGURE 103 Twachtman, John, *Winter Harmony*, c. 1900, Courtesy of National Gallery of Art, Washington, D.C. Gift of Avalon Foundation, 1964.

Weir were the leading members of the group. Mary Cassatt was the only American contemporary of the French impressionists to participate in that development, and by the time the Ten and the American public became enamored of impressionism, it was over 20 years old and an established style. The variety of impressionism they practiced grew out of French impressionism but was far from identical with it. Americans have never been interested in painting theories that are too doctrinaire. The in-depth analysis of light in a work by the Frenchman Claude Monet, for example, was not the goal of these American artists. Whereas Monet's palette was dictated by the changing conditions of light, the Americans preferred to choose the colors of their painting according to the painting's mood, colors that gave the painting "atmosphere." The broken, irregular brushstrokes of French impressionism were not entirely attractive to these Americans. American impressionists liked their forms to retain a certain solidity. A representational image does not disappear under close scrutiny in an American painting the way it does in a work by Monet. The American impressionists took the formula but not the theory of French impressionism. The distinct brushstrokes and

pastel colors of the French were used by the Ten to create landscapes of mood. (See Fig. 103.)

The expatriates and the artists who returned to live in America—Chase, Duveneck, and the Ten—broadened this nation's search for an artistic identity. What they wanted for their country was not an American art, but an international art. To do this they stressed a concept that had been obscured in mid-nineteenth-century America. To the interest in subject matter they added an intense awareness of the manner in which a subject is depicted, an awareness that a work of art communicates more effectively through its form than through likeness. This broadening of interest and scope is their legacy to our nation's art, a heritage that will prove especially important for American art in the twentieth century.

FIGURE 104
Hassam, Childe, *Allies Day*, 1918, Courtesy of National Gallery of Art, Washington, D.C. Gift of Ethelyn McKinney in memory of her brother Glenn Ford McKinney 1943.

CHAPTER 10

THE EPIC OF THE COMMON MAN

If America is to produce great painters, and if young art students wish to assume a place in the history of the art of their country, their first desire should be to remain in America, to peer deeper into the heart of American life. It would be far better for American art students and painters to study their own country and portray its life and types. Of course, it is well to go abroad and see the works of the Old Masters, but Americans . . . must strike out for themselves, and only by doing this will we create a great and distinctly American art.[1]

Artists in every generation of eighteenth- and nineteenth-century America seemed obsessed by this goal. The one who made this particular statement—Thomas Eakins—followed his own advice. He went to Europe to study, but he came home to "peer deeper into the heart of American life" and to create a powerful body of art. His contemporary, Winslow Homer, did the same. Together, Homer and Eakins made an enormous contribution to American art.

[1] Statement by Thomas Eakins quoted in Gordon Hendricks, *The Life and Work of Thomas Eakins,* New York: Grossman Publishers, 1974, pp. 271, 272.

WINSLOW HOMER

Homer's Early Years

Winslow Homer was born in 1836, 8 years before Thomas Eakins. Though celebrated for his vision of American rural life, Homer spent most of his early years in urban areas, notably Boston and New York. Trained in a lithography shop in Boston and at the National Academy of Design in New York, Homer developed his ability as a draftsman, and became a regular contributor to *Harper's Weekly*, a popular pictorial periodical of the time. Many of his illustrations documented the leisure activities of fashionably dressed American society. Homer's drawings were reproduced by wood engraving, after he had drawn these scenes on a block of wood painted white. An engraver then cut away all but the lines of the drawing, after which the block was electrotyped, a process which permitted many copies to be made. In this same way, the artist also created illustrations of life in army camps and at the front during the Civil War. The

FIGURE 105 Brady, Mathew, and studio, *Dead Confederate Soldier*, c. 1865, Courtesy of the Library of Congress.

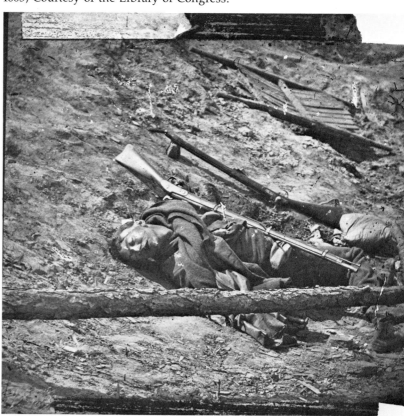

FIGURE 106 Homer, Winslow, *Prisoners from the Front*, 1866, The Metropolitan Museum of Art. Gift of Mrs. Frank B. Porter, 1922.

sketches he made while marching with the Northern armies under General George McClellan became his first oil paintings. It is interesting to compare Homer's vision of the war with that of Mathew Brady and the many photographers who worked for him. Homer's oils seem very detached from the grim reality which the Brady photos reveal. Violence, destruction, or bloodshed are rarely shown in the painter's work. One of his finest paintings based on the war was also one of the most popular, *Prisoners from the Front*. The work depicts a Union officer receiving three Confederate prisoners: a dashing example of a Southern gentleman, an old man, and an awkward youth barely beyond adolescence. A subtle psychological tension pervades the piece, expressed not so much in the facial expression of the figures as in their stance and gesture. Interesting as well is Homer's approach to the depiction of forms, which are rendered here without interior modeling, much in the manner of works by the contemporary French painter Edward Manet. This approach is based on a new interest in the act of perception, in how three-dimensional forms are seen in light, and represents a departure from the more traditional approach of placing a form in deep space.

In 1866, Homer went to Europe for the first time, where he spent 10 months looking at works in the Louvre. He studied the paintings of the old masters, and, though it is not known for certain, he may

have also seen works by more radical artists such as Gustave Courbet, Edward Manet, and Claude Monet. Though art historian Lloyd Goodrich calls Homer "an innocent eye," the young American artist was undoubtedly affected by what he saw in Europe. Homer's work of the 1870s reflects the influence of his trip abroad, yet it is characteristic of the man that he adapted what he had learned to his own content and approach.

Upon his return to the United States, Homer began to paint life around him, like the beautiful countryside filled with children (Figure 5). Some of his paintings of the 1870s are the visual counterparts of some of the literature that was popular at that time—novels like Mark Twain's *Tom Sawyer* and Louisa May Alcott's *Little Women*. The pale tonalities employed by Homer in his first oils were replaced by a warmer palette, and his approach to color changed radically in the seventies. Under the brilliance of this new palette, shapes became still more generalized, as though diffused by strong sunlight.

The 1870s saw a new subject enter Homer's work as well—that of Negro life. The black people that Homer saw in these years attracted him greatly as subjects for paintings, and the richness of their skin tones challenged his new concern for color.

Tynemouth, England

In 1881, Winslow Homer traveled to Europe again. This time, however, he did not go to a large, urban center. Instead, he went to a small English fishing village on the North Sea not far from Tynemouth. This obscure location provided him with the privacy he needed to work on his paintings. In his seclusion, he found a new theme and a new way of painting it. The most celebrated work to emerge from Homer's Tynemouth period was *Life Line*. Although the artist did not complete this work until he returned to his studio on 10th Street in New York, it dramatically reflects the Tynemouth experience. Like most of the works done during Homer's stay in England, *Life Line* is dominated by the figure of a woman. This is not, however, the fashionable lady Homer drew for *Harper's* or painted in the sixties and seventies. This is an earthier vision of femininity, a woman familiar with the demands of hard physical labor. Unlike the more populated early paintings, this work has only two people in it, and these figures are larger than those in Homer's earlier work. They dominate the painting; their forms are more substantial than any Homer had painted up to this point. Rather than enjoying the countryside or sitting out a war, these people are immersed in a life-and-death struggle to survive. The sea surrounds them, threatening to engulf them at any moment. It is this theme—man's struggle with nature—that was to dominate Homer's art for the rest of his career.

FIGURE 107 Homer, Winslow, *Life Line,* 1884, Philadelphia Museum of Art, George W. Elkins Collection.

Life Line was an enormously popular painting. The first day it was exhibited it sold for $2500. Two graphic versions of the painting also sold well. It was at this time that Homer chose to move to Prout's Neck, Maine, where he would live for the remaining 27 years of his life.

Life in Maine

Along the rugged Maine shore, Homer devoted himself to the subject he had discovered in England, man and the sea—the passionate, often violent relationship between nature and humanity. Paintings from his years in Maine document specific natural phenomena. Unlike Thomas Cole or Frederic Church, Homer claimed that his imagination did not supplement the power of the natural scene. He said, "You must wait and wait patiently until the exceptional, the wonderful effect or aspect comes." Trying to stay as close as possible to the visual realities of the scene, Homer believed that his own emotional response would appear naturally. He said, "When you paint, try to put down exactly what you see. Whatever else you have to offer will come out anyway." In fact, Homer's paintings may look like nature unaltered, but they are very carefully composed to attain that effect.

The new direction in the subject of these paintings is reflected in their style as well. Homer's brushwork has become bolder. The texture of the paint is rougher, and the marks from the brush's movement impart an animation, an energy, a rhythm to the painting.

Homer's compositions grew increasingly more inventive during his years in Maine. In a painting like *The Lookout—All's Well* from 1896, Homer divides the scene with a strong diagonal line. A sailor is placed in the lower left-hand corner, his gesture and the angle of his head bisecting the diagonal. The contradictory directions of these compositional lines swing our eye from left to right in a rapid motion that simulates the motion of the ship tossing on the waves (p. 142).

The palette Homer employed in these later works was often rich with brilliant color. In *The Gulf Stream* vivid blues and greens are intensified by bits of red placed throughout the water and across the hull of the ship. This rich tropical color is so seductive visually that the atmosphere it creates, with its evocation of the light and warmth of the tropics, is in marked contrast to the subject of the painting. We are witnessing a scene of impending disaster—a black man alone in a ruined ship, surrounded by sharks. On the far right, a water spout approaches, and in the distance on the left, rescue seems very far away. Yet the horror of this scene is not apparent at first glance. Our

FIGURE 109 Homer, Winslow, *Right and Left,* 1909, National Gallery of Art, Washington, D.C. Gift of the Avalon Foundation 1951.

eyes are seduced into an appreciation of the painting's light and color before we ever realize the desperation of the situation. Somehow this conflict, the perversity of placing horror beside beauty, intensifies the impact of the scene. As a result of this tension, the painting becomes more terrifying, more beautiful, and, ultimately, more real. (See Color Plate III.)

This kind of psychological and visual insight was typical of Homer's later work. The theme of hunter and hunted, for example, was explored in an innovative manner in a work like *Right and Left* of 1909. The title refers to hunting terminology for bringing down two birds with successive blasts of a double-barreled shotgun. Homer focuses our attention on the target. The hunter is indicated only by the red flash of his gun from behind a distant wave. Thus, we first see this work as a record of the playful aerobatics of two ducks, cavorting above the waves. With a tiny dot of red and a smudge of gray, however, Homer has turned this frolic into a dance of death.

Homer's Work in Watercolor

Homer's years in Maine also saw the fruition of his experiments with watercolor. Having been introduced to the medium by his mother, Homer painted some of the most innovative and beautiful works ever produced in watercolor. He particularly enjoyed working in watercolor when on vacation in the Canadian North Woods or the Caribbean. Unlike earlier watercolorists, Homer did not begin with a detailed sketch. His preparatory drawings were only large, generalized outlines of the work that was to emerge once he applied the pigment. The nature of watercolor seemed to exploit Homer's sensitivity to color. He used the transparency of the medium and the whiteness of the paper to intensify the luminosity of the color. His bright colors were applied in thin washes that permitted the white of the paper to shine through, making them seem all the brighter. On occasion, Homer actually let some of the paper remain bare. This was a daring idea, challenging the preoccupation with finish which was common in the nineteenth century. Can a work be complete if some of the paper is left unpainted? Homer's affirmative reply gives a freshness and modernity to his watercolors. Apparently, he recognized the quality of these instantaneous recordings of nature, for he wrote, "In the future, I will live by my watercolors" (see Fig. 110).

THOMAS EAKINS

Spontaneity and brilliant color are not to be seen in the work of Homer's contemporary, Thomas Eakins. Eakins's version of reality was very different from Homer's, though both shared a dedication to

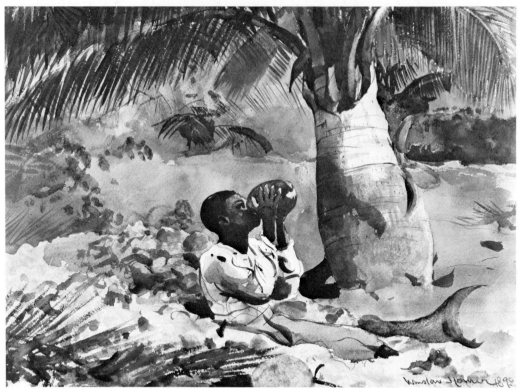

FIGURE 110 Homer, Winslow, *Under the Coco Palm,* 1898, The Fogg Art Museum, Harvard University. Louise E. Betters Fund.

the American scene. Homer and Eakins disagreed, however, on what constituted visual accuracy—simple, "innocent" vision or empirical knowledge. Realism is not simply an objective approach to art. It is also a way of seeing and thinking, just as neoclassicism or impressionism were. How artists define reality depends on their own vision of the world. Eakins turned to mathematics and science in his search for truth. He loved math, sometimes relaxing by reading logarithmic tables. Eakins said: "In mathematics, the complicated things are reduced to simple things. So it is in painting."

For a painting of the professional oarsmen Barney and John Biglin, Eakins calculated at least three different angles: the boat's response to the wind, its reaction to the waves, and its direction in relation to the picture plane.

The Gross Clinic

In the same fashion, Eakins was fascinated by medicine and had even considered becoming a surgeon. Eakins attended classes and dissected cadavers at the Jefferson Medical College in Philadelphia,

the same school for which Eakins painted *The Gross Clinic* of 1875. The first large work created by the artist after 4 years of study in Europe, it is reminiscent of Rembrandt's *Anatomy Lesson*, displaying the same vigorous honesty toward the grim realities of medicine. In terms of color and composition, *The Gross Clinic* owes much to the seventeenth-century artist, Diego Velásquez. The Spanish master's position in *The Maids of Honor* appears to be the basis for Eakins's placement of Dr. Samuel David Gross as we see him in his clinic at the Jefferson Medical College. Like most of Eakins's work, *The Gross Clinic* (Fig. 112) was thoroughly researched and planned. Every face is a portrait. Each doctor can be identified, including Samuel Gross's son, who stands in the doorway to the amphitheater watching his father lecture while a clerk records the great surgeon's remarks. On the left, the patient's mother cringes on horror. The scientific detachment of students and doctors alike accentuates the woman's reaction, and the dark street clothing worn by everyone focuses our attention on the brightly lit flesh and bloody scalpel (as well as reminding us that sterile operating procedures had not yet been developed). The painting is remarkably powerful, and it is this very power that probably caused its rejection from the art section of the Centennial Exposition of 1876. What sort of art is this? Where is the beauti-

FIGURE 111 Eakins, Thomas, *The Biglin Brothers Racing,* National Gallery of Art. Washington, D.C. Gift of Mr. and Mrs. Cornelius Vanderbilt Whitney.

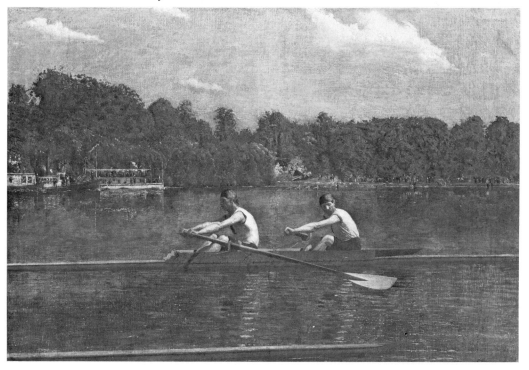

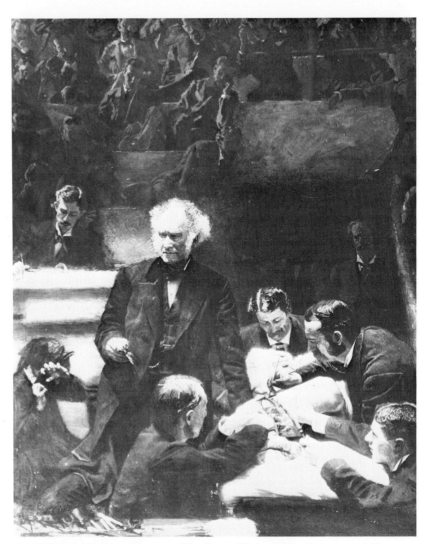

FIGURE 112 Eakins, Thomas, *The Gross Clinic*, 1875, Courtesy of Thomas Jefferson Medical College, Philadelphia.

ful setting, the uplifting landscape, the idealized scene? *The Gross Clinic* was hung in the medical section of the Exposition, for that was how the nineteenth century saw this masterpiece—as a faithful record of a scientific occasion. Today *The Gross Clinic* hangs in the Jefferson Medical College in Philadelphia.

Fourteen years later, Eakins painted a similar subject at the request of the students of Dr. D. Hayes Agnew of the University of Pennsylvania Medical School. *The Agnew Clinic* was the artist's largest canvas and contains a portrait of Eakins in the far right corner, a touch added to the painting by his artist-wife, Susan MacDowell Eakins.

The Portraits

Eakins in turn painted portraits of his wife, works which are indicative of the approach the artist took with his sitters. Looking at his wife, Eakins rejected flattery or sentimentality in favor of a candid vision that seems to peer into the very personality of the sitter. He saw his wife with tenderness, but with unrelenting honesty as well.

As a result of this honesty, Eakins was not a popular society portraitist but painted primarily the people who interested him—family, friends, professors, scientists, students, other artists. Walt Whitman wrote, "I never knew of but one artist, and that's Tom Eakins, who could resist the temptation to see what they thought ought to be rather than what is." (See Color Plate IV.)

Eakins the Instructor

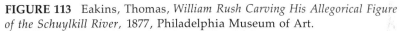

Susan Eakins had been a student of her husband's at the Pennsylvania Academy of the Fine Arts. His experiences while there made him identify very closely with the early nineteenth-century American sculptor William Rush. Like Rush, Eakins had wanted to expand the artistic consciousness of his native Philadelphia. Like Rush, he was rejected because of his inability to tolerate prudery. Just as Rush

FIGURE 113 Eakins, Thomas, *William Rush Carving His Allegorical Figure of the Schuylkill River,* 1877, Philadelphia Museum of Art.

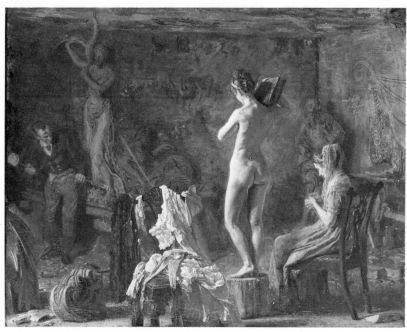

had scandalized Philadelphia society by using a nude model for his allegorical image of the Schuylkill River, so Eakins was ostracized for his insistence on working from "the absolute nude." The final break with the Academy came when, in the midst of a women's drawing class, Eakins pulled a loin cloth from a male model. The American attitude toward nudity had changed very little from the beginning of the nineteenth century. The representation of the nude devoid of mythological, allegorical, or moralistic associations was still unacceptable to the American public. Eakins, who saw the nude with the detachment of a surgeon, was fired from his directorship.

Eakins and Photography

Despite scandal and professional ostracism, Eakins continued to pursue his interest in the human form. One of his methods for ex-

FIGURE 114 Eakins, Thomas, photograph of the site of *The Swimming Hole,* 1883, Courtesy of Hirshhorn Museum and Sculpture Garden, Smithsonian Institution.

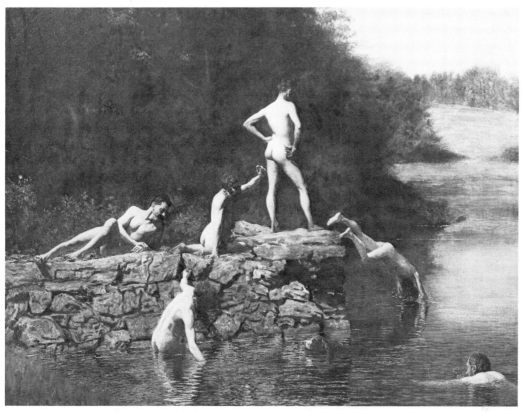

FIGURE 115 Eakins, Thomas, *The Swimming Hole,* 1883, Collection of The Fort Worth Art Museum.

ploring the intricacies of this complex mechanism was by means of photographs. Many nineteenth-century American painters used the camera as an aid in their work, but Eakins's involvement with photography was more innovative than that of any other painter at that time.

By devising a single camera with two revolving disks pierced with openings, Eakins was able to photograph a series of frames of a nude man walking, running, or jumping. The mechanism of human motion was revealed by this series of photos, while, at the same time, part of the groundwork was laid for the motion-picture camera.

Occasionally, Eakins used photos as reference material for his work. In one picture, the artist's students are seen relaxing at a local swimming hole. The raw material this photo supplied—the repertoire of poses and the anatomical detail—were shaped by Eakins into his painting *The Swimming Hole* of 1883. It has often been pointed out that the group of men lined up across the center of the painting resemble a series of still-photographs, illustrating the key poses of a body moving from stillness to action. It is significant that despite

FIGURE 116 Eakins, Thomas, photo of Walt Whitman, Philadelphia Museum of Art.

Eakins's dedication to his view of reality—to the truth of a scene as it meets the eye—he did not merely record the facts of a scene as a photo presented them. On the contrary, Eakins always felt that his own eye penetrated beyond that of the camera. A clear example of this is his photo of the great American poet Walt Whitman. Eakins photographed Whitman 4 years after the artist had painted the writer's portrait. It is fascinating to compare the two to see the subtle transformation that the image of Whitman underwent from one medium to another. In the photograph, the poet is simply a handsome old man, but in Eakins's portrait the gentle power of the man emerges. Without idealizing the physical details of Whitman's face, Eakins reveals the strength, the humor, and the good nature of the poet. Whitman was one of the few people who sat for Eakins who could accept the truth of his portrait. Indeed, he remarked, "Eakins is not a painter, he is a force."

The power of Eakins's analytical likenesses and Winslow Homer's fresh view of nature moved American painting closer to the "great and distinctly American art" which Eakins had defined as a goal for the American artist. The heritage of their art was important to the future generations of American artists. Eakins and Homer created great works of art not by painting idealized subjects from mythology, history, or the frontier but by painting American men and women as they saw them, in the context of their daily lives. Sailors, hunters, artists, professors, friends, and family—each seen in confrontation with nature, society, and their own inner life. It was in the lives of these people that Eakins and Homer saw a meaning of epic proportions and the basic resource for their paintings.

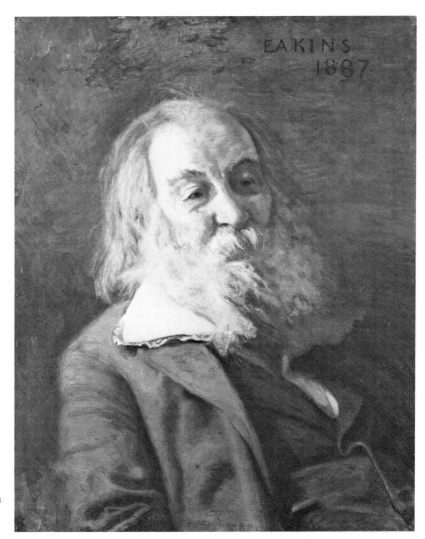

FIGURE 117
Eakins, Thomas,
Walt Whitman,
1887, Courtesy of
The Pennsylvania
Academy of the
Fine Arts.

CHAPTER 11

THE COLUMBIAN EXPOSITION

In 1893 the World's Columbian Exposition opened in Chicago with great ceremony and public acclaim. Commemorating the 400th anniversary of the discovery of America by Christopher Columbus, the event not only marked an historic moment but also affirmed the nation's achievements and self-confidence on the eve of the twentieth century. The White City, as the Exposition was popularly known, was a magnificent sight with its grand architecture, lovely lagoons and canals, electric lighting, moving sidewalk, and numerous exhibition halls displaying the latest in technological and cultural achivements. This was an American world's fair to rival the great expositions of Europe, such as the Paris Universal Exposition of 1889 and the London World's Fair of 1851.

The planners of the Columbian Exposition were prestigious American architects and sculptors of the day. Their confidence in their ability was boundless. At one early planning session, Augustus Saint-Gaudens remarked that "this is the greatest meeting of artists since the fifteenth century." Although hardly equal to the achievements of the Italian Renaissance, the Chicago fair was one of the most ambitious projects in America in the nineteenth century and was to influence several generations of artists and architects to come.

THE WHITE CITY

Chicago's Jackson Park was selected as the site by Frederick Law Olmsted, the esteemed landscape architect who designed Central Park in the 1870s. He proposed to beautify the location with quiet lagoons and pathways winding through verdant parkland. As planning progressed under the direction of Daniel H. Burnham, Olmsted's original, informal design gave way to a more formal one centering on a rectangular "Court of Honor" derived from the plan of the Paris 1889 Exposition. Homogeneity and regularity became the overriding concerns. The architects, who were drawn from prestigious firms in the East, as well as Chicago, agreed to observe a uniform cornice height, to color their buildings white, and to generally follow a classical style reminiscent of antiquity. Richard Morris Hunt, the veritable dean of nineteenth-century American architects, designed the Administration Building, the focal point of the Court of Honor. Elaborately encrusted with sculpture and crowned with a celebrated dome, 50 feet higher than that of the United States Capitol,

FIGURE 118 *World's Columbian Exposition,* 1892–1893, Chicago, Courtesy of Library of Congress, photo by Frances B. Johnston.

the building was admired in its day for its "fine spirit of scholarly reserve." The Fine Arts Building, designed by Charles Atwood, was lauded by the sculptor Augustus Saint-Gaudens, who called it the "best thing done since the Parthenon." The Fine Arts Building, which still stands on the shores of Lake Michigan as the present Museum of Science and Industry, was the only Exposition building to be reconstructed of permanent materials.

The Women's Pavillion, daring in concept as the first building at a world's fair designed, planned, and staffed entirely for and by women, was also of a classical design. The architect, 22-year-old Miss Sophia V. Hayden, had been trained at the architectural school of the Massachusetts Institute of Technology. Her building was praised in contemporary accounts of the fair for its "feminine feature, . . . delicacy and elegance of general treatment, . . . and a certain quality of sentiment [which] differentiates it from its colossal neighbors and reveals the sex of the author."[1]

The architecture for the Columbian Exposition was based on that of ancient Greece and Rome, as well as the Roman baroque style of the seventeenth century. Often consisting of borrowings from all three sources, the buildings were grand re-creations of the past inspired by the French School of Fine Arts or beaux arts style in which many American architects had been trained. The grandiose building program offered architects a rare opportunity to formulate an architectural prototype for civic and cultural buildings. Although based mainly on antique styles, architectural designs were also chosen as a means of displaying what was considered to be the best among the nations of the world.

OTHER PROJECTS BY FAIR ARCHITECTS

Many of the prominent architects who worked on the fair had established their reputations designing palatial residences in the affluent postwar era. The variety of revival styles within the beaux arts tradition was considerable and not limited to the baroque classicism chosen for the Columbian Exposition. Richard Morris Hunt's mansion for George Washington Vanderbilt in Asheville, North Carolina, called Biltmore, for example, was a sumptuous re-creation of the French chatueaux of the sixteenth century. Landscaping for the huge estate was supervised by Frederick Law Olmsted. The architectural firm of Charles Follen McKim, William Rutherford Mead, and Stanford White, responsible for several key buildings at the fair, also designed lavish summer homes in Newport, R.I. (Figure 91), as well as city dwellings, such as The Villard Mansions in New York City,

[1] See Hubert Howe Bancroft, *The Book of the Fair*, Bounty Books, New York, 1894, vol. I, for a contemporary "picture book" of the Columbian Exposition.

FIGURE 119 Richardson, Henry Hobson, *Marshall Field Wholesale Store*, 1885, Chicago.

based on Renaissance city palaces. McKim, Mead, and White, following the lead of another important architect, Henry Hobson Richardson, also designed comfortable and handsome "shingle style" houses, based on English Tudor and Queen Anne architecture with half-timber construction and steeply pitched roofs.

Richardson, who had studied at the École des Beaux-Arts, was one of the most outstanding American architects in the second half of the century. Trinity Church on Copley Square in Boston, with its powerfully massed forms enhanced by rough-cut granite masonry, is one of his most impressive designs. Although derived from an his-

torical European source, the French Romanesque with its paired towers and rusticated masonry, the church has energy and individuality that set it apart from other architectural works in historical styles. Perhaps Richardson's most distinctive building was the *Marshall Field Wholesale Building* in Chicago. Built of conventional materials with a design composed of rough-cut masonry and a series of arches and windows, the building's commercial purpose is frankly and handsomely stated (Fig. 119).

The chief of construction for the Columbian Exposition, Daniel H. Burnham, and his partner, John Wellborn Root, created another daring commercial structure in Chicago, the Monadnock Building, completed 2 years before the fair. The creative control over the design of the office building was exerted by Root, who was not as tied to styles of the past as his partner Burnham. Realizing that "trade palaces"—as the commercial buildings were called—should be simple and not eclectic re-creations of historic buildings whose functions were totally different, Root asserted that "the relation between dwellings and trade palaces is the relation between an orchestra and a brass band. Whatever is to be spoken in a commercial building must be strongly and directly said." The Monadnock Building, while constructed of masonry and brick rather than steel and iron, has the impact of a skyscraper with its facade composed of bays of windows rising sixteen stories without ornament.

Exposition buildings were not in the truest sense commercial buildings, and according to John Root's criteria, were more fitting for "an orchestra" than a "brass band." Designers, therefore, paid little attention to commercial or residential architecture, and looked instead to the municipal buildings of Europe and the beaux arts revival styles.

MODERN TECHNOLOGY AT THE FAIR

Buildings for the Exposition were constructed of an impermanent material called "staff," consisting of jute fiber, plaster of paris, and cement. The framework for the buildings was made of wood, and in some cases, iron. Prefabricated iron and glass had been dramatically used in the construction of the celebrated Crystal Palace at the London World's Fair in 1851, and the Paris Exposition featured the Eiffel Tower, one of the most famous of early iron structures. At the Columbian Exposition, however, there were no demonstrations of new uses of iron and glass; instead, the iron frameworks were hidden under mantles of imitation masonry.

Richard Morris Hunt explained the reluctance of the fair architects to experiment with new engineering techniques and materials by saying that "much yet remained to be accomplished with iron be-

fore the artistic mind will be satisfied." American engineers, and not architects, were actually the first to experiment with the design potential, as well as the structural possibilities, of iron and steel in constructions of bridges and factories. The only bold use of iron to be seen in the Chicago fair was in one of the most popular constructions there, the ferris wheel.

The most original of the fair architects, Louis Sullivan, experimented with the malleable qualities of staff and the lightweight framework for the design of his Transportation Building. Located far from the central Court of Honor, Sullivan's structure did not follow the classicising formula, and, in addition, was painted bright colors. Its focal point, the Golden Doorway, was made by molding staff onto a metal frame and covering it with gold leaf, relief decorations, and brightly colored paint. The ornament for the doorway was unique as well—not the typical acanthus leaves and ionic decorations of the classical vocabulary used freely throughout the fair, but rather an innovative foliate design. Sullivan by this time was famous for ornate designs based on natural plant forms, which he freely applied to various parts of his buildings.

It is not surprising in light of his earlier accomplishments in architecture that Louis Sullivan dared to be different in his design for an Exposition building. Although trained at the Massachusetts Institute of Technology and the French École des Beaux-Arts, Sullivan went beyond traditional precepts and became a pioneer in the development of the tall office building, or "skyscraper."

Basically opposed to architecture that relied on "dictum or tradition, or superstition or habit," Sullivan instead promoted the principle that "form follows function."[2] With the advantages of handsome design precedents in Chicago, such as H. H. Richardson's Marshall Field Building, and the engineering expertise of his partner, Dankmar Adler, Sullivan constructed some of the finest commercial buildings of the last quarter of the nineteenth century. Using a steel frame to support a thin facade of windows and brick, he was freed from working with the heavy proportions required by supporting masonry and was able to exploit the clean lines and vertical thrust implicit in the framework. Decoration, which he considered a "mental luxury," was subordinated to the overall design of each skyscraper, yet his lush, distinctive ornamentation also enhanced and complemented the rhythmical combination of windows, piers, and lintel. His last important commission for a tall structure, the Carson-Pirie-Scott Building, completed in Chicago in 1904, was an outstanding structure which was to influence progressive European architects in the 1920s. Even his small buildings, such as the National Farmer's Bank (now the Security Bank of Owatonna, Minnesota), remained original in design and concept.

[2] Louis Sullivan, *Autobiography of an Idea*, Peter Smith, New York, 1953. This book contains Sullivan's philosophy and principles of architecture.

FIGURE 120 Sullivan, Louis, *The Wainwright Building*, 1890–1891, St. Louis, Mo.

The classical revival style of the Columbian Exposition buildings and not Sullivan's innovations, however, was to dictate the direction of public architecture in the early twentieth century. Louis Sullivan's prediction that the "White City would set off a violent outbreak of the Classic and Renaissance . . . contaminating all it touched" came true in that public buildings, art galleries, colleges, civic centers, state capitols, and even skyscrapers across the country were built bearing the mark of the fair's beaux arts grandeur. Although criticized by a later generation and in and out of favor over the years, the beaux arts tradition launched by the fair produced a number of very successful and handsome buildings in the United States.

SCULPTURE FOR THE WHITE CITY

Like most of the architecture, the sculpture gracing the Columbian Exposition was classical in inspiration and made of impermanent material. Allegory reigned supreme. In the lagoon of the Court of Honor stood a large sculptural group by Frederick MacMonnies, the *Triumph of Columbia*, or the *Barge of State*, as it was also known. A winged figure of Fame and the national eagle decorated the prow of a vessel rowed by eight maidens personifying the arts and industries and steered by Neptune at the tiller. The passenger of the ship was Columbia, represented as a bare-breasted woman in helmet and toga, perched on an awkwardly high pedestal. While admittedly to modern eyes the sculptural group looks a bit ludicrous, to the gentlemen and ladies of the late nineteenth century such figures, nude or partially draped, properly personified the nobler aspects of democracy and culture.

Across the lagoon from the *Triumph of Columbia* was a colossal, 65-foot statue of the *Republic* by Daniel Chester French. Described in a contemporary book on the fair as the "chief marvel of western sculpture," the *Republic* was clothed in a flowing toga with a laurel wreath in her hair and held aloft the symbols of peace and might—a globe, an eagle, and a standard. Today a smaller bronze replica of the *Republic* still stands in Jackson Park, Chicago.

French, whose grand allegorical pieces such as the *Republic* were in great demand throughout his illustrious career, received his training in the United States under William Rimmer and John Quincy Adams Ward, sculptors who emphasized the importance of working directly from life rather than depending upon academic formulas. When French first journeyed to Europe, it was as a young sculptor with several successful works to his credit. One of these, *The Minute Man*, had been commissioned by his home town of Concord, Massachusettes, for the centennial celebration in 1876. His model was a strong local farm boy wearing the original clothing of an eighteenth-century farmer and standing beside an antique plow and holding a rifle. French's only bow to classicism was his adaptation of the pose of the famous Greek statue, the *Apollo Belvedere*, for *The Minute Man*. Another fine work of French's was a portrait bust of the celebrated philosopher, writer, and resident of Concord, Ralph Waldo Emerson, who sat for the portrait in 1869 and agreed that it was a strikingly accurate likeness. "That is the face I shave," he observed.

As his professional reputation increased, French was called upon to work on more grandiose schemes and was inundated with commissions. One of his best-known works, the colossal statue of *Abraham Lincoln* (p. 158), was installed in the early 1900s in the Lincoln Memorial in Washington, D.C. Here, the sculptor succeeded in

creating a powerful and compelling likeness of the national hero. One of the foremost American sculptors in the second half of the nineteenth century, French grappled with the problems inherent in the beaux arts approach to public monuments. On the one hand, he was motivated by his inclination to represent natural appearances, and on the other, he was guided by the taste for classical forms. Thus, when he worked on the *Republic* for the Columbian Exposition and the *Alma Mater* for Columbia University, French employed allegorical personifications, antique costumes, and rhetorical gestures. Fittingly, the *Alma Mater*, which is beaux arts in spirit, is located in front of Low Library, a beaux arts building by the firm of McKim, Mead, and White. Nineteenth-century sentiment, as well as the

FIGURE 122 French, Daniel Chester, *Alma Mater,* 1902–1903, Columbia University, New York. Gift of Mrs. Robert Goelet and Robert Goelet, Jr., in memory of Robert Goelet, Class of 1960.

FIGURE 123 French, Daniel Chester, *Milmore Memorial*, 1893, Forrest Hills Cemetery, Boston.

beaux arts style, dictated works such as French's *Milmore Memorial*. Also known as *The Angel of Death Staying the Hand of the Sculptor,* the work was created in memory of a young sculptor and friend of French's, Martin Milmore, who died at the age of 37. The theme of the work is depicted by a heavy-winged angel of death who gently grasps the hand of the youth carving a relief sculpture of an Egyptian sphinx. Not only is the piece a stately and fitting tribute but a handsome sculpture as well.

Ranking above French as the most sought-after and significant American sculptor in the second half of the century was Augustus Saint-Gaudens. Pressed by the demands of his position as director of sculptural decoration for the fair as well as many other commitments, Saint-Gaudens was unable to contribute an original piece for the Exposition. However, a version of his statue of *Diana,* which crowned the first Madison Square Garden building in New York, was placed on top of the Agricultural Building. The lithe proportions and grace of the *Diana* contrast with the heroic, bulky proportions of the other pieces at the fair executed by sculptors such as MacMonnies and the Austrian-born sculptor Karl Bitter. Saint-Gaudens spent 8 years in Europe, studying at the École des Beaux-Arts in Paris and living for a

time in Rome. Although schooled in the beaux arts tradition, Saint-Gaudens brought his own special artistic vision to the creation of monumental sculpture, one which avoided the pitfalls of clichés and trite sentimentality. His statue of *Abraham Lincoln* in Lincoln Park, Chicago, captures the quiet dignity and warmth of the man. In his monument to Admiral David Farragut in Brooklyn, New York, the naval leader stands as if on the bridge of his ship with the wind whipping at his uniform while he surveys the horizon with a steady gaze. The base of the statue, designed by Stanford White, is a curved bench decorated with bas-reliefs of female figures with drapery flowing like waves on the sea.

In another monument to a military hero, *The Shaw Memorial*, Saint-Gaudens used the format of a shallow niche with high-relief figures of soldiers marching with their leader mounted on horseback. The meaning of the memorial, the dedication of Colonel Rob-

FIGURE 124 Saint-Gaudens, Augustus, *The Farragut Memorial*, 1881, Madison Square, New York.

FIGURE 125 Saint-Gaudens, Augustus, *Adams Memorial*, 1891, Rock
Creek Cemetery, Washington, D.C.

ert Gould Shaw to his men, is conveyed with poignant simplicity by
the representation of the white officer riding alongside rather than
ahead of his men, an all-black unit.

The most remarkable work by Augustus Saint-Gaudens is the
Adams Memorial in Rock Creek Cemetery, Washington, D.C. Created
in memory of the wife of the historian and educator, Henry Adams,
it is an unusually reserved work for a time in which sentiment and
symbolism were usually more freely expressed. A simple stone
base sets off the lone bronze figure, which is enveloped in heavy
drapery. This is not a woman from classical times, not a portrait of
the deceased, but a timeless image of deep introspection. Marian
Adams had taken her own life. Henry Adams found solace in the
monument which, in the spirit of Oriental philosophy, depicted the
mental repose and peace he believed that his wife had at last
found in death. In his autobiography, *The Education of Henry Adams*,
Adams gave a rare explanation of the work, stating that "the inter-
est of the figure lies not in the meaning, but in the response of the

observer." Here, an abstract concept is compellingly conveyed without resort to anecdote or classical allusions. This sculpture, has a timeless appeal. Here, emotion and detachment, the real and the ideal meet.

MURAL DECORATION AND PAINTINGS AT THE FAIR

American artists had been wrestling with the problem of a suitable style of mural decoration for years without great success. William Morris Hunt, brother of the chief architect of the fair, Richard Morris Hunt, painted a particularly effective mural for the assembly chamber of the New York State Capitol in 1878. Called *The Flight of Night,* the painting depicted the Persian goddess of the heavens, Anahita, as a personification of cultural enlightenment, banishing the darkness of ignorance. Tragically, the mural was threatened by faulty dome construction shortly after its completion. Not long after the mural started to disintegrate, the distraught artist died. Preparatory sketches and photographs of the work in progress as well as fragments of the mural in place are all that remain. They reveal, however,

FIGURE 126 Hunt, William Morris, *The Flight of Night* (study for the New York State Capitol mural), c. 1868, Pennsylvania Academy of the Fine Arts. Gilpin Fund Purchase, 1898.

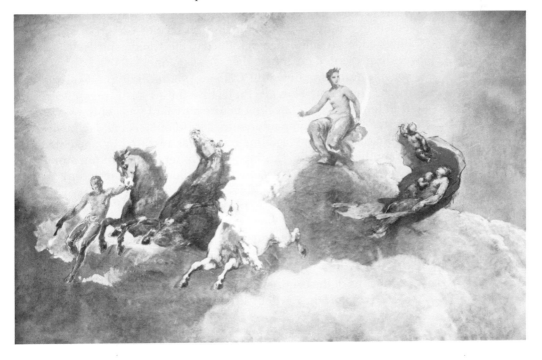

FIGURE 127 LaFarge, John, *Athens*, 1898, Bowdoin College Museum of Art, Walker Art Building, Brunswick, Maine. Gift of the Misses Walker.

a powerful painting with sweeping movement, dramatic impact, and imaginative design.

The standard for mural painting in the last decades of the century was established by a student of Hunt's, John La Farge, and other painters of the younger generation. Most muralists tended to rely on classical references and allegorical personifications of abstract concepts. Just as Good and Bad Government were personified by women in antique costumes in the Library of Congress murals by Elihu Vedder, themes such as Industry, Electricity, and The Elements were represented in much the same manner at the fair.[3] Abbott Thayer's mural for Bowdoin College, Maine, is typical of this approach. The theme Florence Protecting the Arts is expressed by idealized female figures kneeling before a distant view of the skyline of the city. *Athens,* a companion mural by John La Farge, is drawn from specific classical sources. One figure was inspired by ancient statuary, another by a relief carving, and another by an antique mural. For La Farge's contemporaries, such archeological accuracy lent greater significance to the mural and its theme.

Under the direction of Frank D. Millet, most of the murals for the Columbian Exposition were painted in much the same manner. There was one outstanding exception, however—Mary Cassatt's mural in the Women's Pavillion (Chapter 9). Painted on canvas in her Paris studio, the mural dealt with the theme Modern Woman. All that remains of the original painting are preparatory sketches such as *Women Picking Fruit,* a poor lithograph of the mural in place, and

[3] See Chapter 8 for a discussion of Vedder's murals.

contemporary descriptions. This evidence, when considered in light of Miss Cassatt's achievements as an associate of the French Impressionists, indicates that her mural was a refreshing change from the classicizing allegories in most of the paintings at the Exposition.

Along with a number of artists who were highly regarded in their day but are now largely forgotten, many important American painters were represented at the fair. Paintings by John Singer Sargent, James McNeill Whistler, Winslow Homer, George Inness, Thomas Moran, and Thomas Eakins were exhibited in the Fine Arts Building. It is interesting to note that Eakins's painting *The Agnew Clinic* was hung in the Fine Arts section, while only 20 years earlier his *The Gross Clinic* (See Chapter 10, Figure 112) had been relegated to the medical section of the Centennial Exposition in Philadelphia.

Although a good portion of the exhibition was given over to the display of European and American paintings conforming to conservative academic tastes, some recognition was also given to native painters who dared to take a more individual course. The Exposition also included a stained-glass window by Louis Comfort Tiffany, designer of art-nouveau glassware and decorations.

The Columbian Exposition represented the varied tastes and accomplishments of the second half of the nineteenth century, bringing to a close a very complex period in the nations' cultural history. The classic style of the architecture there continued to dominate civic architecture in America for several decades. At the same time, however, advances in technology were being made in techniques of construction and lighting and one of the contributing architects, Louis Sullivan, was laying the cornerstone for architecture of the future. While striving for a uniform cultural statement to equal the illustrious political and industrial achievements of the country, the fair also acknowledged the variety of individual accomplishments of artists, as well as engineers, scientists, and business people. The World's Columbian Exposition was not only a culmination of a century of cultural development but a revealing testament to the aspirations of the nation on the eve of the twentieth century.

CHAPTER 12

THE MELTING POT

One of the first innovations in American art in the twentieth century was the introduction of a new subject to painting—urban life. Genre painters of the previous century had drawn their content from the pleasant, picturesque rural life of the nation. After the Civil War, the character of the country began to change because of a widespread exodus from rural areas to industrialized urban areas. In addition, hundreds of thousands of foreign immigrants began arriving every year. In 1907 alone, a million and a quarter people arrived at Ellis Island hoping for a new life. For many, their first stop became home, and thus New York City became the great melting pot of the nation.

The immigrants, ancestors of so many of us, were an amazing people. Tough, yet naïve to the ways of the New World, they were a vigorous mass of humanity. For some native Americans, however, their foreign faces, their strange clothing and customs, and their dark

and crowded homes aroused feelings of apprehension and distrust. American artists trained in the academic standards of decorum and good taste found them unsuitable and even unattractive as subjects for painting. The immigrants and urban life in general also seemed contrary to the American self-image of the idealized rural life.

Despite controversy and professional ostracism, a group of young artists at the turn of the century decided that the immigrants were an intriguing and fitting subject for painting and chose to broaden the content of American art to include urban life. Among the artists to first introduce this new urban genre were four artist-reporters from Philadelphia—John Sloan, George Luks, Everett Shinn, and William Glackens. Their leader, Robert Henri, was a painter and teacher who joined them for semiweekly gatherings of the Charcoal Club, a group who pooled their resources to hire a model for drawing practice. After becoming friends, the artists began to gather at Henri's studio on Walnut Street, where they shared their ideas about art and their experiences as artist-reporters, as well as some lighthearted comaraderie.

From Henri, the most experienced artist in the group, they learned about European art, studying in particular the old masters, Titian, Velásquez, Hals, Goya, and the nineteenth-century painter, Edward Manet. They discussed literature too, their favorite writings being the poetry of Walt Whitman and the novels of the French authors Balzac and Zola. When Henri moved back to New York to teach at the New York School of Art, his friends from Philadelphia followed. The paintings that grew out of their new life in New York combined an eye for journalistic fact with a sensitive portrayal of humanity, yet these works earned them such names as the Apostles of Ugliness, the Revolutionary Black Gang, or, as they are generally known today, the Ashcan School.

Many of the ideas behind their art stemmed from Henri's teachings. Between 1900 and 1903 Henri painted views of New York City but then devoted himself primarily to portraits. The subjects of his paintings were ordinary people, frankly portrayed. Subject matter was Henri's primary concern, and as the most influential art teacher in the first quarter of this century, he shared this lesson with his friends and students: "An artist must first of all respond to his subject . . . and then he must make his technique so sincere, so translucent that it may be forgotten, the value of the subject shining through it . . . all art that is worthwhile is a record of intense life, and each individual artist's work is a record of his special effort, search and findings."

The *Blind Singers,* with their foreign faces and ragged clothes, is markedly different from the subjects of a nineteenth-century American genre scene. The frankness of the painting's content, however, is

FIGURE 128 Henri, Robert, *Blind Singers*, 1913, Courtesy of Hirshhorn Museum and Sculpture Garden, Smithsonian Institution.

more revolutionary than the manner of presentation. Technically, the work refers to European masters. The dark colors bring to mind Velásquez and Goya, as well as the early Manet. In addition, the dramatic lighting suggests Rembrandt's influence and the fluid brushwork has been seen before in the work of Franz Hals. For Henri, technique was of secondary importance, not something to be dwelt on or worried over. In his influential book *The Art Spirit*,[1] Henri advised artists to "Work quickly. . . . Don't stop for anything but the essential. . . . Keep the flow going . . . it's the spirit of the thing that counts."

Henri was also concerned with the life of artists themselves, how and where they lived, what they did for entertainment, who their

[1] *The Art Spirit,* a compilation of Henri's notes, articles, and features, was published in Philadelphia in 1923 by Lippincott Publishers.

friends were—all these things would determine what they painted. Henri wished to do away with the image of the American artist as an individual aloof from the life and concerns of the lower classes. As a Socialist, Henri identified with the masses, and his image of an artist was that of a worker, a worker who made paintings rather than building railroads or houses. Another aspect of his ideal of the American artist was as a paradigm of masculinity, and in pursuit of that goal, he and his friends, Sloan, Luks, and Glackens, staged boxing matches and played baseball. Henri told his students: "The first prerequisite of the artist is that he be a man, and by that is meant that he have guts—without the attributes of the fighter, he can expect little or no success with an uninterested public."

If "guts" were the standard for achievement in art, then surely George Luks was destined to succeed. Called "Lusty Luks" by his fellow artists, Luks studied at the Philadelphia Academy of the Fine Arts and the academy in Düsseldorf, Germany. While abroad, he learned to love the paintings of Franz Hals, and he tried to achieve the same boisterous, robust quality in his own art. Luks learned to work quickly as an artist-reporter for the *Philadelphia Evening Bulletin,* covering Teddy Roosevelt's Rough Riders and the war in Cuba.

FIGURE 130 Luks, George, *The Spielers,* 1905, Addison Gallery of American Art, Phillips Academy, Andover.

He never seemed to have any conflict between his commercial work and his painting. (See Fig. 129, p. 174.)

> I have utterly no patience with fellows whose style is ruined if they must use it to get daily bread. Any style that can be hurt, any art that can be smirched by such experiences is not worth keeping clean. Making commercial drawings, and especially doing newspaper work, gives an artist unlimited experience, teaches him life, brings him out. If it doesn't there was nothing to bring him out of, that's all.

Like Henri, Luks focused on the personality of his subjects. There is little use of anecdote or detail. To Luks, as to Henri, technique was a secondary consideration: "I can paint with a shoestring dipped in lard! . . . Technique did you say! . . . Say listen you—it's in you or it isn't. Who taught Shakespeare technique? . . . Guts! Guts! Life! Life! That's my technique."

John Sloan did not entirely agree with Luks or Henri. Slower and more deliberate than his fellow Apostles of Ugliness—Henri once called him "the past participle of Slow"—Sloan sought to capture more than just the vitality and personalities of individual characters. He placed his people in their surroundings and the situations of everyday life.

Sloan observed the life of downtown New York and depicted episodes from what he saw. An etching of city dwellers escaping from their hot apartments to the coolness and companionship of the roof on a hot summer's night (Figure 6) is typical of Sloan's talent for making the urban commonplace memorable. Today this work has a sweet and nostalgic quality, but to the jury of the American Watercolor Society to which it was submitted in 1905, it was considered too vulgar for exhibition. After this rejection, Sloan poked fun at his critics in an etching called *Connoisseurs of Prints*.

Frequently there is something of the voyeur about Sloan. A work entitled *Three A.M.* is described in Sloan's diary for April 28, 1909: "A good day's work, painting on a subject that has been stewing in my mind for some weeks. I have been watching a curious two room household, two women and, I think, two men, their day begins after midnight; they cook at 3:00 a.m." (See Fig. 131.)

Sloan, who was the most politically active of the group, campaigned for socialist causes and designed covers and satirical cartoons for the socialist journal *The Masses*. The concerns of Sloan and his fellow Ashcan School artists paralleled those of the novelists Theodore Dreiser and Frank Norris, though the painters saw American life in a more optimistic, positive light than their literary counterparts.

Sloan was also capable of a gentle touch of melancholy missing in the rest of the Black Gang. To the guts and vitality of urban genre, he added the quiet strength of paintings such as *The Wake of the Ferry*. (See Color Plate V.)

FIGURE 131 Sloan, John, *Three A.M.*, 1909, Philadelphia Museum of Art, photograph by A. J. Wyatt, staff photographer.

The remaining two members of the Ashcan School looked less at the life of the poor and more at the pleasures of the middle class. William Glackens enjoyed depicting the parks and restaurants where average citizens amused themselves. His style, in its use of pastel tones and its feathery brushwork, owes much to French impressionism. In *Chez Mouquin,* he depicted a restaurant that Henri, Sloan, and Glackens often visited with their wives. This painting bears a strong, though superficial, resemblance to the work of the French impressionists—superficial because there is no theory of color or light underlying this work as there is in an Impressionist

work by Manet or Renoir. What Glackens observed in the French masters was a general atmosphere or tone which he felt was well suited to paintings of the leisure life of the middle class.

There is none of this genteel gaiety in the work of Everett Shinn. Shinn's view of the theater and the circus sometimes borders on satire. His people are frequently caricatures, grotesque characters whiling away their time. Frequently, he used pastels rather than oil paint. Shinn's use of asymmetry and oblique angles leading to the

FIGURE 132 Glackens, William, *Chez Mouquin,* 1905, Courtesy of The Art Institute of Chicago. Friends of American Art Collection.

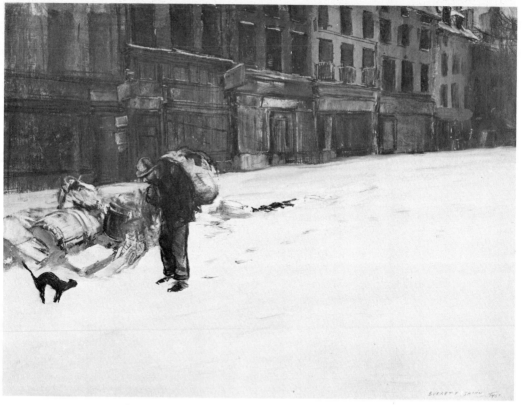

FIGURE 133 Shinn, Everett, *Early Morning, Paris,* 1939, Courtesy of The Art Institute of Chicago.

center of action owes much to the influence of the French impressionist Edgar Degas, and works well with the content, making the viewer feel like part of the audience.

Many other young artists took up the content and theories of the Ashcan School. George Bellows, Glenn O. Coleman, Guy Pène du Bois, all students of Henri's, became painters of urban genre. From the Henri group, they received the sense of community that too often had been denied artists living in America. Together they could exchange ideas and have the satisfaction of knowing that their subject matter was uniquely American, taken straight from the streets of New York. It must have been a fine life for an artist. Wandering throughout the city, stopping at a men's club or a restaurant or down at the docks, and all the time working, studying, and absorbing the raw materials for their art. They felt no guilt about time spent away from the studio, for life was the basis of their art, and a life that was lived well only made for a better, truer art.

183 **THE EIGHT**

In 1908, the Ashcan School made its major debut into the New York art world in an exhibition at the Macbeth Gallery. The exhibition was an unofficial event, a Salon des Refusés like the one the nineteenth-century French artists had had. The eight artists who made up the Macbeth Gallery show had tried to exhibit their work through the conservative National Academy of Design. Henri had been on the jury for the Academy's annual show, but, despite his presence, the works of Luks, Glackens, and Shinn were rejected. Even the paintings of Henri and Sloan that were accepted were hung in a poor location. In protest, these artists decided to stage an exhibition of their own, along with three other artists who also rebelled against the exhibition policies of the National Academy of Design—Arthur B. Davies, Ernest Lawson, and Maurice Prendergast. Together with the five Ashcan School painters, they came to be known as "the Eight."

Independence and opposition to the idea of academies brought this group together. In style and content they were individuals. Arthur B. Davies was, perhaps, the most individual of them all. His lyrical, dreamy paintings were often inspired by literature. Fairy

FIGURE 134 Davies, Arthur B., *Valley's Brim*, 1910, Courtesy of Hirshhorn Museum and Sculpture Garden, Smithsonian Institution.

tales, the poetry of Blake, Coleridge, and Poe, and Elizabethan drama combined with his own imagination to produce evocative landscapes. Obviously, his works bear no resemblance to the people or places in paintings by the members of the Ashcan School. Why, then, did Davies exhibit with them at the Macbeth Gallery in 1908? The answer lies in his work which, like that of Henri and his followers, was not suitable to the Academy. If his works did not reflect the urban American scene, neither did they resemble the fashionable paintings of the time. Davies found his visual precedents in the art of the French symbolists. From them, he learned how to create the strange light, mysterious space, and pale nudes that are the basis of his artistic vision (Fig. 134).

FIGURE 135 Davies, Arthur B., *Dust of Color,* c. 1915–1920, Courtesy of Hirshhorn Museum and Sculpture Garden, Smithsonian Institution.

FIGURE 136 Lawson, Ernest, *Boathouse, Winter, Harlem River*, 1916, in the Collection of The Corcoran Gallery of Art.

Unlike another visionary artist, Albert Pinkham Ryder, Arthur B. Davies did not remove himself from society. On the contrary, he was an active figure in the art world. As president of the Association of American Painters and Sculptors, he was instrumental in the planning and production of the landmark exhibition of American and European art, the Armory Show, held in New York City in 1913. Like Henri, Davies believed that American art had come of age. He felt that a major exhibition of modern works, European and American, would prove this point. In a sense, the Armory Show backfired for the Americans, for European art stole the show and dominated the public's and the artists' attention (Chapter 13).

Even Davies's work underwent a change as a result of this experience. *Dust of Color,* which dates from between 1915 and 1920, expresses Davies's awareness of cubism. It is also indicative of the problem most American artists had in adopting European modernism. Davies has used the superficial elements of cubism—the fragmentation of the body into planes of color, the shallow space, the multiple points of view—but his work is not cubist. Instead, it is a restatement of his characteristic visionary painting, now clothed in a quasi-modernist space and form.

In addition to his paintings, Davies designed tapestries and fashioned small and personal sculptures—precious, three-dimen-

FIGURE 137 Prendergast, Maurice, *Beach at Gloucester,* 1912–1914, Courtesy of Hirshhorn Museum and Sculpture Garden, Smithsonian Institution.

sional versions of the nudes that people his landscapes. It has been suggested that Davies made his sculptures while traveling back and forth between his two families. Not until his death was it discovered that Davies had two wives and two sets of children, each totally unknown to the other.

Another of the Eight, Ernest Lawson was not as colorful or active a figure as Davies. He was probably the least daring of the Eight, often painting views of the rivers and countryside around New York City in the manner of the American impressionists (Fig. 136).

Of all the Eight, Maurice Prendergast was the most interested in technique and design. His works are like mosaics of color laid out in flattened space to produce a gay, decorative arrangement. This approach developed from his work in watercolor during a visit to Venice, Italy, in 1898. Impressed by the beautiful light and clear, bright color he saw there, he tried to capture his impressions in this visual shorthand. Later in Paris around 1913, he saw the work of the Nabis, a group of French Symbolist painters, and the flatness of the forms in their work influenced the design of his own paintings. Despite the innovative nature of his paintings, his subjects were

similar to those of Glackens and the Ashcan School. Prendergast enjoyed recounting the pastimes of the middle classes—promenading through Central Park or sitting and strolling by the seashore.

DOCUMENTARY PHOTOGRAPHY

While the exhibition of the Eight at the Macbeth Gallery brought urban genre painting to the public's attention, another art form also had begun to focus on the life of the city. It was, in fact, photographers who put artist-reporters such as Sloan, Luks, Glackens, and Shinn out of the journalism business. By 1904, photographic halftones were sufficiently developed to be used for photo-reproduction in newspapers. Men with cameras replaced artists with sketchpads at the scene of a fire, and photographers like Jacob Riis sought new subjects on which to focus. Though he had developed his technique as a police reporter for New York's *Evening Sun*, Riis's fame stems from his muckraking images of tenement life. In 1890, he published a book entitled *How the Other Half Lives*, filling it with photos of the poverty and misery of urban life. Riis made slides from

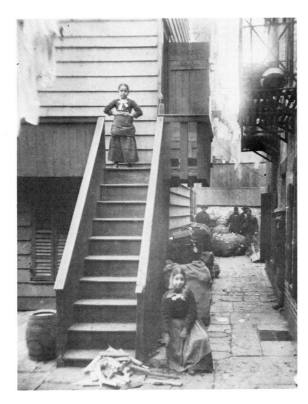

FIGURE 138 Riis, Jacob, *Baxter Street Alley: Rag Pickers Row*, New York, 1888, Museum of the City of New York, Jacob A. Riis Collection.

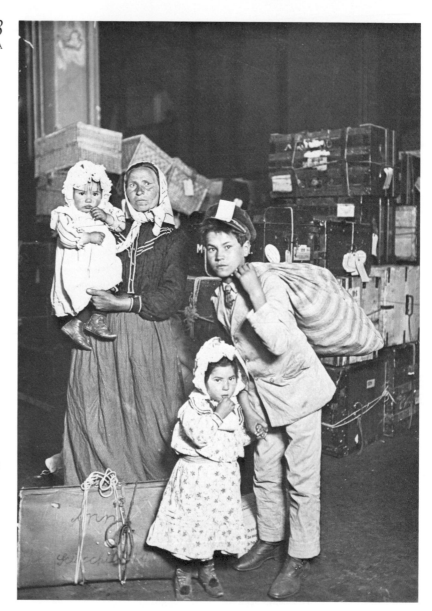

FIGURE 139
Hine, Lewis,
*Italian Immigrants
Seeking Lost
Baggage,* Ellis
Island 1905,
International
Museum of
Photography,
George Eastman
House,
Rochester, N.Y.

his photos and used them in lectures, always driving home his words with the visual image.

Lewis Hine used his photographs for a similar purpose. As a trained sociologist, Hine supplemented his written observations with photos of Ellis Island immigrants, children at work in factories and fields, and small boys selling newspapers late into the night. In 1911 he was appointed the staff photographer for the National Child

Labor Committee, an organization created to investigate the abuse of children in the work force. The haunting photographs that resulted from Hine's work helped to bring about the first child-labor laws.

Not all of Hine's work dealt with social injustice, however. He was also the official photographer for the construction of the Empire State building.

One group of immigrants neglected by painters was captured in Arnold Genthe's photographs. In 1894, Genthe arrived in San Francisco and soon began photographing the largest Oriental community outside Asia—San Francisco's Chinatown. Genthe was also able to document the devastation of the San Francisco earthquake of April 18, 1906.

PHOTOGRAPHY AS ART

The most famous of all the photographers who turned their attention to the urban scene at the beginning of the twentieth century was Alfred Stieglitz. Unlike Riis, Hine, and Genthe, Stieglitz did not see himself as a reporter or documentary photographer. Stieglitz insisted

FIGURE 140 Genthe, Arnold, *Morning Market, Chinatown,* Courtesy of Library of Congress.

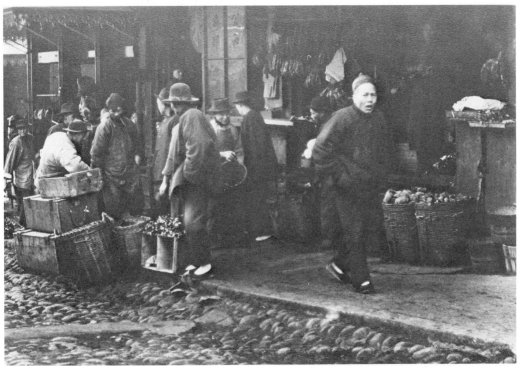

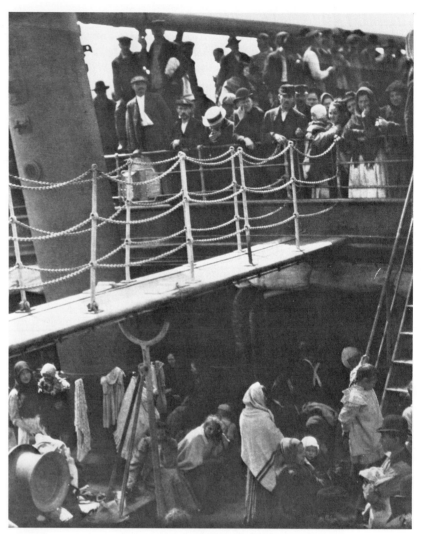

FIGURE 141 Stieglitz, Alfred, *The Steerage,* from *Camera Work,* 1911, No. 36, International Museum of Photography, George Eastman House, Rochester, N.Y.

that his work was art. True to life, yes; but more than an objective record, his work was a precious object too, the result of craftsmanship and personal reflection. The photograph that best expresses this new approach to photography is Stieglitz's great image, *The Steerage* of 1907. The steerage was that portion of a ship nearest the rudder, the cheapest but most uncomfortable place to occupy on the 15-day trip from Europe to America. In 1907, it cost as little as $30 to cross the Atlantic in steerage. It was not the facts of the scene that concerned Stieglitz. What he tried to photograph was his experience of

the scene, the ideas that ran through his mind as he clicked the shutter. So pivotal was this image to Stieglitz that he wrote down his thoughts after he created the photo:

On the upper deck, looking over the railing, there was a young man with a straw hat. The shape of the hat was round. He was watching the men and women and children on the lower steerage deck. The whole scene fascinated me. I longed to escape from my surroundings and join these people. . . . I saw shapes related to each other. I saw a picture of shapes and underlying that of the feeling I had about life. And, as I was deciding, should I try to put down this seemingly new vision that held me—people, the common people, the feeling of ship and ocean and sky and the feeling of release that I was away from the mob called the rich—Rembrandt came into my mind and I wondered—would he have felt as I was feeling? . . . I had but one plate holder with one exposure plate. Would I get what I saw, what I felt? Finally I released the shutter. My heart thumping . . . Had I gotten my picture? I knew that if I had, another milestone in photography would have been reached. Here would be a picture based on related shapes and on the deepest human feeling.[1]

Stieglitz's impact on art in America would not be limited to photography. His art gallery, his publications, his personality would help move American art closer to a wedding of modernist form with the new American subject matter, the subject matter that Robert Henri and the rest of his "Black Gang" had found on the streets of New York.

[1] An interview with Stieglitz that appeared in *Twice A Year*, 1942, p. 128.

CHAPTER 13

THE ARMORY SHOW

I t is rare that any one event can be singled out as a turning point in the history of art. Change occurs slowly, and the character of an era seems only to emerge with the passage of time. At the beginning of the twentieth century an event occurred which crystallized the situation of American artists and clarified the relationship of American art to Western European painting and sculpture. That event was an art exhibition.

In February of 1913, the International Exhibition of Modern Art opened in New York City. Since the exhibition was held at the Sixty-Ninth Regiment Armory, it has come to be called the Armory Show.

EXHIBITION OPPORTUNITIES IN THE UNITED STATES

As an exhibition, the Armory Show is without precedent or peer in American art history. It was planned, assembled, hung, and publicized by a group of artists who believed that American art had come

FIGURE 142 Interior view of the Armory Show, 1913, Walt Kuhn Papers, Armory Show, Courtesy of Archives of American Art, Smithsonian Institution.

of age and could be displayed favorably alongside of European masters. These artists also believed that the American public needed a chance to see what this country's artists were capable of producing.

Exhibition opportunities were scarce for American artists in the early twentieth century, just as they had always been. Commercial art galleries were few, and in general, they catered to the American predilection to "buy European."

What the organizers of the Armory Show hoped to accomplish, then, was a realization in the minds of the American public that American art had merit, and should be displayed and collected with the same passion that had marked the acquisition of European works of art.

To accomplish so ambitious a goal required a very special kind of exhibition. The guiding hand of Arthur B. Davies, painter of idyllic landscapes and president of the Association of American Painters and Sculptors, helped to make the Armory Show a landmark event. Other artists, like Walter Pach and Walt Kuhn, also made important contributions.

ORGANIZATIONAL EFFORTS

The pine-tree flag of Massachusetts during the Revolutionary War was chosen as the symbol of the show to emphasize its revolutionary purpose. This same spirit was expressed at the opening of the exhibition by one speaker who told the audience: "This exhibition will be epoch-making in the history of American art. Tonight will be the red letter night in the history not only of American but of all modern art."

With the German Sonderbund exhibition as inspiration, the conception of the Armory Show became monumental in size and in scope. Thirteen hundred works were included, an enormous number of paintings and sculptures to have installed for an exhibition of only 1 month's duration. To understand the enormity of this task, consider that the National Gallery of Art in Washington, D.C., generally exhibits less than 1500 works at a time in its permanent displays.

As the exhibition's catalog illustrates, the Armory Show was an encyclopedic gathering of major European and American artists from the mid-nineteenth century through 1913.

THE EUROPEAN CONTINGENT

An effort was made to show modern art as a development, since, for many years, the rationale for modern art was based on a developmental approach to art history. With the help of Walt Kuhn and Walter Pach and several other artists, the European section was as-

sembled and then grouped into roughly four categories based on a system of classification devised by the show's organizers: the classicists such as Ingres or Degas, the realists such as Courbet or Manet, the romanticists such as Delacroix or Renoir, and the moderns. One of the artists included under the romanticists, Odilon Redon, had the largest representation of works in the exhibit, thirty-eight in all, reflecting Davies's intense interest in the French Symbolists.

It was the fourth group of artists, the moderns, that exhibited the greatest variety of styles and attracted the most attention. For many Americans, the Armory Show was a first glimpse of works by European artists such as Constantin Brancusi, Vincent van Gogh, Henri Rousseau, Georges Rouault, Georges Seurat, Edward Munch, Aristide Maillol, and Wilhelm Lehmbruck. Henri Matisse's sculpture and painting were first seen here by the general public, and the work of Wassily Kandinsky and Pablo Picasso was also exhibited.

CUBISM IN THE ARMORY SHOW

The cubist paintings aroused much outright hostility. Unable to accept this radical departure from representational art, critics and the public alike expressed indignation and dismay when confronted with works in this style by Picasso (Fig. 143) and Braque. Kenyon Cox, prominent painter and conservative American art critic of the time, commented that the "real meaning of this cubist movement is nothing else than the total destruction of the art of painting—of which the dictionary definition is the art of representation by means of figures and colors applied on a surface, objects presented to the eye or to the imagination. . .'" According to Cox, cubist painters "abolished the representation of nature and all forms of recognized and traditional decoration; what will they give us instead?" Cox expressed the bewilderment of a majority of the American public who expected art to be in some degree a reproduction of reality. For them, a cubist work seemed to be a joke, an aberration.

AMERICANS IN THE ARMORY SHOW

The American section of the Armory Show did not arouse as much protest or pose as many challenges. Older American masters such as Albert Pinkham Ryder, who came as an honored guest to the exhibition, were represented. Paintings by Robert Henri's circle of Ashcan School painters were also shown, as were paintings by American impressionists such as John Twachtman and J. Alden Weir. Davies himself exhibited, as did Walt Kuhn. Works by artists from Alfred Stieglitz's 291 group were also in evidence.

FIGURE 143 Picasso, Pablo, *Nude*, 1910, The Metropolitan Museum of Art, The Alfred Stieglitz Collection, 1949.

The most radical examples of American art were by artists who called themselves synchromists. This art movement, small and short-lived, was nevertheless the first American art movement with a strong theoretical basis. Morgan Russell and his fellow synchromist Stanton MacDonald-Wright believed that pure, spectrum colors in compositions of nonrepresentational form could inspire aesthetic emotions in the same direct, nonnarrative fashion as music. In other words, when looking at a synchromist work, one experiences the color, forms, and composition acting directly on the senses.

PUBLIC AND CRITICAL REACTION

A casual glance at newspaper clippings about the Armory Show illustrates only too clearly that most Americans were not prepared for what modern art did to their traditional concepts of painting and sculpture. American art had generally avoided any departure from traditional aesthetic theory and showed a fondness for art based

upon the objective appearance of nature. To make something as incomprehensible to the public as many of the works in the Armory Show seemed somehow contrary to democratic ideals. Marcel Duchamp's *Nude Descending a Staircase*, the greatest scandal of a scandal-filled exhibit, became the symbol of the public's appalled response to this strange new art. Faced with what was seen as a visual enigma, newspapers staged mock contests urging readers to find the nude in Duchamp's painting. Caricatures abounded, including one entitled "The Rude Descending the Staircase: Rush Hour on the Subway."

Theodore Roosevelt spoke for many Americans when, after viewing the exhibition, he wrote:

Probably we err in treating most of these pictures seriously. It is likely that many of them represent in painters the astute appreciation of the power to make folly lucrative which the late P. T. Barnum showed with his fake mermaid. There are thousands of people who will pay small sums to look at a faked mermaid and now and then one of this kind, with enough money, will buy a Cubist picture or a picture of a misshapen nude woman.[1]

This feeling of being duped by artists and dealers with an eye for easy money is very much alive today. It has become an almost traditional response to avant-garde art.

[1] Barbara Rose (ed.), *Readings in American Art, 1900–1975.* New York: Praeger, 1971.

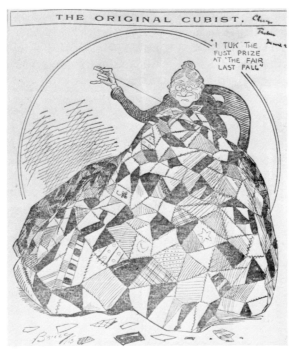

FIGURE 144 Cartoon, *The Original Cubist, Chicago Tribune,* March 20, 1913, Walt Kuhn Papers, Armory Show, Courtesy of Archives of American Art, Smithsonian Institution.

Not only the general public but also many well-informed and serious critics echoed the public's cries of fraud. A cartoon from the *World Daily Magazine* poked fun at the modern artist's uninhibited approach to paint application. This kind of art was considered ugly by traditional standards of beauty and displayed no concern for the sentiment or history which infused most nineteenth-century art. Like Kenyon Cox, many critics believed that "there are still commandments in art as in morals, and laws in art as in physics."

Another variety of criticism which has developed into a tradition is the association of radical developments in art with political radicalism—despite the fact that radical political movements have historically had little use for radical art. A headline from the New York *Herald* complained of "art extremists" and subsequently, any ideology objectionable to Americans, from socialism to anarchism, came to be linked with modern art.

More serious objections to the Armory Show were raised by a number of American artists. A painting by one of the Ashcan School, for example, looks very old-fashioned beside the works of the European moderns such as Matisse. Small wonder that a great many other American artists felt that their native art had once again been eclipsed by the Europeans. Foreign dominance seemed only too apparent at an event that was designed to place American art on equal footing with the established order.

Not all American artists, however, rejected the influence of European art. The synchromists were influenced during their stay in Europe before 1913, and several artists in the circle of Alfred Stieglitz had been involved with modern European movements.

William Glackens, an Ashcan School painter represented in the Armory Show, stated his own version of the problem: "Everything worthwhile in our art is due to the influence of French art. We have not yet arrived at a national art."

POSITIVE EFFECTS

Whatever the unpleasant results of the Armory Show—alienation of the general public, a long-lasting suspicion that realism cannot be truly modern—they were superseded by its positive effects, for the Armory Show exposed the United States to artistic experiences of a new kind. In numbers alone, it expanded the American audience for art, for it was an immensely popular show. Over 100,000 people attended the month-long exhibit in New York, and by the time the exhibit had traveled to Boston and Chicago, another 150,000 had witnessed this unique event.

A number of the visitors who came to look bought paintings and sculptures. Alfred Stieglitz purchased Kandinsky's *Improvisation No.*

27 for $550. Of the almost 300 works sold from the Armory Show, a good percentage were the beginning of major collections of modern art. Lillie P. Bliss bought a number of works now in the Museum of Modern Art in New York. At the Armory Show, Walter Arensberg began the collection which today is part of the Philadelphia Museum of Art. The Metropolitan Museum of Art bought its first modern work, Cézanne's *Poorhouse on the Hill,* from the Armory Show.

Wherever there are buyers, commercial galleries are bound to spring up. Before 1913, the only forums for most American artists to exhibit were the Academy exhibitions, the exhibitions sponsored by other art organizations, the windows of framers' shops, or, with great luck, one of the few galleries that sold American art. In the 5 years following the Armory Show, 34 New York galleries and art organizations sponsored 250 exhibitions of modern painting and sculpture. The National Arts Club of 1914, the Forum Exhibition of 1916, and the first exhibition of the Society of Independent Artists in 1917 were all major opportunities to present new American works to the public.

One final advantage of the Armory Show must also be mentioned. Artists' clubs grew out of the exhibition and gave artists an opportunity to join together to share ideas and encouragement. Simultaneously, the Armory show helped to make New York into the great cultural center it is today, for the interest it stimulated in the arts made the city a more congenial center for American and European artists. The museums, the galleries, the art societies became responsive to living artists, and one particularly significant artist, Marcel Duchamp, was drawn to the United States in the aftermath of the Armory Show.

DUCHAMP AND NEW YORK DADA

Marcel Duchamp's *Nude Descending a Staircase* (Figure 145) had brought him national attention, and he was quick to respond to the new American awareness of radical art. Duchamp was one of the first European artists to reverse the expatriates' journey and come to the United States. In 1915, when he arrived in America, the French artist was greeted like a celebrity and welcomed into the home of collector Walter Arensberg. In 1913, having abandoned traditional ways of painting and sculpture, he brought two seemingly unrelated objects together to make *Bicycle Wheel* (Fig. 146). The following year, Duchamp selected his first readymade, a bottle rack. This utilitarian object was tranformed into a work of art simply by the artist designating it so. Divorced from its function, exhibited as an art object, the bottle rack was transformed not physically but conceptually. It has become art because we think of it as art.

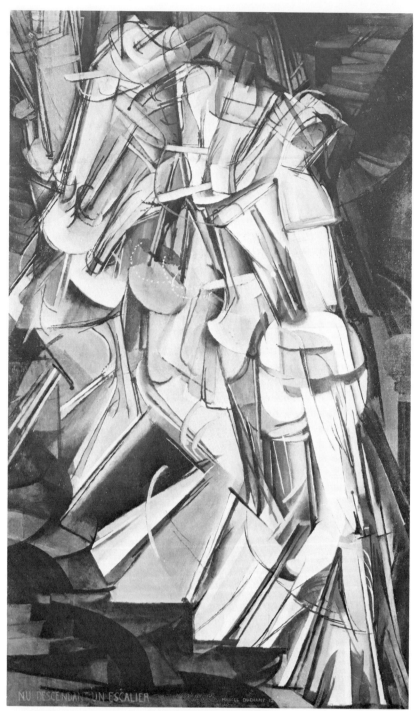

FIGURE 145 Duchamp, Marcel, *Nude Descending a Staircase*, No. 2, 1912, Philadelphia Museum of Art, Photograph by A. J. Wyatt, staff photographer, Louise and Walter Arensberg Collection.

Although subsequent critics have found profound meaning and beauty in the succession of readymades which Duchamp produced, the artist himself denied that these objects possessed such qualities. He said: "A point that I want very much to establish is that the choice of these "readymades" was never dictated by aesthetic delectation. The choice was based on a reaction of visual indifference with a total absence of good or bad taste . . . in fact, a complete anesthesia."

The most celebrated of Duchamp's readymades is the urinal he submitted to an exhibition in 1917 under the title *La Fontaine* and signed with the name of the plumber it was purchased from, R. Mutt (Fig. 147). The exhibition, which was sponsored by the Society of Independent Artists, of which Duchamp was vice president, was an unjuried show—open to anyone with the entrance fee. Yet *The Fountain* was rejected for exhibition, and Duchamp resigned in protest. His wry comment on the rejection contains at least a little truth:

Now Mr. Mutt's fountain is not immoral, that is absurd, not more than a bathtub is immoral. It is a fixture that you see everyday in plumber's show windows.

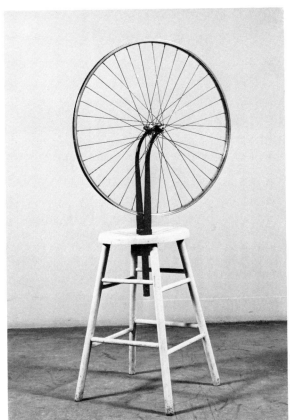

FIGURE 146 Duchamp, Marcel, *Bicycle Wheel*, 1913 (reconstructed 1951), Museum of Modern Art.

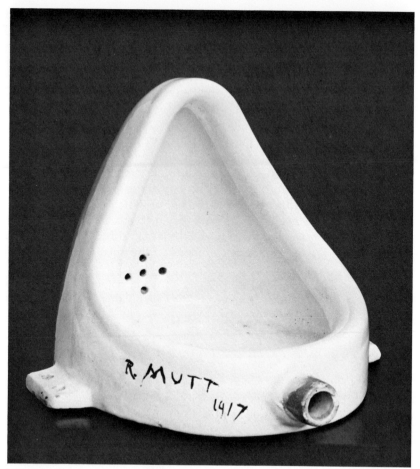

FIGURE 147 Duchamp, Marcel, *The Fountain*, 1913, Courtesy of Sidney Janis Gallery, New York (1950 reconstruction).

Whether Mr. Mutt with his own hands made the fountain or not has no importance. He chose it. He took an ordinary article of life, placed it so that its useful significance disappeared under the new title and point of view—created a new thought for the object.

As for plumbing, that is absurd. The only works of art America has given are her plumbing and her bridges.

Duchamp's contribution to the development of American art consists not so much of the objects he made but of the ideas he challenged. For the next 50 years, Duchamp's radical approach to art would inspire American artists as diverse as Jasper Johns and Andy Warhol. Together with the American photographer and artist Man Ray, Duchamp established the first American stronghold of an international art movement—dada. Dada, with its nonsense name, was

an approach to art which grew out of the disillusionment with traditional ideas during World War I. Groups of artists in Switzerland, Germany, France, and New York engaged in the avant-garde activities that came to signify dada. These activities constituted a frontal attack on middle-class standards of good taste and morality. Using humor, scandal, and ironical paradoxes, dada was a form of anti-art. Walter Arensberg, the collector and friend of Marcel Duchamp, said: "All those who live without formula, who like only the floors of the museums, are dada."

Duchamp's personal variety of dada challenged the whole concept of the uniqueness of the work of art. His ready-mades questioned the preciousness of the art object and subverted the economic structure of the art world. A snow shovel, which he made art and ironically titled *In Advance of a Broken Arm,* could be purchased at any hardware store. Anyone could own it.

Duchamp's roto-reliefs, mechanized sculptures that produce optical illusions as they spin in circles, introduced technology into art.

Duchamp's alter ego, Rrose Sélavy, was a fictional self that the artist invented by dressing himself up as a woman and having himself photographed. Her name employs one of Duchamp's favorite de-

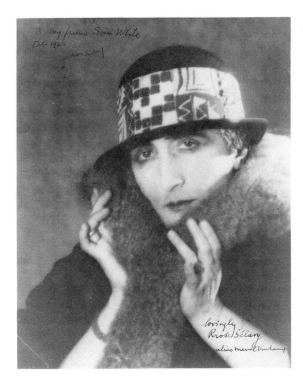

FIGURE 148
Photo of Rrose Sélavy, (Marcel Duchamp) by Man Ray. Courtesy, The Philadelphia Museum of Art.

FIGURE 149 Duchamp, Marcel, *The Waterfall: #2, The Illuminating Glass*, 1946–1966, Philadelphia Museum of Art, photograph by A. J. Wyatt, staff photographer.

vices, the pun. Sélavy is French for "That's life." Rrose signed works of art, such as the adjusted ready-made punningly titled *Fresh Widow*, a carpenter's model of French windows covered with leather. The pride of creation, the artist's signature on the work of art, is erased by the invention of this other self.

In 1930 Duchamp began to circulate the rumor that he had given up art for chess. He was, in fact, a great chess player, one of the best in the United States. Like much of his art work, however, the rumor was a ruse, a deception that freed him from tradition. In private,

without the pressure to exhibit or to sell, Duchamp continued to work. The most important piece of his later years cannot be illustrated here. It resides in the Philadelphia Museum of Art's Arensberg Collection behind a barn door, and it cannot be photographed. Duchamp preserved the power and the surprise of this piece by preventing its reproduction in another media (see Fig. 149).

From the Armory Show to Marcel Duchamp, from Duchamp to Robert Rauschenberg to pop art to conceptual art into the present day—this is but one of the many lines of development that led out of that amazing exhibition of 1913. In a real sense, the effects of the Armory Show are still being felt today. Kenyon Cox was right when he said that the Armory Show was not an exhibition but an exposure.

CHAPTER 14

AMERICA ACHIEVES AN AVANT-GARDE

At the turn of the century, artists in the United States could be divided into three broad camps. First, there were those who belonged to the National Academy of Design, whose traditional approach to painting and sculpture and whose choice of subject matter made them the officially sanctioned artists of the time. Second, there were the urban realists, or the Ashcan School, who declared their independence from the Academy and asserted that the life around them was the most meaningful subject matter for their art. Finally, there was a group of artists who shared the attitudes of the European avant-garde and searched for a new formal language for American art. This third group, small and isolated, was associated with a gallery at 291 Fifth Avenue in New York City which came to be known simply as "291." Because they were ahead of their time and apart from both the Academy and the urban realists, their work met with rejection by critics and public alike. Only at 291 was there a haven for their radical ideas about painting, sculpture, and photography. Here the American avant-garde was born. 291 came to signify more than a location or a gallery or an assembly of artists: it embodied a new spirit for art in the United States.

ALFRED STIEGLITZ AND 291

The force and the genius behind the spirit of 291 was the great photographer Alfred Stieglitz. He was the organizer of the gallery and, in the original title he chose for it, The Little Galleries of the Photo-Secession, he indicated its aim. The photographers who exhibited their work there had seceded from the traditional notion of photography. In a sense, they set the tone for the innovations in painting that were nurtured here as well. At the beginning of the twentieth century, most American photography, indeed most photography, was limited to portraiture, straightforward photo-journalism (Chapter 12), or a theatrical painterly mode that attempted to disguise the method by which it was made. Alfred Stieglitz wanted photography to develop beyond these roles and declare its independence as an art form. In his portraits and city scenes dating from the 1880s and 1890s, Stieglitz tried for a natural, unstudied quality that was alien to most nineteenth-century photography. At the same time, he tried to break through the technical limitations of the medium by taking photos in the snow and rain and taking some of the first night pictures as well. Frequently he used a hand-held camera, eliminating the tripod and black cloth that had been considered essential for serious photography. In 1907, he produced a remarkable photograph, *The Steerage*, in which he succeeded in bringing art and life together (Figure 141). The picture is strikingly composed with the upper and lower portions linked together by the diagonal of the gangplank. Its wide variety of tonal variations from soft blacks to lustrous whites guide the eye through the scene. At the same time, the photograph captures a memorable image of immigrants enduring the cramped and squalid conditions of the cheapest quarters in the ship to make their way to America and a new life.

By 1915 Stieglitz's photographic explorations took him into the realm of portraiture, not in the traditional sense of recording a facial likeness but as a penetrating study of character and physical presence. Stieglitz's most complete portrait study was of his second wife, the painter Georgia O'Keeffe, whom he photographed many times over the years. By photographing her face, her hands, and her body, Stieglitz created a remarkable cumulative portrait, recording her inner life through insight into physical form.

In the twenties and thirties, Stieglitz worked with abstraction in a series of photographs of clouds which he called "equivalents." These subtle images were Stieglitz's answer to those who thought that photographs depended entirely on subject matter for their meaning. The forms and tones of these photos speak as eloquently as any face or landscape captured by the camera.

In addition to his own involvement in photography and his gallery, Stieglitz published a quarterly magazine, *Camera Work*, from

1903 to 1917. *Camera Work* advocated the acceptance of photography as an art form and contained superb photogravure reproductions of works by photo-secession photographers. The first issue of *Camera Work* contains photogravures by Gertrude Käsebier. Käsebier's approach to photography was similar to that of other members of the photo-secession like Joseph T. Keiley, Clarence White, and Edward Steichen. Though her subject matter was traditional—anecdotal genre scenes, famous faces, or women and children—Käsebier was attempting to expand the boundaries of what has been called *pictorial photography*, the soft-focus, misty images of the late-nineteenth-century photos that were made to imitate paintings. Rather than relying exclusively on the manipulation of the negative during developing to achieve painterly effects, Kasebier stressed the importance of light and in spontaneity of pose and expression.

Another early pioneer in photography, Edward Steichen, was affiliated with the photo-secession from its beginnings and played a key role in the development of the ideals of 291. His affiliation with 291 was only part of an amazingly long, active, and diversified career. Born in 1869, by his twenty-first year Steichen had caught the attention of Stieglitz with experimental photographs of landscapes, informal soft-focus portrait studies, and self-portraits. In 1900, Steichen traveled to Paris to pursue a career as a painter and photographer. There he became Steiglitz's contact in Europe, keeping him up-to-date with the latest trends in art. When *Camera Work* was first published, Steichen's design appeared on the cover, and he continually contributed photographs to the magazine, including some of the earliest color pictures made. In 1903, his friendship with Rodin led to the famous series of photos of the great sculpture of Balzac. In 1911, Steichen turned his camera on high-fashion subjects. During the twenties, he became chief photographer for Condé Nast Publications, and his fashion pictures appeared regularly in *Vogue* and *Vanity Fair*. Also in the twenties he accompanied Isadora Duncan to Athens and made memorable images of the great dancer and her students dramatically posed against a backdrop of the Acropolis and Parthenon. (See Fig. 150, p. 206.)

His portrait photographs span his career and record the faces of many celebrated figures including J. P. Morgan, the banker and financier, Gloria Swanson, the actress, George Bernard Shaw, the playwright, Henri Matisse, the painter, and Greta Garbo, the film star. Using a multiple-exposure technique to capture a wide range of expressions and emotions, Steichen made a memorable portrait of his brother-in-law, the poet Carl Sandburg, on the morning after Sandburg had completed his mammoth definitive biography of Abraham Lincoln.

Steichen's dedication was not only to photography but to art in general. In Paris he was introduced to modern painting and sculp-

FIGURE 151 Käsebier, Gertrude, *Evelyn Nesbit,* 1903, Courtesy International Museum of Photography, George Eastman House.

ture by the American art collectors, Gertrude, Leo, and Michael Stein, who were among the most devoted patrons of the European avant-garde. At their weekly gatherings Steichen met such important artists as Henri Matisse and Pablo Picasso. Although he eventually gave up his own ambitions to become a painter, Steichen's associations with artists made him an active proselytizer for modern art. Through his influence on Steiglitz, the spirit of 291 came to include prints, watercolors, painting, and sculpture, as well as photography.

The first exhibition of works other than photographs at the Little Galleries of the Photo-Secession was a show in January 1908 of wash drawings by the French sculptor Auguste Rodin. Rodin's reputation as a sculptor was already well established in America with such works as *The Thinker* and *The Kiss*. His drawings, however, had never been seen in this country before, and they appeared crude, unfinished, and scandalous to the American public.

More controversial European art followed in exhibitions at 291. For the first time Americans saw exhibitions of work by Constantin Brancusi, Toulouse-Lautrec, Amadeo Modigliani, and Henri Rousseau. Works by Picasso and Cézanne were also shown, as well as displays of children's art and African sculpture. Unlike Robert Henri and the artists of the Ashcan School, Stieglitz felt that art

FIGURE 152 Stieglitz, Alfred, *Portrait of Georgia O'Keefe*, 1931. Courtesy of Doris Bry.

FIGURE 153 Strand, Paul, *Bowls,* 1916, The Metropoli-
tan Museum of Art, The Alfred Stieglitz Collection.

knew no national boundaries. Rejecting the traditional democratic
American outlook, Stieglitz maintained that art was an elitist activ-
ity, "for the few and by the few." In this atmosphere artists gathered,
along with writers, critics, and intellectuals, turning 291 into, as
Stieglitz put it, a "laboratory" for experimenting with new ideas. All
of these activities were documented in the pages of *Camera Work,*
where writers, such as Gertrude Stein discussed painting and sculp-
ture as well as photography. The last issue of *Camera Work* signaled
Stieglitz's new photographic aesthetic and pointed the way beyond
the soft-focus, idealized vision of the earlier photo-secessionists like
Käsebier and Steichen. Devoted to the work of Paul Strand, it
marked a turning point for photography in this century. Strand,
whose images have often been called "straight photography," advo-
cated a more direct and objective approach to photography than pic-
torialism. When he first met Stieglitz in 1916, Strand was pho-
tographing simple objects, a picket fence, for example, or empty
bowls, shown up close to reveal the innate elegance and simplicity of

their design. In this way, he created abstract patterns and imagery equivalent to those of modern paintings. In addition, Strand broadened the range of acceptable photographic subject matter, depicting not only ordinary objects such as street signs and machinery but also indigent city dwellers, laborers, a blind beggar, and an old man. To obtain natural, unstudied poses and closeup studies of his subjects, Strand sometimes used a false lens on the side of his camera, which he pretended to focus when in fact the real one captured the person at his side. Most significantly, he refused to adjust his negative in any way, printing exactly the picture that appeared on the film without cropping or manipulating lights and darks. This technical purity became the goal of straight photography, an outlook that has dominated this medium until recent times.

AMERICAN PAINTERS AT 291

Many of the American painters who found a haven for their art and ideas at 291 had spent several years in Europe frequenting the Steins' weekly gatherings, studying with modernists such as Henri Matisse, and participating in the major developments in art in those exciting years of the first decade of the twentieth century. As they returned home, the young Americans followed several courses in their efforts to establish modern art in the United States. Some embraced the European avant-garde while living abroad and attempted to carry their own versions of it to America. Oscar Bleumner's vivid landscapes, for example, were inspired by the work of Henri Matisse, as were Alfred Maurer's paintings dating from the early 1900s. Others, most notably, Stanton MacDonald-Wright and Morgan Russell, attempted to establish a movement of their own. Calling their style of painting *synchromism*, meaning "with color", Russell and MacDonald-Wright worked with orchestrations of color and geometric forms, creating one of the most daring American ventures into nonrepresentational painting of that time. Although short-lived, their innovative approach paralleled the developments of off-shoots of cubism—one in France, *orphism*, led by Robert Delaunay, and the other in Germany, the nonobjective *"improvisations,"* led by Wassily Kandinsky (see also a reference to synchromism in Chapter 13).

A number of artists looked to the American scene for subject matter and themes. Marsden Hartley, for example, painted geometric abstractions inspired by the emblems, flags, and insignia of the German military he saw in Europe (Fig. 154), but after returning to the United States, he began painting scenes of his home state of Maine. In his series of paintings of the Maine landmark *Mount Katahdin* (Fig. 155), Hartley continued to pursue new ways of dealing

with space and color introduced by modern European art; yet another influence guided him as well, the work of the nineteenth-century American mystic, Albert Pinkham Ryder. Although Hartley's colors are brighter and the paint applied with more immediacy, his strong shapes and rhythms are echoes of the earlier master's work. Acknowledging the intimate relationship of an artist with his home and roots, Hartley observed that, "The quality of nativeness is colored by heritage, birth, environment, and it is for this reason that I wish to declare myself a painter from Maine."

Joseph Stella, after working in Italy for 3 years, found New York City to be a subject whose vitality and excitement suited the dynamic approach of the Italian futurists. In his paintings of the New York skyline, the Brooklyn Bridge (Fig. 156), and Coney Island, Stella employed futurist lines that cut across forms with vectorlike force and

FIGURE 154
Hartley, Marsden, *Portrait of a German Officer*, 1914, The Metropolitan Museum of Art, The Alfred Stieglitz Collection, 1949.

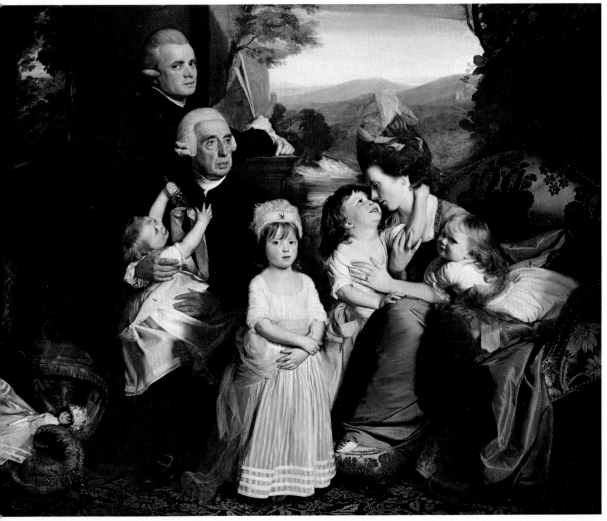

pley, John Singleton, *The Copley Family*, 1776, Courtesy of National Gal-
of Art, Andrew Mellon Collection.

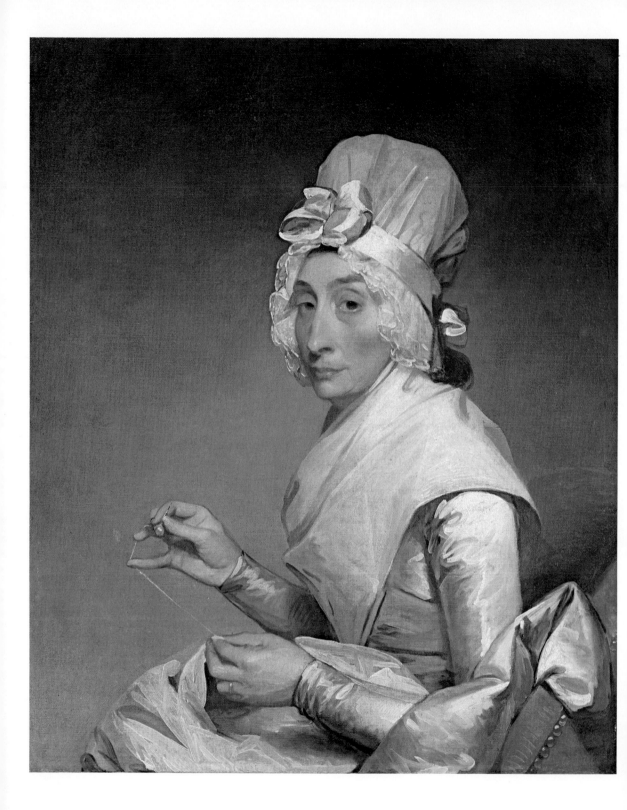

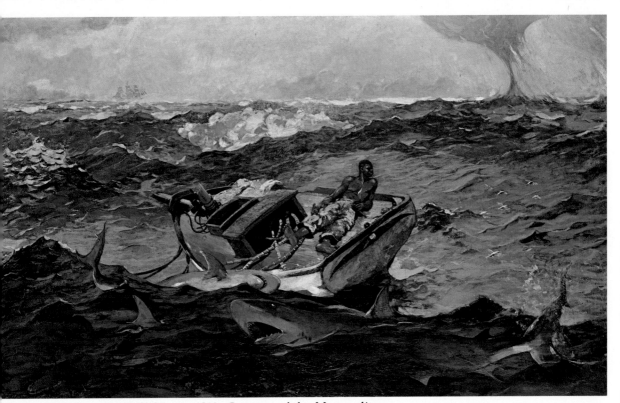

Homer, Winslow, *The Gulf Stream,* 1899. Courtesy of the Metropolitan
seum of Art.

tuart, Gilbert, *Mrs. Richard Yates,* 1793, Courtesy of National Gallery of
, Andrew Mellon Collection.

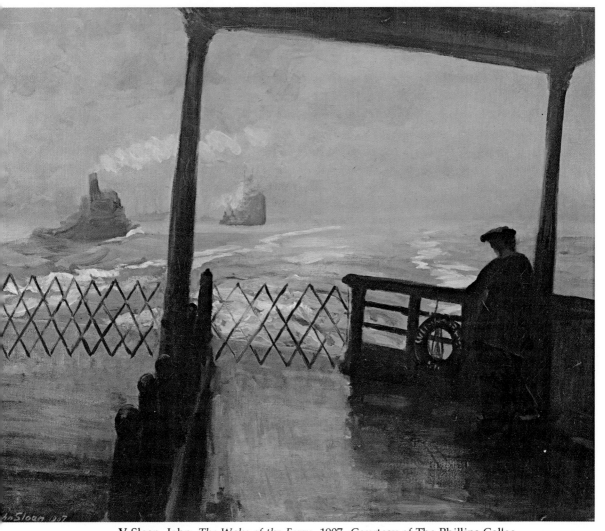

V Sloan, John, *The Wake of the Ferry*, 1907. Courtesy of The Phillips Collection, Washington.

IV Eakins, Thomas, *Portrait of Mrs. Eakins*, 1899. Courtesy of Hirshhorn Museum and Sculpture Garden, Smithsonian Institution.

VI Wright, Frank Lloyd, Courtesy of the Kaufman House ("Fallingwater"), 1936, Bear Run, Pennsylvania.

VII Rothko, Mark, *Number 10*, 1950. Courtesy of the Museum of Modern Art, New York.

VIII Eggleston, William. *Memphis*, 1972. Courtesy of Caldecot Chubb, New York.

FIGURE 155 Hartley, Marsden, *Mt. Katahdin*, 1941, Courtesy of Hirsh-horn Museum and Sculpture Garden, Smithsonian Institution.

colored shapes that pulsate and glow with light and energy. The city also provided a motif for Max Weber's cubist-inspired paintings dating from the teens. His version of *Rush Hour, New York*, for example, conveys the energy of the crowded streets at quitting time through fragmented shapes and swirling lines. Weber's *Chinese Restaurant* (Fig. 157) is one of the most successful American variations on cubist painting. Although composed of abstract patterns in a flat, two-dimensional format, the painting evokes the feeling of a restaurant in New York City with checkered patterns, bright red decor, and oriental flavor. Like many of the artists first associated with 291, Weber found the artistic climate in America unsuited for the development of modern art and was unsuccessful in continuing along his original course. Max Weber, for example, abandoned abstraction based on cubist innovations for a figurative approach using themes drawn from his Jewish background.

FIGURE 156
Stella, Joseph, *The
Bridge,* 1922, Collec-
tion of The Newark
Museum. Felix Fuld
Bequest.

O'KEEFFE, MARIN, AND DOVE

Three 291 artists, however, Georgia O'Keeffe, Arthur Dove, and John
Marin, succeeded in firmly establishing and developing their per-
sonal contributions to avant-garde painting. They were also the art-
ists who remained closest to Alfred Stieglitz throughout his career
and continued to exhibit at the galleries which succeeded 291—An
Intimate Gallery, in operation from 1925 to 1929, and An American
Place, in operation from 1929 to 1946.

John Marin was in his forties and well into his career when he
first encountered modern art in Europe. When Alfred Stieglitz dis-
covered him in 1911, Marin was painting watercolor landscapes and
city scenes in a manner inspired by Paul Cézanne's reduction of na-
ture to geometric forms. The spark that set off his successful develop-
ment upon his return to the United States was the energy that he

found in New York City. His cityscapes took on new dynamism: skyscrapers became surging, moving colossi set in motion by active brush-strokes reflecting the excitement of urban life. "I see great forces at work," Marin explained, "great movements, the large buildings and the small." Marin also found vitality in nature. His paintings of the coast of Maine surge and explode with color and light. To hold the dynamics of his paintings in check, in what he called "blessed equilibrium," Marin left white enclosures of paper free from paint to frame and contain the energetic activity of the forms and colors. As indicated by his titles, *Pertaining to Stonington Harbor*, for example, or *Region of the Brooklyn Bridge Fantasy*, Marin wished to capture only the essential qualities of a scene rather than faithfully represent a specific location. Although Marin's paintings have the freedom of expression implicit in abstract, non-representational art, they never lose touch with images and associations found in nature and the life around him. (See Fig. 158.)

FIGURE 157 Weber, Max, *Chinese Restaurant*, 1915, Collection of Whitney Museum of American Art, New York, Geoffrey Clements photographer.

FIGURE 158 Marin, John, *Region of the Brooklyn Bridge Fantasy*, 1932, Collection of Whitney Museum of American Art, New York, Geoffrey Clements photography.

Arthur Dove also used nature as the starting point for his art. By simplifying the forms of plants, animals, and growing things to their basic organic patterns and rhythms, Dove was able to use color and design for expressive and at times lyrical purposes. Not only nature but emotions and experiences were also sources for paintings such as *Ferry Boat Wreck* and his haunting *Fog Horns*. Dove also made collages. The collage, which is made by adding bits of paper and materials to a painting, was a new idea that had been introduced by the French cubists at the beginning of the twentieth century. Dove's collages, some of the first made in America, are different from those of the cubists, however. When Picasso added a piece of wood to a painting, his concern was primarily with the design and texture of his composition. Dove, on the other hand, chose elements for his collages with great attention to their meaning. A collage such as *Goin'*

Fishin' incorporates the denim from a fisherman's coveralls and a bamboo fishing pole into an abstract composition. The wit and whimsy implicit in a collage such as this play a part in a number of Dove's paintings as well (Fig. 160).

In 1916, nearly 10 years before her marriage to Alfred Stieglitz, Georgia O'Keeffe became affiliated with 291. When Stieglitz selected a series of her drawings for exhibition that year, he was moved to make his now famous remark, "Finally, a woman on paper!" Strength, as well as an intense sensitivity, continued to mark the paintings and drawings that followed, a strength based on O'Keeffe's perception of forms in terms of their clarity, order, and innate elegance. Like Arthur Dove, O'Keeffe found inspiration in nature—in flowers, clouds, mountains, and desert landscape. Not only did she seek the essence of forms in nature but she also worked with geometric configurations. In paintings such as *Blue and Green Music*, she also equated visual forms and color with nonvisual experiences. As she explained: "I found I could say things with color and shapes that I couldn't say any other way." (See Fig. 161.)

Frequently she focused on objects closeup in a way that brought

FIGURE 159 Dove, Arthur, *Fog Horns*, 1929, Courtesy of Colorado Springs Fine Arts Center.

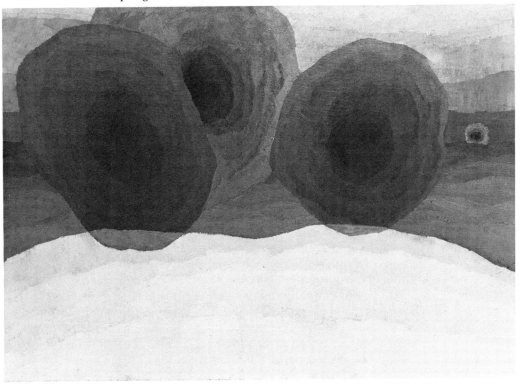

FIGURE 160 Dove, Arthur, *Goin' Fishin'*, 1926, The Phillips Collection, The Alfred Stieglitz Collection, 1949. Washington, D.C.

to mind pictures by Paul Strand and Edward Weston and was possibly inspired by photography. From this intimate viewpoint she saw nature in subtle gradations of color and sharply defined edges. Her painting *Black Iris*, for example, fills the canvas; enlarged and simplified, the flower takes on new significance as a visual experience.

O'Keeffe has always been responsive to her environment. For a time that environment was New York City, where she celebrated the stark power of the modern skyscraper in works such as *The Radiator Building* painted in 1927. Later, after moving to New Mexico, she began making paintings inspired by the desert landscape. Detachment and clarity and at the same time a sense of mystery and symbolism mark her images of the Southwest. (See Fig. 162.)

FRANK LLOYD WRIGHT AND ARCHITECTURE

In the early years of the twentieth century, architecture, like painting and sculpture, followed both conservative and progressive directions. The beaux arts tradition launched by the Columbian Exposition in 1893 continued alongside experiments with technology and design. The most outstanding and innovative architect to emerge in these years was Frank Lloyd Wright. He began his career in Chicago as a draftsman in the firm of Louis Sullivan, the nineteenth-century father of the modern commercial building—the skyscraper. Rather than following in Sullivan's footsteps, Wright set an independent

FIGURE 161 O'Keeffe, Georgia, *Black Iris,* 1926, The Metropolitan Museum of Art.

FIGURE 162 O'Keeffe, Georgia, *Cow's Skull, Red, White, and Blue,* 1931, The Metropolitan Museum of Art.

FIGURE 163 Wright, Frank Lloyd, *The Robie House*, 1909, Chicago.

course as a designer of residential architecture. The Frederick C. Robie house, built in Chicago in 1909, is one of his outstanding types of early structures, called Prairie Houses because of their suitability to the Midwestern landscape. With its sweeping horizontal lines, wide flaring roof, terraces and interlocking vertical core, the house is handsome and dramatic, and is still modern today. Its floorplan of intersecting spaces centers on the hearth—a core which is both structural and symbolic, recalling the central hearth of early colonial houses. Rather than cutting the interior into boxes of enclosed space, Wright chose to, as he explained, "let walls, ceiling, floors become seen as component parts of each other, their surfaces flowing into each other, the new reality that is space, instead of matter." Wright's designs grew out of several sources. Oriental architecture, which he first saw in Japan's pavillion at the World's Columbian Exposition in Chicago in 1893, inspired his organization of flowing space and use of simple geometry. The shingle-style houses of Henry Hobson

Richardson influenced Wright's choice of native materials and a plan suited to the building's site.

The interior design and decoration of his buildings were also carefully integrated into the overall plan. In the Universalist Church built in Oak Park, Illinois, in 1906, Wright offered one solution to the problem of creating a single unified interior that is both spacious and scaled to the individual. The organization of intersecting walls and piers is reinforced visually by simple linear details of wooden beams and molding. For the exterior, Wright used poured concrete mix and pebble aggregate to create a texturally interesting surface which is decorated sparingly.

In the teens and twenties, Wright's career suffered not only because of the war and national economic problems but also because his independence and innovative beliefs clashed with those of the general architectural community in America. At the same time that his reputation at home declined, Wright began to receive acclaim abroad. The publication of his designs in Germany in 1910 and 1911 significantly influenced the development of the International style of architecture which emerged in the 1920s in Europe and would dominate American architecture by mid-century.[1] From 1916 to 1922 Wright worked in Tokyo, Japan, designing and overseeing the construction of the Imperial Hotel, a structure merging eastern and western sensibilities which, due to carefully planned flexible supports, survived the devastating earthquake of 1923.

In the United States, Wright began a distinctive new period in his career in the thirties. The integration of structure, space, materials, and location into a single, functional design marked the succession of innovative structures in this period. The Paul Hanna house in Stanford, California, made of brick and redwood indigenous to the area, is composed of interlocking hexagons centering on the hearth. Rising from the earth like a prairie sod house, the Herbert Jacobs House in Middleton, Wisconsin, opens up in back with a sweeping expanse of curved window. Wright's desire to integrate the structure with the site is most spectacularly accomplished in Fallingwater—the Kaufmann House in Bear Run, Pennsylvania (Color Plate VII). Cantilevered dramatically over a waterfall, the house is rooted in living rock which rises through the center of the house as part of the chimney and pier. Terraces and windows which run continuously up all three floors open the private interior to the outdoors. The culmination of Wright's principles of design for domestic architecture can be found at his home and architectural community, Taliesin, located near Scottsdale, Arizona. The ground-hugging structure laid out as a series of interlocking triangles echoes the rugged beauty of mountain and desert. Inside, spaces flow from cool, low-ceilinged living areas to the drafting rooms which soar outward under sail-like canvas ceilings.

[1] See Chapter 15 for a discussion of the "International style."

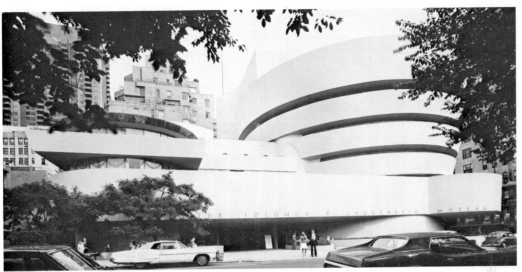

FIGURE 164 Wright, Frank Lloyd, *The Solomon R. Guggenheim Museum*, 1959, New York City.

Wright's most famous and controversial public building is *The Solomon R. Guggenheim Museum* in New York City. Begun in 1943 but not completed until 1959, the museum is strikingly different from the more conventional high-rise buildings along Fifth Avenue. The main exhibition space is a monumental spiral, curving out and up from the base and the adjacent cantilevered office wing. The interior space is arranged so that the paintings are viewed by walking down from the top of the spiral, which is reached by an elevator. It is a spectacular architectural monument with its dramatic layout of curving ramps and the breathtaking space of the core.

Wright was never one to bow to convention or avoid controversy. Like Alfred Stieglitz and the artists of 291, he chose to take the controversial course. Stieglitz once said that his goal was simply to "establish for myself an America in which I could breathe as a free man." Through the efforts of Stieglitz and pioneers such as Frank Lloyd Wright, this goal of freedom for American art has been fulfilled.

RAPT AT RAP APORT'S

CHAPTER 15

POLITICS AND ART BETWEEN THE WARS

FIGURE 165
Davis, Stuart,
*Rapt at
Rappaports,* 1952,
Courtesy of
Hirshhorn
Museum and
Sculpture
Garden,
Smithsonian
Institution.

I n the United States in the 1920s and 1930s, artists began to reconsider the relationship of their work to the realities of life in this country. Reviving the long-standing debate on the need for art to be relevant politically, a number of artists began to use their art as a vehicle for social commentary. Others hoped to foster confidence in the nation by extolling the virtues of the American way of life through their art. Even artists more concerned with formal problems than subject matter looked to the American scene for inspiration at this time. Although their outlook and approaches differed considerably, their works touched at the heart of a critical period in our history—the years after one world war, the era of the Great Depression, and the outbreak of the Second World War.

THE TWENTIES

One artist who responded to the upbeat tempo of the turbulent years of the 1920s was Stuart Davis. As a young man, Davis had studied with Robert Henri, and was thoroughly versed in the use of Ameri-

can life as a source for paintings; however, the impact of the modern art he saw at the Armory Show guided him toward a more modern approach to the formal issues of painting. Beginning in 1921 with a series of paintings based on cigarette packages and given titles such as *Lucky Strike* and *Bull Durham,* Davis experimented with the application of cubist spatial principles to the depiction of American themes with the imagery of the commercial designs serving as his motifs. Using equally common objects—an eggbeater, an electric fan, and a rubber glove—Davis continued his exploration of abstract design in a succession of paintings called his *Eggbeater Series.* Serving as a starting point for the arrangement of forms and colors, the objects themselves remained subordinate to the interior logic of the paintings, in which patterns, colors, and forms are interrelated.

In the thirties, Davis began using images from the American scene such as barber poles, storefronts, and signs to create pulsating two-dimensional designs that express the energetic pace of life. Explaining the sources for his work, Davis named "travel by train, auto and airplane which brought new and multiple perspectives; electric signs . . . five and ten cent store kitchen utensils; movies and radio; Earl Hines' hot piano and Negro jazz music in general." Davis also introduced words and symbols into his paintings. His titles, such as *Rapt at Rappaports,* not only function as an integral part of the painting's design but also reinforce the syncopated rhythms of the work by their sound. They are catchy, even jazzy, and well suited to the age which inspired them. The frank acknowledgment of commercial imagery in Davis's work would be taken up again by pop artists such as Andy Warhol and Roy Lichtenstein in the sixties.

Davis was not alone in his discovery of the urban American scene as a source for fresh formal interpretation. Members of the 291 circle were exploring this motif in the twenties, as well. The industrial scene, in particular, inspired Charles Demuth and a group of artists sometimes called the *precisionists.* Demuth initially worked in the medium of watercolor, using delicately controlled line and washes of color to paint still-lifes, landscapes, and illustrations for popular novels and short stories. In the twenties, he found a new source of pleasure in the smooth, impersonal forms of industrial objects and architecture. Using the denser medium of tempera, as well as oil, Demuth painted factories, machines, and, in a work titled *My Egypt,* a grain elevator. Like Stuart Davis, Demuth was inspired by the French cubist painters and adapted certain aspects of their work, in particular, the reduction of forms to simple geometry. Rather than breaking the surface into the multiple views as in a work by Picasso, Demuth simplified and clarified forms. Borrowing from the Italian futurists, he used lines to direct light in shafts of controlled energy and to unify the elements in the composition. As a result, the image of the grain elevator takes on a new abstract quality.

FIGURE 166 Demuth, Charles, *My Egypt,* 1927, Collection of Whitney Museum of American Art, New York, Geoffrey Clements photographer.

One of Demuth's most significant works based on machinery is not a depiction of an impersonal object but instead a very personal portrait of a friend, the poet William Carlos Williams. Using the sleek power of a firetruck racing through city streets, Demuth created what he called a "literary picture," based on one of Williams's poems. Called *I Saw the Figure 5 in Gold,* the painting relates directly to a line from Williams's poem *The Great Figure:*

> Among the Rain/ and Lights/ I saw the Figure 5/ in gold/
> on a red firetruck/ moving/ tense/ unheeded/ to gong clangs/
> siren howls/ and wheels rumbling through the dark city.

The painting recreates the imagery and spirit of the poem and incorporates Charles Demuth's and William Carlos Williams's initials as well as the poet's nickname Bill. What more fitting portrait of a poet than an evocation of one of his own verses!

The precisionists, who included Preston Dickinson, Niles Spencer, and Charles Sheeler, shared Demuth's preference for precisely defined, hard-edged form and industrial objects. Charles Sheeler's paintings developed out of his work as a professional photographer. By translating the clear delineation of light and shadow and flattened space of his photographs into paintings, Sheeler found he was able to "incorporate the structural design implied in abstraction without straying from reality." The clean lines and handsome simplicity of the architecture and crafts of the Shakers from Sheeler's home in Bucks County, Pennsylvania, also played a part in the development of his painting. When Sheeler painted factories, machines, or the upper deck of a ship he stripped them of clutter and grime and enhanced the satisfying order of their geometric forms. From a series of paintings based on photographs of the Ford Motor Company's River Rouge Plant, Sheeler selected one view and titled it, *Classic Landscape*, suggesting like Demuth's *My Egypt* a relationship to the great monuments of the past, not only in the columnlike structure of

FIGURE 167
Sheeler, Charles, *Upper Deck*, 1929, The Fogg Art Museum, Cambridge, Mass.

FIGURE 168
Burchfield,
Charles, *Church
Bells Ringing, Rainy
Winter Night*, 1917,
Courtesy of Cleve-
land Museum of
Art. Gift of Louise
M. Dumer in mem-
ory of Henry Keller.

the factory but also in its significance as an achievement of industri-
alized America.

This assessment of the industrial scene took on a gloomy, almost
sinister interpretation in the work *Black Iron* by another artist of this
period, Charles Burchfield. Burchfield was not a precisionist. Rather
than focusing exclusively on the formal elements of his subjects,
he also dwelt upon their expressive qualities. In *Black Iron* a massive
mining apparatus looms dark and ominous in the landscape—an
intruder—which is hardly an optimistic symbol of progress. Burch-
field had the ability to impart an almost anthropomorphic quality to
inanimate objects and to evoke abstract concepts such as fear,
menace, evil, and melancholy through mundane scenes such as a
quiet street in a small midwestern town or a grassy field alive with
chirping crickets. In the twenties, this imaginative quality was given
free rein in his paintings, but in the thirties when regional subjects
and themes became popular, Burchfield focused on life in his home
state of Ohio. In his paintings dating from this period there is a sense

FIGURE 169 Hopper, Edward, *House by the Railroad,* 1925, The Museum of Modern Art.

of the tediousness and the dreary isolation of life in small towns in America, sentiments expressed at the same time in the literature of Sherwood Anderson and Sinclair Lewis and in the paintings of Edward Hopper.

Hopper had been a student of Robert Henri in the early 1900s and continued to deal with subjects drawn from the life around him for the next 50 years. His view of America differed considerably from his Ashcan School predecessors however. While John Sloan and George Luks embraced the vitality and life of the city, Hopper recorded the lonelier side of urban and suburban life: a deserted city street on Sunday morning, an old Victorian house forlornly fronted by a railroad track, a gas station on a lonely stretch of highway. Gone is the energetic brushwork of Luks and Henri and in its place are smoothly finished, clearly defined forms and strong contrasts of light and dark. The people in Hopper's paintings are anonymous, types— merely actors in the daily routine of life.

Though different in their means of expression, Hopper, Burchfield, and the precisionists, and even Stuart Davis, shared an appraisal of American life that was cool, detached, and a little cynical. After the Crash of 1929, however, the direction of American painting changed. Suddenly, purpose, meaning, and involvement became important issues for many artists. The Depression and the social and economic problems it engendered forced artists to think quite differently of their own country. Three basic issues dominated art in that decade: first, the desire for a national art based on regional subject matter and presented in a deliberately simple, popular fashion; second, a suspicion of all art based on modern European developments; and third, the conviction that it was time to take stock of American social values and to comment forcibly on the good and bad aspects of society. Two divergent groups grew out of these concerns—the regionalists and the painters of social consciousness, or as they are sometimes known, the social realists.

The Regionalists

The regionalists looked to the nation's heartland to celebrate the virtues of life in America. In the years of drought and farm foreclosures, their paintings often took the form of a nostalgic look at an era that had already ended. John Steuart Curry, for example, painted scenes from his boyhood in Kansas. His approach to painting was simple and straightforward, and his basic concern was with telling a story. At the heart of each story was the theme of man's struggle with nature and his efforts to control the land.

Thomas Hart Benton was the most articulate spokesman for the regionalists and also the most antagonistic toward both the avant-garde and the social commentators. After experimenting with every "cockeyedism that came along," Benton rejected modern trends for themes and images that he believed more suited to American culture and more readily understood by the general public. The grandson of a U.S. Senator and the son of a Congressman from Missouri, Benton painted what he considered to be the most vital people and values of American life. This sort of painting, Benton maintained, could be understood by everyone, and was, therefore, more democratic and meaningful. While living in New York, Benton traveled to various parts of the country in search of his subjects. *Boom Town* was based on a visit to western Texas in 1932 and the *People of Chilmark* on Benton's regular summer visits to Martha's Vineyard. Not limited to one region, Benton sought to capture the spirit of a rich variety of locations in America.

FIGURE 170 Benton, Thomas Hart, *Arts of the West,* 1932, The New Britain Museum of American Art, New Britain, Conn.

Rather than focusing on specific individuals or events, Benton dealt with the typical, the representative activities of life. People in action, the energy and flux of society became his themes. To deal with them Benton employed the pictorial devices of disjointed perspective, turbulent rhythms created by line and color, and loosely jointed, muscular figures which writhe and gyrate across the canvas. Benton's technique was indebted to fifteenth-century notions of craftsmanship. He used egg tempera because of the smooth finish it produced, and he created low-relief clay figures colored with black-and-white shading as studies for his paintings.

During the thirties, when mural painting was revived under state, federal, and privately sponsored programs, Benton received a number of important commissions to paint murals with topics such as *America Today* and the *Arts of Life in America.* Benton dealt with American history in terms of the contributions of the average citizen rather than those of politicians and public servants. In his painting *Arts of the West,* for example, the activities represented include music, dancing, poker, and marksmanship—folk arts, not the fine arts. Breaking with the traditional format for mural painting in which the design is subordinated to the architecture and flat wall surface, Benton used strong contrasts of light and shadow and cut the picture plane into several perspective views to present the action in a livelier, more dynamic way. In 1934, Benton returned to his home

state to paint a mural cycle on the social history of Missouri for the state capitol. Dealing with characters out of native folklore and literature such as Huck Finn, Frankie and Johnny, and Jesse James, this work caused considerable controversy. Nevertheless, Benton decided to remain permanently in Missouri after completing the mural.

During the late thirties, Benton's work underwent a change. He began to look more closely at the land and to introduce textural variety and details. His paintings became less theatrical and pulsating, and new themes appeared as well, including a reinterpretation of mythological and biblical subjects in a Midwestern context. In his painting of *Persephone,* for example, the ancient Greek goddess of spring is a young country beauty who is discovered sunbathing by a wizened old farmer. Strongly believing that American art should develop from American sources and not European ones, Benton asserted that "if the subject matter was distinctly American, then an American form, no matter what the source of technical means would eventually ensue." Ironically, however, in form his paintings are closer to European sources than American ones. Benton's approach brings to mind paintings by the Italian mannerists or El Greco, rather than paintings by earlier American masters. Despite his dedication to achieving a uniquely American expression, Benton relied only on native subject matter while looking to European art for his manner of presentation.

Another regionalist, Grant Wood, depicted rural life in his home state of Iowa and provided unique interpretations of American history. Wood's most famous painting, *American Gothic,* is a straightforward portrait of a hardworking farmer and his wife posing in front of a typical midwest farmhouse with its characteristic "gothic" window. Like *Whistler's Mother* and Gilbert Stuart's *Portrait of George Washington,* Wood's *American Gothic* (Fig. 171) struck a responsive chord in the public's imagination and has become a nationally recognized image. Exhibited in 1930 at The Art Institute of Chicago, Wood's painting became an emblem of American regionalism and launched the artist's successful career. When first exhibited, *American Gothic* was considered a tribute to the strength and determination of the people of the American midwest. However, there can be another interpretation of this tableau of a farmer and his wife for which Wood's dentist and sister posed. The stern, tight-lipped couple could also represent a narrow-minded and unyielding mentality found in some provincial communities in America.

In his painting of *The Daughters of the American Revolution,* Wood's criticism is more explicit. This depiction of tea-sipping self-righteous old ladies resulted from the DAR's attack on his choice of a Munich factory to fabricate a stained-glass window memorial to Iowa veterans of World War I. Ironically, the famous painting of *Washington Crossing the Delaware* which they stand in front of was painted by Emanuel Leutze in Germany.

FIGURE 171 Wood, Grant, *American Gothic*, 1930, Courtesy of The Art Institute of Chicago, Friends of American Art Collection.

When dealing with incidents from American history, Wood presented a more subtle commentary on American attitudes. Underlying paintings such as *The Midnight Ride of Paul Revere* with its use of diminutive scale and acute clarity, there is a sense of the mythical nature that this event has acquired. In another work based on history and myth entitled *Parson Weem's Fable*, Wood depicts the legend of George Washington chopping down the cherry tree. In a pose reminiscent of Charles Willson Peale's self-portrait in *The Artist in His Museum*, (Figure 3) the narrator of the tale, Parson Weems, draws back a curtain to reveal young Washington caught in the midst of the celebrated act. Poking fun at two legends at once, Wood gives the

pint-sized Washington the mature face of Gilbert Stuart's famous portrait of the President. Wood also painted more straightforward scenes of fertile Iowa farmlands and hard-working natives, but even these works are touched with a note of irony, for they depict a prosperity that was more myth than reality in the Depression years.

Artists of Social Consciousness

Wood and his fellow regionalists did not comment on the pressing social issues of the day or deal directly with the hardships of the Depression: the hunger, drought, financial disaster, and personal despair. They chose, instead, to personify America in terms of a rural ideal. Other artists of the day were more responsive to the ills of society and to the realities of life in urban, industrialized America. Reginald Marsh, for example, found his subject matter in New York City: office workers leaving the subway, chorus girls in a burlesque

FIGURE 172 Wood, Grant, *Parson Weem's Fable,* Amon Carter Museum of American Art, Fort Worth, Tex.

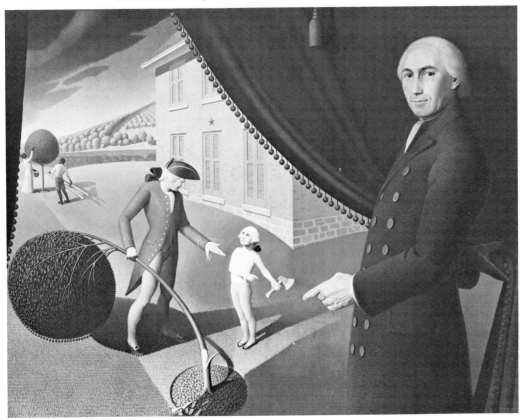

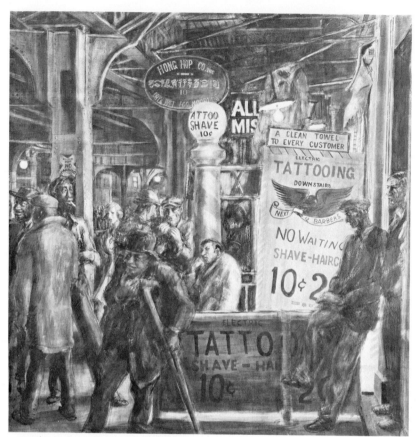

FIGURE 173 Marsh, Reginald, *Tattoo and Haircut*, 1932, Courtesy of The Art Institute of Chicago. Gift of Mr. & Mrs. Earle Ludgin.

show, swimmers off West Washington Street pier, bathers at Coney Island. The movement, restlessness, sordidness, and excitement of the city were his themes. Unlike his Ashcan School predecessors, Marsh did not romanticize urban life. He depicted people in crowds, rather than sympathetic individuals. Fascinated by the mob, but unwilling to mingle with it, Marsh used binoculars to observe people from his studio on Washington Square and also painted from photographs he had taken. Although his subjects were often down-and-out or involved in tawdry activities, Marsh did not criticize, but emphasized instead their picturesqueness and the special character of urban life. Other painters employed a more critical approach in their studies of life in the thirties.

Many were active in liberal political organizations, and, inspired by the Mexican social protest painters, they believed that art should be relevant and address topical issues. Working in close association under government-sponsored programs such as the Works

Projects Administration (WPA), there was a sharing of ideas and commitment among artists. Painters such as Jacob Lawrence, Philip Evergood, George Biddle, Aaron Bohrod, and Alexander Brook looked with sympathy and outrage at the plight of laborers, the rural poor, and the blight-stricken land. Lacking a strong tradition of socially relevant art to draw from, their means of expression varied greatly. The Soyer brothers, Isaac, Raphael, and Moses, sympathetically portrayed the common person: workers trapped in the tedium of everyday life; indigent people seeking nourishment at soup kitchens; transients, bored and numbed by their plight. Other artists dealt more critically with the corruptions of people in positions of power. Jack Levine, for example, presented caricatures of politicians, generals, mobsters, and even art connoisseurs (Figure 9) in situa-

FIGURE 174 Soyer, Raphael, *Transients*, 1936, Michener Collection, University of Texas, Austin, Tex.

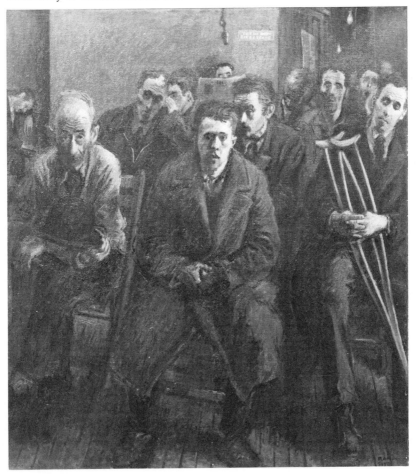

FIGURE 175 Levine, Jack, *Welcome Home*, 1946, Courtesy of The Brooklyn Museum. J. B. Woodward Memorial Fund.

tions that pointed up their basic hypocrisies. Levine's use of distortion and broken, shimmering form gives his works sharp satirical bite and the quality of modern abstraction.

Ben Shahn addressed himself to more specific inequities. In his series of paintings dealing with the Sacco and Vanzetti case, Shahn focused on the circumstances of the trial and the unsuccessful appeals of the two Italian-American anarchists who were tried and executed for the murder of a paymaster in 1927. The injustices of this widely publicized trial had aroused the sympathies of liberals throughout the country, and Shahn focused on it as a symbol of the prejudices inherent in the United States judicial system. By using photographs in the preparation of these paintings, Shahn established a feeling of journalistic authenticity while simultaneously manipulating the composition and forms to reinforce the tension and expressiveness of the image. The tragic figures of Sacco and Vanzetti transcend their roles as victims in a specific situation to become symbols of the oppressed.

Shahn also dealt with the less sensational, private tragedies of American life and supported efforts to improve the lot of the working person. In the forties, for example, he worked for the Political Action

Committee of the CIO (Congress of Industrial Organizations) making posters. During the Depression years Shahn, like many of his fellow artists, worked on federally sponsored art projects as a photographer as well as a painter. (For further discussion of the federal art projects see Chapter 16.)

POLITICS AND ARCHITECTURE

In the years leading up to World War II, architecture in the United States underwent a significant change. The most immediate shift in emphasis came about as a result of the Depression and government

FIGURE 176
Shahn, Ben, *The Passion of Sacco and Vanzetti*, 1931–1932, Collection of Whitney Museum of American Art, New York, Geoffrey Clements photography. Gift of Edith and Milton Lowenthal in memory of Juliana Force.

efforts to improve the housing situation. Under Franklin Roosevelt's New Deal, architects began tackling the issue of creating low-cost housing on a large scale. Projects ranged in type from urban high-rise apartment complexes to suburban subdivisions with individual dwellings and row houses laid out on a regular grid or conforming to the terrain. The ultimate proposal was Frank Lloyd Wright's Broadacre City. Providing for a range of economic levels with both single- and multifamily units and accommodations for industry, parkland, and a full complement of services, Wright's model community was deemed too visionary to be attempted in the thirties when he proposed it. These projects were only the initial steps toward solving the problem of high-density housing that would continue to mount in the years to come.

The second new development in American architecture came about as a result of the influx of European artists and architects fleeing the onslaught of Nazi oppression in the 1930s. This mass exodus of some of the leading intellectuals of Europe had a significant impact on not only cultural life in America but developments in science and technology as well. Among the immigrant artists were the Finnish architects Alvar and Aino Aalto, the painters Josef Albers and Piet Mondrian, the surrealists Yves Tanguy and Max Ernst, and the German architects Richard Neutra, Marcel Breuer, Walter Gropius, and Ludwig Miës van der Rohe. Richard Neutra came to the United States via Frank Lloyd Wright's architectural cooperative, Taliesin, and eventually settled in Los Angeles. Walter Gropius, founder of the Bauhaus, the progressive German school of design and architecture, became Professor of Architecture at Harvard in 1937. Another Bauhaus artist, the Hungarian painter and designer Lazlo Moholy-Nagy, set up the Institute of Design in Illinois, popularly known as the "Chicago Bauhaus." Miës van der Rohe joined the faculty of the Armour Institute in Chicago and designed its new campus when it became the Illinois Institute of Technology.

The design principles that the great majority of European architects brought to the United States were those of the Bauhaus and the "International style" of the 1920s. With an emphasis on modern technology and a clean-lined, machine aesthetic, International style architecture was characterized by the use of steel-cage construction, a nonsupporting glass "curtain" wall, and a clearly articulated modular plan.

Although the presence of European architects in the United States contributed to a major shift in focus for American architecture, the International style was not new to this country. As early as 1923 Walter Gropius, with Adolf Meyer, had submitted a design for the Chicago Tribune Building competition. Ironically, the Gropius design, which was turned down in favor of a neogothic skyscraper by Raymond Hood, looked like a logical successor to Louis Sullivan's

FIGURE 177
Gropius, Walter,
and Adolf Meyer,
*Chicago Tribune
Building,* 1922, Chi-
cago, *Chicago Tri-
bune* photo.

Carson-Pirie-Scott building, a distinctive Chicago landmark built in
1904 (Chapter 11). The Gropius plan for the Tribune building even
included "Chicago style" windows with a center glass panel and two
flanking movable panes. In the twenties, architects indebted to the
beaux arts tradition and not Louis Sullivan dominated American
architecture. As Hood's winning design for the Tribune building in-
dicates, even the skyscraper was not immune. Although maligned by
critics in subsequent years, the beaux arts treatment of skyscrapers
as shaped towers crowned by gothic or French seventeenth-century
decoration was not wholly without merit and resulted in a number of

FIGURE 178
Hood, Raymond, and John Mead Howells, *Chicago Tribune Building,* 1922–1924, *Chicago Tribune* photo.

striking structures including the Woolworth Building in New York by Cass Gilbert (1913) and Hood's Tribune Building.

By the 1930s, the beaux arts tradition was beginning to give way to the International style. The Museum of Modern Art's 1932 Exhibition of Modern Architecture signaled, by its emphasis on European developments, this new trend in American architecture. Even Raymond Hood, architect of the Tribune building, adopted aspects of modern European design for the first McGraw-Hill Building (1931) in New York, which has smooth, streamlined forms and a horizontal emphasis. Indebted to the French art deco movement as well as the

international style, Hood's building reflected a passion for airflow, the streamlined forms that swept the United States in the thirties and forties, affecting industrial design as well as architecture. Trailers, toasters, automobiles, and jukeboxes all bore the mark of art deco and International style modernism.

Bauhaus artists arriving in the thirties introduced a less eclectic variety of modern design and what has been called a purist approach to art and architecture in which much of the decorative quality of art deco is eliminated in favor of stricter geometry. Due to the Depression and World War II which curtailed most major building projects, it was several years before the influence of the immigrant architects

FIGURE 179 Miës van der Rohe, Ludwig, *Lake Shore Apartments,* 1949–1951, Chicago.

was widespread. By 1950, however, as Breuer, Miës van der Rohe, and Gropius began building skyscrapers, apartment houses, and schools, the new movement was underway. As it took root in America under the direction of European architects, the International style was further refined and transformed into the architectural aesthetic that would dominate our cities for the next three decades. The leading figure in this development was Miës van der Rohe, whose use of the steel-cage construction, glass-walled modular design, and elegant, yet simple, lines would transform the skyline of our cities and capture the imagination of many American architects to come.

Bauhaus artists also left their mark on commercial and industrial design. Their concern for wedding technology to sound aesthetic principles was shared in the postwar period by young Americans like Charles Eames who, like Miës van der Rohe and Gropius, applied his skills and knowledge as an architect to designing furniture, such as his famous Eames chair. (See Fig. 179.)

Although the results were long-range ones, the political events that drove progressive European artists to the United States in the 1930s profoundly altered the course of American art and architecture. At the same time, political events in the United States had an immediate impact on American art. Not only were the problems of the Depression reflected in the themes and subjects focused on by painters at that time, but the economic crisis forced the government to reassess its relationship to artists and to sponsor and provide financial support to artists through federally sponsored programs. Indeed, perhaps more than at any other time in our nation's history, art and politics shared a critical relationship in the years between the wars.

CHAPTER 16

ART FOR THE MASSES

FIGURE 183
Tavern Sign,
"Bissell," 1777,
Courtesy of
National Gallery
of Art, Index of
American
Design.

A long with workers in other vocations, artists suffered the economic and psychological hardships of the Great Depression. Few American artists had ever made their living solely by selling their art, but the Depression not only eliminated the possibility of sales but wiped out their other sources of income as well. Like American workers everywhere, artists looked to the federal government for support and assistance. When they asked President Roosevelt for help, they had a clear precedent in mind.

In 1922, a group of Mexican artists had formed the Revolutionary Syndicate of Technical Workers, Painters, and Sculptors. They wanted a public art of monumental scale supported by the government, because they considered easel-size painting a luxury of the elite and alien to the people. The subject matter of their murals reflected their interest in social reform. Mexican muralists like Diego Rivera, David Alfaro Siqueiros, and Jose Clemente Orozco painted the history of their people, cataloging their oppression and their triumphs on the walls of public buildings for every citizen to see. The Mexican government paid for these murals. During the presi-

dency of General Alvaro Obregon, Mexican artists were paid laborers' wages to create a modern mural tradition based on Mexican history.

Thus, it was to Mexico that artist George Biddle referred when he wrote to his former schoolmate, Franklin Roosevelt, in 1933 asking the President to help artists during the Depression. What resulted was not one, but a number of projects. They had different names, among them the Public Works of Art Project, or PWAP, the Treasury Relief Art Project, or TRAP, the Works Progress Administration's Federal Art Project, and the Treasury's Section of Painting and Sculpture. Their titles reveal their bureaucratic affiliations, but, together, they constituted a comprehensive program that sustained the arts in a manner not even the Mexicans had envisioned.

THE MURAL DIVISIONS OF THE FEDERAL ART PROJECTS

The most visible part of the art program was the murals that were painted in federal and nonfederal buildings—schools, office buildings, courthouses, prisons, post offices. The theme for the mural had to be American, and generally had to relate to the function of the building in which the mural was to be located. A mural for an elementary school portrayed children's fairy tales. For the former Social Security building (now the Department of Health, Education and Welfare), Ben Shahn depicted *The Meaning of Social Security.*

Whatever the mural's subject, every artist was required to make sketches and choose the medium—oil, tempera, fresco, mosaic—in which to work. The work was approved by a committee at various stages in its translation from sketch to completed work. A few murals were done on the spot, with the artists and the public sharing the experience of creation. For some Americans, the mural division of the art projects provided their first glimpse of a professional artist at work.

Some of the artists who worked on the murals, such as those under the WPA (Works Projects Administration), were on relief, and getting a salary of $69 to $103 per month for a prescribed number of hours work. The artists who worked for the Treasury Section received a flat sum for their mural work, having received the commission after winning an open competition. The average commission was $800 to $900.

Many of the artists who worked on the projects were concerned with the social relevance of their work. There was relatively little abstract art produced by American artists during the thirties, and most of what little was done originated in New York and was encouraged, in some instances, by artists' organizations like the American Ab-

FIGURE 180 Gorky, Arshile, *Abstraction,* preparatory study for a mural for Newark Airport, c. 1936, Newark, N.J. Collection, the Museum of Modern Art.

stract Artists. Today government censorship is often blamed for the conservative nature of most project art. The example most frequently cited is Arshile Gorky's ten-panel abstract mural for Newark Airport, entitled *Aviation: Evolution of Forms Under Aerodynamic Limitations,* which was painted over when the airport became a military base in World War II. Often overlooked, however, is that the mural's destruction came after the government projects were terminated.[1] In fact, the art projects accommodated a number of abstract painters among them Stuart Davis and Burgoyne Diller, two of the most famous.

Generally, project artists painted representational works by their own choice. Artists were sensitive to the fact that the average person's taxes were supporting the projects, and they wanted to create an art that would be meaningful for everyone. To the artist of the thirties, pure abstraction implied "art for art's sake" rather than for the masses.

THE EASEL DIVISIONS

Social consciousness was reflected in the projects' easel divisions as well. The list of artists represented in these divisions reads like a history of American art of the first half of this century. They can be di-

[1] In 1976, Gorky's mural was uncovered at Newark Airport where it had been hidden under many layers of paint.

FIGURE 181 Nevelson, Louise, *Cat,* c. 1940, WPA Photographs, Courtesy of Archives of American Art, Smithsonian Institution.

vided into several broad categories. The Woodstock School of painting, based in the upstate New York artists' colony, was represented by artists like Alexander Brook and Yasuo Kuniyoshi. The largest group was, of course, the social realists and the regionalists such as John Steuart Curry, Philip Evergood, Jack Levine, and Robert Gwathmey (Chapter 15).

A conservative quality can be found in the work of other younger artists as well, most of whom would achieve fame with more radical art in the forties. This group included Jackson Pollock, Mark Rothko, Ad Reinhardt, William Baziotes, Adolph Gottlieb, and Jack Tworkov. A number of older artists such as Marsden Hartley and Milton Avery also worked on the projects' easel divisions.

THE SCULPTURE DIVISIONS

Sculptors were also stimulated by government support. The projects contributed to the rebirth of major American sculpture after World War II. Giants of American postwar sculpture worked as young artists on the projects. David Smith worked on the New York City project in 1938 (Fig. 182). Louise Nevelson completed an image of a *Cat* while working on the project in 1940.

THE GRAPHIC DIVISIONS
AND PUBLIC EDUCATION

The graphic divisions of the project were equally active. Many art historians believe that the recent revival of graphics as an art form began with the federal art projects. It is certain that many graphic techniques, notably seriography, were stimulated under the government's encouragement and support. Silk-screening was no longer limited to the printshop and the production of posters. It was recognized as a viable medium for the creation of fine art. The projects also helped to create an audience for all the art that was produced. Easel paintings and smaller sculptures were exhibited in galleries sponsored by federal and civic governments. If the public could not get to the galleries, then the project sent the art out to the areas where the people were.

Project programs also educated the public about what they saw. The galleries and the art education sponsored by federal and civic governments in the thirties and early forties helped to break down the cultural provincialism of many Americans. At this time there were areas in this country where many works in the local art museum were copies of European old masters and plaster casts of antique sculpture. One museum even had its founder's gilded baby shoes on display. Education, exposure, and activities such as the celebration of National Art Week helped to stimulate a greater enthusiasm for the arts among the American public.

THE INDEX OF AMERICAN DESIGN

Another significant branch of the projects was the Index of American Design. In thirty-two centers around the country almost 500 illustrators worked to produce drawings and watercolors that documented a body of American crafts and folk art. The Index recorded the history of American decorative and utilitarian design from colonial times to the late nineteenth century. It is a remarkable record of over 17,000 images that help preserve our heritage. The Index was created systematically and thoroughly and included work in public and private collections. Emphasis was placed on those examples considered typical, and those materials not previously studied.

One such group of materials were those produced by the Shakers. The Index treated Shaker furniture, rugs, and utensils with great thoroughness. Looking at these items, it becomes clear that they embody much that one would like to call typically American: they are simple, have a clear design and strong linearity, and are functional.

Not only did the Index illustrate a diversity of objects but it recorded many objects in depth as well. Every object reproduced had a

specific body of research material developed to offer background. When the Index program ended, no one knew what to do with the work amassed. Today the originals are deposited with the collection of the National Gallery of Art in Washington, D.C., and are available for scholars and historians to study. (See Figure 183, p. 248.)

PHOTOGRAPHY

If the Index produced an amazing record of American crafts and folk art, the photography projects left a stunning and often emotional record of the American people who lived through the Depression. Thousands of photographs were taken by the staff of a section of the Rural Resettlement Administration, later called the Farm Security Administration. The FSA program began in 1935 and lasted for 7 years. In that time, photographers were paid a $6 per day (and five cents a mile for gas) to document life in rural America. What a life

FIGURE 182 Smith, David, *Abstraction,* WPA Photographs, Courtesy of Archives of American Art, Smithsonian Institution.

FIGURE 184 Evans, Walker, *General Store, Moundville, Alabama*, 1936, Photograph for the Farm Security Administration, Courtesy of Library of Congress.

they saw! The extreme poverty of the time is difficult to imagine today. There was no federal housing, and at the edge of every town, often near factories, were shacks made of tin and rags. People could not pay their rent. They had nothing to eat. They barely survived. Hardest of all to bear was the disgrace of poverty, the invisible scar "the inner voice [that] whispered, 'I'm a failure.'"[2]

Many of the photographers who recorded the inner and outer scars of the Depression were artists of the first rank. If the quality of the painting and sculpture produced on the projects is often questioned, no one disputes the power of the work of photographers such as Walker Evans. Evans drove through the southeastern part of the country, as well as into parts of West Virginia and Pennsylvania. There he took photographs that sought to capture the universal through the particular. His images of Alabama sharecroppers were

[2] Studs Terkel, *Hard Times: An Oral History of the Great Depression*, Pantheon, New York, 1970, p. 5.

FIGURE 185 Shahn, Ben, *Resettlement Administration Clients, Boon County, Arkansas,* 1935, Photograph for the Farm Security Administration, Courtesy of Library of Congress.

combined with James Agee's text to produce the book *Let Us Now Praise Famous Men.*

Under Walker Evan's influence, Ben Shahn, whose painting has already been mentioned, became part of the FSA project. Shahn came to know Evans when the two men shared a studio in New York City. For the FSA, Shahn traveled through the Midwest and South, into Ohio, the Carolinas, Kentucky, Tennessee, West Virginia, and Louisiana. He equipped his Leica camera with a right-angle viewfinder that allowed him to photograph his subjects unaware.

In California, Dorothea Lange documented the life of the migratory worker. Her photographs, along with those of Evans, Shahn, and the other photographers of the FSA, brought a new life to documentary photography. Their work combined fact with emotion and insight.

In New York, the Federal Art Project of the WPA subsidized an activity that was already underway—Berenice Abbott's documentation of New York City. Abbott's work not only recorded the great architecture of the city, from Stanford White's great arch in Washington Square to Daniel Burnham's Flatiron Building and Raymond Hood's McGraw-Hill skyscraper, but also preserved the intimate,

personal side of the city in her photographs of grocery stores, new-stands, and subway stations.

A record of WPA photographs was maintained over the years, while, unfortunately, other art works produced for the projects did not fare as well. In the late 1960s, however, the federal government undertook a Fine Arts Inventory, attempting to locate and record all works of art that had been federally commissioned and to restore and preserve the surviving works. To date, works have been retrieved from every conceivable source, even from a trash pile outside a building about to be demolished. In addition, since 1969 the Ar-

FIGURE 186 Lange, Dorothea, *Migrant Mother, Nipomo, California*, 1936, Photograph for the Farm Security Administration, Courtesy of Library of Congress.

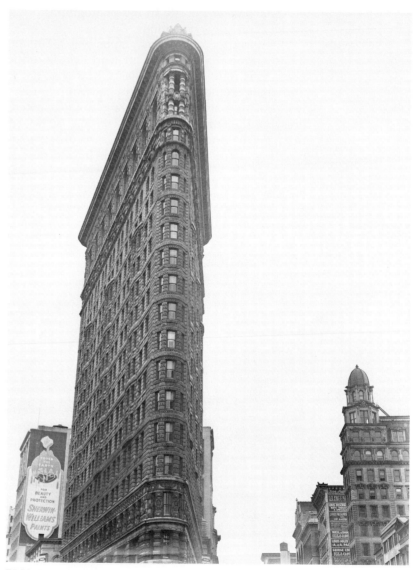

FIGURE 187 Abbott, Berenice, *The Flatiron Building,* 1938, Museum of the City of New York.

chives of American Art and the National Collection of Fine Arts of the Smithsonian Institution have been developing files on the project and stimulating research. The NCFA now has an agreement with the Postal Service to aid in the disposition of works made for post offices during the projects.

Whatever its flaws—the bureaucratic redtape, the sometimes questionable quality of the painting and sculpture produced—there can be no doubt that the projects brought a new vigor to American

art. For one of the few times in American art history, our artists felt that their importance to the nation was recognized by the government that financed their work and by the American people who watched them labor and came to their exhibitions. For the first time, American artists had a real community, had daily contact with other artists who shared their concerns and stimulated new ideas.

The Depression was a time of soul-searching and sadness, but for the arts in America it was a constructive period. The federal art projects paved the way for the triumphs of the next three decades in American art.

CHAPTER 17

ABSTRACT EXPRES- SIONISM

T he works of the abstract expressionists represent, in the words of art historian Irving Sandler, "The triumph of American painting." The paintings these artists created were the realization of a hope long cherished in this country of originating a style of international influence—a style conceived, nurtured, and developed entirely in the United States. Formally in advance of European counterparts, abstract expressionism grew out of the social and intellectual climate that existed in the late thirties and early forties, although it took a form that was considerably different from the painting of those years.

FORMATIVE INFLUENCES

Much of the art produced in America during the 1930s and under the federal art projects in particular was concerned with social themes (Chapter 15 and Chapter 16). Painting was dominated by either regional character or political content which was generally depicted

representationally. In contrast to these works, abstract expressionist paintings look radically different, for it was not the form of painting in the thirties, but the artistic climate during that period that proved to be significant for the future of American art. The close association of artists working together for the federal art projects fostered a spirit of innovation and exploration during a time when the ranks of American artists were being joined by European artist-immigrants fleeing political oppression and the onset of World War II. New York City was becoming an important center, a haven in the free world where artists could gather with their peers and exchange ideas. In 1939, The Museum of Non-Objective Painting, later the Solomon R. Guggenheim Museum, opened. The Museum of Modern Art, established in 1929, was staging important exhibitions. European art magazines like the French *Cahiers D'Art* were circulating. Organizations such as the American Abstract Artists helped to encourage the understanding and acceptance of abstraction. By 1940, New York City had become, for the first time in our nation's history, the unchallenged capitol of world art. Among the artist-immigrants who were drawn to the city in the wake of the world war were a number of major figures in the development of twentieth century art, including Piet Mondrian, Max Ernst, Marc Chagall, Yves Tanguy, André Masson, and André Breton. Their influence on the development of art in America, and abstract expressionism in particular, was considerable.

One emigré, Hans Hofmann, who taught in New York, Massachusetts, and California, introduced important principles of art that he had developed while living in Munich and Paris. Rejecting the role of painting as a political or social tool, Hofmann promoted belief in the self-sufficiency of art. For Hofmann, art was a world unto itself, with its own language of form and, most importantly, color. In order to enter this world Hofmann believed that artists had to look to their own interior life, their intuition and instinct, and to the medium in which they worked. Every medium, according to Hofmann, had qualities that were special to it. Oil paint, for example, has a consistency, a texture that should be exploited rather than concealed in a work of art. Hofmann's own work is eloquent testimony to his theories. These paintings explore the nature of color, the quality of paint, and the action of painting in a way that links them directly to abstract expressionist works.

While Hofmann's works influenced the formal aspects of action painting, another European development—surrealism—influenced the content of abstract expressionism. The surrealists in exile in this country brought with them the concept of art drawn from the unconscious—art as a way to convey meaning without the limitations of representing reality. One way to the artist's unconscious was through automatism, the supposedly spontaneous transcription of the unconscious made by the artist's hand moving automatically

FIGURE 188 Gorky, Arshile, *The Liver Is the Cock's Comb*, 1944,
Albright-Knox Art Gallery, Buffalo, N.Y. Gift of Seymour H. Knox.

without the deliberate interference of reason. In other words, automatism was an attempt to circumvent the rational mind and plunge straight to the unconscious. According to this method, accident was the principal vehicle of automatism, for the surrealists, like Freud, they believed that slips of the tongue or hand could be interpreted as messages from the unconscious. By exploiting this approach, artists such as Arshile Gorky sought to create an art of deeply personal meaning and expression.

Some American artists working with these techniques who had an almost naïve faith in the significance and integrity of the images which seemed to come from the unconscious were knowledgable about the theories of Sigmund Freud and Carl Jung. Jackson Pollock, for example, in the painting *Water Figure* of 1945 (Fig. 189), drew from his unconscious an image that he felt was mythic and archaic. Hoping to tap the "universal unconscious" which Carl Jung believed we all share, Pollock used the triangle and arrow, symbols found throughout the ages in many cultures.

A similar goal is at the heart of Adolph Gottlieb's pictographs, for these strange primitive forms are meant to stir deep, forgotten feelings which exist in all human beings. These works attempted to

FIGURE 189 Pollock, Jackson, *Water Figure*, 1945,
Courtesy of Hirshhorn Museum and Sculpture
Garden, Smithsonian Institution.

reach the viewer at the deepest level of consciousness. They are meant to be timeless and universal images that could be understood by an American or an aborigine, since both theoretically share the same storehouse of myths and symbols that Jung believed to be part of the unconscious of all humanity.

Although the principles of surrealism were an important source for abstract expressionism, as the new approach to painting evolved, it moved in a new direction. For the surrealists, automatism was just a starting point. When the Spanish artist Miro made a painting like *Woman and Little Girl in Front of the Sun,* he began with doodles—blobs of paint, tracings from a brush. But then the accidental marks suggested an image to Miro, and he proceeded to organize and restructure the painting to articulate the associations suggested in the title. (See Figure 190, p. 260.)

Jackson Pollock, in early works like *Water Figure* (Figure 189), also directed his image to a certain degree. As his approach developed, however, spontaneous gesture was no longer dictated by specific image. The rapid execution, the veils of spilled paint, are unlike anything seen in surrealist painting. The psychic material suggested by the entire creative process was allowed to dominate. Large scale became increasingly characteristic of abstract expressionist painting as well, since the larger, mural-size canvas provided a more expansive arena within which the artist worked.

JACKSON POLLOCK

Jackson Pollock came to personify the process called "action painting," and perhaps is the prototype for the image of the contemporary artist as superstar (Figure 11). He lived his art, and together his life and works formed a legend. For Pollock, the act of painting was as significant as the product produced. When he worked he was a dancer, a barbarian, a magician. He both controlled and was controlled by the action of painting. He approached the canvas, in the true spirit of automatism, without any preconceived notions, and his gesture, the swirling lines of the pigment, became the geiger counter of his moods. The painting was the record of life itself; the act of painting, the reenactment of the ritual of creation. Process became as important as product. The mythic subject matter of his earlier work was subsumed into the ritual act itself. He began to drip his paint onto the canvas, rather than applying it directly to the surface with a brush, though by 1953, he abandoned drippings in favor of thicker, puddled blotches of paint. Pollock's technique was only important insofar as it led him to his inner self and continued to offer him surprises. As Pollock himself said, "New needs need new techniques." His own description of the process by which he painted eloquently describes the total absorption and instinctiveness of his approach.

FIGURE 191 Pollack, Jackson, *Autumn Rhythm*, 1950, The Metropolitan Museum of Art. George A. Hearn Fund, 1957.

My painting does not come from the easel. I hardly ever stretch my canvas before painting. I prefer to tack the unstretched canvas to the hard wall or the floor. . . . On the floor I am more at ease. I feel nearer, more a part of the painting, since this way I can walk around it, work from the four sides and literally be in the painting. This is akin to the method of the Indian sand painters of the West.

I continue to get further from the usual painter's tools such as easel, palette, brushes, etc. I prefer sticks, trowels, knives, and dripping fluid paint or a heavy impasto with sand, broken glass, and other foreign matter added. When I am in my painting, I'm not aware of what I am doing. It is only after a sort of 'get acquainted' period that I see what I have been about. I have no fears about making changes, destroying the image, because the painting has a life of its own. I try to let it come through. It is only when I lose contact with the painting that the result is a mess. Otherwise there is pure harmony, an easy give and take, and the painting comes out well.[1]

The paintings that resulted from Pollock's new approach were works whose size seemed not to be confined by the edge of the canvas—paintings with no single center of interest. Our eyes are carried along throughout the painting, continuous energy transporting us. Space is not separated into distinct compartments, nor do lines

[1] Jackson Pollock, "My Painting," *Possibilities* 1, Winter, 1947–48.

define forms. Drawing has been liberated, and has become an equal with color in the partnership of creation. Pollock's work presents new definitions of space, line, scale, and content, definitions which are still being explored by artists today.

GESTURAL PAINTING

Pollock's type of abstract expressionism was strongly gestural—his marks on the canvas have the expansiveness, the sweep of a large gesture. Although a number of other abstract expressionists shared Pollock's gestural approach, there are distinct, individual variations in the form of their work. Willem de Kooning, academically trained in his native Rotterdam before coming to America at the age of 20, was more attached to tradition than Pollock. His work in the thirties and early forties combined cubist-inspired space with exquisite draftsmanship. By the late forties de Kooning had made the leap into his mature abstract expressionist style. The abstractions of this period display a nervous, agitated manner of painting, and, as in Pollock's work, the edges of the painting seem to defy the frame. Around 1951, de Kooning wed this style to a recognizable subject matter. His sub-

FIGURE 192 De Kooning, Willem, *Woman I,* 1950–1952, The Museum of Modern Art.

ject, the image that has come to typify his work, is that of woman. De Kooning's women belong to no recognizable time or place. The conventions of fashion do not qualify them. They are, at once, prehistoric idols and, to use Henry Miller's phrase, "all the slippery Babylonian whores." De Kooning loves the vulgar, earthy side of humanity, the fleshy nature of the body, and the texture of the paint itself. The works are celebrations of all three. The canvas is alive with the struggle of forms—some abstract and others resembling anatomy. His gestures and the image are inseparable. Both are energy-packed and allow us to see the process of his thought. For the record of the act of painting is also here for us to witness. Every change that de Kooning made in drawing or painting a form is retained rather than painted over.

Throughout his long and continuing career as an artist, de Kooning has swung back and forth between representation and abstraction. To both he brings a lusty appreciation for his medium and for painting in general.

Another gestural painter, Franz Kline, is an artist whose work is often misinterpreted as having representational subject matter. In the black-and-white forms of Kline's work have been read references to skyscrapers, trains, highways, even Oriental calligraphy. The substance of these interpretations is wrong: Kline was a nonobjective painter. The spirit of this interpretation is correct, however, for

FIGURE 193 Kline, Franz, *Chief*, 1950, The Museum of Modern Art.

Kline's work, with the wide, strong marks of a house painter's brush, has the vigor of modern industrial life and an Eastern sensitivity to space and gesture.

Adolph Gottlieb's series of *Bursts and Blasts* (Fig. 194), begun in 1957, contrasts quiet, almost geometric circles with active, calligraphic forms. This juxtaposition sets up a duality of meaning, suggesting archetypal opposites such as female and male, passion and reason, static and active.

Clyfford Still's jagged soaring forms imply boundlessness, while his palette ranges from earthy tones to elegant, almost spiritual colors. Still has always preferred personal solitude and independence, qualities suggested by his work (Fig. 195).

Bradley Walker Tomlin's paintings have moved progressively toward tighter structure. Early fluid works have given way to the organization of gestural brushstrokes into gridlike patterns occupying a shallow space indebted to cubism (Fig. 196).

Robert Motherwell created a monumental series of paintings entitled *Elegies to the Spanish Republic*. In these works, huge, black, biomorphic forms take on powerful emotional meaning (Fig. 197).

REDUCTIVE PAINTING

Not all abstract expressionist artists were gestural painters. Several of the most influential artists produced work that at first glance appears considerably different. However, their works share with gestural painting the involvement of the artist, large scale, and emotional content. These are elemental, totally reductive paintings, paintings in which form and color have been so distilled and so purified that they seem to be striving for a formal state of grace. Mark Rothko is the best known of this group. Unlike Pollock, Rothko has concealed his presence from the viewer. There is no thick impasto in his work, no active brushwork, none of the turbulence of form associated with abstract expressionism. Only the blurred edges of the rectangles hint at the presence of the brush. The composition of the work is equally simple. Several shimmering rectangles of color hover in front of a solid field. The canvas size itself is huge, but as Rothko himself explained, largeness is a means toward intimacy and emotional involvement.

I paint very large pictures. I realize that historically the function of painting large pictures is painting something very grandiose and pompous. The reason I paint them, however, is precisely because I want to be very intimate and human. To paint a small picture is to place yourself outside your experience, to look upon an experience as a stereopticon view. . . . However, you paint the larger picture, you are in it.[2]

[2] Mark Rothko, *Interiors*, May 1951.

FIGURE 194 Gottlieb, Adolph, *Blast I,* 1957, The Museum of Modern Art.

 Barnett Newman was also attracted to large paintings—indeed, even larger than most of Rothko's paintings. Newman's work beginning in the early fifties took on wall-sized dimensions. This size served several functions. First, it made the painting dominate the viewer's field of vision, encompassing the line of sight. Second, the enormous expanse saturated with a single color intensified the color itself. The more one sees of a single color in a single area, the purer,

FIGURE 195 Still, Clyfford, *Untitled*, 1953, Courtesy of Hirshhorn Museum and Sculpture Garden, Smithsonian Institution.

FIGURE 196 Tomlin, Bradley Walker, *Number 20*, 1949, The Museum of Modern Art.

FIGURE 197 Motherwell, Robert, *Elegy to the Spanish Republic XXXIV,* 1953–1954, Albright-Knox Art Gallery, Buffalo, N.Y. Gift of Seymour H. Knox.

the more vivid the color becomes. Although their format suggests an emphasis on design alone, these paintings, as do Rothko's, aspire to transmit the infinite and the sublime. They are visual expressions of nonverbal, mystical states, and are strongly grounded in philosophy. The solid fields of color are crossed by straight lines Newman called "zips," which divide the canvas into rectangles, and according to Newman, emulate the original act of creation itself, the separation of light from dark. For Newman, "The basis of an esthetic act is the pure idea."

Newman stood apart from his fellow abstract expressionists because the deliberation involved in his approach to painting denied a great deal of the spontaneous creation implicit in abstract expressionist works.

Ad Reinhardt's work of the late forties and early fifties was closely related to abstract expressionism; later, however, he began to move toward a purer, more objective approach to painting, stripping aside emotion, accident, and personal expression. The culmination of his ideas can be seen in his totally black paintings, solid fields of black which reveal, after contemplation, intersecting rectangles in

subtly different tones of black. Reinhardt has embraced the idea that art is totally self-referential, that it is an exercise in visual and spiritual perception. Although Reinhardt's search for a purely formal language for his art led him away from the abstract expressionists and

FIGURE 198 Rothko, Mark, *Blue, Orange, Red,* 1961, Courtesy of Hirshhorn Museum and Sculpture Garden, Smithsonian Institution.

FIGURE 199 Newman, Barnett, *Vir Heroicus Sublimis,* 1950–1951, The Museum of Modern Art.

precursed a development of a decade later, his work belongs with a discussion of this group, which served as both a source and point of reaction for his paintings.

Abstract expressionism was not a style that resulted merely from combining various sources, nor was it a style that conformed to any hard and fast rules. The abstract expressionists shared, again in the words of Irving Sandler, "a common aesthetic evolution: the rejection of existing realist and geometric tendencies, the attraction to Surrealistic content and the technique of automatism, and . . . the achievement of new styles that could no longer be subsumed under existing labels."[1]

Abstract expressionists run the gamut from the nonobjective to the figurative, from gestural to reductive painting. Each of the abstract expressionists selected from various influences, and, in the continuing spirit of artistic creativeness, each combined them with expressions of his or her inner life to produce a unique and personal synthesis.

Many of the works of the abstract expressionists were, at first, hard for the general public to comprehend. People questioned the skill of the artists, their seriousness, their intention. It took almost a decade for Americans to begin to understand the beauty of these works. Adolph Gottlieb put the problem clearly when he said in 1955, "I frequently hear the question, 'What do these images mean?' This simply is the wrong question. Visual images do not have to con-

[1] Irving Sandler, *The Triumph of American Painting,* Praeger, New York, p. 3.

form to either verbal thinking or optical facts. A better question would be, 'Do these images convey emotional truth?'"

Subsequent history has given Gottlieb an overwhelmingly positive reply.

FIGURE 200 Reinhardt, Ad, *Number 119, 1958 (black)*, 1958, Courtesy of Hirshhorn Museum and Sculpture Garden, Smithsonian Institution, Washington.

CHAPTER 18

PAINTING AND SCULPTURE AT MID-CENTURY

By mid-century, American art had come of age. The success of abstract expressionism in the late forties had established the United States as an international leader in art for the first time in this nation's history and New York City as the new art capitol of the world. Although still strongly under the sway of the abstract expressionists, painting took on new dimensions and direction, and sculpture, which existed in the shadow of painting for years, finally achieved equal distinction. One of the most significant developments in the fifties, which in a sense encouraged the proliferation of new art forms, was the establishment of a reliable home market for American art. In an affluent society, contemporary art became a valuable commodity for investment purposes as well as personal enjoyment, and a wider segment of the public began to accept and buy American painting and sculpture. Critics like Clement Greenberg promoted and explained the new art, and commercial galleries opened to cater to the increased public demand.

AMERICAN SCULPTURE IN THE EARLY TWENTIETH CENTURY

In the first three decades of the twentieth century, sculpture had been more conservative than painting in the United States. Figurative sculpture in the academic tradition of the late nineteenth century continued to be made by artists such as Stirling Calder and Paul Manship well into the thirties, while portrait sculpture remained a mainstay for many artists including Jo Davidson and Malvina Hoffman. Although a new type of subject matter centering on urban life and the working classes was introduced by Maharoni Young and other sculptors inspired by the Ashcan School painters, no significant change in formal approach accompanied it. The most daring formal experiments were made by artist-immigrants such as Elie Nadelman and Gaston Lachaise who had been involved with modern art in Europe before settling in the United States before World War I. Although freed from academic tradition and stripped of rhetoric and conventional symbolism, their sculpture remained, for the most part, based on the human figure and natural forms.

Early in the century a shift in patronage from the government and institutions to the private collector brought a change in the conventional concept of sculpture in the United States as public monuments and contributed to a greater interest in more intimate and personally expressive pieces, such as John Flannagan's carved animal figures and William Zorach's work in wood. Nevertheless, American sculptors took longer than painters to realize that a meaningful artistic statement could be made through color and form alone without relying on representation. By mid-century, however, sculpture had caught up with modern American painting under the influence of artists such as Alexander Calder.

SCULPTURE AT MID-CENTURY

Son of the sculptor Stirling Calder, Alexander Calder earned a degree in mechanical engineering before studying painting at The Art Students League of New York. In 1926, Calder set off for Paris where he began one of his favorite projects—making sketches and sculptures of circus animals and performers. As his work grew into a full-fledged miniature circus, Calder staged performances to entertain all his friends from the avant-garde community. Not only would these delightful wire and carved figures continue to be part of Calder's creative activity for most of his career, but they served as a laboratory for the development of his larger wire, metal, and mechanized sculptures and monumental pieces. In his circus figures, Calder worked with wire which he bent, shaped, and joined together in a way that

FIGURE 201 Calder, Alexander, *Effect of Red,* 1967, Courtesy of Hirshhorn Museum and Sculpture Garden, Smithsonian Institution.

was considerably different from the traditional casting technique employed in the creation of metal sculpture. No longer limited to a solid mass, Calder's sculptures became the equivalent of drawings in space.

Influenced by the works of Arp, Miro, and Mondrian, Calder began working with abstract metal objects that he set in motion mechanically. Because the motorized motion he initially achieved seemed too regular and predictable, Calder developed moving sculpture propelled by wind currents. Dubbed the "mobile" by Marcel Duchamp, Calder's new kinetic sculpture was made by suspending found objects, colored discs, and free-form shapes on wire. Because their balance is delicate, the slightest change in the air currents sets the mobile in action, making a great variety of configurations possible. First made in 1932, the mobile as sculptural form is widely known today and has inspired countless popular adaptations.

Another form of sculpture which Calder developed in the thirties was the "stabile," so dubbed by Arp as the appropriate opposite of the mobile. Although their relationship with the ground is maintained, Calder's stabiles continue to evoke the feeling of motion which is so integral a part of the mobile. From the forties on, Calder's stabiles became more monumental in scale, asserting their presence in space with spiny, biomorphic shapes that soared and arched against the sky. To construct his huge iron and steel stabiles, Calder

FIGURE 202 Calder, Alexander, *Two Disks*, 1965, Courtesy of Hirshhorn Museum and Sculpture Garden, Smithsonian Institution.

would design a small-scale model, or "maquette," and then send it along with other specifications to a factory for fabrication. Although their materials, engineering, and construction are industrial in nature, Calder's mobiles and stabiles are spontaneous, even playful-looking, retaining the innocent whimsy of the wire circus characters which spawned them.

George Rickey

The expressive use of technology and new materials was a significant factor in the coming of age of modern sculpture, for it opened up a new range of possibilities to the sculptor. George Rickey's sculpture *Three Red Lines* at the Hirshhorn Museum and Sculpture Garden, for example, is indebted to Calder's wedding of technology to art. Made of huge metal spars that swing from their base, Rickey's wind-powered sculpture is more precise than Calder's dancing forms be-

cause the motion is confined to the trajectory of a pendulum. Although Rickey's large-scale sculptures are suited for display out-of-doors because of their monumental size and involvement with light and space, they respond to and are acted upon by their environment in a way that is quite different from traditional outdoor monuments and statues. Rather than being totally self-contained or set apart by a pedestal, the new monumental sculpture interacts with the environment and confronts the viewer with an additional dimension—time and the transformations its passage brings.

David Smith

One of the giants of twentieth-century sculpture in America, David Smith, also thought in terms of modern technology, large scale, and the relationship of his work to the environment. Describing the motivation behind his sculptures in the *Cubi Series*, Smith stated:

I like outdoor sculpture and the most practical thing for outdoor sculpture is stainless steel, and I make them, and I polish them in such a way that on a dull day, they take on a dull blue, or the color of the sun in the late afternoon, the glow, golden like the rays, the colors of nature. And in a particular sense, I have used atmosphere in a reflective way on the surfaces . . . They are designed for outdoors.[1]

The Cubi Series was one of the last projects of a career dating back over 30 years to the 1920s when Smith was a painting student at The Art Student's League of New York City. His career as a sculptor was launched in 1933 after reading about the use of welding techniques for metal sculpture in *Cahiers D'Art* and seeing the work of the Spanish artists Julio Gonzalez and Pablo Picasso. Aided by his practical experience as a welder at a Studebaker plant, Smith enthusiastically accepted the new technique. Working side by side with factory employees at the Terminal Iron Works in Brooklyn, Smith began creating art out of steel and iron. Having first been a painter, he felt free to apply colored paint to the metal shapes, explaining that he felt there were no real boundaries between the two arts. At the same time, however, he exploited the rugged qualities of the metal itself. Although sculptures like *The Letter* and *Hudson River Landscape* recall their industrial origins, they also have symbolic or expressive forms that suggest signs or hieroglyphs with hidden meanings, imagery that Smith acquired from his early interest in surrealism. By welding his materials together, Smith, like Calder, freed his sculpture from conforming to a solid mass and created a calligraphic interplay of lines and forms that resemble drawings in space. Smith's work, however, is more static and aggressive than Calder's delicately animated pieces. (See Fig. 204.)

[1] David Smith, *David Smith by David Smith*, New York: Holt, Rinehart, and Winston, 1968, p. 123.

David Smith liked to work in series. In addition he often used found materials, ready-made, but placed them in a new context. Using agricultural tools, boiler heads, tank tops, and prefabricated steel pieces, for example, Smith created his Tank Totem and Forgings series. As Smith completed his sculptures, he placed them on the grounds of his studio in Bolton Landing, New York, where he settled permanently in 1940. Smith was an incredibly prolific sculptor, and his fertile imagination was undampened by the physical demands of the labor. In 1962, for example, Smith was invited to Italy to participate in the arts festival in Spoleto, Italy. Provided with a workshop and skilled assistants, Smith engaged in, as he put it, "a creative orgy," producing between May and June over twenty-six sculptures and germinating ideas for many more, which were completed after his return to New York. Some of the most powerful works from this series resemble the industrial machines and tools that went into their creation.

FIGURE 203
Smith, David, *Cubi XII*, 1963, Courtesy of Hirshhorn Museum and Sculpture Garden, Smithsonian Institution.

FIGURE 204 Smith, David, *Hudson River Landscape*, 1951, Collection of
The Whitney Museum of American Art, New York, Geoffrey Clements
photography.

In his Cubi and Zig series which date from the sixties, Smith ex-
panded the range and role of color and reflected light in his sculp-
ture, and carried his work in a strong new direction cut short tragi-
cally in 1965 when he died in an automobile accident. David Smith's
contribution to twentieth-century sculpture was a major one. He suc-
cessfully used modern industrial materials to create powerful forms
that are rugged, dynamic, and yet elegant. His friend, the painter
Robert Motherwell, expressed the special nature of Smith and his
work when he wrote:
"Oh David, you are as delicate as Vivaldi, and as strong as a Mack
Truck."

Isamu Noguchi

Although industrial materials and processes expanded the vocabu-
lary of modern sculpture, traditional materials and techniques of
wood and stone carving remained a part of contemporary art in the
work of many sculptors, among them, Isamu Noguchi. Noguchi's
pieces, whether a sensual marble form or a finely planed wooden

monolith, are a fusion of traditional materials and craft with the formal vocabulary of modern nonobjective art. Of Japanese descent, Noguchi was born in San Francisco and first studied sculpture with Gutzon Borglum, famous for his presidential figures carved into the face of Mount Rushmore. Discouraged by this academic training, Noguchi briefly studied medicine and then traveled to Paris, where he became an assistant to Constantin Brancusi and encountered the work of Picasso and the constructivists. While in France he began to experiment with creating three-dimensional stone pieces by joining thin slabs of marble together with hinges and joints. In this way he created a construction in space with marble and stone rather than with metals or plastics, and thereby wed traditional materials to a modern sensibility.

After first returning to New York in 1929, Noguchi traveled to Peking, where he studied the ancient art of brush drawing, and then to Japan, where he learned the crafts of ceramics and garden design. From Noguchi's Oriental experience came his innovative use of ceramics for sculpture and his sculpture gardens, in which forms interact in dramatic outdoor settings. (See Fig. 205, p. 276.)

Louise Nevelson

Noguchi's interest in the interaction of objects in space was shared by another sculptor who came to prominence in the fifties, Louise Nevelson. Rather than defining open forms in the out-of-doors, Nevelson's sculpture is closed, contained, meant for shadowy interiors. Her earliest wood pieces are cut and shaped into vertical forms and grouped in ways that suggest ancient, totemic figures. In the late fifties, Nevelson began to confine her forms to shallow wall reliefs, placing found and fabricated objects in wooden boxes and unifying these disparate elements by the application of monochrome matte color, generally black though sometimes white or gold. Shadows are an important aspect of these works, for they add ambiguity and mystery to the spatial configurations of the sculpture.

Assemblage Sculptors

Nevelson, like David Smith, incorporated found objects into some of her sculptures, an idea that was not new to art since cubist collages and Marcel Duchamp's ready-mades were generally well-known precedents. While Smith and Nevelson subordinated the found object to the aesthetic logic of the piece, other sculptors in the fifties exploited the qualities of cast-off materials, scrap metal and junk. John Chamberlain, for example, welded bent and scratched parts of automobile chassis together to surge and flow like great strokes of paint,

FIGURE 206 Nevelson, Louise, *Black Wall*, 1964, Courtesy of Hirshhorn Museum and Sculpture Garden, Smithsonian Institution.

and Richard Stanckiewicz assembled discarded metal machine parts, the rusted detritus of modern civilization, and transformed them into new abstract, often sardonic, entities. *Assemblage,* as this art made of found objects was called, applies to not only sculpture in the fifties but painting as well, with painters such as Robert Rauschenberg making *combines* in which three-dimensional materials were attached to the surface of the canvas.

PAINTING AT MID-CENTURY

For painters caught in the wake of abstract expressionism's incredible impact, the fifties was a time for reevaluation, for continuing to explore the implications of the work of artists such as Jackson Pollock, Willem de Kooning, Mark Rothko, and Barnett Newman. Their

FIGURE 207 Held, Al, *Ivan the Terrible,* 1961, and *Eusopus,* 1971, Collection of Sylvia Stone, installation view, Whitney Museum of American Art.

scale, directness, and abstraction remained essential elements for the younger painters, but the possibility of expressing personal meaning and symbol through gesture and fields of color began to be questioned. As a departure from the gestural or painterly quality of abstract expressionism, the new painting that emerged in the fifties has been placed under the general heading *post-painterly abstraction.*

Post-Painterly Abstraction

Post-painterly abstraction rejected the arbitrary, loosely defined structure of gestural painting in favor of more ordered compositions defined by large, emphatic shapes. To create precise shapes, some artists eliminated the chance effects of a blurred, stained edge found in Rothko's and Newman's works by using thick, opaque paint to create clear outlines and crisp edges. Among the artists called "hard-edge" painters because of the linear quality of their work were Jack Youngerman, Ellsworth Kelly, and Al Held. After working with abstract expressionism in the forties, Held tightened the structure of his paintings into huge geometric figures that seem to push beyond the borders of the canvas and assert a strong physical presence. Kelly worked with the interaction of saturated colors contained with a concise, dynamic design, while Jack Youngerman focused on generating interesting shapes. Essentially, all three artists were moving away

from the introspective implications of gestural painting toward a more objective expression.

Another way to deal with the physical qualities of paint and canvas was suggested by the work of Helen Frankenthaler. A second-generation abstract expressionist, Frankenthaler expanded upon Jackson Pollock's direct approach to applying paint by dripping, pouring, and brushing paint onto raw, unprimed canvas and thus staining the surface with color while eliminating all textural effects except those of the canvas itself. Her use of delicate colors and controlled spontaneous effects resulted in a lyrically sensuous wedding of color and form.

In 1952, when the art critic Clement Greenberg brought the Washington artists Morris Louis and Kenneth Noland to New York to see Frankenthaler's painting *Mountains and Sea*, the impact of her work was immediate and dramatic. Louis began pouring acrylic paint onto unprimed canvas and allowing the colors to bleed into one another and soak into the fabric. The paint and canvas are fused,

FIGURE 208 Frankenthaler, Helen, *Mountains and Sea*, 1952, National Gallery of Art, Washington.

FIGURE 209 Louis, Morris, *Where,* 1960, Courtesy of Hirshhorn Museum and Sculpture Garden, Smithsonian Institution.

and the personal mark of the artist's brushstroke eliminated, leaving the pure sensation of color flowing in translucent veils. He expanded this technique in the late fifties, creating his *unfurled series,* in which rivulets of color flow diagonally from the upper corners of the canvas, leaving a large expanse of canvas free to breathe and work as part of the whole painting.

To this same end, Kenneth Noland used predetermined formats of concentric circles, parallel bands, and chevrons. By applying his paint free-hand, without masking off sections, and saturating the canvas with pigment, Noland created slightly blurred, uneven lines, and unlike the hard-edge painters who emphasized the shapes within each composition, Noland emphasized the color play within a standard design. Noland and Louis were joined by other Washington artists in the fifties and sixties including Gene Davis, Tom Downing, and Paul Reed, a group that has been called the Washington Color School.

While the formal qualities of painting preoccupied many artists in the fifties, the issues of subject matter and meaning were reassessed by others. Rejecting the abstract expressionists' view of painting as the acting out of private emotions in the arena of the canvas,

artists like Larry Rivers began to reintroduce recognizable images to their paintings—some based on commercial items, as in the *Dutch Masters and Cigars* (Fig. 211), others on subjects taken from everyday life and even the reworkings of famous paintings from the past. The imagery in Rivers's paintings not only has significance as subjects but serve as pictorial motifs offering alternatives to nonrepresentational abstraction as well.

By returning to objective imagery, artists like Larry Rivers intended to challenge not only the form of abstract expressionist painting but also its introspective, personal quality. The acknowledged leader of this new movement in the fifties, Robert Rauschenberg, shocked the art world in 1953 by erasing a drawing by the famous abstract expressionist Willem de Kooning and then signing the empty paper as a work of art. In addition to this celebrated act of independence, Rauschenberg posed other challenges to abstract expressionism. In 1957, for example, he painted two works, *Factum I* and *Factum II*, in which each of the splatters, drips, and apparent accidents of the first painting are duplicated in the second. In addition to

FIGURE 210 Noland, Kenneth, *Beginning*, 1958, Courtesy of Hirshhorn Museum and Sculpture Garden, Smithsonian Institution, Geoffrey Clements photography.

FIGURE 211
Rivers, Larry,
*Dutch Masters and
Cigars,* 1963, Harry
N. Abrams Family
Collection, New
York.

the virtuoso performance of re-creating the painterly effects of one
work in another, Rauschenberg incorporated identical collage mate-
rials into *Factum I* and *Factum II.* The newspaper photographs, pic-
ture postcards, and old calenders, like the subjects of River's paint-
ings, interject recognizable content alongside gestural strokes of
paint.

Rauschenberg introduced not only traditional paper collage
materials but also three-dimensional objects to his paintings. In the
spirit of Richard Stanckiewicz's assemblage sculptures, Rauschen-
berg's choice of materials often included an eccentric assortment of
junk: a quilt and pillow splattered with paint, which he hung on the
wall and called *The Bed* in 1955; a stuffed eagle and a pillow tied with a
rope which hung from the canvas and which he called *Canyon* in
1959; real clocks, an old buggy tire, and electric fans, which he called
Pantomime in 1961. These paintings to which he added materials
Rauschenberg called *combines,* and the items he used—ropes, rags,
found objects, letters cut from newspapers, photographs, photo-
silkscreens—he referred to as part of his palette.

Although indebted to cubist collages, Rauschenberg's combines were not created for aesthetic effects alone, nor created as lyrical metaphors. Like Marcel Duchamp's readymades, Rauschenberg's combines are ambiguous and arouse speculation. They also provide a means of extending the visual vocabulary, of more closely dealing with the real world in art. As Rauschenberg explained it, "A pair of socks is no less suitable to make a painting with than wood, nails, turpentine, oil, and fabric. . . . Painting relates to both art and life. Neither can be made. (I try to act in the gap between the two.)" Rauschenberg was interested in more than just the meaning or significance of the commonplace objects he used. He sought a balance between the subjective interpretation of his works and their physical existence as objects devoid of narrative meaning. For example, when he included photosilkscreen prints of newspaper and magazine pictures documenting sports, current events, and well-known public figures, he diminished the psychological impact of the images by

FIGURE 212
Rauschenberg, Robert, *Fossil for Bob Morris,* 1965, Courtesy of Hirshhorn Museum and Sculpture Garden, Smithsonian Institution.

FIGURE 213 Rauschenberg, Robert, *Monogram*, 1963, Nationalmuseum, Stockholm.

presenting them in the indirect manner created by the printing process. Their juxtaposition with painted areas of canvas offers no clue to meaning. Instead they must be read as physical elements of the painting. In a similar fashion, Rauschenberg's use of commonplace objects disassociated from their original context confronts the spectator with the reality of painting stripped of allusions and illusion. In his work entitled *Monogram,* for example, a stuffed angora goat, a tire around its torso, stands on the painted canvas. The goat has immediate identity as an object but defies any sort of logical interpretation. Contributing to Rauschenberg's challenging reappraisal of art were the ideas of his friend, the experimental composer and writer, John Cage. *Monogram* exemplifies the meaning of Cage's declaration that the artist should "unfocus the spectator's mind [enabling him or her to] experience a work of art and not just see or hear it." As a conductor, composer, lecturer, and author, Cage structured arbitrary elements—sounds, noise, melodies, a siren on the street, a radio broadcast—into an overall composition, just as Rauschenberg took an incongruous object, a goat, and caused it to function as part of a painting. Since life consists of a kaleidoscope of sensations, so too, does their art. As Cage put it, "The novelty of our work derives therefore from our having moved away from simply private human concerns towards the world of nature and society of which we all of us are a part." Cage then went on to say, "The object is fact, not symbol."

The implications of the objective approach to art expressed by Cage can also be felt in the work of the painter Jasper Johns. Taking images that are instantly and universally recognizable, like flags, targets, maps, numbers, and letters, Johns proceeded to manipulate them, draining the symbols of their meaning by focusing on their formal qualities of color, shape, and design. In his *Three Flags*, for example, the national symbol is shown as a series of superimposed designs. Using the technique of encaustic, in which the pigment is suspended in melted wax, Johns created thick, varied textures for designs that normally appear flat. His maps, targets, and flags were also given new color schemes: green stars and stripes, for example, and an all-white map of the United States. He also painted a map of the United States with dripping strokes of colored paint and stenciled names, and he combined bright targets with compartments containing casts of parts of the body. By altering items that are so familiar as to be visual clichés, Johns created fresh and interesting imagery.

Like Rauschenberg, Johns also explored printmaking techniques. Intrigued with the idea of multiple images, Johns made a

FIGURE 214 Johns, Jasper, *Three Flags*, 1958, From the collection of Mr. and Mrs. Burton Tremaine, Meriden, Conn.

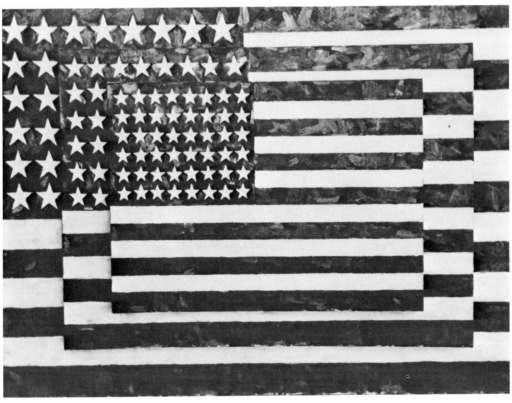

FIGURE 215 Johns, Jasper, *Painted Bronze,* 1964, Collection of the artist.

series of lithographs of the numbers 0 to 9. He then printed the numbers overlapped in sequence, thus creating a print of their composite image as well as prints of each number, all from a single lithography stone. Johns also worked with overlapping images in paintings of the number sequence.

Like Rauschenberg's combines, Johns's works are ambiguous and their meaning left unresolved by contradictions and paradoxes. In his painting called *False Start,* for example, Johns painted color splotches and then stenciled in the names of the colors incorrectly so that there is a gap or interference between what we perceive and what we comprehend. In his painted bronze sculptures, the paradox is carried further. What appears to be his paint brushes in an old Savarin coffee can is, instead, a bronze cast painted to resemble them. In another piece, *Painted Bronze* (1964), two ale cans are really the mold and hollow cast of cans painted to resemble, in almost trompe l'oeil fashion, the original objects. At first we think they are real; then when we discover they are made in the traditional sculpture medium of bronze, we consider them art. This shifting, paradoxical relationship is at the core of Johns's art as it is in Rauschenberg's too.

Despite the diversity of painting in the fifties, there was one common denominator for all types of post-painterly abstraction, and that was the acknowledgement of the physicality of the work of art,

its existence as an object outside of any external frame of reference. The implications of this concept would shape the direction of art in the next two decades. Rauschenberg's combines and Johns's popular iconography contributed to pop art, happenings, environmental pieces, and multimedia works in the sixties, while color abstraction and hard-edge painting spawned the formalist art of minimal painting and sculpture.

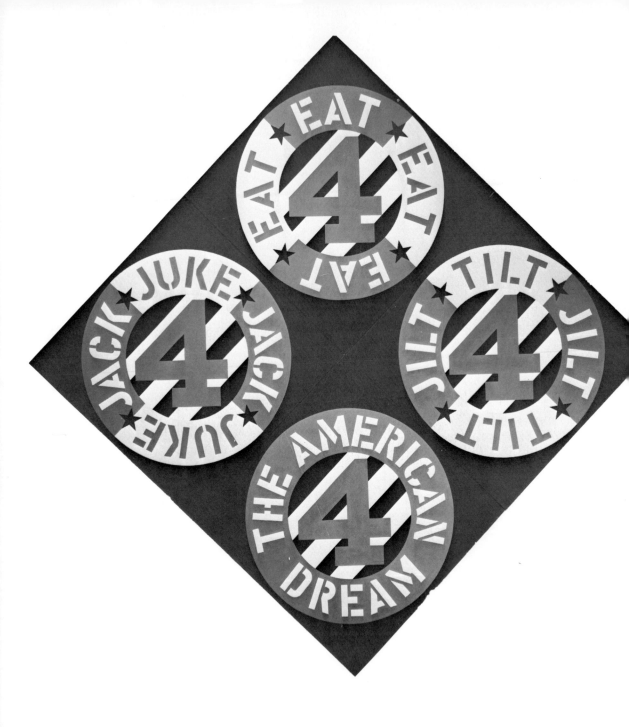

CHAPTER 19

THE SIXTIES

FIGURE 216
Indiana, Robert,
*The
Beware—Danger
American Dream
#4*, 1963,
Courtesy of
Hirshhorn
Museum and
Sculpture
Garden,
Smithsonian
Institution.

The 1960s was among the most diverse, challenging, and per-
plexing decades in the history of American art. By the begin-
ning of the decade, New York City was firmly established as
the cultural center of the world. The United States' economy was
booming, and in politics, morality, and the arts, Americans were
challenging the old definitions and traditions. By 1960 abstract ex-
pressionism had become part of the tradition of American painting.
Since the early fifties, artists like Jasper Johns and Robert Rauschen-
berg had been looking for new modes of expression, alternatives to
the passionate abstractions of the preceding years. The sixties
brought this search to fruition, suggesting not one, but many alter-
native directions.

POP ART

The most celebrated kind of art to emerge in the sixties—the one that
was loved, hated, discussed, bought, and publicized more than any
other—was given the name pop art. Certain distinctive qualities

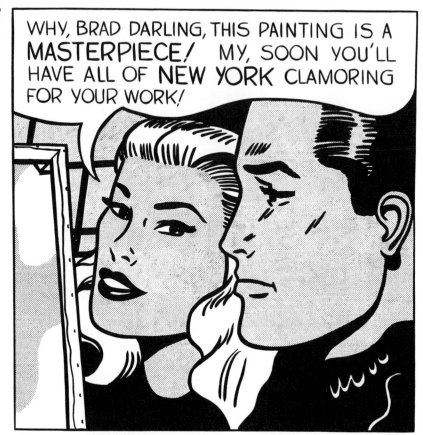

FIGURE 217 Lichtenstein, Roy, *Masterpiece*, 1962, Private Collection, U.S.A., Photo courtesy Leo Castelli Gallery, New York.

made this style so shocking and yet so popular. Though large in scale like the abstract works of the forties and fifties, pop art differs markedly from its predecessors. When compared to abstract expressionism with its more emotive qualities, it is, at times, monotonous; the colors are strident and unmixed, with flat, even surfaces.

This style of presentation is wed to a new and surprising content based on American vernacular imagery, depicting subjects that permeate our national life but have generally been overlooked by artists. In a painting like *The Beware—Danger American Dream #4* by Robert Indiana, for example, the words "Eat," "Tilt," and "Jilt" cry out from the brilliant surface of the picture, calling to mind the insistent messages formed by neon lights on the commercial strip. Made with the same stencils used by commercial sign fabricators, these works deliberately evoke mundane associations. Taken from their usual context and placed in this new "art" situation, however, their mean-

ing is transformed and becomes provocatively open-ended and disturbing. (See Fig. 216, p. 296.)

The content of pop art is often drawn from the mass media or from situations and objects that are common parts of contemporary life—advertising, comics, consumer products, automobiles, and movie magazines. The pop artist takes mass culture straight and does not pass judgment on the subject matter, accepting it as part of American life. Roy Lichtenstein, for example, drew many of the images in his early work from adventure and romance comic books. He presents their grotesque parody of emotions laconically, adapting from the comics even their commercial method of reproduction. The black dots which cover a painting like *Masterpiece* are part of the photoengraver's technique. On a printed page, they can be seen only with a magnifying glass, but Lichtenstein chose to exaggerate them and, thereby, further identify his work with its commercial sources.

Pop art has been among the most visible of contemporary movements, for the media has chronicled pop artists and their activities in a manner befitting film stars. The most notable example of the artist as "superstar" is Andy Warhol. Rather than living the isolated, introspective life characteristic of some American artists, Warhol is a celebrity. He is seen at highly publicized social gatherings, and newspapers and magazines delight in even the most trivial aspects of his life. Warhol, in turn, has depicted celebrities in his art, repeating their images with the same relentlessness as their publicity. This interest in seriality extends to Warhol's other subjects—dollar bills, electric chairs, Brillo boxes, and, of course, his famous Campbell soup cans—and his fascination with the mechanics of repetition can be seen in his approach to materials as well. Rather than painting his pictures by hand, or even working with a brush and stencils like Indiana, Warhol has his images photo-silkscreened onto the canvas by one of the assistants at his studio, a cavernous loft space in New York City known as The Factory. For a time, Warhol did not even sign his pieces, preferring instead to rubber stamp his name onto the back of a work. This involvement in mass production and the machine aesthetic seems, in retrospect, to have led naturally to Warhol's interest in film. From 1963 and his early in-studio productions to his more recent full-length features for general release—among them *Chelsea Girls, Lonesome Cowboys,* and *Blue Movie*—Warhol has added still another dimension to his laconic presentation of contemporary life. These films, together with his art works and his own style of living, are a comment on and a caricature of the value system of modern society—its technology, its conformity, its monotony, its absurdity.

Claes Oldenburg's objects have drawn as much attention as Warhol's flamboyant manner of living and working. In 1961, Oldenburg opened a mock grocery where the food which he displayed was

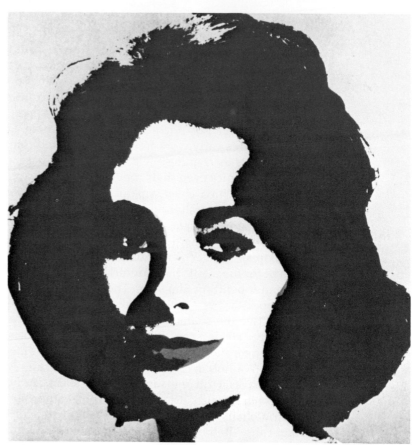

FIGURE 218 Warhol, Andy, *Liz Taylor*, 1963, Collection of Mr. and Mrs. Robert B. Mayer, Chicago.

created from plaster—grotesque yet charming parodies of the American diet. Other common objects were transformed by Oldenburg's wry vision. Rather than simply representing things as he saw them, Oldenburg altered their nature or context, changing hard things to soft, small things to large, and the mundane to the monumental. Oldenberg has been particularly concerned with how to create a relevant monumental art for today. Recognizing that the age of the equestrian statue as public monument ended with the advent of the automobile, Oldenburg asserted that new monumental statements could be made from ordinary, everyday objects. Accordingly, he began conceiving subjects for large-scale sculpture, which were humorous, often surprisingly suitable images for modern life. A Good Humor bar in downtown Manhattan and a gear shift for Trafalgar Square in London exist only on paper, but a monumental clothespin, a 24-foot-high lipstick, and a giant three-way plug have actually been made.

The designation pop art, like all art historical categories, is a convenience, a way of signifying a common identity among a group of highly individual artists. Thus, most artists fit such classifications only partially, sharing only some of the general traits of the group. Red Grooms, for example, draws extensively from contemporary life as the source for his work, but his lively, linear cartoon figures are hardly cool or detached and his subjects are frequently personal. His *Loft on 26th Street* (Fig. 220) documents a studio he occupied (later torn down for urban renewal). All the people depicted are Grooms's family and friends, gathered for a party which took place just before the building's demolition. The artist's use of cardboard in the construction of this piece is typical of Grooms's interest in artistically unconventional though readily available media, and his use of three-dimensional stand-up figures anticipates his later life-size environments (Chapter 20). Like Warhol, Grooms prefers working with a group of assistants, which he has designated the Ruckus Construction Company. Unlike Warhol, however, the work they produce is all made by hand, and its colorful, idiosyncratic appearance is far removed from technology or mass production.

FIGURE 219 Oldenberg, Claes, *Lipstick Ascending on Caterpillar Tracks,* 1969, Yale University Art Gallery.

FIGURE 220 Grooms, Red, *Loft on 26th Street,* 1965–1966, Courtesy of Hirshhorn Museum and Sculpture Garden, Smithsonian Institution.

George Segal also shares some general concerns with other pop artists. His subjects are taken directly from urban life, often, as in *Bus Riders,* incorporating real objects that are a common part of the contemporary American experience. He uses untraditional materials as well, having invented a technique whereby he casts his sitters' bodies in plaster. The work that results, however, seems far removed from pop sensibility, its austere whiteness recalling ancient statuary and suggesting timelessness rather than flux or impermanence.

Happenings

George Segal's designation as a pop artist may be due not so much to the character of his work as to his personal involvement with the creators of pop art events known as "happenings." First created in the late fifties by a group of artists who came to be associated with pop—most notably Allan Kaprow and Claes Oldenburg—happenings challenged the traditional boundaries between the visual arts and theater, and between art and life, becoming activities that incorporated real space, sound, smell, and time. A typical happening such as Allan Kaprow's "Household" involved a situation in which the artist required spectators to complete the experience, to spontaneously carry it through to an unpremeditated conclusion. In "Household," a crowd was assembled in a field near Cornell University in 1964, and participated in a sequence of activities which in-

cluded the appearance of an old Volkswagon, smearing jam on the car, licking the jam off, and, finally, the ritual burning of the automobile.

Happenings resemble avant-garde theater to the extent that they have no narrative, no clearly structured order. They are more akin to an unusual or unexpected situation in which an individual is placed. The artist creates the situation, and, unlike traditional theater, requires the spectator to complete the experience. The happening takes on the quality of life, albeit a strange and wondrous life, for time unfolds according to the clock and activities are based on the spontaneous response of the participants. In a sense, the happening is a logical extension of Jackson Pollock's obsession with spontaneous involvement in the process of making art, but the end product, the finished painting, is denied. Like much art from the mid-fifties on—Rauschenberg's combine paintings, for example—the happenings enter and occupy actual space and involve objects removed from their functional associations. All that remains of the work of art, however, are the written accounts, the photographic record, and the memories of the participants. The activity itself, rather than an actual object, is the end product.

FIGURE 221
Segal, George, *Bus Riders*, 1964, Courtesy of Hirshhorn Museum and Sculpture Garden, Smithsonian Institution.

FIGURE 222 Kienholz, Edward, *The Wait*, 1964–1965, Collection of Whitney Museum of American Art, New York, Geoffrey Clements photographer. Gift of the Howard and Jean Lipman Foundation, Inc.

The final aspect of pop art's considerable impact on the art of the sixties was its internationalism. As with much of the art of this decade, it becomes invalid to talk only of an American or a European movement, for rapid communication and transport have brought the art world together. Pop art was created throughout Europe and the United States at the same time it was being made in New York. Regional character may have emerged—with California pop exhibiting its own distinctive qualities, for example—but, on the whole, territorial boundaries between artists diminished due to modern technology.

NEW REALISM

Pop art was not the only representational art to be created in the sixties. By the end of the decade, another literal approach to contemporary life entered the art scene. Dubbed the *new realism* to distinguish it from older forms of realism like that of Thomas Eakins or Robert Henri, this development followed two general courses. One direction, pursued by artists such as Ralph Goings, Richard Estes, and Robert Cottingham, involved using photographs as the basis for

artists' work. These *photo-realists* made no effort to disguise the source of their painting. Instead the works faithfully record the processed appearance of popular (as opposed to art) photography. The content of the work, typically modern American subjects like trucks, cars, and neon signs, is presented in a detached way that links these paintings to pop art.

The other variety of new realism that enjoyed critical and popular attention in the late sixties and early seventies was involved not with processed images—whether from the mass media or photography—but with direct, visual perception. Philip Pearlstein's nudes, for example, contrast sharply with jazzy pop images or the photo-derived paintings of other contemporary realists. By working in his studio from the live model, Pearlstein deals with the complex and changing patterns of direct experience. His works are also cool and detached in tone, a result of his faithful recording of a studio situation in which the model under flourescent light laconically waits out the sitting, rather than his reliance on photographs (Fig. 224).

The work of Alfred Leslie might be included in this category as well, for his monumental canvases are created only in the presence of the people or objects represented. However, Leslie differs from other contemporary realists in his conscious effort to align himself with the historical tradition of representational painting. In a painting like *The Killing of Frank O'Hara*, the work's composition and lighting are derived from the seventeenth-century Italian master Caravaggio but

FIGURE 223 Goings, Ralph, *Olympia Truck*, 1972, Yale University Art Gallery, Richard Brown Baker Collection.

FIGURE 224 Pearlstein, Philip, *Male and Female Nudes with Red and Purple Drape,* 1968, Courtesy of Hirshhorn Museum and Sculpture Garden, Smithsonian Institution.

used to depict a contemporary subject, the death of the poet and art critic Frank O'Hara on the beach at Fire Island in 1966. With a similar intent, Leslie painted *View of the Connecticut River as Seen from Mount Holyoke,* a modern version of Thomas Cole's *The Oxbow,* and another attempt to connect contemporary representational painting with its heritage. Unlike other contemporary realists, Leslie desires to restore narrative content of major historical or personal importance to paintings, subjects whose significance is equal to that of the formal elements in the paintings.

FORMALISM

If some American artists in the 1960s chose to paint people and objects, many others continued to explore the nature of abstraction. There is no single name for this latter group, their work having been described variously as minimal, reductive, post-painterly abstraction. One variety of sixties' abstraction seems most comfortable under the heading of formalism, for its distilled, purified nature is concerned primarily with the formal qualities of art—line, color, shape, texture, space. In *Arundel Castle*, for example, Frank Stella chose to concentrate on visual concerns to the exclusion of all other interests. His composition, an all-over network of lines with no single center of interest, is calculated to present the work as a totality. Stella's own explanation for his approach to painting is especially illuminating:

I always get into arguments with people who want to retain the old values in painting—the humanistic values that they always find on the canvas. If you pin them down, they always end up asserting that there is something there

FIGURE 225 Stella, Joseph, *Darabjerd III*, 1967, Hirshhorn Museum and Sculpture Garden.

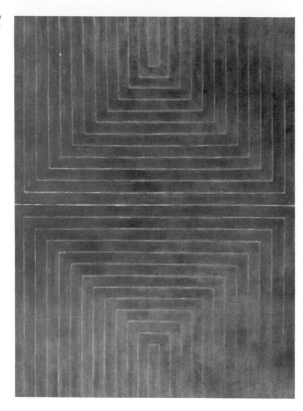

FIGURE 226
Stella, Frank,
Arundel Castle,
1959, Courtesy of
Hirshhorn Museum
and Sculpture
Garden, Smith-
sonian Institution.

besides the paint on the canvas. My painting is based on the fact that only what can be seen is there. It really is an *object*.[1]

This interest in the work of art as an object unto itself, apart from any other system of reference, is closely connected to the writings of the critic Clement Greenberg. In the formalism that Greenberg espouses, and through which he has influenced many artists, art is moving toward self-definition. As formalists see it, painting and sculpture over the last century have been disregarding everything that is not unique to them as media. For example, three-dimensional perspective, the attempt to create an illusion of real space on a canvas, has gradually been eliminated from modern art, and a flatness that was deemed more "natural" to the two-dimensional surface of the painting took its place. Thus, formalist artists invented ways to present the flatness of the picture plane in their work. Morris Louis, Kenneth Noland, and Helen Frankenthaler (Chapter 18), for example, stained the canvas with pigment, soaking colors into the raw surface of the unprimed support. Jules Olitski achieved a rich, two-dimensional, sensual surface by spraying his paint onto the canvas, one thin, transparent layer on top of another.

[1] Bruce Glaser, "Questions to Stella and Judd," *Art News,* September 1966.

Other concerns were part of formalism as well. Abstraction replaced the depiction of people or objects. Rather than concealing the nature of their materials (oil to simulate flesh tones or fabric, for example), formalists present their materials frankly, treating paint as paint, metal as metal.

None of these ideas originated in the 1960s. They were implicit in much of American abstraction since the time of the Armory Show.

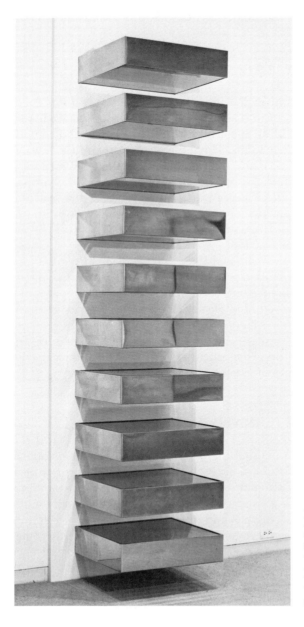

FIGURE 227
Judd, Donald, *Untitled*, 1969, Courtesy of Hirshhorn Museum and Sculpture Garden, Smithsonian Institution.

In formalism, however, these principles are enforced with an unprecedented rigor. Donald Judd, for example, would not paint color onto his sculpture. The color must be one with the material—"natural" to the material—in order for him to intellectually justify its use. Therefore, he often uses colored plexiglas in metal frames to refract light, simultaneously introducing color (Fig. 227).

The concerns which dominate formalist works are philosophical ones. Inquiries into the relationship of these pieces to the outside world are pointless. These are works about the philosophy of art, and are not meant to resemble anything in nature. They do not relate to mathematics, technology, or architecture but are investigations into the nature of materials and the formal elements of art.

OP ART

Another development of the sixties, op (an abbreviation of optical) art, bears a superficial physical resemblance to formalist art, since op painting and sculpture is also abstract and composed of simple, geometric forms. There the resemblance ends, however, for the op artist is less a philosopher than a scientist—an explorer into the perceptual process of optics. Op art deals with the retina, transforming the physical fact of the painting itself by the reaction of our eyes to the images on the canvas. Although colors in an op work seem to vibrate, they, in fact, lie still upon the canvas. Because of certain properties of light, color, and human vision, however, an illusion of movement is created. The German-born artist Josef Albers settled in the United States in the thirties and has had a particularly important influence on young artists' optical awareness. In his series of paintings entitled *Homage to the Square* and in his book *Interaction of Color,* Albers explored the properties of interrelating color, and while not himself interested in optical pyrotechnics, laid the groundwork for op artists such as Richard Anuskiewicz, who studied with the German master at Yale.

ALTERNATIVE FORMS

Throughout the sixties, a number of artists attempted to expand the territory of art by making works that cannot be simply classified as painting or sculpture. The search for a new definition of art has been going on since the beginning of this century with the readymades of Marcel Duchamp, the black paintings of Ad Reinhardt, and the combines of Robert Rauschenberg, to name only some of the most prominent examples. Formalist work assets the existence of art as an object in itself, and not simply as a representation of something else.

Despite the visual simplicity of paintings by Stella, Olitski, and Louis, however, their work still can be contained under the category of painting. Some artists chose to develop this concept in a more radical way and abandoned painting and sculpture as ends in themselves in favor of an object as a stimulus to analysis. The experience of the piece, rather than the piece itself, is the end product of their creative process.

In Sol LeWitt's work, for example, the object is of relatively little consequence. The art work is made by LeWitt speaking or writing the idea that is the basis for the piece. In *Arcs from Four Corners and Four Sides, Circles and Grids,* he issued the order to draw a grid on the wall and then draw four arcs from four sides of the wall over the grid. The work of carrying out this order may or may not be done by the artists, but since the fabricator is only following a predetermined plan, the work will look the same no matter who makes it. In this way, the art work that results—whether one of his sculptures or

FIGURE 228 Lewitt, Sol, *Arcs from Four Corners and Four Sides, Circles and Grids,* 1972, Sperone Westwater Fischer Gallery, New York.

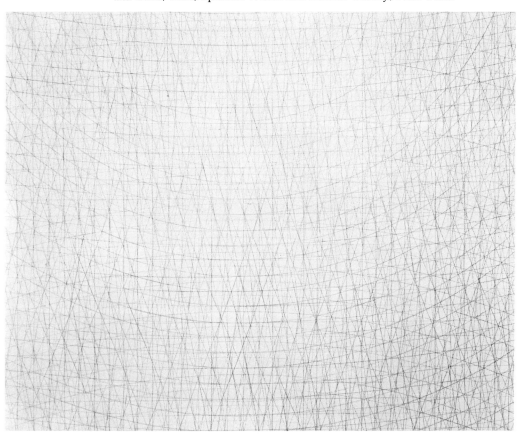

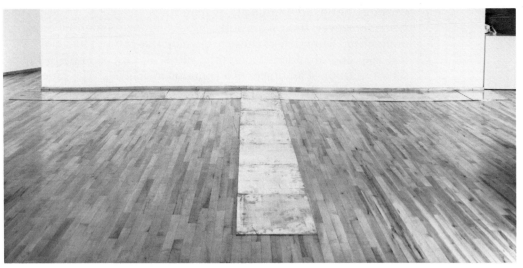

FIGURE 229 Andre, Carl, *13 Copper Triode*, 1975, Sperone Westwater Fischer Gallery, New York.

wall-drawings—will be the physical form of an idea. It does not represent the idea, but actualizes it, existing in the gap between the world of the mind and reality itself.

Carl Andre's work shares with LeWitt's pieces a use of simple, geometric form and a reliance on random or monotonously repetitive compositions. Both artists deliberately create a neutral, nonassociative physical construct, so that the idea, rather than the material qualities of the piece, dominate the viewer's experience. Andre's floor pieces, like *Copper Triode,* for example, are most unassuming, and many people walk over or by the piece before they realize that they are encountering a work of art. Part of the inconspicuous quality of the piece is its horizontality, for most artists' works—buildings, sculpture, etc.—are vertical and engage our vision at eye level. By laying his pieces along the ground, Andre stresses the naturalness of the encounter and the fact that his works deal with place rather than form. In a floor piece by Andre, the viewer experiences the material in a nonfunctional situation, since it does not form a house or a wall or a pipe as it might in everyday life. Instead, the copper is seen as copper, the lead as lead, in an abstract, philosophical sense, and the sculpture itself is only the place—the location in space—where this encounter with an idea takes place.

When the idea is the dominant concern, the form of the art object adapts itself to the issue under consideration. This is especially true in the work of Robert Morris, for the objects he has created do not share any single visual style but vary in size, form, and medium with the concept under consideration. In *Box with the Sound of its*

Own Making (1961), a simple wooden box conceals a tape playing the noises—sawing, hammering, etc.—that were part of the box's creation. This piece unites the process of creation with its product; the viewers see the finished work while hearing it being made.

Morris's involvement with the relationship between essence and appearance continued into the sixties and seventies, taking on an incredible variety of forms—I-beam, L-beam, felt sculpture, earthworks, scatter pieces, and work with video (Chapter 20).

As with Morris's pieces Richard Serra's work manipulates the viewer's awareness of time and space. In his monumental ''prop'' pieces huge pieces of steel or lead lean against one another, the forms held in precarious balance not by welding but by the forces of gravity. The apparent tenuousness of the construction threatens that tons of lead or steel might topple down at any moment. In this manner, Serra confronts the viewer with the underlying structure of nature, making us aware of elemental forces like gravity that maintain order in the world.

FIGURE 230 Morris, Robert, *Untitled*, 1965–1967, Philip Johnson Collection, Photo courtesy Leo Castelli Gallery, New York.

FIGURE 231 White, Minor, *Moon and Wall Encrustations*, 1964, Minor White Estate, Arlington, Mass.

In *Sawing*, Serra scattered the evidence of this activity through the gallery—wood, sawdust, sawhorses, and saws are randomly placed about the room. Obviously, this represents the visualization of a process, and, therefore, Serra did not use a static or permanent object to convey this concept. *Sawing*, by its lack of closure, its implication of an ongoing process, suggests a continuum of time and energy.

The many ways in which artists like Serra, Morris, Andre, and LeWitt have directed the concerns of art can only be suggested here. Shared by all is a commitment to the analytical (as opposed to the representational) function of art, and a desire to propose open-ended systems of inquiry rather than to formulate conclusions. Their work implies and suggests relationships, rather than delineates solutions. In most instances, the value of the object itself within this system of inquiry is only secondary—a mere conduit for the larger issues being considered.

PHOTOGRAPHY

Two distinct trends seem to have dominated photography in the sixties, trends somewhat akin to the distinction between formalism and pop art. Some photographers were more concerned with the formal elements of their image than with its content, an idea intro-

duced into photography by the abstractions of Paul Strand and the "equivalents" of Alfred Stieglitz. Minor White and Aaron Siskind were among the photographers who pursued this approach. Their subtle, often abstract images reveal a great sensitivity to the nature of their medium. The source for Siskind's abstractions is often the walls of urban buildings, while for White, nature seen in exquisite detail is the stimulus for a searching analysis of form. For both, lighting is all important and the massing of shadows, the clarity or diffusion of forms, is the true content of their photographs.

A radically different approach to the purpose and interests of photography can be seen in the work of Robert Frank and Diane Arbus. Robert Frank's book *The Americans* was published in 1959, and much of the same territory that the pop artists and the new realists explore can be seen in this landmark volume. Frank's images of American bars, diners, small-town parades, motorcycle gangs, and life apart from the American dream established the mundane, the untidy, even the trivial, as a proper concern for photography.

Diane Arbus's work probed even deeper into the underside of

FIGURE 232 Arbus, Diane, *Child with Toy Hand Grenade in Central Park,* 1962, estate of Diane Arbus.

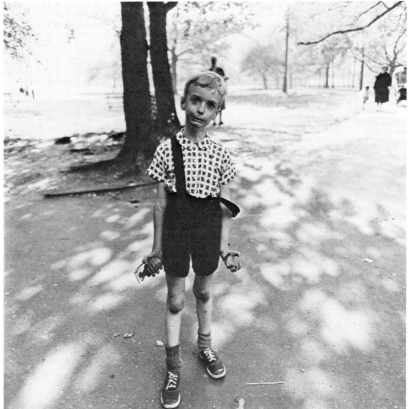

FIGURE 233 Callahan, Harry, *Weed Against Sky*, Detroit, 1948, The Light Gallery, New York.

American life, focusing on dwarfs, nudists, and people on the fringe of society. Her photographs, in their content, their aggressive frontality, and their calm acceptance of the scene, are disturbing as well as fascinating.

Spanning the concerns of these two approaches is the work of Harry Callahan. His images defy categorization—some are tough, candid pictures of urban life, others, austere abstractions of weeds or telephone wires set against the sky. Anticipating developments in the photography of the seventies (Chapter 20), Callahan sometimes works with double or triple exposure, and has created sequences of pictures, each work in the series reflecting the meaning of the other. The intensely personal, almost mystical quality of his photographs has had a significant impact on the present generation of photographers.

By the late sixties, commercial galleries devoted to photography had begun to open, and many serious photographers were finding a wider audience and more active market for their work. Photography as an art form began to achieve visibility and popular respect on an unprecedented scale.

ARCHITECTURE

American architecture in the sixties was characterized by a reevaluation of the purist approach of Miës van der Rohe that had dominated architecture in the previous two decades. Philip Johnson, a follower and associate of Miës, elaborated on the steel and glass elegance of the International style in commercial and civic buildings and private residences. For Johnson, architecture should not only serve a specific practical function (office, home, art gallery, and so forth), but also be a strong formal statement. In his quest for clarity and reductive beauty, Johnson, like Miës, promoted what has been called *exclusivist*

FIGURE 234 Johnson, Philip, *Guest House*, 1949, New Canaan, Conn. Photo courtesy of Alexandre Georges.

FIGURE 235 Fuller, Buckminster, *Geodesic Dome*, Expo '67, photo courtesy of the architect.

architecture—architecture that is refined in form with function subordinate to design. Unlike Frank Lloyd Wright's buildings that conform to and act as extensions of their settings, Johnson's are closed, separate, and related to their site in a monumental, distinct way.

Since a number of architects in the sixties found the purist approach of Johnson and Miës too confining and limited, a less reductive, more expressive aesthetic emerged. Eero Saarinen's Dulles Airport near Washington, D.C., with its sweeping lines that soar upward like a jet taking off, typifies the striving for dramatically expressive forms. Another dynamic form of the sixties was the *Geodesic Dome*, R. Buckminster Fuller's brilliant and influential multipurpose design. Consisting of a skeleton of interlocking polyhedrons that can be covered with virtually any material, its spherical dome can span vast, uninterrupted spaces.

Still another alternative to the classicism of Miës can be seen in the work of Louis Kahn, who has emerged as one of the foremost architects of the past two decades. A romantic who considered architecture in terms of the diversity and flexibility of life, Kahn was a

proponent of the *inclusive approach*. Rather than separating buildings into boxlike units of steel and glass, Kahn, using brick, wood, concrete, and stone, created buildings with complex, informally arranged components. In the *Salk Institute for Biological Studies*, a medical research community overlooking the Pacific Ocean in La Jolla, California, individual study areas, seminar rooms, and laboratories are articulated as separate, yet complimentary, units of adjoining buildings. His daring and innovative design solutions, accommodating physical functions, light, space, and symbolic impact, contributed not only to an alternative to the vision of the International style but also to a number of developments in architecture in the years to come.

While the sixties left a ponderous body of art, architecture, and new ideas, it also posed many questions. What are the boundaries between forms? Is a work of art the object created, or is it the concept behind the piece that makes it art? Where does art end and life begin? Is a work of art meant to last forever? Will there always be art? Will painting and sculpture continue as the principle modes of visual expression?

The exploration of these questions suggests some of the future directions for art, American as well as international.

FIGURE 236 Kahn, Louis, *Salk Institute for Biological Studies*, 1959–65. La Jolla, Calif.

CHAPTER 20

THE VISUAL TRADITION AFTER TWO HUNDRED YEARS[1]

Looking back over the history of American art, it is possible to see trends, masters, and masterpieces, but in general, art history reveals the frailty of most contemporary critical judgments and the inadequacy of most methods of classification. It is a cliché of art history, perhaps a valid one, that it is difficult to say whether a work of art is good or bad without the perspective afforded by time. A discussion of American art in the 1970s is further hampered by the fact that no single, distinct character has yet emerged. Instead, art today is diversified, varied, and wide open. Artists are following individual courses, exploring many ideas that were engendered in

[1] When the *Art America* television series was taped, the seventies were still young and pinpointing and commenting critically upon current events in the art world seemed premature. An alternative approach was employed—that of questioning people actively involved in the arts in America: artists, dealers, critics, museum directors, and photographers. Not only was the current state of art discussed but also certain issues that have been at the heart of this survey, issues like the relationship of American art to life in the United States and the distinguishing characteristics of American art.

This text, however, was written in 1977, and a more critical look at the art of this decade seemed warranted. In this final chapter, therefore, we have discussed the art of the seventies, our focus being not so much the individual artists as the traits and developments that seem to typify this decade.

the fifties or the fast-paced sixties, but doing so in greater depth; they are delving more deeply, enriching and enlarging upon earlier art forms, and experimenting with new mediums and issues.

Creative and formal concerns aside, there have also been important developments in the marketplace affecting art and artists in the seventies. After the booming art market of the sixties in which prices soared and art escalated in value with each sale, questions were raised about artists' rights, especially monetary ones. In 1976 California led the way by granting artists copyrights for their works, giving them a percentage of every sale of their work in that state, a decision rife with ramifications for the art world of the future. In addition, there has been a shift in the nature of patronage, as government and big business have assumed a greater role in the sponsorship of the arts.

Pop art and formalist art, the two trends that dominated the sixties, continue to be factors today, although they have changed in significant ways. Although no longer the *enfant terrible* he was a decade ago, Andy Warhol remains the ultimate art celebrity. His silkscreen portraits of high society are in great demand, and his name is still in the news. Red Grooms's small-scale, slice-of-life tableaux have evolved into an ambitious and delightful recreation of New York City life, *Ruckus Manhattan* (Fig. 237, p. 320), a project undertaken communally with his wife Mimi and several associates. Large enough for visitors to walk its streets and even climb to the top of its World Trade Center, the miniature version of the city is a burlesque of life in New York. The residents of Grooms's city are cartoonlike, and their activities wry exaggerations of normal urban life: the Statue of Liberty wears platform shoes, and a subway car has a grotesque but humorous band of passengers aboard.

Claes Oldenberg still deals with commonplace objects, but they have become less playful and more intrinsically handsome or formally oriented. His *Bicycle Seat* series, for example, or his monumental marble sculpture of an upside-down letter Q, or even his series titled *Bread Shadows,* are striking as forms, beautifully crafted, intriguing because of their sources, but not tricky or even notably humorous. Oldenberg's work has also revealed a consciousness of art historical antecedents: the early modern sculptor Constantin Brancusi's *Sleeping Muse* is echoed in Oldenberg's *Mouse,* and Brancusi's *The Kiss* is transformed in a monumental clothespin.

Some artists associated with formalism have broken away from the purism and reductiveness of their earlier work. Frank Stella's painting has evolved from his flat, shaped canvases of the sixties to polychrome works of contrasting shape and texture in the early seventies and now aluminum pieces that extend out from the wall as relief sculptures. The incredible variety of textures and techniques seen in these recent works, ranging from active brushstrokes and

FIGURE 238
Oldenberg,
Claes, *Inverted
Q*, 1976, Leo
Castelli Gallery,
New York.

pencil drawing to glitter mixed with paint, gives them a garish, decorative quality considerably removed from the austere formalism of his early black and metallic paintings (Fig. 239).

Further evidence of the continuing break with the reductive approach of early formalist art can be seen in the work of Dorothea Rockburne who, though using the basic geometric shape of an isosceles triangle, creates complex and varied configurations by folding and turning the triangle in upon itself. The single, predetermined shape is thus permutated. The material itself (paper or canvas) is given a mottled color rather than any kind of uniform finish (Fig. 240).

EARTHWORKS AND ENVIRONMENTAL ART

On a greater, more ambitious scale, earthworks and environmental art have grown out of the sixties' interest in the relationship of art objects to their place or site. In 1969 Christo wrapped a section of a coastline near Sydney, Australia, with white plastic sheeting. Robert Smithson made a huge spiral jetty in the Great Salt Lake, Utah, in 1970, and Dennis Oppenheim plowed patterns into a Nebraska field. This dramatic, literal use of the landscape for art could be seen as part of the environmentalists' focus on nature and our natural resources,

FIGURE 239 Stella, Frank, *Wake Island Rail,* 1976, Knoedler Gallery, New York.

as well as a sign of the dissatisfaction with the constraints of conventional commercial exhibitions. Also evident is a return to the kind of monumental shaping of the environment that has precedent in the great Pyramids and Stonehenge. Most of the pieces are subject to changes wrought by nature: erosion, rains, wind, and even human intervention. They are not easily accessible to the general public, for they are often located in remote regions of the country. An example is Michael Heizer's *Double Negative,* in which 40,000 tons of earth were cut from the ground at River Mesa, Nevada. Heizer's earthworks are known primarily through photographs, as are works by Robert Smithson. Smithson also documents his earthworks with written accounts and references to myths, legends, geology, and his-

FIGURE 240 Rockburne, Dorothea, *Discourse,* 1976, John Weber Gallery, New York.

FIGURE 241 Smithson, Robert, *Spiral Jetty,* 1970, Great Salt Lake, Utah.

FIG. 240

FIG. 241

FIGURE 242 Christo, *Running Fence,* 1976, near San Francisco, Calif. Photo courtesy of Wolfgang Volz, West Germany.

tory. Christo extensively documents not only the work in place but the efforts that went into its creation. His *Running Fence* (1976), an environmental piece that consisted of over 24 miles of white nylon fence running along the hills north of San Francisco to the Pacific, involved a 42-month collaborative effort, mimicking, in a sense, the methods of big business and government. Carefully documented are the public hearings before various boards and commissions, the signing of numerous lease agreements with ranchers, the appeals to California courts, and the sabotage threats from opponents. Although it stood intact for only 14 days, its impact was long-range. Admirerers lauded the lyrical effect of the miles of white billowing lines winding through valleys and across hills, while detractors either complained about environmental damage or cried fraud. The general public marveled over the idea of the artwork, and museums and collectors bought photographs and documents of the piece, thus helping to finance its construction. Thus, for the spectator, the appeal of environmental art and earthworks lies not only in their form but also in the ideas that brought them about.

More extreme still—another step toward what critic Lucy Lippard has called the "dematerialization of the art object"—is conceptual art. In conceptual art there is no object, just a document or some form of verbal communication that bears witness to the existence of the piece. Like earthworks, conceptual art defies the traditional workings of the art market. The act or idea at the core of the work cannot be bought because it cannot be possessed. A collector must be content with a memento of the act, like a photograph or a typed explanation of the piece. Conceptual art also defies the museum, since it favors nontraditional means of distribution—books, art magazines, gossip. Some conceptual works are precise and mathematical, with pseudoscientific overtones. Others, like those of Chris Burden, are more emotional in orientation. Burden's piece *Shoot,* for example, took place at 7:45 P.M. on November 19, 1971. At that time, Burden was shot in the left arm by a friend standing 12 feet away. This piece, a reflection on violence in our time, epitomizes conceptual art's exaltation of information at the expense of traditional material. It is art as event, rather than art as object, and as such, it challenges and expands traditional definitions of art.

FIGURE 243 Burden, Chris, *Shoot: F Space, November 19, 1971,* Courtesy of Ronald Feldman Fine Arts.

FIGURE 244 Burton, Scott, *Pair Behavior Tableaux,* 1976, The Solomon R. Guggenheim Museum, New York.

PERFORMANCE ART

Performance art, a kind of hybrid theater in which the artist is his art, triggering experiences through situations they create, was also a part of the broadening of the base of the visual arts. In Scott Burton's *Pair Behavior Tableaux,* which was performed at the Guggenheim in 1976, two similar-looking men wearing T-shirts, trousers, and platform shoes assume a series of positions on stage. The audience sits at least 50 feet from the stage overlooking rows of empty seats so that the piece is seen with a degree of detachment. While more traditionally oriented members of the art community and the viewing public object to performance art on the grounds that it is theater rather than visual art, the debate remains open, for the art form is still in the process of being formulated and critical language has not yet caught up with this development.

VIDEO ART

Video art, born in the late sixties, has taken on a wide and varied form in recent years. One of the most influential artists in this area is Nam June Paik who declared, "I have treated the cathode ray tube [TV screen] as a canvas, and proved that it can be a superior canvas. The piano has only eighty-eight keys, we have, in color TV twelve million dots per second." Paik's work is based on the manipulation of electronic signals, and with the video synthesizer, a device he helped produce, he is able to warp and alter the image on the televi-

sion screen to create planned and accidental effects. Until recently, the high cost of equipment limited the production of video art, but as smaller, less expensive equipment has been developed, the number of artists experimenting with video has increased.

Paik's emphasis on electronic gadgetry and manipulation of the broadcast image has been supplanted to a great degree by an interest in the use of video as a vehicle for documenting ideas, activities, and unique constructs. Not only are there new artists taking up video but artists are also coming to it from other media. The sculptors Robert Morris and Richard Serra, the conceptual artist Bruce Nauman, and the painter–conceptual artist Keith Sonnier have experimented with video, dealing for the most part with altering the visual perception of the spectator. Nauman set up a video screen at the end of a long hall with a camera over it so that spectators saw themselves walking toward themselves. Although most video art takes the form of video-tapes that can be distributed for private viewing in cassette form, some artists in the media have experimented with broadcast television, thanks to the cooperation of public broadcasting networks.

Douglas Davis was permitted by the Austrian Television Network in 1974 to insert his *Austrian Tapes* unannounced into a regular broadcast schedule. By pressing his hands and face against the camera and engaging the television viewer in an almost hypnotic physical and mental dialogue, Davis sought to stress the personal, intimate nature of a medium that has been seen as a basically impersonal, mass medium by most people.

THE RETURN TO CRAFTMANSHIP

At the same time that artists have been pursuing this interest in technologically oriented art forms, there has been a renewed interest in traditional art forms, craftmanship, and traditional materials. There is less plastic and neon being used by artists and more wood, paper, clay, cloth, and canvas; there is also an emphasis on the fabrication of artwork by the artist himself or herself. After years in which acrylic paints enjoyed a great popularity, many artists have returned to the greater luminosity and special qualities of traditional oil painting techniques. Painters such as Rodney Ripps, Joan Snyder, and Herb Schiffrin seem to be trying literally to "get into" their work in a sensual, tactile, almost physical way. As a result, the smooth, impersonal finish of pop and minimal art is being replaced by denser paintings, in which the surface is pushed, pulled, layered, cut, stamped, folded, built up, and dug into almost compulsively (Fig. 245).

There has developed an interest in the use of craft techniques and materials for making fine art. Twine, cord, feathers, cloth, felt, and various fibers have become a part of the artist's vocabulary.

FIGURE 245
Schiffrin, Herbert,
White Music, 1974,
Collection of Mr.
and Mrs. Tim Rad-
ford, Middleburg,
Va.

Ceramic art has had a particularly strong development. Flourishing
in California in the sixties under the stimulation of Peter Voulkos,
ceramics has taken, on the one hand, a sardonic, neo-Dada form in
the work of artists such as Robert Arneson, and, on the other hand, a
more formalist sensibility in the work of Kenneth Price.

ART AND FEMINISM

If one trend of the seventies can be easily identified, it is in the area
of women's art. Not only have women artists actively participated in
the feminist movement but they have also dealt specifically in their
art—in an attempt to raise the consciousness of the viewer—with
subjects and themes related to the experience of being a woman. The
Feminist Art Program in California, founded by Judy Chicago in the
early seventies, created *Womanhouse* (1971–1972), a house made into
a complete environmental piece with each room a commentary on
women's roles and problems. As part of a revolutionary social move-
ment, feminist art has at times been taken to brutal extremes, exhib-
iting sharp criticism of a male-dominated society and the tensions

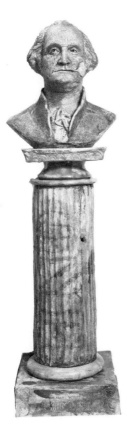

FIGURE 246 Arneson, Robert, *I'm the One,* 1976, Photo by John Tennant, courtesy of Fendrick Gallery, Washington, D.C.

between the sexes. In its less strident form, women's art is self-revelatory, personalized, and autobiographical. Claudia De Monte, for example, in *Process Art Trade: T-Shirts* (Fig. 247) had fifty shirts printed with her last name and the shape on the front of the Del Monte vegetable can, playing on a mispronounciation of her name that has occurred for years. The shirts were displayed at a gallery, and spectators brought shirts of their own to exchange for them. Thus, the piece continues in time as the artist wears shirts obtained in the trade and the participants wear their De Monte shirts. In a recent *Calendar* piece, De Monte meticulously noted both the trivial and important episodes in her life, day by day and month by month, and thereby revealed the texture and framework of one woman's daily existence.

Not all women artists choose to emphasize their sex or sexuality, and many prefer working outside of a specifically gender-oriented framework. A more significant result of the women's movement, perhaps, is, as the sculptor Sylvia Stone has pointed out that "You can never produce good work unless you're taken seriously and that is what has (finally) happened to women, not just in art, but really throughout the whole society."

FIGURE 247 De Monte, Claudia, *Process Art Trade: T-Shirts,* 1976, Max Protetch Gallery, Washington.

PHOTOGRAPHY

Straight photography continued to flourish in the 1970s, with young photographers like John R. Gossage bringing new vitality to this purist aesthetic. Gossage's prints are often as large as 11 × 14 inches, and this scale tends to soften the forms without sacrificing the detail that is the hallmark of the straight picture.

Color photography found its first sizable group of noncommercial practitioners in such artists as William Eggleston and Lucas Samaras. Eggleston treats his mundane subjects with the simplest of formal devices, but by saturating the image with color, he achieves work of astonishing power. Known as well for his sculpture, Samaras works with the liquid on the surface of a Polaroid, manipulating the chemicals before they dry into bizarre distortions of the natural image. (See Color Plate VIII.)

Perhaps the most controversial aspect of recent photography has been the reemergence of what might be categorized as a pictorialist

sensibility. Artists like Jerry Uelsmann, Emmet Gowin, and Duane Michals have rejected straight, unmanipulated photography in favor of a lyrical presentation of personal imagery. Uelsmann combines several negatives in a single print, overlayering his images to create strange symbolic landscapes or interior scenes (Fig. 249). Gowin photographs his family and friends in Danville, Virginia, frequently framing his subjects in a misty oval of soft grey tones which accentuates the moody, mysterious quality of the scene. Duane Michals often arranges his photos in series and frequently adds a handwritten commentary to the borders of the print. Both words and picture express a poetic sensibility, with images drawn from his personal anxieties or his imagination. Michals, in a statement that might characterize much of the seventies' pictorialism, said: "What I cannot see is infinitely more important than what I can see."

ARCHITECTURE

Architecture in the seventies has been marked by the continuation of challenges to the International style. The acknowledged leader of this development is Robert Venturi, whose landmark book *Complexity*

FIGURE 248 Gossage, John, *Huntingdon Gardens*, 1975, Castelli Graphics, New York.

FIGURE 249 Uelsmann, Jerry, *Untitled,* 1969, Washington Gallery of Photography.

and Contradiction in Architecture, published in 1967, promoted the principle of "accommodation" in design. Like his mentor, Louis Kahn, Venturi's is an inclusive rather than exclusive approach, with his accommodation involving the reconciliation of the formal and physical needs of a building with the environmental and economic factors. Instead of imposing a classical order in the manner of Miës van der Rohe, Venturi adapts his designs to the ironies and imagery of contemporary life. With his partners Robert Rauch and Denise Scott-Brown, Venturi shocked his colleages by studying Las Vegas and the phenomenon of the commercial strip. Learning from this urban plan that dates back to pioneer days in the West, Venturi began orienting his architecture to the highway and to the fast speed at which most buildings are perceived from a moving automobile. Sensitive to the problems of urban planning and renewal, Venturi chose to plan buildings that harmonize with the older neighborhoods rather than to tear up the urban core with sleek, inappropriate architectural monuments. His home for the aged in Philadelphia, called *Guild House,* was built of brick and identified with large letters and a gilt television antenna, which served to not only acknowledge the quality of the surrounding buildings but also boldly proclaim the building's function.

Charles Moore, a California architect influenced by Venturi, has sought not only to accommodate his architecture to the complexities

of modern life but also to exploit the picturesque qualities of regional traditions as well as modern iconography. In Sea Ranch, a resort community created in the mid-sixties near San Francisco by Moore and his associates Donlyn Lyndon, William Turnbull, and Richard Whitaker, the design resembles the shacklike beach cottages of the area. To reinforce and enliven the complex interior spaces of the grouped structures, supergraphics—bright, bold painted stripes and designs by Barbara Stauffacher—traverse the walls.

For the followers of Moore and Venturi in the seventies, Miës van der Rohe's purist doctrine of "less is more" is long forgotten. Today young architects like Peter Eisenman, Roland Choate, and Patricia Copeland are eclectic in their tastes, each striving for individuality. With the private dwelling as their chief laboratory for experimentation, the new generation of architects unabashedly paints facades bright colors, buries their structures in the ground, creates shifting planes and floor levels, and accommodates the idiosyncrasies of their patrons. As the purism and classical orientation of the International style are being abandoned, the new philosophy of architecture centers increasingly on the complexities and diversity of modern life.

The questions that guided this study are still pending, as they must inevitably be. The character of American art—its subject, its form, and its relationship to the lives and concerns of this nation's people—is ever in flux. No work of art is a final solution, and it is this continual questing that gives life and power to the American artistic tradition.

FIGURE 250 Venturi, Robert, and Robert Rauch (with Cope and Lippincott Associates), *Guild House*, Philadelphia, 1960–1965.

BIOGRAPHIES

Abbott, Berenice (1898–) Born in Springfield, Ohio, Abbott arrived in New York in 1918 with the intention of becoming a sculptor. She remained there until 1921, when she left for Europe. While in Paris Abbott was an assistant to the American photographer Man Ray from 1923 to 1925. During this time, she also began to work as a portrait photographer. In 1929, Abbott returned to New York City, where she began to document all areas of the city. From 1935 to 1939, she pursued this project for the New York branch of the WPA Federal Art Project. In 1968, she left New York for Maine, where she lives today.

Abbott, Berenice. *Photographs*. New York, 1970.

Adams, Ansel (1902–) Born in San Francisco, Adams took his first photographs with a Brownie box camera at the age of 14 during a visit to Yosemite Valley. Adams then began study with a photofinisher in San Francisco. Nevertheless, at the age of 18 he decided to become a musician, and despite the instant success of his first portfolio of photographs published in 1927, he did not change his profession to photography until 1930. The year 1930 also saw the publication of his first book, *Taos Pueblo*, based on his travels in New Mexico in 1929, where he met John

Marin, Georgia O'Keeffe, and Paul Strand. In 1932, Adams, along with a group that included Edward Weston, Willard Van Dyke, and Imogen Cunningham, founded Group f/64, and a year later he met the photographer Alfred Stieglitz. *Making a Photograph*, Adams's first book on technique, was published in 1935. In 1940, Adams helped Beaumont Newhall establish the department of photography at the Museum of Modern Art in New York. In 1941, he was appointed photomuralist to the Department of the Interior. Adams was responsible for the first photography department at the California School of Fine Arts in 1946. Between 1948 and 1950, his first series of *Basic Photo-Books* on technique and application were published. In recent years, he has served as consultant to the Polaroid Land Corporation, and teaches a workshop at Yosemite every spring.

Ansel Adams: Images 1923–1974. Boston, 1974.

Albers, Josef (1888–1976) Albers was born in Bottrop, Germany. From 1920 to 1933, Albers studied, worked, and taught at the Bauhaus. He was the first Bauhaus instructor invited to teach in America. From 1933 to 1949, Albers taught at the newly established Black Mountain College in North Carolina. In 1939, he became a United States citizen. From 1950 to 1960, Albers taught at Yale. In 1963, he published *Interaction of Color*, a comprehensive treatise on color. Albers died at his home in Orange, Connecticut.

Spies, Werner. *Albers.* New York, 1970.

Allston, Washington (1779–1843) Born in South Carolina, Allston graduated from Harvard in 1800. The following year he went to London to study painting with Benjamin West. In 1803, he traveled to Paris and then Rome, where he remained for 4 years. After living in England for 3 years, Allston settled in Cambridgeport, Massachusetts, where he spent the rest of his life. His large circle of friends and admirers included Samuel Taylor Coleridge, John Vanderlyn, and Washington Irving.

Richardson, E. P. *Washington Allston: A Study of the Romantic Artist in America.* Chicago, 1948.

Andre, Carl (1935–) Andre was born in Quincy, Massachusetts. From 1951 to 1953, he studied at the Phillips Academy in Andover, Massachusetts, where he met fellow students Frank Stella, Hollis Frampton, and Michael Chapman. In 1954, Andre worked briefly for the Boston Gear Works and then traveled in France and England. From 1955 to 1956, he served in the United States Army as an intelligence analyst. In 1957, Andre settled in New York City, and some of his first wood sculptures were made in Frank Stella's studio there. From 1960 to 1964, he worked as a freight brakeman and conductor for the Pennsylvania Railroad. In 1964, the first public exhibition of Andre's work was held. Presently, Carl Andre lives and works in New York City.

Waldman, Diane. *Carl Andre.* New York, 1970.

Anshutz, Thomas (1851–1912) Born in Newport, Kentucky, Anshutz studied at the National Academy of Design from 1871 to 1875. From 1875 to

1876, he studied with Thomas Eakins at the Philadelphia Sketch Club, and from 1876 to 1881, he studied at The Pennsylvania Academy of the Fine Arts, again with Eakins. From 1892 to 1893, he studied at the Académie Julian, notably with William-Adolphe Bouguereau. In the early 1880s, Anshutz worked with Eakins and Eadweard Muybridge on photographic experiments at the University of Pennsylvania. From 1881 to 1891 and from 1893 to 1912, Anshutz taught at The Pennsylvania Academy, serving in his last 3 years there as the head of the faculty. In 1898, he cofounded the Darby School of Painting with Hugh Breckenridge. Anshutz's students included A. Stirling Calder (Alexander Calder's father), Charles Demuth, William Glackens, Robert Henri, John Marin, Everett Shinn, John Sloan, and Henry O. Tanner. Anshutz received many honors during his lifetime, including election as an associate of the National Academy in 1910. He died in Fort Washington (formerly Darby), Pennsylvania.

Thomas Anshutz: A Retrospective Exhibition. New York, John Graham and Sons, February–March 1963.

Anuszkiewicz, Richard J. (1930–) Born in Erie, Pennsylvania, Anuszkiewicz received a B.F.A. from the Cleveland Institute of Art in 1953. In the graduate program at Yale, Anuszkiewicz studied under Josef Albers, whose theories on color influenced his development. Presently, Anuszkiewicz lives in Frenchtown, New Jersey.

Lunde, Karl. *Richard Anuszkiewicz.* New York, forthcoming.

Arbus, Diane (1923–1971) Born in New York City, Arbus, along with her husband Allan, began her career by photographing fashions for major magazines. In 1959, she studied photography under Lisette Model. In addition to her work as a free-lance photographer, Arbus taught a number of classes. In 1971, she committed suicide. A year later, her photos were the first American photographs to be selected for exhibition at the Venice Biennale.

Diane Arbus: An Aperture Monograph. Millerton, N.Y., 1972.

Audubon, John James (1785–1851) Born in Haiti to a French father and Creole mother, Audubon was raised and educated in France. In 1803, he moved to America to supervise his father's estate in Pennsylvania. After marrying in 1808, Audubon moved to the upper Ohio Valley, where he entered into various unsuccessful business ventures. Increasingly preoccupied with his hobby of drawing and making watercolor sketches of birds and other native wildlife, Audubon eventually abandoned his business and attempted to find a publisher for his watercolor studies. Rejected by Philadelphia publishers, Audubon traveled to England in 1826. In 1830, his works were finally published in four double elephant folio volumes, *The Birds of America, from Original Drawings with 435 Plates Showing 1,065 Figures.* The following year, an accompanying text, *Ornithological Biography*, was published. After 10 years in England, Audubon returned to the United States.

Ford, Alice. *John James Audubon.* Norman, Okla., 1964.

Avery, Milton (1893–1965) Born in Altmar, New York, Avery moved with his family to Hartford, Connecticut, at the age of 12. When he was 18, his ambition was to become a commercial artist, so he took an art correspondence course. His only formal art class was life drawing at the Connecticut League of Art Students. Avery spent the summer of 1925 painting in Gloucester, Massachusetts, where an art colony was located and later that year, he moved to New York, where he lived for the rest of his life. In 1933, Avery made the first of his many prints. In 1952, he made his first trip to Europe.

Breeskin, Adelyn. *Milton Avery*. Greenwich, Conn., 1969.

Baskin, Leonard (1922–) Born in New Brunswick, New Jersey, Baskin moved with his family to Brooklyn, New York, in 1929. From 1937 to 1939, he studied at the Educational Alliance Art School in New York, and from 1939 to 1941, he attended New York University. From 1941 to 1943, he studied at Yale University. In 1942, he founded the Gehenna Press. From 1943 to 1946, Baskin served in the United States Navy. In 1949, he received his B.A. from the New School for Social Research in New York. In 1950, Baskin studied in Paris, and in 1951, he studied in Florence. From 1952 to 1953, he taught printmaking at the School of the Worchester Art Museum in Massachusetts. Since 1953, Baskin has taught at Smith College in Northhampton, Massachusetts. He has illustrated many books, including *The Iliad* (1962), *The Divine Comedy* (1969), and Jonathan Swift's *A Modest Proposal* (1970). Baskin lives and works in Northampton, Massachusetts.

Fern, Alan, and Baskin, Leonard. *Leonard Baskin*. Washington, D.C., 1970.

Baziotes, William (1912–1963) Born in Pittsburgh, Pennsylvania, Baziotes moved with his family to Reading, Pennsylvania, in 1913. From 1933 to 1936, he studied painting at the National Academy of Design in New York, where Leon Kroll was his teacher. From 1936 to 1938, Baziotes himself was a teacher for the WPA Federal Art Project in New York, and from 1938 to 1941, he worked on the easel division. In 1948, Baziotes helped found Subjects of the Artist: A New Art School in New York with David Hare, Robert Motherwell, Barnett Newman, and Mark Rothko. Baziotes taught at a number of schools, including Hunter College and The Brooklyn Museum Art School. He died in New York City.

William Baziotes: A Memorial Exhibition. New York, The Solomon R. Guggenheim Museum, 1965.

Bellows, George (1882–1925) Born in Columbus, Ohio, Bellows attended Ohio State University from 1901 to 1904, where he excelled as an athlete. After leaving college in his senior year to pursue (without success) a career in professional sports, Bellows enrolled at the New York School of Art in 1904. He studied there with Robert Henri until 1906. From 1910 to 1911 and again from 1917 to 1919, Bellows taught at The Art Students League in New York. In 1912 and in 1919, he taught at the Ferrer Center in New York. Among his students were William Gropper and Moses Soyer. In 1913, he assisted in the organization of the Armory Show, in which fourteen of his works were exhibited. From 1912 to 1917, Bellows

contributed illustrations to *The Masses*. In 1916, he made his first lithographs. Bellows died in New York City.

Braider, Donald. *George Bellows and the Ashcan School of Painting*. Garden City, N.Y., 1971.

Benglis, Lynda (1941–) Born in Lake Charles, Louisiana, Benglis received her B.F.A. from Newcomb College in 1964. From 1970 to 1972, Benglis was an Assistant Professor of Sculpture at the University of Rochester in New York. She was a visiting artist at the Yale-Norfolk Summer School in 1972 and has also taught at Hunter College, California Institute of the Arts, and Princeton University. Benglis lives in New York City.

Pincus-Witten, Robert. "Lynda Benglis: The Frozen Gesture," *Artforum*, vol. XIII, no. 3, November 1974.

Benton, Thomas Hart (1889–1975) Born in Neosho, Missouri, Benton was the son of a Missouri congressman and the grandson of a senator. In 1907, he entered the School of The Art Institute of Chicago, and in 1908, he went to Paris for 3 years to study at the Académie Julian. In 1912, he moved to New York City, where he participated in several synchromist exhibitions. From 1918 to 1919, Benton served as a draftsman in the United States Navy. From 1926 to 1935, Benton taught at The Art Students League of New York. His students included Jackson Pollock and Fairfield Porter. In 1935, Benton returned to Missouri and settled there, often summering on Martha's Vineyard, Massachusetts. His autobiography, *An Artist in America*, was published in 1937, and a later volume, *An American in Art*, in 1969. Benton's many murals include his mural for the New School for Social Research (1928) and his one for the Missouri state capitol (1936). He died in Kansas City, Missouri.

Baigell, Matthew. *Thomas Hart Benton*. New York, 1975.

Bierstadt, Albert (1830–1902) Born in Germany, Bierstadt was brought to America in 1832 and spent his youth in New Bedford, Massachusetts. In 1853, Bierstadt returned to Düsseldorf to study at the Royal Academy, where his teachers included Emanuel Leutze. He also studied painting in Rome for a year before returning to America in 1857. In 1859, Bierstadt traveled with a United States government expedition sent to map an overland trail to the Pacific. Once back in his New York studio, Bierstadt painted large panoramic views based on his sketches of the Wind River, Shoshone Mountains, and other memorable Western locations. Elected to the National Academy of Design in 1860, Bierstadt revisited Europe several times and received many commissions abroad as well as at home. From 1872 to 1873, he worked with the photographer Eadweard Muybridge in Yosemite Valley, California. With the wealth acquired from the sale of his works Bierstadt built a thirty-five-room studio-home in Irvington-on-the-Hudson, New York. After a fire destroyed his mansion in 1882 and his fortunes and reputation declined, he moved to New York City to spend the last years of his life. He died there in 1902.

Hendricks, Gordon. *Albert Bierstadt: Painter of the West*. New York, 1974.

Bingham, George Caleb (1811–1879) Born in Virginia, Bingham moved with his family to Missouri at the age of 8. There he was apprenticed to a cabinetmaker at the age of 16, and he later took up sign and portrait painting. During the years 1840 to 1844, he lived in Washington, D.C., where he continued to paint portraits. In 1844, Bingham returned to Missouri and found a new subject matter for his paintings—life along the Missouri River. In 1865, he traveled to Düsseldorf to study for 3 years. Upon his return, Bingham became involved in politics as a union loyalist during the Civil War. Between 1862 and 1865, he was state treasurer of Missouri and in 1875 became that state's adjutant-general. In 1877, he was appointed professor at the art school of the University of Missouri. Stricken by cholera, Bingham died in Kansas City, Missouri.

Block, E. Maurice. *George Caleb Bingham: The Evolution of an Artist and Catalogue Raisonné.* Berkeley and Los Angeles, Calif., 1967.

Blakelock, Ralph (1847–1919) Born in New York City, Albert Blakelock entered the Free Academy of the City of New York (City College) in 1864, but left in 1866, never completing the 5-year curriculum. A self-taught painter, Blakelock began exhibiting his work at the National Academy of Design in 1867 and continued showing until 1873. His travels in the West between 1869 and 1872 provided him with the motif of Indian life in the wilderness, which dominated his painting for the rest of his career. In 1891, he suffered a mental breakdown, his nervous disorder diagnosed as dementia praecox. In 1899, he was moved to Long Island Hospital and from 1900 to 1918 was confined to mental institutions. During this time his work became popular, and while unable himself to enjoy the belated recognition, his family received some financial aid from a fund that was established. In 1918, Mrs. Van Rensselaer Adams had him moved to a cottage in the Adirondacks, where he died in 1919.

Goodrich, Lloyd. *Ralph Albert Blakelock.* New York, 1947.
Stuurman, Phyllis. *The Enigma of Ralph Blakelock,* Santa Barbara, Calif., 1969.

Bluemner, Oscar (1867–1938) Bluemner was born in Preuzlau, Germany (now Breslau, Poland). He studied architecture and design in Berlin before immigrating to the United States in 1892 to work as an architect in Chicago. In 1901, he moved to New York and the following year received a commission to design the Bronx County Courthouse. After his partner stole his designs, Bluemner won a lawsuit against him and left for Europe to become a painter. In 1913, he returned to exhibit in the Armory Show. He wrote critical reviews for Alfred Stieglitz's *Camera Work* and in 1916 moved to New Jersey. Ten Years later, he moved to South Braintree, Massachusetts, where from 1934 to 1935, he was an employee of the Public Works of Art Project. He committed suicide in January 1938.

Oscar Bluemner Papers. Archives of American Art, Smithsonian Institution, Washington, D.C.

Borglum, Gutzon (1867–1941) John Gutzon de la Mothe Borglum, son of Danish pioneers, was born in Idaho but was raised in Nebraska. After

attending Saint Maries College in Topeka, Kansas, Borglum was apprenticed to a lithographer and mural painter in Los Angeles and studied at the Mary Hopkins Art Institute in San Francisco. In 1890, he went to Paris to study sculpture at the Académie Julian and the École des Beaux-Arts. Borglum returned to the United States in 1893 and exhibited at the Columbian Exposition in Chicago. After a trip to London, Borglum settled in New York City in 1902. A successful artist who never lacked commissions, Borglum worked in marble and bronze. His most famous work was his monumental carving on Mount Rushmore, South Dakota, of the faces of George Washington, Thomas Jefferson, Abraham Lincoln, and Theodore Roosevelt.

Price, Willadene. *Gutzon Borglum: Artist and Patriot.* New York and San Francisco, 1961.

Brady, Mathew (1823–1896) Born in Lake Charles, New York, Brady studied portrait painting under William Page and in 1839 accompanied Page to New York City. In 1840, he took daguerreotype classes from Samuel F. B. Morse and John William Draper in New York City. From 1841 to 1844, Brady owned a factory which manufactured cases for jewelers and daguerreotypists. In 1844, he opened a daguerreotype studio in New York. In 1847, Brady opened a similar studio and gallery in Washington, D.C., which was frequented by Presidents (including Abraham Lincoln), Cabinet members, and congressmen. In 1850, Brady's *The Gallery of Illustrious Americans* was published. In 1853, Brady switched to the ambrotype and enlarged his staff of assistants, which included operators (now called cameramen) and artists. Brady also ran a school of photography, and in 1853, he opened another luxuriously decorated gallery in New York City. During the Civil War, Brady devoted his energies to documenting the war through photography. To this end, he sent out teams of photographers to cover the war effort. Brady himself barely escaped death at Bull Run. Brady suffered from poor eyesight all his life and was practically blind when he died. He was buried in Arlington National Cemetery in Washington, D.C.

Civil War Photographs 1861–1865: A Catalogue, compiled by H. D. Milhollen and D. H. Mugridge. Washington, D.C., 1961.
Horan, J. D. *Mathew Brady: Historian with a Camera.* New York, 1955.

Brook, Alexander (1898–) Brook was born in Brooklyn, New York. From 1915 to 1919, he studied at The Art Students League of New York, where he was awarded a scholarship and studied under Kenneth Hayes Miller. Brook was married to the painter Peggy Bacon in the thirties and worked on WPA projects, most notably a mural for the United States Post Office in Washington, D.C. Brook served for many years as assistant director of the Whitney Studio Club in New York. He now resides in Sagharbor, New York.

Brook, Alexander. *Brook.* New York, 1945.

Bulfinch, Charles (1763–1844) Born in Boston, Bulfinch graduated from Harvard in 1781 and studied architecture in Europe from 1785 to 1787. Upon his return to Boston, Bulfinch designed the Massachusetts State

House, which was completed in 1798. Working mostly in Boston, Bulfinch was responsible for the Beacon Hill Monument and various other buildings and monuments in the Federal style, improvement of the Boston Common, installation of street lights, and designs for residential architecture. In 1817, Bulfinch was asked by President James Monroe to succeed Benjamin H. Latrobe as supervising architect for the United States Capitol. Before his retirement in 1830, Bulfinch drew plans for the Unitarian Church in Washington, D.C., and the Maine state capitol. He died in Boston in 1844.

Place, Charles A. *Charles Bulfinch: Architect and Citizen.* Boston, 1925.

Burchfield, Charles (1893–1967) Burchfield was born in Ashtabula Harbor, Ohio. In 1898, he and his family moved to Salem, Ohio, where he spent his youth. During the years 1911 and 1912, he was an accountant for a company which sold automobile parts. From 1912 to 1916, he studied on scholarship at the Cleveland School of Art (now Cleveland Institute of Art). In 1916, he was awarded another scholarship from the National Academy of Design in New York City. He left the National Academy, however, after only 1 day of life-drawing class. Burchfield returned to Salem, Ohio, and his accounting job but continued to paint in his spare time. In 1921, he moved to Buffalo, New York, where he became head of the design department for a wallpaper company. In 1929, he resigned from his job to devote all his energies to painting. Burchfield died in West Seneca, New York.

Baur, John I. H. *Charles Burchfield.* New York, 1956.

Burden, Chris (1946–) Born in Boston, Massachusetts, Burden received a B.A. from Pomona College, California in 1969 and an M.F.A. from the University of California at Irvine in 1971.

Chris Burden. Los Angeles, Calif., 1974.

Horvitz, Robert. "Chris Burden," *Artforum,* May 1976, pp. 24–31.

Burnham, Daniel Hudson (1846–1912) Born in Henderson, New York, in 1846, Burnham grew up in Chicago, Illinois. He was educated by a private tutor in Massachusetts and upon failing the entrance examination to Harvard, returned to Chicago in 1868. Burnham became apprenticed to the architect William LeBaron Jenney and subsequently worked as a draftsman for several architectural firms. In 1872, he and a fellow draftsman, John Wellborn Root, formed a partnership to practice architecture. The firm of Burnham and Root was active during the years 1880 to 1892. When Root died in 1892, Burnham practiced alone until 1896 and was the leader of the architectural planners of the World's Columbian Exposition in Chicago in 1893. In 1901, Burnham was commissioned to oversee the completion of Pierre L'Enfant's original plans for Washington, D.C. Subsequent municipal improvements supervised by Burnham included the cities of Cleveland, Detroit, Chicago, and San Francisco. He served as chairman of the National Commission of Fine Arts in 1910 and president of the American Institute of Architects in 1894. While traveling in Europe, illness struck, and Burnham died in Heidelberg, Germany, in 1912.

Moore, Charles. *Daniel H. Burnham: Architect and Planner of Cities.* Boston and New York, 1921.

Calder, Alexander (1898–1976) Calder was born in Philadelphia, Pennsylvania, the son and grandson of sculptors. Calder received a degree in mechanical engineering from Stevens Institute of Technology in Hoboken, New Jersey, in 1919. From 1923 to 1926, he studied at The Art Students League of New York and worked as an illustrator for the *National Police Gazette.* In 1926, Calder went to Europe, where he began to develop his famed miniature *Circus,* which he performed for many years for American and European audiences. His friendships and associations during the Paris years included Piet Mondrian, Joan Miro, and Jules Pascin. In the thirties, he began making his "stabiles," stationary metal sculptures so named by Arp, and his sculptures propelled at first mechanically and then by wind currents dubbed "mobiles" by Duchamp. During the war Calder and his wife returned to the United States, settling in Roxbury, Connecticut. Since the forties, they lived both at home and abroad and his works received widespread international acclaim. At the time of Calder's death on November 11, 1976, a retrospective of his work was being held at the Whitney Museum of American Art.

Calder, Alexander. *An Autobiography with Pictures.* New York, 1966.
Mulas, Ugo, and H. Harvard Arnason. *Calder.* New York, 1971.
Lipman, Jean. *Calder's Circus.* New York, 1972.

Callahan, Harry (1912–) Born in Detroit, Michigan, Callahan first explored photography when he joined a photography club in Detroit in 1938. He dates his mature work as that executed after hearing a lecture by Ansel Adams in 1941 in Detroit. From 1944 to 1945, Callahan worked as a processor in a General Motors photography lab. From 1946 to 1961, he taught at the Institute of Design in Chicago, heading the photography department from 1949. In the summer of 1951, Callahan taught at Black Mountain College, North Carolina, and beginning in 1961, at the Rhode Island School of Design. From 1976 to 1977, a major exhibition of his photographs was held at the Museum of Modern Art in New York. The photographer now lives in Providence, Rhode Island, retiring as head of the department of photography at the Rhode Island School of Design in 1976.

Paul, Sherman. *Harry Callahan.* New York, 1968.

Cassatt, Mary (1844–1926) Allegheny City (now part of Pittsburgh), Pennsylvania, was the birthplace of Mary Cassatt. In 1851, she went with her family to Europe. In 1858, they returned to Philadelphia, where Cassatt received private art lessons. From 1861 to 1865, she attended the Pennsylvania Academy of the Fine Arts and then left for Paris, where she remained until 1869. A brief return to Philadelphia during the Franco-Prussian War of 1870–1871 was followed by travel and study in Italy, Spain, Belgium, and Holland. In 1874, Cassatt settled permanently in Paris. In 1877, Edgar Degas asked Cassatt to join the impressionists. She exhibited with them in 1879, 1880, 1881, and 1886. Cassatt made a trip to

America in 1898, and again in 1908. In 1901, she traveled to Italy and Spain with Mr. and Mrs. H. O. Havemeyer, and to Egypt in 1910. In 1911, her vision began to fail. She died in her country home near Paris.

Breeskin, Adelyn. *Mary Cassatt: A Catalogue Raisonné of the Oils, Pastels, Watercolors, and Drawings.* Washington, D.C., 1970.

Sweet, Frederick. *Miss Mary Cassatt: Impressionist from Pennsylvania.* Oklahoma, 1966.

Catlin, George (1796–1872) Catlin was born in Wilkes-Barre, Pennsylvania, in 1796. After studying and practicing law for a short time, he began painting portraits in Philadelphia, New York, Baltimore, and Richmond. When a delegation of Indians passed through Philadelphia in 1826, Catlin decided to devote his career to preserving their life style and customs through sketches and paintings. From 1830 to 1836, Catlin traveled among the Plains Indians between the Mississippi River and the Rocky Mountains. Sketching, painting, and collecting artifacts, he accumulated enough material on the Indians to form a traveling exhibition, which he took to major cities in America and Europe. Catlin remained in Europe for several years and traveled to South America in 1852. In 1870, he returned to New York, 2 years before his death. He was author of *The Manners, Customs, and Conditions of the North American Indians, Notes of Eight Years' Residence and Travel in Europe,* and *Life Among the Indians.*

McCracken, Harold. *George Catlin and the Old Frontier.* New York, 1959.

Chase, William Merritt (1849–1916) Chase was born in Williamsburg (now Ninevah), Indiana. In 1867, he began taking art lessons from a local painter. In 1869, he left for New York, where he studied at the National Academy of Design. In 1871, he returned to his family, who were then living in St. Louis. Local admirers of Chase's work gathered funds to enable him to study at the Royal Academy in Munich. He left in 1872 and spent 6 years abroad, sharing studios and travels with Frank Duveneck and John Twachtman. In 1878, upon his return to New York, Chase began to teach. Between 1881 and 1885, Chase traveled in Spain, France, Holland, and England. In London, he and Whistler painted each other's portrait. Chase taught at many schools, among them The Art Students League of New York, the Brooklyn Art School, The Art Institute of Chicago, and The Pennsylvania Academy of the Fine Arts. In 1896, he opened The Chase School, renamed the New York School of Art in 1898. In 1902, Chase began taking art classes to Europe for the summer. His many students included Charles Sheeler, Joseph Stella, Marsden Hartley, and Georgia O'Keeffe. In 1902, he was elected a member of "the Ten." He died in New York City.

Roof, Katherine M. *The Life and Art of William Merritt Chase.* New York, 1917.

Chamberlain, John (1927–) Chamberlain was born in Rochester, Indiana, and spent his childhood in Chicago, Illinois. From 1941 to 1944, he served in the United States Navy and from 1950 to 1952, he studied at The Art Institute of Chicago. To complete his art training he attended Black Mountain College in North Carolina in 1955. Chamberlain moved

to New York in 1956. Influenced by David Smith and abstract expressionist painting, Chamberlain began welding metal sculpture. From 1959 to 1963, he worked exclusively with scrap metal automobile parts from junk yards, and in 1962, he began painting his pieces. In 1967 and 1968, he started producing his crushed aluminum sculptures, and in 1970, he changed to melted plexiglas treated with resin and watercolor. He presently resides in New York and Los Angeles.

Waldman, Diane. *John Chamberlain: A Retrospective Exhibition.* New York, 1971.

Christo (1935–) Christo Javacheff was born in Gabrovo, Bulgaria. He studied at the Fine Arts Academy in Sofia from 1952 to 1956, when he went to Prague to study theater design. After spending a semester at Vienna's Fine Arts Academy in 1957, he visited Florence and lived in Geneva for several months. He moved to Paris in 1958 and became associated with the *nouveau réalistes* in Paris in 1961. Christo moved to New York City in 1964. He started making his first package art and wrapped objects in 1958. One of his first large-scale environmental pieces was the placing of vertically stacked oil drums in Cologne harbor in 1958. By 1969, his projects had attained the ambitious scale and intention of *Wrapped Coast* at Little Bay in Sydney, Australia. In 1972, he draped 200,000 square feet of nylon fabric across a valley in Colorado, and in 1976, he made *Running Fence* near San Francisco, California.

Alloway, Lawrence. *Christo.* New York, 1969.
Bourdon, David. *Christo.* New York, 1970.

Chicago, Judy (1939–) Judy Chicago was born in Chicago, Illinois, and began taking art lessons at The Art Institute of Chicago in 1947. She received her B.F.A. and M.F.A. degrees from the University of California at Los Angeles, where she held an assistantship in sculpture in 1962 and also studied painting. After completing her degrees, Chicago studied spray painting at an auto body school. She taught at Fresno State University in 1971 before organizing the Feminist Art Program at the California Institute of Arts in Valencia. She also was a leader in the creation of *Womanhouse* in 1973.

Chicago, Judy. *Through the Flower: My Struggle as a Woman Artist.* New York, 1975.

Church, Frederic Edwin (1826–1900) Born in Hartford, Connecticut, Church received his first art training from two local painters. From 1844 to 1848, he was a pupil of Thomas Cole, living in the artist's home in Catskill, New York. After Cole died, Church took a studio in New York City, where he exhibited at the National Academy and the American Art-Union. In 1848, Church was made an Associate of the National Academy and in 1849, a full member. In 1853 and 1857, he traveled to Ecuador and in 1859, to Labrador to study icebergs. In 1865, Church visited the West Indies, and in 1868, he toured Europe and the Near East. Crippled with rheumatism in 1877, Church spent the last years of his life at his home on the Hudson River, Olana.

Huntington, David C. *The Landscapes of Frederic Edwin Church: Vision of an American Era.* New York, 1966.

Clarke, John Clem (1937–) Clarke was born in Bend, Oregon, and grew up on a ranch. He studied at Oregon State University from 1955 to 1957, in Mexico City in 1959, and received his B.F.A. in 1960 from the University of Oregon. Clarke served in the United States Coast Guard for 1 year, and then traveled to Paris, Greece, and Spain during the years 1961 to 1964. Clarke moved to New York City in 1964 and had his first one-man show at Kornblee Gallery in 1963. Clarke made his first prints in 1969. Clarke continues to live in the city, as well as in the British West Indies and on a farm in upstate New York.

Siegel, James. "An Art of Transmission: John Clem Clark at Kornblee," *Arts Magazine,* vol. 43, summer 1969, p. 44.

Cole, Thomas (1801–1848) Born in England, Cole worked as an engraver's assistant in Liverpool around 1817 before immigrating to the United States with his family in 1818. Cole than worked as a wood engraver in Philadelphia for about 6 months. From 1820 to 1823, Cole taught painting and drawing at a seminary for girls in Steubenville, Ohio, while learning the rudiments of painting from a portrait painter named Stein. From 1823 to 1825, Cole supported himself through small commissions in Philadelphia, while studying at The Pennsylvania Academy of the Fine Arts. Early in 1825, Cole moved to New York and made his first sketching trip along the Hudson River. Cole spent the summer of 1826 in Catskill, New York, which was to be his custom until 1836, when he finally settled there. From 1829 to 1832, Cole toured England and Europe. From 1841 to 1842, Cole made a second trip to Europe. In 1844, Cole took as his first pupil Frederic E. Church. Cole died in Catskill after a brief illness.

Merritt, Howard S. *Thomas Cole.* New York, 1969.
Noble, Louis Legrand. *The Life and Works of Thomas Cole.* New York, 1853; ed. by Elliot S. Vessell, Cambridge, Mass., 1964.

Coleman, Glenn O. (1884–1932) Born in Springfield, Ohio, Coleman studied art and worked as a newspaper illustrator in Indianapolis, Indiana, before moving to New York in 1905. From 1906 to 1909, he studied at the New York School of Art with William Merritt Chase and Robert Henri. Except for a few brief visits to Cuba and Canada, Coleman lived in New York his entire life. His work was included in the 1913 Armory Show, and from 1912 to 1916, he contributed illustrations to *The Masses.* Coleman died in Long Beach, Long Island.

Glassgold, C. Adolph. *Glenn O. Coleman.* New York, 1932.

Copley, John Singleton (1738–1815) Copley was born in Boston, Massachusetts, in 1738, son of a tobacconist. After his father died, Copley's mother married Peter Pelham, a mezzotint engraver who introduced his stepson to printmaking techniques and art. At the age of 16 Copley launched his career as a portrait painter in Boston, and by the 1760s, he had become the foremost artist in the Colonies. Although successful in

the Colonies, Copley yearned to test his talents against the great painters of Europe and in 1766 sent his painting *Boy with a Squirrel* to be exhibited with the Society of Artists in London. Although encouraged by the reception of his work, Copley was unable to travel to Europe until 1774, when he visited Paris, Rome, Italy, Holland, and Flanders before heading for England to join his family fleeing the outbreak of the Revolutionary war. Copley remained in England for the rest of his life, although he voiced sympathy for the American cause. In addition to a prosperous trade as a portrait painter, Copley also received a number of commissions for history paintings and won admission to the Royal Academy. He died of a stroke in London in 1815.

Prown, Jules David. *John Singleton Copley,* 2 vols. Cambridge, Mass. 1966.

Flexner, James Thomas. *John Singleton Copley.* Boston, 1948.

Cornell, Joseph (1903–1972) Cornell was born in Nyack, New York. He attended the Phillips Academy in Andover, Massachusetts, but never received any formal training in art. After high school, he worked for a while in his father's dry goods business. Cornell moved with his family to a house on Utopia Parkway in Flushing, New York, where he lived for the rest of his life. In the 1930s, he began making boxes in which he placed found and fabricated objects. He was an ardent collector of old documents and prints, which he kept so that they could be used in his sculptures. During World War II, he became associated with André Breton, Max Ernst, Salvador Dali, and Piet Mondrian, immigrant artists who had settled in New York City. In the 1950s, however, Cornell became a recluse. He had his first one-man show in 1939 at the Julian Levy Gallery in New York City. Cornell was also included in many surrealist group exhibitions. Cornell died at his home on Utopia Parkway.

Ashton, Dore. *A Joseph Cornell Album.* New York, 1974.

Joseph Cornell. New York, Solomon R. Guggenheim Museum, 1967.

Cottingham, Robert (1935–) Cottingham was born in Brooklyn, New York. He received his art training and degree in advertising art from Pratt Institute in Brooklyn, New York. Cottingham's first one-man show was in Los Angeles in 1968 at the Molly Barnes Gallery. He presently resides in London, England.

Crawford, Thomas (181?–1857) It is believed that this sculptor was born in New York City to Irish parents, although he was possibly born in Ireland and brought to the United States as a young child. He was apprenticed to the stonecarving firm of Frazee and Launiz in New York City until 1835, when he went to Rome to study under the Danish neoclassical sculptor Thorvaldsen. Although Crawford returned to New York on several occasions, he settled permanently in Rome, where he was a prominent member of the American community. He received several important commissions for the United States Capitol including the dome statue *Freedom,* the bronze doors for the House and Senate, and the pediment for the Senate wing.

Gale, Robert. *Thomas Crawford: American Sculptor.* Pittsburgh, 1964.

Cropsey, Jasper (1823–1900) Jasper Cropsey was born in Rossville, New York. He first studied architecture in the office of Joseph Trench but after 5 years turned to landscape painting. He was a pupil at the National Academy of Design in New York City, exhibited there in 1843, and was elected a member in 1851. Cropsey traveled in Europe from 1847 to 1850, returning to London in 1857, where he stayed until 1863 and exhibited at the British Royal Academy. Upon his return to America, Cropsey continued painting landscapes. He died in Hastings-on-Hudson, New York, in 1900.

The Cleveland Museum of Art, *Jasper Francis Cropsey 1823–1900.* July 8–August 16, 1970.

Cunningham, Imogen (1883–1976) Born one of ten children in Portland, Oregon, Cunningham graduated from the University of Washington, where she majored in chemistry. In 1909, she received a scholarship to study photographic chemistry in Dresden, Germany. Upon her return to the United States in 1910 she established a commercial portrait studio in Seattle, Washington. Cunningham had her first one-woman show at the Brooklyn Museum of Arts and Sciences in 1912. In 1915, she photographed her husband nude on Mount Ranier—perhaps the first male nude photograph taken by a woman. In 1932, Cunningham founded the f/64 Group, along with Ansel Adams, Willard Van Dyke, Edward Weston, and several other photographers who shared the same interest in sharply focused, detailed pictures. Cunningham remained active until her death on June 24, 1976.

Mann, Margery. *Imogen! Imogen Cunningham Photographs.* Seattle, 1974.

Currier, Nathaniel (1813–1888) The lithographer Nathaniel Currier was born in Roxbury, Massachusetts, and served his apprenticeship under William and John Pendleton, owners of the first lithographic shop in Boston. This apprenticeship took Currier to Philadelphia in 1829 and to New York in 1833. In 1835, Currier established his own lithographic shop in New York with J. H. Bufford. His association with James M. Ives began in 1857, and the firm of Currier and Ives, carried on by their sons, flourished until 1907. Currier retired in 1880. He died in New York City.

Peters, Harry T. *Currier and Ives: Printmakers to the American People.* 1942. *Currier and Ives Chronicles of America.* Maplewood, N.J., Hammond Publishers, 1968.

Curry, John Steuart (1897–1946) Curry was born on a farm in Dunavent, Kansas. He studied at the Kansas City Art Institute in 1916 and from 1916 to 1918, at The Art Institute of Chicago. In 1919, he moved to New Jersey, where he worked as a free-lance illustrator. In 1926 he went to Paris, where he lived for a year. In the 1930s, after traveling with the Ringling Brothers Circus for several months in 1932, Curry taught at Cooper Union in New York and the Art Students League until 1936. In 1934, he worked for a WPA Federal Art Project, painting two lunettes on the fifth floor of the Justice Department building in Washington, D.C. From 1936 to 1938, he was the artist in residence at Agricultural College, University of Wisconsin. In 1937, he was commissioned to paint murals

for the Kansas state capitol in Topeka. He died in Madison, Wisconsin, in 1946.

John Steuart Curry. Kansas State University, 1970.

John Steuart Curry. *American Artists Group, Inc.* New York, 1945.

Davies, Arthur Bowen (1862–1928) Born in Utica, New York, Davies first studied art from a local artist in 1877. A year later, he moved with his family to Chicago and enrolled in the Chicago Academy of Design. After traveling to Colorado for health reasons in 1879, Davies moved to Mexico City, where he worked as a draftsman for an engineering firm and studied at the Mexico City Academy of Art. He returned to Chicago in 1882 and entered The Art Institute of Chicago. After moving to New York City in 1886, he worked as a magazine illustrator and studied at the Gotham Art School and The Art Students League. Davies bought a farm in Congers, New York, and moved there in 1892. He exhibited at the National Academy of Design in 1893 as he would continue to do annually until his death. Davies visited Italy in 1893. He exhibited with "the Eight" at the Macbeth Gallery in 1908, and as president of the American Association of Painters and Sculptors was chief organizer of the Armory Show in 1913, along with Walt Kuhn and Walter Pach. Davies exhibited six of his paintings in that show. In addition to his easel paintings, Davies also painted murals and designed tapestries, which were executed by the Gobelins Manufacturers in Paris. Davies died in Florence, Italy, in 1928.

Cortissoz, Royal. *Arthur B. Davies. New York, 1931.*

Davis, Douglas (1934–) Born in Washington, D.C., Davis received his B.A. from American University in 1956 and his M.A. from Rutgers University in 1958. From 1968 to 1970, Davis was a contributing editor to *Art in America;* from 1970 to 1975, he was an art critic for *Newsweek* magazine; and in 1976, he became critic in the arts for that magazine. After he moved to New York in 1970, he began to work in video. Davis presently lives and works in that city.

Davis, Douglas. *Art and the Future.* New York, 1973.

Davis, Stuart (1894–1964) Davis was born in Philadelphia, Pennsylvania, where his father was art director of the *Philadelphia Press,* whose staff at that time included John Sloan, William Glackens, and Everett Shinn. In 1901, Davis's family moved to East Orange, New Jersey, where his father was art editor and cartoonist for the *Newark Evening News.* In 1910, Davis left high school after only a year to study with Robert Henri in New York. By 1913, he was an illustrator for *The Masses* when John Sloan was art editor. He also drew illustrations for *Harper's Weekly.* His watercolors were exhibited in the Armory Show in 1913, and he exhibited with the Society of Independent Artists in 1917. Davis was a cartographer for the United States Army Intelligence Department in 1918. He lived in Paris from 1928 to 1931, and in 1931, he taught at The Art Students League of New York. From 1933 to 1939, he worked on several art projects for the WPA. He joined the Artists Union in 1934 and was editor of *Art Front* and national secretary of the American Artists Congress in

1935. In 1940, he began teaching at the New School for Social Research, where he remained for 10 years. He also taught at Yale University from 1954 to 1964. Among his retrospective exhibitions was a show at the Museum of Modern Art in New York in 1945.

Blesh, Rudi. *Stuart Davis*. New York, 1960.
Sweeney, James Johnson. *Stuart Davis*. New York, 1945.
Kelder, Diane. *Stuart Davis*. New York, 1971.

De Kooning, Willem (1904–) De Kooning was born in Rotterdam, Holland, and was apprenticed to a local firm of commercial artists and decorators at the age of 12. He also attended night classes at the Rotterdam Academy of Fine Arts and Techniques until 1924. De Kooning emigrated to the United States in 1926, first supporting himself as a house painter. From 1935 to 1936, he worked for the Federal Art Project on both mural and easel divisions. During the summer of 1948, de Kooning taught at Black Mountain College, North Carolina, and from 1950 to 1951 taught at Yale University. In 1963, de Kooning became an American citizen, and in 1964, he was awarded the Freedom Award Medal by President Lyndon B. Johnson for his contribution to the arts. Known primarily as an abstract expressionist painter, de Kooning has, since 1969, also worked with bronze sculpture. De Kooning lives at The Springs, Southhampton.

Hess, Thomas B. *Willem de Kooning*. Greenwich, Conn., 1968.

DeMonte, Claudia (1947–) Born in Astoria, New York, DeMonte moved to Washington, D.C., in 1969 upon graduation from the College of Notre Dame in Maryland. In 1971, she received her M.F.A. from the Catholic University of America in Washington, D.C. She held her first teaching position at Bowie State College in Maryland in 1971, and in 1972 began teaching at the University of Maryland. In 1976, her first major museum exhibition was held at the Corcoran Gallery of Art in Washington, D.C. DeMonte now lives in Washington, D.C., and New York City and heads the design division of the University of Maryland.

Claudia 1976–77. Washington, D.C., Corcoran Gallery of Art, 1976.

Demuth, Charles (1883–1935) Demuth was born in Lancaster, Pennsylvania. A hip injury suffered at the age of 4 left him permanently lame. After private art lessons, Demuth studied at the Franklin and Marshall Academy (a private preparatory school) from 1899 to 1901. In 1901, he began his formal art education at the Drexel Institute, and in 1905, he entered The Pennsylvania Academy of the Fine Arts and studied with William Merritt Chase and Thomas Anshutz. In 1907, he made his first trip to Europe, and upon his return in 1908, he reentered The Pennsylvania Academy of the Fine Arts and met the poet William Carlos Williams, who became his lifelong friend. He returned to Paris in 1912 and met Marcel Duchamp, Marsden Hartley, and Gertrude and Leo Stein, and from 1913 to 1914 studied at the Académie Colarossi and the Académie Julian. In the spring of 1914, he returned to the United States. In the teens, Demuth worked primarily with watercolor, illustrating

Émile Zola's *Nana* and Henry James's *The Turn of the Screw* and *The Beast and the Jungle*. In the twenties, he began his industrial landscapes, watercolor still-lifes, and metaphorical portraits. He exhibited at Alfred Stieglitz's Intimate Gallery in 1926 and at An American Place in the thirties. Suffering from diabetes, Demuth died in Lancaster, Pennsylvania, in 1935.

Farnham, Emily. *Charles Demuth: Behind a Laughing Mask.* Norman, Okla., University of Oklahoma Press, 1971.

Ritchie, Andrew. *Charles Demuth.* New York, 1950.

Diebenkorn, Richard (1922–) Born in Portland, Oregon, Diebenkorn served as an artist in the United States Marine Corps from 1943 to 1945. In 1949, he received his B.A. from Stanford University in California. In 1946, he studied with David Park at the California School of Fine Arts, and in 1951, he received his M.A. from the University of New Mexico in Albuquerque. Diebenkorn has taught at the California School of Fine Arts (1947 to 1950), the University of Illinois in Champaign (1952 to 1953), and the California College of Arts and Crafts in Oakland (1955 to 1957). From 1963 to 1964, he was artist-in-residence at Stanford University. Since 1966, Diebenkorn has taught at the University of California in Los Angeles. He lives in Santa Monica, California.

Richard Diebenkorn. New York, Albright-Knox Gallery, 1976.

Diller, Burgoyne (1906–1965) Diller was born in New York City but spent his childhood in Battle Creek, Michigan. He studied at Michigan State College in East Lansing from 1926 to 1927 and a year later moved to New York City, where he attended The Art Students League from 1928 to 1931. From 1935 to 1940, he headed the mural division of the Federal Art Project in New York and provided artists such as Stuart Davis, Arshile Gorky, and Fedinand Léger with mural commissions. In 1940, he was appointed assistant technical director of the WPA New York Art Project and from 1941 to 1942 served as director of the WPA New York City War Service Art Section. He was commissioned a lieutenant in the United States Navy in 1941, working in the visual aid division. In 1945, he began teaching at Brooklyn College, and from 1943 to 1964, he taught at the Pratt Institute. He was also a visiting critic at the Yale University School of Art and Architecture in 1954. Diller was a sculptor as well as a painter.

Burgoyne Diller: Paintings, Sculptures, Drawings. Minneapolis, Walker Art Center, 1971.

Dine, Jim (1935–) Born in Cincinnati, Ohio, Dine attended the Art Academy of Cincinnati in the evening from 1952 to 1953. He also studied at the School of the Museum of Fine Arts in Boston and the University of Cincinnati before graduating from Ohio University in Athens in 1958. In the same year that he received his B.F.A., Dine moved to New York, where he met Jasper Johns and Robert Rauschenberg. In 1959, he exhibited with Claes Oldenburg at the Judson Gallery and began to participate in happenings. From 1965 to 1966 and again from 1967 to 1971, Dine

lived in London. From 1966 to 1967, he taught at Cornell University. Presently, he lives and works in Putney, Vermont.

Gordon, John. *Jim Dine*. New York, 1970.

Di Suvero, Mark (1933–) Born in Shanghai to Italian parents, Marco Polo di Suvero emigrated to the United States with his family in 1941, settling in San Francisco. He attended San Francisco City College and the University of California at Santa Barbara before receiving his B.A. in philosophy from the University of California at Berkeley. In 1957, he moved to New York City, where he began exhibiting his art until 1960, when he suffered a near fatal accident which confined him to a wheel chair for 2 years. During this period di Suvero made small welded metal sculptures and by 1964 was able to work on a larger scale. In 1971, in protest against the war in Vietnam, di Suvero moved to Europe. In addition to several major shows in Europe, di Suvero was given a one-man show at the Whitney Museum of American Art in 1975.

Monte, James K. *Mark di Suvero*. New York, 1975.

Dove, Arthur Garfield (1880–1946) Born in Canandaigua, New York, Dove attended Hobart College and then transferred to Cornell University, where he received his B.A. in 1903. After leaving Cornell, Dove moved to New York City, where he worked as a free-lance illustrator for *Colliers, Saturday Evening Post,* and *Harpers*. In 1907, he traveled to France to study painting, returning in 1909 to New York. The following year he had his first exhibition at Alfred Stieglitz's 291 gallery and launched a friendship with the photographer that would last for the rest of his career. With few sales of his work, Dove struggled to support himself with a succession of jobs including farming and lobster fishing. From 1920 to 1927, he lived on a series of boats. Despite his itinerant life, Dove continued to paint and exhibit at Stieglitz's galleries, making his first collage in 1924 and occasionally selling his work to discerning collectors such as Duncan Phillips. Dove died in Huntington, Long Island, in 1946.

Haskell, Barbara. *Arthur Dove*. Boston, 1974.
Arthur G. Dove. Berkeley and Los Angeles, University of California Press, 1958.

Downing, Andrew Jackson (1815–1852) Born in Newburgh, New York, Downing's interest in botany and landscaping began when he and his brother managed a nursery founded by their father. The author of many treatises on landscaping, including *A Treatise on the Theory and Practice of Landscape Gardening* (1841), Downing became editor of the periodical *Horticulturist* in 1846. In 1851, he was commissioned to landscape the grounds of the White House, the Capitol building, and the Smithsonian Institution. Downing was killed when the steamship *Henry Clay* burned on the Hudson River.

Du Bois, Guy Pène (1884–1958) Born in Brooklyn, New York, Du Bois studied at the New York School of Art from 1899 to 1905, most notably with

William Merritt Chase and Robert Henri. In 1905, he traveled to Paris to study art and in 1906, he exhibited at the Salon des Beaux Arts. He returned to New York that year to work as a reporter and art critic for the *New York American,* the *New York Herald Tribune, The New York Evening Post,* and *Vogue* magazine. He was editor of *Arts and Decoration* from 1913 to 1920. He exhibited his paintings at the Independent Show in New York in 1908 and at the Armory Show in 1913. Du Bois also taught at The Art Students League in the twenties and thirties and worked on several WPA art projects during the thirties. He lived in Europe from 1924 to 1930. His autobiography, *Artists Say the Silliest Things,* was published by the American Artists Group in 1940.

Cortissoz, Royal. *Guy Pène Du Bois.* New York, 1931.

Duchamp, Marcel (1887–1968) Born near Blainville in Normandy, France, Duchamp began painting in a post-impressionist manner in 1902. From 1904 to 1905 he studied painting at the Académie Julian in Paris. In 1912 Duchamp executed *Nude Descending a Staircase.* He exhibited four works in the Armory Show in 1913 and sold all four (including *Nude Descending a Staircase,* which was bought sight unseen). Duchamp made his first readymade in 1914 in the form of a bottle rack. In 1915 he visited the United States, where he met Man Ray and stayed in New York with his patrons, Louise and Walter Arensberg. In 1916 he was a founding member of the Society of Independent Artists, Inc., where in 1917 he submitted his readymade *Fountain* for exhibition under the pseudonym of "R. Mutt." The rejection of the *Fountain* led to both Duchamp and Arensberg resigning from the society. In 1923 Duchamp returned to Paris and remained there until 1942, making three brief visits to New York (1926–1927, 1933–1934, 1936). By 1924 Duchamp was deeply involved in chess tournaments and remained so for the rest of his life, winning several championships including the Paris Chess Tournament of 1932. That same year he coined the name "mobiles" for Calder's sculptures. In 1946 Duchamp returned permanently to New York, and in 1947, he applied for United States citizenship, becoming a naturalized citizen in 1955. In 1960 he was elected to the National Institute of Arts and Letters. Duchamp died in Neuilly, France, on October 2, 1968.

D'Harnoncourt, Anne, and Kynaston McShine, eds. *Marcel Duchamp.* Greenwich, Connecticut, 1973.
Schwartz, Arturo. *The Complete Works of Marcel Duchamp.* New York, 1969.

Durand, Asher Brown (1796–1886) Durand was born in Jefferson Village (now Maplewood), New Jersey, and first learned the basics of engraving in his father's watchmaking shop. In 1812, he served his apprenticeship under the engraver Peter Maverick in Newark and in 1871 became his partner. Durand later went on his own and in 1823 completed an engraving after Trumbull's *Declaration of Independence,* establishing his reputation as an engraver. Between 1835 and 1836, Durand began to concentrate on painting. His first works were portraits, but he soon became identified with the Hudson River School. From 1840 to 1841,

Durand traveled abroad. In 1826, he helped found the National Academy, and he was its president from 1845 to 1861. Durand retired in 1869 to New Jersey, where he died in 1886.

Durand, John. *The Life and Times of Asher B. Durand.* New York, 1894; reprint, New York, 1968.

Duveneck, Frank (1848–1919) Duveneck was born Frank Decker in Covington, Kentucky. When his father died in 1849, his mother married Joseph Duveneck, and Frank adopted that last name. Duveneck worked as a church decorator in Covington and in Cincinnati before attending the Munich Academy in 1870. In 1874, he had his first exhibition in Cincinnati, where he worked until 1875, returning then to Munich. In 1877, he traveled to Venice with William Merritt Chase, remaining 9 months. Upon his return to Munich, Duveneck opened an art school for American and English students. In 1882, Duveneck returned to Venice, where he worked at painting and etching until 1885. Upon his marriage to a painter, Elizabeth Boott, in 1886, he moved to Florence. After the death of his wife in 1888, Duveneck returned to the United States, and in 1890, he began to teach at the Cincinnati Art Museum. He later joined the faculty of the Art Academy of Cincinnati in 1900. Though Duveneck continued to travel and exhibit abroad, he made his home in Cincinnati, where he died in 1919.

Duveneck, Josephine Whitney. *Frank Duveneck: Painter-Teacher.* San Francisco, 1970.

Eakins, Thomas (1844–1916) Eakins was born in Philadelphia. After graduating from Central High School in 1861, he studied drawing at The Pennsylvania Academy of the Fine Arts and took classes in anatomy at Jefferson Medical College. In 1866, he went to Paris and studied at the École des Beaux-Arts under Jean Léon Gérôme and Augustin-Alexandre Dumont. During a trip to Spain from 1869 to 1870, he admired the work of Velasquez and Ribera. In 1870, Eakins returned to Philadelphia and resumed his studies at the Academy and the Jefferson Medical College. In 1879, Eakins became professor of drawing and painting at The Pennsylvania Academy, and in 1882, he became director of the Academy. In 1886, he was forced to resign, ostensibly because of his scandalous use of a nude male model in a women's class. He subsequently taught at The Art Students League in Philadelphia. In 1884, he married Susan Hannah Macdowell, a former pupil. In 1896, he had his only one-man show during his lifetime at the Earle Galleries in Philadelphia. In 1902, he was elected to the National Academy of Design. After 1910, he painted little due to poor health, and in 1916, he died in the house he had lived in most of his life.

Goodrich, Lloyd. *Thomas Eakins: His Life and Work.* New York, 1933.
Hendricks, Gordon. *Thomas Eakins.* New York, 1974.
Hendricks, Gordon. *The Photographs of Thomas Eakins.* New York, 1972; *The Sculpture of Thomas Eakins.* Washington, D.C., 1969.

Eastman, Seth (1808–1875) Eastman was born in Brunswick, Maine. He was appointed to the United States Military Academy in 1824 and graduated

2 years later as a second lieutenant. His first posts were at Fort Crawford, Wisconsin (1829 to 1830) and Fort Snelling, Minnesota (1830 to 1831), where he began sketching Western landscapes. In 1833, he returned to West Point as an assistant teacher of drawing. During this time Eastman began to exhibit regularly at the National Academy of Design and was elected "Honorary Member Amateur" of the Academy in 1839. Eastman served in the Florida (Seminole) War from 1840 to 1841. He then returned to Fort Snelling, where he stayed until 1848, attending to his military duties and studying and drawing Indian life. Eastman was assigned in 1850 to the Bureau of the Commissioner of Indian Affairs in Washington, D.C., to illustrate Henry R. Schoolcraft's six-volume history of Indian tribes in the United States. He returned to regular army duty in 1855 and served throughout the Civil War. He retired from active service in 1863 and 3 years later was breveted colonel and brigadier general. In 1867, Eastman was commissioned to paint nine scenes of Indian life based on his Minnesota sketches and seventeen views of United States forts for the United States Capitol. Eastman died in Washington, D.C.

McDermott, John Francis. *The Art of Seth Eastman.* Washington, D.C., 1960.

McDermott, John Francis. *Seth Eastman's Mississippi.* Urbana, Ill., University of Illinois Press, 1973.

Eggleston, William (1939–) Born in Memphis, Tennessee, near his family's cotton farm, Eggleston attended Vanderbilt University, Delta State College, and the University of Mississippi. In 1962, he discovered the work of Cartier-Bresson and began to pursue photography as a serious study. Since the late sixties, his work has been in color. In 1974, he taught at the Carpenter Center, Harvard University.

Szarkowski, John. *William Eggleston's Guide.* Cambridge, Mass., and London, 1976.

Evans, Walker (1903–1975) Evans was born in St. Louis, Missouri, and grew up in the Chicago suburb of Kenilworth. When his parents separated, he moved to New York City with his mother and was educated at the Loomis School in Connecticut and Phillips Academy in Andover, Massachusetts; he also attended Williams College from 1922 to 1923. In 1926, Evans went to Paris, returning to the United States in 1927. After several temporary jobs, he decided to become a photographer. In 1930, he illustrated Hart Crane's *The Bridge.* From 1931 to 1933, he shared a house in Greenwich Village with Ben Shahn. In 1933, Evans had his first one-man exhibition at The Museum of Modern Art. In 1935, he joined the photographic unit of the Farm Security Administration. In 1941, Evans illustrated James Agee's book *Let Us Now Praise Famous Men.* In 1943, Evans became a contributing editor at *Time* magazine, moving to *Fortune* in 1945, where he spent nearly 20 years. In 1964, Evans was appointed professor of graphic design at Yale University, retiring in 1971, the year of his major retrospective exhibition at The Museum of Modern Art. He died in New Haven, Connecticut.

Szarkowski, John. *Walker Evans.* New York, 1971.

Evergood, Philip (1901–1973) Evergood was born Philip Blashki in New York City. His father, Meyer Evergood Blashki, was a painter. When Evergood was 8 years old, his mother sent him to boarding school in England. He attended Cambridge University but left in 1921 to study art at the Slade School in London. Evergood returned to New York in 1923 and continued his studies at The Art Students League under George Luks. In 1924, he went to Paris and enrolled at the Académie Julian. It was at this time that he met his future wife, Julia Cross, a ballet dancer. After a trip to Italy he returned to America in 1926 and the following year had his first one-man show at the Dudensing Gallery in New York. After another trip to Europe, Evergood settled in New York in 1931. From about 1934 to 1937, Evergood worked for the Public Works of Art Project and its successor, the Federal Art Project of the WPA. Evergood was a member of the Artists Committee of Action and the American Artists Congress and president of the Artists Union, all of which were organizations concerned with the civil rights of artists. In 1946, he sold his New York house and moved to Long Island. He moved again in 1952 to Southbury, Connecticut. In 1960, the Whitney Museum of American Art gave Evergood a retrospective exhibition. In 1963, he moved to Bridgewater, Connecticut, where he died a decade later.

Baur, John I. H. *Philip Evergood.* New York, 1975.

Feke, Robert (c. 1705–c. 1750) Feke was born in Oyster Bay, Long Island. Little is known about his life. He was married in Newport in 1742, and was a mariner for a time. Between 1741 and 1750, working in Boston, Philadelphia, and Newport, he produced seventy portraits. He then mysteriously disappeared from history, and according to some sources, died in the West Indies.

Foote, Henry. *Robert Feke.* Cambridge, Mass., 1930.

Flannagan, John (1895–1942) Flannagan was born in Fargo, North Dakota. He was placed in the St. John's Orphanage in Little Falls, Minnesota, from 1905 to 1910. He studied at St. John's University in Collegeville, Minnesota, from 1910 to 1913, then at The Minneapolis School of Art from 1914 through 1918. He served in the Merchant Marines from 1918 until 1920, which enabled him to travel through Europe and South America. Flannagan worked as a farmhand for Arthur B. Davies in Congers, New York, from 1922 to 1923. There he began to paint and also to carve wood. Davies offered Flannagan encouragement, and shortly afterwards, he participated in a 1923 group show at The Montross Gallery in New York City. Flannagan lived in Rockland County and in Woodstock, New York, from 1924 until 1930 and in Clifden, Ireland, from 1930 to 1931. He began carving directly into stone about 1925. After receiving a Guggenheim Fellowship, Flannagan made another trip to Ireland from 1932 to 1933. He worked in Woodstock and in New York City from 1934 to 1938. Flannagan died in New York City.

John B. Flannagan: Sculpture/Drawings, 1924–1938. Saint Paul, Minn., 1973.

Flavin, Dan (1933–) Flavin was born in Jamaica, New York. In 1953, he graduated from the United States Air Force Meteorological Technical

Training Program. In 1954, he studied in Osau-ni, Korea. In 1956, Flavin attended Hans Hofmann's school in New York City and took art history courses at The New School for Social Research. From 1957 to 1959, he studied at Columbia University. In 1961, Flavin's first one-man show was held at The Judson Gallery in New York City. He began adding electric light to his constructions in 1961. He lives in Garrison, New York and Bridgehampton, Long Island.

Drawings & Diagrams: 1963–1972 by Dan Flavin. St. Louis, The St. Louis Art Museum, 1973.

Corners, Barriers & Corridors in Fluorescent Light by Dan Flavin, vol. II. St. Louis, The St. Louis Art Museum, 1973.

Frankenthaler, Helen (1928–) Frankenthaler was born in New York City. In 1949, she received her B.A. from Bennington College in Vermont. In 1947, she studied at The Art Students League of New York City. During the summer of 1948, Frankenthaler traveled in Europe. She entered Columbia University for one term in 1949. In 1950, she spent 3 weeks in a summer study course with Hans Hofmann in Provincetown, Massachusetts. Also in that year, through the art critic Clement Greenberg, Frankenthaler met the leading abstract expressionists. In 1951, Frankenthaler had her first one-woman exhibition at the Tibor de Nagy Gallery. In 1952, Frankenthaler began to stain her canvas with paint. In 1953, Kenneth Noland and Morris Louis visited her studio. In 1958 after her marriage to Robert Motherwell, Frankenthaler traveled extensively through France and Spain and rented a villa at St. Jean de Luz that summer to paint. From 1958 through 1961, she taught on a part-time basis for the School of Education at New York University. In 1969, she produced her first lithographs. Frankenthaler established her Provincetown studio in a barn during the summer of 1961 and continued to paint there during the summers until 1969, spending winters in New York City. Frankenthaler began using acrylic paints in 1963. From 1963 through 1965, she served on the Fulbright Selection Committee. Frankenthaler taught for the School of Art and Architecture at Yale University and for the School of Visual Arts in New York City in 1967. In 1963, she was a fellow at Calhoun College of Yale. In 1974, Frankenthaler was elected a member of The National Institute of Arts and Letters. She presently lives in New York City.

Gossen, E. C. *Helen Frankenthaler.* New York, 1969.

Rose, Barbara. *Frankenthaler.* New York, 1970.

French, Daniel Chester (1850–1931) French was born in Exeter, New Hampshire, and spent his boyhood in Cambridge and Concord, Massachusetts. His first instruction in modeling clay came from the artist Abigail May Alcott. During the 1870s, French studied anatomy with William Rimmer, drawing with William Morris Hunt, and modeling with John Quincy Adams Ward. When French was commissioned by the citizens of Concord to create the bronze sculpture *Minute Man,* he took a studio in Boston from 1873 to 1874. In 1875, he left for Florence, where he studied in the studio of Thomas Ball. Returning to America in 1877, French set up a studio in Washington, D.C., where he received commissions for numerous portrait sculptures of national figures. In

1886, French left for Paris. After 2 years, he was back in America, this time establishing a studio in New York. French achieved great success during his lifetime and remained active until 1930. He died at his Berkshire mountain home.

Cresson, Margaret. *Journey Into Fame: The Life of Daniel Chester French.* Cambridge, Mass., 1947.

Fuller, R. Buckminster (1895–) Fuller was born in Massachusetts. He left Harvard University in the middle of his freshman year and joined the United States Navy. While in the Navy for 2 years, he invented a seaplane rescue mast and boom and a vertical take-off aircraft. In 1917, Fuller devised energetic-synergetic geometry. In 1927, he began a period of research and development. His writing, including *Human Trends and Needs* and the *Inventory of World Resources,* is directed to social and architectural change. Calling himself a "scientific engineer" rather than an architect, Fuller has tackled the problem of enclosing living spaces in innovative ways since 1927, when he designed his "Dymaxion House" ("dynamic" plus "maximum service"). Although it proved impractical for widespread use, the house was built with a central supporting mast and cables. In 1933, the house was followed by a "Dymaxion" car, equally unique in design with a three-wheel chassis. Fuller's most significant contribution was the geodesic dome made of units of octahedrons or tetrahedrons and capable of covering large spaces without the use of beams or pillars. Fuller's geodesic dome was used for the American Pavilion at the Montreal Expo in 1967, the year that the architect was awarded the American Institute of Architect's gold medal. In 1970, Fuller designed the Samuel Beckett underground theater at St. Peter's College at Oxford, England. Fuller is a research professor at the University of Illinois in Carbondale, where he presently resides.

Marks, Robert W. *The Dymaxion World of Buckminster Fuller.* New York, 1960.

Genthe, Arnold (1869–1942) Genthe was born in Berlin. In 1888, he entered the University of Jena. Genthe also studied at the University of Berlin for 1 year, receiving his doctorate in philology from that institution in 1894. In 1895, Genthe came to the United States, settling in San Francisco as a tutor for the son of Baron Heinrich von Schroeder. Genthe decided to take photographs of the city to send his family in Germany. Largely a self-taught photographer, Genthe's first pictures were of San Francisco's Chinatown. In 1899, his work as a tutor ended and he decided to remain in the United States and pursue photography as a career. In 1904, Genthe traveled to Germany to collect his belongings. He documented the 1906 earthquake in San Francisco with a borrowed hand camera after all his equipment had been destroyed by the catastrophe. In 1911, Genthe had his first one-man show at the Vickery Galleries in San Francisco. In the same year, he moved to New York City. Presidents Theodore Roosevelt, William Howard Taft, and Woodrow Wilson sat for portraits by Genthe along with many other notables. In 1909, Genthe first published *Pictures of Old Chinatown.* In 1926, he published *Impressions of*

New Orleans, and in 1929, Genthe completed a volume of photographs of Isadora Duncan. He died in New Milford, Connecticut.

Genthe, Arnold. *As I Remember.* New York, 1936.

Gifford, Sanford Robinson (1823–1880) Born in Greenfield, New York, Gifford graduated from Brown University in 1842. After studying with a drawing master in New York City, he toured the Catskill and Berkshire mountains in 1846 and began his career as a landscape painter. In 1854, he was elected a National Academician by the National Academy of Design. Between 1855 and 1858, Gifford traveled widely in Europe as well as Greece, Syria, and Egypt, making numerous sketches, many of which he translated into finished paintings. After settling in New York, Gifford ventured to the American West to sketch the Rocky Mountains. After a long and successful career, Gifford died in New York City.

A Memorial Catalogue of the Paintings of Sanford Robinson Gifford, N.A. New York, The Metropolitan Museum of Art, 1881.

Glackens, William (1870–1938) Glackens was born in Philadelphia, Pennsylvania. After graduating from high school, he became an artist-reporter for the *Philadelphia Record,* and later, for the *Philadelphia Press.* John Sloan (with whom he had gone to high school), George Luks, and Everett Shinn also worked on the *Press* staff. In 1892, Glackens took night classes at The Pennsylvania Academy of the Fine Arts, where he studied briefly with Thomas Anshutz. In 1894, Glackens and Robert Henri shared a studio in Philadelphia. In 1895, Glackens made his way abroad while working aboard a cattle boat. In 1896, Glackens returned to the United States. In 1903, he and John Sloan illustrated volumes of the collected stories of Charles Paul de Kock. In 1904, Glackens exhibited with George Luks, Robert Henri, Maurice Prendergast, and Arthur B. Davies at The National Arts Club in New York City. In 1907, his paintings were rejected by the National Academy of Design. In 1908, he exhibited his work with "the Eight" at the Macbeth Galleries. In 1910, Glackens helped organize the Independents Exhibition in New York City. The summers of 1911 through 1916 were spent in Bellport, Long Island. In 1912, he went to Europe as a buyer for Dr. Albert C. Barnes, whose collection of French painting is one of the most outstanding in the United States today. For the 1913 Armory Show Glackens acted as chairman of the American selection committee. During this year, he illustrated Theodore Dreiser's *A Traveler at Forty.* In 1914, Glackens gave up illustration to paint full-time. In 1917, he was elected the first president of the Society of Independent Artists. From 1925 through 1932, Glackens visited France intermittently. On May 22, 1938, Glackens died suddenly while visiting Charles Prendergast in Westport, Connecticut.

William Glackens in Retrospect. St. Louis, The City Art Museum of St. Louis, 1966.

Glackens, Ira. *William Glackens and the Ashcan Group.* New York, 1957.

Goings, Ralph (1928–) Goings was born in Corning, California, and studied at the California College of Arts and Crafts and Sacramento State

College. His first one-man show was held at The Artists Cooperative Gallery in Sacramento in 1960, followed by exhibitions there in 1962 and at the Artists Contemporary Gallery in Sacramento in 1968. He has also had one-man shows at O. K. Harris in New York City in 1970 and 1973. He resides in Charlotteville, New York.

Gorky, Arshile (1904–1948) Vosdanig Manoog Adoian was born in Khorkom Vari Haiyote Dzor in Turkish Armenia. In 1908, he and his family moved to Aykestan, close to the city of Van. Along with his mother and sisters he was forced into Soviet Armenia in 1915 and remained there until 1919. Gorky, who changed his name in 1925, immigrated to the United States in 1920. Initially he lived in Providence, Rhode Island, and in Watertown, Massachusetts. From 1920 to 1921, Gorky studied at the Technical High School in Providence, and during the summer of 1921, he worked in the Hood Rubber Factory in Watertown. From 1922 to 1924, he lived in Boston, Massachusetts, where in 1922 he taught at the New School of Design. In 1925, Gorky moved to New York City and studied at the Grand Central School of Art, teaching there from 1925 to 1931. In the late twenties, he met David Burliuk, John Graham, and Stuart Davis. In 1932, Gorky became a member of the Association Abstraction-Creation. In 1933, Gorky began his friendship with Willem de Kooning. In 1934, his first one-man show was held at The Mellon Galleries in Philadelphia. From 1933 to 1934, he worked on The Public Works of Art Project and from 1935 through 1941, the Federal Art Project mural division in New York City. In 1935, he began the *Aviation* murals for Newark airport, and in 1939, he executed murals with the same title for the New York World's Fair. In 1939, Gorky became a United States citizen. In 1942, he taught military camouflage at the Grand Central School of Art. In 1944, he met André Breton, Giorgio de Chirico, Yves Tanguy, Matta and other surrealists-in-exile in New York City. In 1946, his Sherman, Connecticut, studio was destroyed by fire. Gorky died by suicide in Sherman, Connecticut, in 1948.

Rosenberg, Harold. *Arshile Gorky: The Man, The Time, The Idea.* New York, 1962.
Schwabacher, Ethel K. *Arshile Gorky.* New York, 1957.

Gossage, John R. (1946–) Born in New York City, Gossage studied with Lisette Model, Alex Brodovitch, and Bruce Davidson from 1962 to 1964. In 1964, he began to work as a free-lance photographer for magazines. In 1965, Gossage graduated from the Walden School in Washington, D.C. In 1973 and 1974, he received fellowships from the National Endowment for the Arts. Presently, he lives in Washington, D.C., and is on the faculty of the University of Maryland.

Gossage, John R. *The Nation's Capital in Photographs, 1976.* Washington, D.C., 1976.

Gottlieb, Adolph (1903–1974) Gottlieb was born in New York City. In 1920, he studied at The Art Students League, where his instructors were John Sloan and Robert Henri. In 1921, Gottlieb went to Europe, studying at the Académie de la Grande Chaumière in Paris from 1921 to 1923. In

1923, he returned to New York City, finished high school, and studied at Parsons School of Design. In 1930, Gottlieb had his first one-man show at The Dudensing Galleries. In 1935, he cofounded "the Ten," along with Ilya Bolotowsky, Lee Gatch, Mark Rothko, Joseph Solman, and others devoted to abstract painting. In 1936, Gottlieb worked for the WPA Federal Art Project, easel division. In 1937, he moved near Tuscon, Arizona. In 1939, Gottlieb returned to New York City and was commissioned by the United States Treasury Department's Section of Fine Arts to paint a mural for the United States Post Office in Yerington, Nevada. That summer, as he would in subsequent summers, Gottlieb stayed with Milton Avery in Gloucester, Massachusetts. In 1941, Gottlieb began to make his pictographs. In 1946, he began spending his summers in Provincetown, Massachusetts. In 1957, he exhibited work from his *Burst* series for the first time. In 1958, Gottlieb taught at The Pratt Institute in Brooklyn, New York, and at the University of California at Los Angeles. In 1960, he moved to East Hampton, Long Island. In 1966, a fire destroyed his studio and its contents. From 1967 to 1969, Gottlieb was an elected member of The Art Commission for New York City. In 1972, he also became a member of The National Institute of Arts and Letters. Gottlieb died in New York City.

Adolph Gottlieb: Paintings 1959–1971. New York, Marlborough Gallery, 1972.

Doty, Robert, and Diane Waldman. *Adolph Gottlieb*. New York, 1968.

Gowin, Emmet, (1941–) Gowin was born in Danville, Virginia. In 1967, he received his M.F.A. from the Rhode Island School of Design. Among his major influences are the work of Walker Evans, Alfred Stieglitz, Robert Frank, and Harry Callahan, his teacher in graduate school. He presently lives in Pennsylvania and teaches at Princeton University.

Emmet Gowin Photographs. New York, 1976.

Graham, John D. (1887–1961) Born Ivan Gratianovitch Dombrovski in Kiev, Russia, Graham studied at the University of Kiev and served in the infantry. Imprisoned after the Revolution, he fled to Warsaw in 1918. In 1920, Graham immigrated to the United States, where he changed his name. From 1922 to 1924, he studied at The Art Students League in New York. From 1926 to 1929, he lived in Baltimore, and in 1929, he had his first American one-man show at the Phillips Memorial Gallery in Washington, D.C. His work and his ideas about art influenced many of his friends, including Jackson Pollock, Arshile Gorky, Willem de Kooning, and David Smith. In 1936, Graham organized an exhibition of African sculpture. In the late forties, he withdrew from the art world, delving into mysticism and the occult. He died in London in 1961.

Graham, John. *System and Dialectics of Art*. Baltimore, 1971.

Greenough, Horatio (1805–1852) Born in Boston, Greenough was one of the first American sculptors to achieve international recognition. From 1824 to 1826, he studied in Italy, returning there again in 1829 to settle in Florence. In 1832, he received the commission to create a sculpture of

George Washington for the United States Capitol Rotunda (located today in The Museum of History and Technology, Smithsonian Institution). In 1842, he visited Washington, D.C., to present the sculpture. In 1851, he left Italy to reside in Newport, Rhode Island. The following year he died of brain fever in Somerville, Massachusetts.

Greenough, Horatio (under the pseudonym "Horace Bender"). *Travels, Observations, and Experiences of a Yankee Stonecutter*. Gainesville, Fla., 1852; reprinted 1958.

Wright, Nathalia. *Horatio Greenough: The First American Sculptor*. Philadelphia, 1963.

Greenwood, John (1727–1792) Greenwood, the son of a merchant and ship builder, was born in Boston. After his father's death he was apprenticed to an engraver, and at the age of 16 he began painting portraits. After John Smibert died and Robert Feke disappeared, Greenwood became the leading portraitist in Boston. In 1752, Greenwood left Boston permanently, spending 5½ years in Surinam (Dutch Guiana, South America), a port of call for Yankee merchant ships. In 1758, he went to Holland and 4 years later settled in London, where he became a successful art dealer. He died there in 1792.

Burroughs, Alan. *John Greenwood in America 1745–1752*. Andover, Mass., 1943.

Grooms, Red (1937–) Charles Rogers Grooms was born in Nashville, Tennessee. In 1955, he studied at The Art Institute of Chicago and in 1956 at the George Peabody College for Teachers in Nashville, Tennessee, and at The New School for Social Research in New York City. In 1957, Grooms attended the Hans Hofmann School of Fine Arts in Provincetown, Massachusetts. In 1958, Grooms had his first one-man show at The Sun Gallery in Provincetown. He lives in New York City.

Grossman, Nancy (1940–) Grossman was born in New York City. She received her B.F.A. from Pratt Institute in New York City. In 1964, Grossman had her first one-woman show at The Krasner Gallery. She presently lives in New York City.

Gwathmey, Robert (1903–) Gwathmey was born in Richmond, Virginia. From 1924 to 1925, he studied at the North Carolina State College at Raleigh and from 1925 to 1926 at The Maryland Institute for the Promotion of the Mechanic Arts and the School of Fine and Practical Arts in Baltimore. From 1926 to 1930, he attended The Pennsylvania Academy of the Fine Arts in Philadelphia. From 1931 to 1937, Gwathmey taught at Beaver College in Philadelphia and from 1938 to 1942 at The Carnegie Institute of Technology in Pittsburgh. In 1938, he was commissioned by The Public Buildings Administration, Federal Works Agency, Section of Fine Arts to paint a mural for the United States Post Office in Eutaw, Alabama. In 1940, Gwathmey held his first one-man show at The A C A Gallery in New York City. In 1947, he was a founding member of The Artists Equity. From 1968 to 1969, Gwathmey taught at Boston University and in 1972 at Syracuse University in New York. In 1971, he be-

came a member of The National Institute of Arts and Letters. Gwathmey lives in Amagansett, Long Island.

Hanson, Duane (1925–) Hanson was born in Alexandria, Minnesota. Hanson taught at public schools in America and Germany for 16 years. He began his startlingly lifelike figures in polyester and fiberglass in 1967, using political and social catastrophies for themes. After 1969, he began dealing with typical American types: housewives, tourists, etc. He lives in Davie, Florida.

Kusbip, Donald B. "Duane Hanson's American Inferno," *Art in America,* November–December 1976, pp. 89–91.

Harnett, William (1848?–1892) William Harnett was born in Clonakilty, Ireland. His exact birth date is uncertain, differing in various accounts from 4 to 16 years. He immigrated with his family to Philadelphia. Harnett's father died there when Harnett was young. In order to support his mother he began to sell newspapers, and later became an errand boy. At 17, Harnett began to learn the engraver's trade. In 1867, he entered The Pennsylvania Academy of the Fine Arts as a night-class student. From 1869 to 1875, he studied at the National Academy of Design and took free art classes from the Cooper Institute in New York City. During the day, he worked for jewelers. From 1875 on, however, Harnett devoted himself exclusively to painting. In 1875, he rented a studio in New York City, but the following year returned to Philadelphia. His still-life paintings are celebrated for their photographic realism called *trompe l'oeil.* He visited Europe, spending time in England, France, and in Munich, Germany, from 1880 to 1886. Harnett died in New York City.

Frankenstein, Alfred. *After the Hunt: William Harnett & Other American Still Life Painters 1870–1900.* Berkeley and Los Angeles, 1969.

Hartley, Marsden (1877–1943) Born in Lewistown, Maine, Hartley studied at the New York School of Art, notably under William Merritt Chase. In 1909, he had his first one-man show at Alfred Stieglitz's gallery, 291. His landscapes of 1909–1910 were influenced by Albert P. Ryder, but in 1911 Hartley "discovered" Cézanne and Picasso at Stieglitz's Gallery. From 1912 to 1913, he was in Europe and exhibited in *Der Blaue Reiter's* second show. Upon his return to the United States he exhibited in the Armory Show of 1913. In 1915, while again in Europe, he began to work with abstraction. In 1922, while in Paris, he published his first book of poems, *Twenty-Five Poems.* In 1930, the economic crisis forced Hartley to return to the United States, where he worked for the WPA Federal Art Project easel division in New York City in 1936. In 1938, Hartley began his series of "archaic memory portraits." During the last 8 years of his life, he divided his time between New York City and Maine.

McCausland, Elizabeth. *Marsden Hartley.* University of Minnesota Press, 1952.

Hassam, Childe (1859–1935) Frederick Childe Hassam was born in Dorchester, Massachusetts. After graduating from Dorchester High School, Hassam started working for the Boston publishers, Little, Brown and

Company. In the late 1870s, he contributed illustrations to magazines and periodicals. He studied at the Boston Art Club and the Lowell Institute before making a trip to Europe in 1883, which resulted in his first public exhibition of sixty-seven watercolors in Boston later that year. In 1886, a second European visit encouraged Hassam to take his career as a painter seriously, and he settled in Paris, studying at the Académie Julian. During this time in Paris, Hassam's work began to reflect an awareness of French impressionism. Returning to New York in 1889, Hassam continued to work in this style in his paintings of New York street scenes, New England coastal views, and rural landscapes. In 1898, Hassam cofounded "the Ten," a group of American impressionists. Hassam exhibited in the 1913 Armory Show. In 1906, he was elected to the National Academy of Design, and he became a member of the National Institute and The American Academy of Arts and Letters, to which he bequeathed his estate. Hassam died in East Hampton, Long Island.

Pousette-Dart, Nathaniel. *Childe Hassam.* New York, 1922.
Hoopes, Donelson F. *The American Impressionists.* New York, 1972.

Hawes, Josiah Johnson (1808–1901) Hawes was born in East Sudbury (now Wayland), Massachusetts. Apprenticed to a carpenter, Hawes became a self-taught painter and an itinerant portraitist. In 1840, he attended Gouraud's lecture and demonstration on daguerreotypes in Boston. This event ultimately turned his career intentions toward photography. Around 1843, Hawes became the partner of Albert Sands Southworth (replacing Joseph Pennell) in a daguerreotype studio. They produced portraits of many of the notables of their day, as well as landscapes, city and interior views. In 1853, they displayed their "Grand Parlor Stereoscope," pioneering three-dimensional photography. When Southworth left the firm in 1862, Hawes continued the studio, relinquishing the daguerreotype process for more advanced photographic methods. He died in Crawford's Notch, New Hampshire.

Sobieszek, R., and O. Appel. *The Spirit of Fact: The Daguerreotypes of Southworth and Hawes, 1843–1862.* Boston and Rochester, 1976.

Hayden, Sophia V. (1868–1953) Born in Santiago, Chile, Hayden was the daughter of a New England dentist and a South American lady. The Haydens left Chile while Sophia was still a child and settled near Boston. In 1886, Sophia Hayden entered the architectural school of the Massachusetts Institute of Technology. Four years later, she became the first woman to earn a bachelors degree in architecture from that school. Her one and only building was designed in 1891, the Women's Building of the World's Columbian Fair held in Chicago in 1893. The hard work of designing this building and the criticism the finished structure drew resulted in her nervous breakdown. In 1894, she recovered and prepared plans for a building proposed by the Women's Club of America. However, these plans were never implemented.

Heade, Martin Johnson (1819–1904) Born in Lumberville, Bucks County, Pennsylvania, Heade studied with Edward Hicks before traveling to

Italy, England, and France from 1837 to 1840. Upon his return to America, Heade exhibited at galleries in New York and Boston. From 1852 to 1854, he lived in St. Louis and Chicago. From 1863 to 1864, Heade traveled in South America with the Reverend J. C. Fletcher, a naturalist with whom Heade collaborated on a book of hummingbirds. During the 1870s, Heade returned to South America to paint tropical flowers and birds. Living in New York City and Washington, D.C., in the 1880s, Heade retired to St. Augustine, Florida, in 1883, where he died in 1904.

Stebbins, Theodore, Jr. *The Life and Works of Martin Johnson Heade*. New Haven and London, 1975.

Heizer, Michael (1944–) Michael Heizer was born in Berkeley, California, and attended the San Francisco Art Institute from 1963 to 1964. Heizer is known largely for his earthworks, among them *Double Negative* (1970) and *Munich Depression* (1969). Today the artist lives and works in the Nevada desert near his ongoing project and largest earthwork, *City*.

Heizer, Michael. "The Art of Michael Heizer," *Artforum*, vol. 8, December 1969, pp. 32–39.

Held, Al (1928–) Al Held was born in Brooklyn, New York. He joined the Navy at the age of 17, and in 1949, after his military service, traveled to Paris to study painting at the Grande Chaumière. In 1953, he returned to New York City. In 1964, he received the Logan Medal from The Art Institute of Chicago and in 1966 received a Guggenheim Fellowship in painting. Since the early sixties, he has taught at the Yale School of Art in New Haven, Connecticut. In 1974, a retrospective of his work was held at The Whitney Museum of American Art. Presently, Held and his wife, the sculptor Sylvia Stone, divide their time between their homes in Boiceville, New York and New York City.

Tucker, Marcia. *Al Held*. New York, 1974.

Henri, Robert (1865–1929) Born Robert Henry Cozad in Cincinnati, Ohio, Henri attended The Pennsylvania Academy of the Fine Arts in Philadelphia from 1886 to 1888 and 1891 to 1892 and the Académie Julian in Paris from 1888 to 1891. In 1892, he met John Sloan in Philadelphia and the following year organized the *Charcoal Club*. From 1903 to 1909, Henri taught at the New York School of Art. In 1908, Henri and John Sloan organized an "Exhibition of Eight American Painters," the landmark show held at the Macbeth Gallery in New York. In 1909, the artist established the Henri School of Art, which lasted until 1912. Henri exhibited five works in the Armory Show in 1913, and 10 years later, his notes, diaries, and articles were compiled by a student and published in a book called *The Art Spirit*. His students included George Bellows, Glenn O. Coleman, Edward Hopper, Stuart Davis, and Guy Pène du Bois. Henri died in New York City.

Homer, William Innes. *Robert Henri and His Circle*. Ithaca, N.Y., 1969.

Hesselius, Gustavus (1682–1755) Hesselius was born in Sweden. His training is not known, but he came to America in 1711 with a knowledge of seventeenth-century baroque portraiture. He settled in Philadelphia, where he became a leading portrait painter and introduced new subject matter to American painting. His portraits of the Delaware Indians were the first pictures of American Indians. Hesselius also painted some of the first religious paintings in the Colonies, where Calvinist doctrine prohibited such subjects. He introduced classical mythology to the Colonies, as well. When he arrived in America, Hesselius had advertised as a ship and house painter, and he was later hired as a wall painter for the new state house in Philadelphia. At the end of his life, he turned to organ building at a time when his son, John, was ready to undertake portrait commissions.

Christian Brinton. *Gustavus Hesselius.* Philadelphia, 1952.

Hicks, Edward (1780–1849) Born in Attleborough, Pennsylvania, Hicks was apprenticed to a coach maker at the age of 13 and for a time worked as a coach and house painter. After 1810, he traveled the country as a Quaker preacher. A talented self-taught artist, Hicks completed his first work when he was over 40 years old. Hicks is generally known for his depictions of *The Peaceable Kingdom,* a series begun in 1820. In all, he made approximately fifty paintings of this famous subject. Hicks, a Quaker, was deeply impressed with the biblical theme of the lion lying down with the lamb (Isaiah, Chapter 11), which he used as the basis for *The Peaceable Kingdom* paintings.

Ford, Alice. *Edward Hicks, Painter of the Peaceable Kingdom.* Philadelphia, 1952.

Hine, Lewis Wicks (1874–1940) Born in Oshkosh, Wisconsin, Hine was trained as a sociologist at Chicago, Columbia, and New York universities. He taught at the School of Ethical Culture, where his students included Paul Strand. In 1905, Hine began his first documentary series, a study of Ellis Island immigrants. In 1908, he began to devote himself exclusively to photography, starting his surveys of social conditions. In 1911, he became the photographer for the National Child Labor Committee. From 1918 to 1919, Hine worked in Europe for the American Red Cross, recording the organization's war work. In 1932, he published *Men at Work,* in which his documentation of the Empire State Building's construction is included.

Gutman, Judith Mara. *Lewis W. Hine and The American Social Conscience.* New York, 1976.

Hofmann, Hans (1880–1966) Born in Weissenburg, Germany, Hofmann studied at various art schools in Munich during his youth. From 1904 to 1914, he lived in Paris and in 1915 returned to Munich to establish an art school. In 1932, he immigrated to the United States. From 1932 to 1933 he taught at The Art Students League in New York, and in 1933, he opened his own art school in New York, followed by the opening of a second art school in Provincetown, Massachusetts, in 1934. His students

included Helen Frankenthaler, Larry Rivers, Louise Nevelson, and Red Grooms. Considered one of the great art teachers of this century, Hofmann continued to teach until 1958, when he began to devote his time exclusively to his own work. Hofmann died in New York City.

Hofmann, Hans. *Essays, Search for the Real and Other.* Cambridge, 1948.
Hunter, Sam. *Hans Hofmann.* New York, 1963.
Bannard, Walter Darby. *Hans Hofmann, A Retrospective Exhibition.* Washington and Houston, 1976.

Homer, Winslow (1836–1910) Homer, born in Boston, grew up in nearby Cambridge. When he was about 19, Homer was apprenticed to the Boston lithographer J. H. Bufford. In 1857, Homer began to free-lance as an illustrator. His first drawings were done for *Harper's Weekly*, to which he contributed regularly until 1875. In 1859, he moved to New York and attended a drawing school in Brooklyn. In 1861, he studied at the National Academy of Design night school. During the Civil War, Homer was often sent by *Harper's* to make sketches of camps at the front. In 1862, he began working in oils. In 1865, he was elected National Academician. From 1866 to 1867, he traveled abroad. In the summer of 1873, Homer's first watercolor series was done. In 1881, he left for England to paint near Tynemouth, a fishing port on the North Sea. In 1883, Homer settled permanently in Prout's Neck, Maine. He traveled with a fishing fleet to Nassau and the Bahamas in 1885, 1898, 1900, 1901, and 1902. Homer also painted in the Adirondacks during the summers. In 1908, he suffered a paralytic stroke and died 2 years later at Prout's Neck.

Goodrich, Lloyd. *Winslow Homer.* New York, 1944.
Gardner, Albert TenEyck. *Winslow Homer.* New York, 1961.

Hopper, Edward (1882–1967) Born in Nyack, New York, Hopper was first trained as an illustrator. From 1900 to 1906, he studied at the New York School of Art under Robert Henri, George Luks, and Kenneth Hayes Miller. From 1906 to 1907 and in 1909 and 1910, Hopper traveled in Europe, though his home was in New York City, where he worked as a commercial illustrator from 1908 to 1924. Between 1915 and 1923, he made many graphics, and in 1923, he took up watercolor. Hopper received many honors, including the National Institute of Arts and Letters gold medal for painting in 1955. He died in New York City, and his artistic estate was bequeathed to the Whitney Museum of American Art. Hopper's notebooks have been published by this institution.

Goodrich, Lloyd. *Edward Hopper.* New York, 1971.

Hosmer, Harriet (1830–1908) Born in Watertown, Massachusetts, Hosmer's professional ambitions were encouraged by her physician father. In 1850, after failing to gain admission to a medical school, she studied anatomy with a physician in St. Louis. In 1852, she went to Italy, where she studied with the neoclassical sculptor John Gibson. Her friends abroad included the Brownings, and in time she became the most celebrated woman sculptor of her day. In 1900, Hosmer settled permanently in the United States, and died in Watertown, Massachusetts in 1908.

Hosmer, Harriet. *Letters and Memories.* New York, 1912.
Gerdts, William, Jr., *The White, Marmorean Flock: Nineteenth-Century American Women Neo-classical Sculptors.* Poughkeepsie, 1972.

Hunt, Richard Morris (1827–1895) Hunt, younger brother to the painter William Morris Hunt, was born in Brattleboro, Vermont. Graduating from the Boston Latin School in 1843, Hunt studied in Geneva, Switzerland, and Paris, enrolling in the École des Beaux-Arts in 1846. In Paris, Hunt assisted in the design for the Pavillon de la Bibliothèque and in 1854 was appointed inspector of the Louvre and the Tuilleries additions then being built. In 1855, Hunt returned to the United States, where he worked on additions to the Capitol building until 1858, when he opened his own studio in New York City. In 1857, Hunt helped found the American Institute of Architects. Hunt's best-known structures are the mansions and country houses he built for the affluent, including the Astors, Vanderbilts, and Belmonts. He was also the designer for buildings at Yale and Princeton, the base of the Statue of Liberty, portions of the Metropolitan Museum of Art, and the National Observatory in Washington, D.C. Hunt received a gold medal from the Royal Institute of British Architects for his Administration Building at the Chicago World Columbian Exposition in 1893. He died in Newport, Rhode Island.

Burnham, A. "The New York Architecture of R. M. Hunt," *Journal of the Society of Architectural Historians,* May 1952.

Hunt, William Morris (1824–1879) William Morris Hunt, older brother of Richard Morris Hunt, was born in Brattleboro, Vermont. Hunt attended Harvard for 3 years, and then in 1846, he traveled to Europe and enrolled at the Düsseldorf Academy. He later studied in Paris under Thomas Couture. In 1856, Hunt returned to America. Establishing studios in Boston and Newport, Hunt painted fashionable portraits and murals and made lithographs of his Parisian life sketches. He drowned while swimming off the New Hampshire coast.

Gardner, Albert TenEyck. "A Rebel in Patagonia," *The Metropolitan Museum of Art Bulletin,* vol. 3, no. 9, May 1945, pp. 224–227.

Indiana, Robert (1928–) Born Robert Clark in New Castle, Indiana, the artist received his B.F.A. from the School of The Art Institute of Chicago in 1953 and received a scholarship to attend the Skowhegan School of Painting and Sculpture in Maine for the summer of 1953. Indiana then studied at the University of Edinburgh, Scotland, from 1953 to 1954. He first exhibited in 1962 at the Stabile Gallery in New York. The United States Post Office Department incorporated the design for his *Love* sculpture into a stamp issued on Valentine's Day, 1973. Since 1954, the artist has lived and worked in New York City.

Raynor, Vivien. "The Man Who Invented LOVE," *Art News,* vol. 72, February 1973.

Inness, George (1825–1894) Inness was born near Newburgh, New York, but spent his boyhood in the rural area near Newark, New Jersey. In 1841, he was apprenticed to the map engravers Sherman and Smith of

New York City, but, perhaps because he suffered from epilepsy, this work proved too taxing for him. Instead he devoted himself to painting, exhibiting in the National Academy of Design Annual from 1844 to 1894. In 1846, he studied briefly with Régis Gignoux in New York City. Essentially, however, Inness was a self-taught painter. From 1850 to 1852, 1853 to 1854, and 1870 to 1875, he lived and traveled in Europe. During the 1860s, he resided in Medfield, Massachusetts, and Eagleswood, New Jersey. After his stay in Europe during the 1870s, Inness's work became more romantic and mystical. Upon his return to America in 1875, Inness lived in New York City and Montclair, New Jersey. During a visit to Scotland in 1894, Inness died suddenly.

Cikovsky, Nicolai. *George Inness*. Washington, D.C., 1971.

Inness, George, Jr. *The Life, Art and Letters of George Inness*. 1917.

Ireland, Leroy. *The Works of George Inness, Catalogue Raisonné*. Austin, Tex., 1965.

Insley, Will (1929–) Born in Indianapolis, Indiana, Insley received his B.A. from Amherst College in 1951 and received a degree in architecture from the Harvard Graduate School of Design in 1955. The artist has held teaching positions at Oberlin College (1966), the University of North Carolina (1967–1968), Cornell University (1969), The School of Visual Arts, New York (1969–1971) and Cooper Union (1972).

Perrone, Jeff. "Will Insley, Fischbach Gallery," *Artforum*, vol. 14, April 1976.

Ives, James Merritt (1824–1895) Ives was born in New York City. He worked as a lithographer in that city until 1852, when he was hired as a bookeeper by Nathaniel Currier. In 1857, Ives became a partner and served the firm of Currier and Ives as business manager for almost 40 years. He died in Rye, New York.

Currier and Ives Chronicles of America. Maplewood, N.J., Hammond Publishers, 1968.

Jackson, William Henry (1843–1942) Born near Peru, New York, Jackson's first contact with photography was as a retoucher and colorist in a photographic gallery in Troy, New York. He then became an apprentice to Frank Mowrey, a photographer in Rutland, Vermont. In 1862, he enlisted to fight in the Civil War, during which time he did sketches of camp life. He returned to Rutland, but soon left for New York City in 1866. From there he continued West with the intentions of mining for silver in Montana. He relinquished that idea and ended up in California. On a return trip East in 1867, he settled long enough in Omaha to establish a photography studio with his brother Edward. 1869 found him photographing the countryside and Indian life along the route of a newly opened Pacific Railroad. In 1870, Jackson joined the Geological and Geographic Survey expedition to the Wyoming and Utah territories. In 1871, he made the first photos of the Yellowstone area. In 1873, Jackson undertook an expedition to Colorado, and in 1876, he was in charge of the Survey's exhibition at the Philadelphia Centennial Exposition. Commissioned by the Denver and Rio Grande Railway Company,

he photographed views along their route in 1881. Between 1883 and 1884, Jackson established his own publishing company. In 1894, he made his last expedition halfway around the world with the World Transportation Company. Jackson spent the last years of his life in Washington, D.C., where he wrote his autobiography *Time Exposure*. He died there at 99 years of age.

Newhall, Beaumont, and Edkins, Diana E. *William H. Jackson*. Fort Worth, Tex., 1974.

Johns, Jasper (1930–) Born in Augusta, Georgia, Johns grew up in South Carolina. From 1943 to 1947, he attended the University of South Carolina. In 1949, Johns moved to New York City but was soon drafted into the Army and did not return to New York until 1952. Upon his return to the city in 1952, the artist supported himself by working odd jobs until 1958. In New York, Johns became friends with Robert Rauschenberg, Merce Cunningham, and John Cage. He even collaborated with Rauschenberg in creating displays at such New York stores as Tiffany's. In 1954, he began to create his famed paintings of letters, targets, and American flags. In 1960, he produced his first graphics. In 1973, Johns became a member of The National Institute of Arts and Letters. He presently lives in New York.

Kozloff, Max. *Jasper Johns*. New York, 1969.

Steinberg, Leo. *Jasper Johns*. New York, 1963.

Johnson, Eastman (1824–1906) Born in Lovell, Maine, Johnson grew up in the rural areas around Augusta, Maine. At 16, Johnson went to Boston to train with a lithographer for 2 years. From 1841 to 1849, he worked as a portraitist in Maine, Boston, Newport, and Washington. In 1849, Johnson went to study in Europe. His first stop was in Düsseldorf, where he shared a studio with the painter Emanuel Leutze while the latter was painting *Washington Crossing the Delaware*. From 1851 to 1855, Johnson lived in The Hague. In 1858, he settled in New York City, and during the Civil War, he visited the front, sketching the various campaigns. From 1870 through the 1880s, Johnson summered either on Nantucket, Massachusetts, or in Maine. After 1880, he devoted himself primarily to portraits. He died in New York City.

Baur, John I. H. *An American Genre Painter: Eastman Johnson, 1824–1906*. New York, 1940.

Johnson, Philip (1906–) Born in Cleveland, Ohio, Johnson was a student of Greek and philosophy at Harvard University, receiving his A.B. in 1930. In 1930, Johnson went to Europe with the architectural historian Henry Russell Hitchcock to examine modern architecture in preparation for their book *The International Style: Architecture Since 1922*, which was published in 1932. After their return to the United States, Johnson was chosen to found the department of architecture and design at the Museum of Modern Art in New York, where he remained from 1930 to 1936 and served as a trustee from 1946 to 1954. In 1939, Johnson returned to Harvard to study architecture, completing his studies in 1943. In 1947, Johnson published a book on Miës van der Rohe (*Miës van der Rohe,*

1947). In 1953, he opened up his own architectural firm. Some of his more famous works include the Glass House (New Canaan, Conn., 1949), the Leonhardt House (Long Island, 1956) and the New York State Theater at the Lincoln Center (New York City, 1964). Johnson lives in New Canaan, Connecticut, and maintains offices in New York City.

Hitchcock, Henry Russel. *Philip Johnson*. New York, 1966.

Johnston, Henrietta (?–1728) Johnston was one of the first female American artists. Born in England, she settled in South Carolina and from 1700 to 1728 made pastel and crayon portraits of the prominent citizens of that region. She died in Charleston in 1728.

Judd, Donald (1928–) Born in Excelsior Springs, Missouri, Judd served in the United States Army in Korea from 1946 to 1947. After attending The Art Students League in New York and the College of William and Mary, Judd received his B.S. degree in philosophy in 1953 and his M.A. degree in art history in 1962 from Columbia University. From 1959 to 1965, the artist served as a contributing editor to *Arts Magazine* and as a reviewer for *Art News* and *Art International*. Judd was a painter initially, but between 1960 and 1962, he gradually became more involved with three-dimensional form. In 1967, he taught at Yale University. The artist now lives and works in New York City and West Texas.

Judd, Donald. *Complete Writings 1959–1975*. Halifax and New York, 1976.
Donald Judd. Ottawa, The National Gallery of Canada, 1975.

Kahn, Louis I. (1901–1974) Kahn was born on the Island of Ösel in Estonia (now Russia). In 1905, Kahn was brought to the United States, settling in Philadelphia, where he became a naturalized citizen in 1905. Kahn attended the University of Pennsylvania School of Fine Art, where he received his B.A. degree in architecture in 1924. From 1925 to 1926, Kahn served as chief of design for the Sesquicentennial Exposition in Philadelphia. From 1928 to 1929, the architect traveled throughout Europe. In 1934, Kahn registered with the A.I.A. and began his independent practice. From 1949 to 1957, he served as a professor of architecture at the University of Pennsylvania. Some of the architect's more famous buildings include the Richards Medical Research Laboratories in Philadelphia, the Indian Institute of Management in Ahmedabad, India, and the Salk Institute Laboratories in La Jolla, California.

Scully, Vincent, Jr. *Louis Kahn*. New York and London, 1962.

Kaprow, Allan (1927–) Born in Atlantic City, New Jersey, Kaprow was a student at the Hans Hofmann School of Fine Arts from 1947 to 1948 and received his B.A. from New York University in 1949. Between 1949 and 1950, Kaprow did some postgraduate work at New York University but in 1952 received his M.A. from Columbia University. The artist has taught at Rutgers University (1953–61), Pratt Institute (1960–1961), and New York State University (1961–1966). In 1965, Kaprow published a book entitled *Assemblage, Environments, and Happenings*, which deals with his theories and work. Although he is a

painter and sculptor, Kaprow is best known as a creator of happenings and environments. Kaprow now lives and works in Pasadena, California.

Kaprow, Allan. *Assemblage, Environments, and Happenings.* New York, 1965.

Käsebier, Gertrude (1852–1934) Born Gertrude Stanton in Des Moines, Iowa, Käsebier grew up in Leadville, Colorado, and Bethlehem, Pennsylvania. After her father's death, she moved to New York City with her mother, who opened a boarding house. In 1873, she married one of her mother's boarders, Edward Käsebier, and remained in the role of wife and mother for 20 years. In 1888, she entered the Pratt Institute to study portrait painting but became fascinated with photography. In 1897, she opened a portrait studio on Fifth Avenue. Her sitters included many notables, including Auguste Rodin, Robert Henri, and Alfred Stieglitz. Käsebier was also known for her photographs of mothers and children. In 1902, she was a founding member of the Photo-Secession, and in 1906 an exhibition of her work was held at 291. By 1916, she had helped to organize the Pictorial Photographers of America. Käsebier frequently made photos to illustrate popular fiction. By the time of her death, her reputation had languished, and she died a forgotten figure in American photography in New York in 1934.

Tighe, Mary Ann. "Gertrude Käsebier, Lost and Found," *Art in America,* March–April 1977.

Keiley, Joseph T. (1869–1914) Keiley, a Wall Street lawyer, lived all of his adult life with his mother and sister in Brooklyn, New York. In 1899, he joined the Camera Club and began his friendship with Alfred Stieglitz. An associate editor of *Camera Notes* and *Camera Work,* he was a founding member of the Photo-Secession in 1902. Keiley died in January 1914 of Bright's disease.

Green, Jonathan, ed. *Camera Work: A Critical Anthology.* New York, 1973.

Kensett, John F. (1816–1872) Kensett was born in Cheshire, Connecticut. He studied engraving with his father and his uncle, Alfred Doggett, a New Haven banknote engraver. From 1838 to 1840, Kensett worked for the American Bank Note Company of New York City. In 1840, he left to study in Europe. Kensett traveled for almost 8 years in England, France, Italy, and Switzerland, supporting himself by engraving. Returning to New York, he opened a studio and established himself as a landscape painter, with the scenery of the Catskills and Adirondacks, New England's seacoast, and the western mountains of Colorado as subject matter. In 1849, he was elected a member of the National Academy. Kensett died in New York City.

Howat, John K. *John Frederick Kensett 1816–1872.* New York, 1968.

Kienholz, Edward (1927–) Born in Fairfield, Washington, Kienholz is a self-taught artist. The son of a farming family, he was taught me-

chanics and carpentry. After attending several Midwestern colleges for short periods of time, Kienholz supported himself by working at odd jobs. In 1953, he moved to Los Angeles, and in 1954, he began to create his "wooden paintings." In 1956, Kienholz opened The Now Gallery in Los Angeles and a year later opened the Ferus Gallery with Walter Hopps. In 1959, he made his first free-standing piece. By 1961, Kienholz had begun making tableaux with found objects. The artist now lives and works in Los Angeles.

Tuchman, Maurice. *Edward Kienholz*. Los Angeles, 1966.

King, Charles Bird (1785–1862) King was born in Newport, Rhode Island. He first studied art with Edward Savage in New York City, then in 1805 continued his studies in Benjamin West's London studio. When he returned to America in 1812, he opened a studio in Philadelphia. In 1816, he settled in Washington, D.C., where he spent the rest of his life painting portraits of visiting dignitaries, distinguished Americans, and Indians.

Ewers, John C. "Charles Bird King, Painter of Indian Visitors to the Nation's Capitol," *Annual Report of the Board of Regents of the Smithsonian Institution*. Washington, D.C., 1953.

Kline, Franz (1910–1962) Born in Wilkes-Barre, Pennsylvania, Kline studied at Boston University (1931–1935) and Heatherley School of Fine Art in London (1937–1938) before moving to New York in 1938. Kline taught classes at Black Mountain College (1952), Pratt Institute (1953) and the Philadelphia Museum School of Art (1954). Kline died in New York City.

Gordon, John. *Franz Kline 1910–1962*. New York, 1968.

Krebs, Rockne (1938–) Born in Kansas City, Missouri, Krebs received his B.F.A. from Kansas University in 1961. From 1962 to 1965, he served in the United States Navy and established residence in Washington, D.C., in 1964. In 1969, he participated in the Art and Technology Program of the Los Angeles County Museum of Art. In 1970, Krebs did a laser piece for the United States Pavillon at the Osaka World's Fair.

Hopps, Walter. *Gilliam, Krebs, McGowin*. Washington, 1969.

Kuhn, Justus Engelhardt (?–1717) Born in Germany, Kuhn painted in Maryland between 1707 and 1717. He specialized in portraits of children of Maryland families, placing them in elaborate settings of gardens and mansions. Kuhn also painted coats-of-arms.

Pleasants, J. Hall. "Justus Engelhardt Kuhn, An Early Eighteenth Century Maryland Portrait Painter," *Proceedings of the American Antiquarian Society*, vol. 46, April 15, 1936–October 21, 1936.

Kuhn, Walt (1877–1949) Born in Brooklyn, New York, Kuhn received some formal art training at the Polytechnic Institute of Brooklyn (1893), the Academy Colarossi, Paris (1901), and the Academy of Creative Arts, Munich (1901–1903). From 1899 to 1900, Kuhn worked for a time as a cartoonist for *Wasp* in San Francisco and until 1914 continued in this voca-

tion for such newspapers and magazines as *Life* and the New York *Sunday Sun*. Late in 1911, Kuhn and three other artists formed the Association of American Painters and Sculptors. From 1912 to 1913, Kuhn served as that organization's executive secretary. Along with Arthur B. Davies and Walter Pach, he helped assemble the European section of the 1913 Armory Show. Kuhn advised art collectors John Quinn, Lillie P. Bliss, and Marie Harriman. In 1908, he taught at the New York School of Art and from 1927 to 1928 at The Art Students League of New York. Kuhn died in White Plains, New York.

Painter of Vision. Arizona, The University of Arizona Art Gallery, 1966.

Kuniyoshi, Yasuo (1893–1953) Born in Okayama, Japan, Kuniyoshi immigrated to the United States in 1906. While on the West Coast, Kuniyoshi attended the Los Angeles School of Art and Design from 1907 to 1910, moving to New York in 1910. While in New York, Kuniyoshi studied at the National Academy of Design, the Henri School of Art, the Independent School of Art, and The Art Students League. From 1920 to 1925, the artist supported himself by working as a free-lance photographer. He served as the first president of the Artists Equity. In 1925 and 1928, Kuniyoshi visited Europe and in 1931, Japan. From 1936 to 1938, he served on the WPA Federal Art Project, graphics division, New York. Kuniyoshi taught at The Art Students League in New York from 1933 until his death in New York in 1953.

The Art of Kuniyoshi. Tokyo, Bijutsu Shuppan-Sha, 1954.

La Farge, John (1835–1910) La Farge was born in New York City to a wealthy and cultured family. In 1853, he graduated from Mount St. Mary's College in Maryland and studied law for a brief period. In 1856, La Farge left for Europe, where he hoped to devote himself to art. In Paris, he studied under Thomas Couture at the École des Beaux-Arts. In 1858, he returned to America and entered the Newport studio of William Morris Hunt. La Farge was in charge of the interior decoration of Trinity Church in Boston. Intrigued by medieval glass, he revived the stained-glass craft by inventing an opalescent glass he used in windows of his own design. During the latter part of the nineteenth century, La Farge traveled with Henry Adams to Japan and the South Seas; these trips resulted in a series of watercolors and two books, *An Artist's Letters from Japan, 1897* and *Reminiscences of the South Seas*. Other books by La Farge include *Considerations on Painting* (1895), *Great Masters* (1903), and *The Higher Life in Art* (1908). La Farge died in Providence, Rhode Island.

Cortissoz, Royal. *John La Farge. A Memoir and A Study*. Boston and New York, 1911.

Lane, Fitz Hugh (1804–1865) Born in Gloucester, Massachusetts, Lane was apprenticed to the Boston lithographic firm of William S. Pendleton in 1832. Three years later, he began working as a lithographer and marine painter in partnership with John W. A. Scott. Around 1848, Lane returned to Gloucester, painting there until his death in 1865.

Wilmerding, John. *Fitz Hugh Lane 1804–1865: American Marine Painter.* Salem, Mass., 1964.

Lange, Dorothea (1895–1965) Lange was born in Hoboken, New Jersey. She studied photography under Clarence H. White at Columbia University. In 1915, she opened a portrait studio in San Francisco. She left her portrait studio to record the struggles of migratory workers in California with Paul S. Taylor, a professor of economics at the University of California at Berkeley. In the 1930s she joined the Farm Security Administration to photograph the effects of the Depression on the rural population. Lange had many of her photographs published in *Life* magazine, and John Steinbeck credited her photographs for inspiring his novel *The Grapes of Wrath.* Among the books she published were *An American Exodus* (1939) and *The New California* (1957). She died in New York City.

Elliot, George P. *Dorothea Lange.* New York, 1966.

Latrobe, Benjamin (1764–1820) Latrobe was born in Fulneck, England. Educated in England and Germany, he began his study of architecture and engineering in 1786. In 1796, Latrobe arrived in the United States and settled in Virginia, where he designed the penitentiary in Richmond and completed, with modifications, Thomas Jefferson's design for the Virginia state capitol. In 1798, he moved to Philadelphia to supervise the building of the Bank of Pennsylvania, and in 1801, he constructed America's first water-supply system for that city. Called to Washington, D.C., in 1803 by President Jefferson, Latrobe redesigned parts of the Capitol as well as planned other buildings in the nation's capital. In 1805, he designed the Baltimore Cathedral, and in 1813, Latrobe moved to Pittsburgh, where he worked with Robert Fulton on an area for building a steamboat. When the British burned many buildings in Washington in 1814, Latrobe was called back to that city to rebuild the Capitol. While working on a water-supply system for New Orleans, Latrobe contracted a fever and died in 1820.

Hamlin, Talbot. *Benjamin Henry Latrobe.* New York, 1955.

Lawson, Ernest (1873–1939) Born in Halifax, Nova Scotia, Canada, Lawton first came to the United States in 1888, settling in Kansas City, Missouri. In 1889, he traveled to Mexico City with his father and took a job as an assistant draftsman for a civil engineering firm. In 1891, Lawson moved to New York, enrolled in The Art Students League, and studied under J. Alden Weir and John Twachtman. In 1893, Lawson went to Paris and studied at the Académie Julian. In 1908, Lawson exhibited his work as a member of "the Eight." In 1913, he exhibited in the Armory Show, and in 1917, he became a full member of the National Academy of Design. Lawson taught at the Kansas City Art Institute and School of Design in 1926 and at the Broadmoor Academy in Colorado Springs in 1927. In 1936, he moved to Coral Gables, Florida, where he lived until his death in 1939.

Berry-Hill, Henry and Sidney. *Ernest Lawson: American Impressionist 1873–1939.* Leigh-on-Sea, England, 1968.

Leslie, Alfred (1927–) Born in the Bronx, New York, Leslie studied at New York University and The Art Students League of New York. His fellow students included George Segal and Larry Rivers, and he studied with William Baziotes and Tony Smith. During the 1950s, his work varied from abstraction to realism. In 1958–1959, he made the film *Pull My Daisy*. In 1963, he began to paint representationally from life. Leslie lives and works in South Amherst, Massachusetts.

Rosenblum, Robert. *Alfred Leslie*. Boston, 1976.

Leutze, Emanuel (1816–1868) Born in Germany, Leutze came in 1825 with his family to America, settling in Philadelphia. There he studied with John Rubens Smith, a portrait painter, and from 1837 to 1839, Leutze was an itinerant portraitist in Virginia, Maryland, and Pennsylvania. In 1841, Leutze returned to Germany to study at the Düsseldorf Academy. He remained in Germany for 2 years, traveling to Munich, Venice, and Rome between 1843 and 1845. Back in Düsseldorf in 1845, he painted a series of American historical subjects including *Washington Crossing the Delaware*. In 1859, Leutze returned to America to paint the mural *Westward the Course of Empire* for the House of Representatives in Washington, D.C., which was completed in 1862. Leutze died in Washington in 1868.

Groseclose, Barbara S. *Emanuel Leutze, 1816–1868: Freedom is the Only King*. Washington, 1975.

Levine, Jack (1915–) Born in Boston, Levine first studied with Harold Zimmerman at the West End Community Center in Roxbury, Massachusetts, where Hyman Bloom was a fellow student. With Bloom, he studied under Dr. Denman Ross at Harvard University from 1929 to 1932. In 1935, Levine joined the WPA Federal Art Project, easel division, where he quickly became known for his paintings of political and social satire. From 1942 to 1945, he served in the United States Army Corps of Engineers. Levine has taught at the Skowhegan School of Painting and Sculpture in Maine (1952–1953) and at The Pennsylvania Academy of the Fine Arts (1966–1969). In 1959, the House Un-American Activities Committee subpoened Levine as a subversive artist. Although well known for his prints, Levine made few until 1965. The artist moved to New York City in 1945, where he lives and works today.

Getlein, Frank *Jack Levine*. New York, 1966.

LeWitt, Sol (1928–) Born in Hartford, Connecticut, LeWitt received his B.F.A. from Syracuse University in 1949. LeWitt had his first one-man show 16 years later at the Daniels Gallery in New York. The artist has taught in New York at the Museum of Modern Art School (1964–1967), Cooper Union (1968), the School of Visual Arts, and New York University (1969–1970). LeWitt lives in New York City.

Sol LeWitt. The Hague, Gemeentemuseum, 1970.

Lichtenstein, Roy (1923–) Born in New York City, Lichtenstein studied for a short time at The Art Students League of New York in 1939

under Reginald Marsh before he attended Ohio State University, where he received his B.F.A. in 1946 and his M.F.A. in 1949. From 1943 to 1946, he served as a draftsman in the United States Army. From 1951 to 1957, the artist lived in Cleveland, Ohio, where he worked intermittently as an engineering draftsman. Lichtenstein taught at Ohio State University (1949–1951), New York State University in Oswego (1957–1960), and Rutgers University in New Jersey (1960–1963). In 1964, Lichtenstein began to devote himself full time to painting. The artist moved to New York in 1965, where he continues to live and work.

Coplans, John. *Roy Lichtenstein.* New York, 1972.

Louis, Morris (1912–1962) Born Morris Bernstein in Baltimore, Maryland, Morris Louis studied at The Maryland Institute for the Promotion of the Mechanic Arts and The School of Fine and Practical Arts in Baltimore from 1929 to 1933. In 1935, he was elected president of the Baltimore Artists' Association. In 1936, Louis participated in David Alfaro Siqueiros's experimental workshop in New York City. From 1937 to 1940, he worked on the WPA Federal Art Project, easel division, New York. In 1947, he moved to Washington, D.C., where he met and worked with Kenneth Noland. From 1952 to 1962, he taught at the Washington Workshop Center. In April 1953, Noland and Louis were shown Helen Frankenthaler's *Mountains and Sea* in her New York studio by the critic Clement Greenberg. Louis died in Washington, D.C.

Carmean, E. A., Jr. *Morris Louis Major Themes & Variations.* Washington, D.C., 1976.
Fried, Michael. *Morris Louis.* New York, 1970.

Luks, George (1866–1933) Born in Williamsport, Pennsylvania, Luks received his training at The Pennsylvania Academy of the Fine Arts and the Düsseldorf Academy and continued his studies in Munich, Paris, and London. After studying abroad, Luks returned to America, where he worked for the *Philadelphia Evening Bulletin,* which sent him to cover the Spanish-American War. In Philadelphia, Luks shared living quarters with Everett Shinn and met Robert Henri, John Sloan, and William Glackens. In 1897, Luks went to New York, where he worked for the *New York World* as a cartoonist. From 1920 to 1924, Luks taught at The Art Students League of New York, where his pupils included Philip Evergood and Reginald Marsh, before opening his own school. Luks exhibited, along with the other members of "the Eight," in the 1913 Armory Show. He died in New York City.

George Luks 1866–1933: An Exhibition of Paintings and Drawings from 1899 to 1931. Utica, N.Y., Museum of Art, Munson-Williams-Proctor Institute, 1973.

Macdonald-Wright, Stanton (1890–1973) Born in Charlottesville, Virginia, Wright began to study art with private tutors at the age of 5. Wright's formal art training included studies at the Art Students League in Los Angeles from 1905 to 1906, the Sorbonne, the Académie Julian, and the École des Beaux-Arts. While in Europe around 1911, Wright met Morgan

Russell and with him later developed synchromism. In 1913, the artist returned to the United States for a short time and then returned to Europe with his brother Willard Huntington Wright. The brothers collaborated on several books, which were later published in New York, including *Modern Art, Its Tendency and Meaning, The Creative Will,* and *The Future of Painting*. In 1916, Wright returned to New York, and in 1917 exhibited at Stieglitz's 291. In 1919, Wright moved to California, where he made a color film based on his drawing. From 1922 to 1930, Wright directed the Art Students League in Los Angeles and began to study Oriental art and philosophy. From 1935 to 1937, he served as director for Southern California under the WPA Federal Art Project. Wright taught at such institutions as U.C.L.A., U.S.C., Scripps College, and the University of Hawaii. He died in Pacific Palisades, California.

Stanton Macdonald-Wright. Washington, D.C., The Smithsonian Institution Press, 1967.

MacMonnies, Frederick William (1863–1937) Born in Brooklyn, New York, MacMonnies was apprenticed to the sculptor Augustus Saint-Gaudens around 1881. Working in Saint-Gaudens's studio during the day, MacMonnies attended evening drawing classes at the National Academy of Design. In 1884, he left for Paris, where he studied at the École des Beaux-Arts until a cholera epidemic forced him to go to Munich, where he studied painting as well as sculpture. In 1887, MacMonnies had opened his own studio in Paris. In 1889, he returned to America. MacMonnies gained national recognition with his *Barge of State,* done for the Columbian Exposition in Chicago. Until 1913, he maintained a studio in Paris, although many of his commissions were from Americans. In 1915, he returned to the United States from war-torn Europe. In 1937, MacMonnies contracted pneumonia and died in New York City.

Strother, French. "Frederick MacMonnies, Sculptor," *World's Work,* vol. II, December 1905, pp. 6965–6981.

McGowin, Ed (1938–) Born in Hattiesburg, Mississippi, McGowin received his B.A. from Mississippi Southern College, working his way through school at odd jobs including draftsman and window dresser. In 1960, McGowin decided to make art his career. In 1961, he began teaching at Mississippi Southern College but left the position in 1962 when he moved to Washington, D.C., to work as a "doorman" in the Capitol building. In 1962, McGowin's first Washington one-man show was held at the Corcoran. In 1963, McGowin returned to teaching, this time at the University of Alabama, where he received his M.A. in 1964. That same year McGowin returned to Washington and opened an art school with Harold Bright. The McGowin-Bright School closed in January 1966. McGowin then began teaching at the Corcoran School of Art, where he is now chairman of the department of sculpture. Presently, McGowin lives and works in Washington, D.C., and New York City.

Ed McGowin's True Stories. Washington, D.C., The Corcoran Gallery of Art, 1975.

Marin, John (1870–1953) Born in Rutherford, New Jersey, Marin studied engineering at the Stevens Institute of Technology in Hoboken, New

Jersey, in 1888 and worked as an architect in the 1890s. He received his formal art training at The Pennsylvania Academy of the Fine Arts (1899–1901) and The Art Students League of New York (1901–1903). Between 1905 and 1911, Marin lived in Europe and had his first one-man show after his return to the United States at 291. In 1913, the artist participated in the Armory Show. In 1914, Marin visited Maine for the first time, later purchasing a house in Cape Split, Maine and summering there while living in Cliffside, New Jersey, until 1916. Marin died at Cape Split.

Curry, Larry. *John Marin 1870–1953.* Los Angeles, Calif., 1970.
Marin, John. *The Selected Writings of John Marin.* New York, 1949; ed. by Dorothy Norman.

Marsh, Reginald (1898–1954) Born in Paris, Marsh was brought to this country by his American parents in 1900. Marsh received his initial art training from his parents, who were both artists, before entering Yale University in 1916. From 1916 to 1920, Marsh worked as an illustrator for the Yale *Record*, and when he graduated from that institution, he moved to New York, where he worked as a free-lance illustrator. From 1922 to 1925, he worked for the New York *Daily News* and from 1925 to 1931 for *The New Yorker.* In 1919, 1920–1921, 1922, and 1927–1928, he studied at The Art Students League of New York under Kenneth Hayes Miller, George Luks, and John Sloan, among others. In 1929, he began working in egg tempera. In 1931 and 1934, Marsh studied disection at Columbia and Cornell medical schools. In 1936, he painted two murals for the Post Office Building in Washington, D.C., and in 1937 did a series of murals in the rotunda of the United States Custom House in New York. From 1935 until his death, Marsh taught classes at The Art Students League of New York. In 1943, he was an artist-correspondent for *Life.* In 1945, he published his book *Anatomy for Artists.* Marsh died in Dorset, Vermont.

Goodrich, Lloyd. *Reginald Marsh.* New York, 1972.

Martin, Agnes (1912–) Born in Maklin, Canada, Martin grew up in Vancouver, British Columbia. In 1932, she emigrated to the United States becoming a citizen in 1940. In 1942, she received her B.S. from Teacher's College, Columbia University in New York, and in 1952, she received her M.A. from the same institution. From 1937 through 1950, she taught at public schools in the states of Washington, Delaware, and New Mexico. From 1947 to 1948, she taught at the University of New Mexico and from 1952 to 1953 at Eastern Oregon College. From 1956 to 1957, Martin lived in Taos, New Mexico, moving to New York City in 1957. A decade later, she left New York, and she presently lives in Cuba, New Mexico.

Agnes Martin. Philadelphia, Institute of Contemporary Art, University of Pennsylvania, 1973.

Maurer, Alfred H. (1868–1932) Born in New York City, Maurer was the son of Louis Maurer, a Currier & Ives artist. From 1884 to 1897, he worked in the family lithography business. Maurer studied at the National Academy of Design and later went to Paris in 1897. There he was a frequent

visitor to the salon of Gertrude and Leo Stein. Upon Maurer's return to the United States, he exhibited at Alfred Stieglitz's 291 gallery in 1909 and at the Armory Show in 1913. Maurer committed suicide in 1932 in New York City.

Alfred H. Maurer 1868–1932. Washington, D.C., Smithsonian Institution, 1973.

Michals, Duane (1932–) Born in McKeesport, Pennsylvania, Michals received his B.A. from the University of Denver in 1953. In 1958, while in Russia, he became seriously interested in photography. Since that time he has worked as a free-lance photographer, his celebrated fashion images appearing regularly in *Vogue* and *Harper's Bazaar.* Michals has published several books including *Sequences* (1970), *The Journey of the Spirit After Death* (1971), and *Things Are Queer* (1973). He now lives and works in New York City.

Grundberg, Andy. "Duane Michals at Light." *Art in America,* vol. 63, May 1975.

Miës van der Rohe, Ludwig (1886–1969) Born in Aachen, on the German border, Miës was the son of a stonemason. After studying at a trade school for two years, Miës moved to Berlin in 1905 and from 1905 to 1907 was an apprentice to the furniture designer, Bruno Paul. In 1907 he built his first home as an independent architect. From 1908 to 1911 Miës was employed in the office of Peter Behrens. From 1912 to 1914 he worked in Berlin before serving in the German army engineering corps. From 1921 to 1925 Miës was director of exhibitions for the Novembergruppe, in 1925 founded the Zehner Ring, and in 1927 was director of the Werkbund exposition in Stuttgart. From 1930 to 1933, Miës was director of the Bauhaus at Dessau and Berlin. In 1937 he made his first visit to the United States. The following year Miës emigrated and became director of the School of Architecture at Armour Institute (later the Illinois Institute of Technology) in Chicago, where he remained until 1959. In 1944 he took out American citizenship. His projects included designing the IIT campus, the Lake Shore Drive Apartments in Chicago (1951), the Museum of Fine Arts in Houston (1956–1958), and the Seagram Building in New York (1958). Miës died in Chicago.

Drexler, Arthur. *Ludwig Miës van der Rohe.* New York, 1960.
Johnson, Philip C. *Miës van der Rohe.* New York, 1947.

Moran, Thomas (1837–1926) Moran was born in England and accompanied his family to America in 1844. He began his art career as an apprentice to a wood engraver in Philadelphia, but this lasted only 2 years. During the 1850s, Moran studied painting under his brother Edward. In 1862, the two brothers visited England for further study. In 1866, Moran traveled abroad again, where he painted a number of watercolor views of Venice. In 1871 and again in 1873, Moran joined expeditions to Yellowstone, sketching scenes that formed the basis for later paintings. These sketches also served as illustrations for travel and history books. Moran maintained a studio in Philadelphia until 1872, when he moved to New York City. A member of the National Academy of Design, The Pennsyl-

vania Academy of the Fine Arts, the Artists' Fund Society of Philadelphia, the Society of American painters in watercolor, and the Society of American Artists, Moran died in Santa Barbara, California.

Fryxel, Fritiof, ed. *Thomas Moran: Explorer in Search of Beauty*. East Hampton, N.Y., 1958.

Wilkins, Thurman. *Thomas Moran: Artist of the Mountains*. Norman, Okla., 1966.

Morris, Robert (1931–) Born in Kansas City, Morris studied engineering at the University of Kansas City and the Kansas City Art Institute from 1948 to 1950. He later studied at the California School of Fine Art in San Francisco in 1951 and Reed College in Oregon from 1953 to 1955. In 1961, Morris moved to New York and studied art history at Hunter College, where he wrote his master's dissertation on Brancusi, receiving his M.F.A., in 1966. In 1963, he had his first one-man show at the Green Gallery. Morris lives and works in New York City.

Sylvester, David, and Michael Compton. *Robert Morris*. London, 1971.

Morse, Samuel Finley Breese (1791–1872) Born in Charlestown, Massachusetts, Morse graduated from Yale University in 1810. He was a pupil of Washington Allston, and in 1811, the two artists left for London, where they studied in Benjamin West's studio. In 1815, Morse returned to America, painting portraits in New England and Charleston, South Carolina, until 1823, when he settled in New York City. In 1826, he helped found the National Academy of Design and served as its first president until 1845, and again from 1861 to 1862. Between 1829 and 1832, Morse was again in Europe, pursuing his painting career. He returned to New York and around 1839 abandoned art to concentrate on his inventions. In addition to his work as an artist and his invention of the telegraph and the Morse code, he was also the first professor of fine arts at New York University, the founder of the New York *Journal of Commerce*, a candidate for mayor of New York City and for Congress, and an experimenter in daguerreotype photography. He died in New York City.

Larkin, Oliver W. *Samuel F. B. Morse and American Democratic Art*. Boston, 1954.

Mabee, Carleton. *The American Leonardo: A Life of Samuel F. B. Morse*. New York, 1943.

Motherwell, Robert (1915–) Born in Aberdeen, Washington, Motherwell's family moved to San Francisco in 1918. At the age of 11 Motherwell received a fellowship to the Otis Art Institute in Los Angeles. In 1932, he attended briefly the California School of Fine Art before going to Stanford University, where he received his A.B. in philosophy. Motherwell then went to Harvard in 1937, where he studied philosophy. In 1940, the artist entered Columbia University's art department, where Meyer Shapiro advised him to pursue painting rather than scholarship. By 1941, Motherwell had decided to devote himself to painting and had met many of the surrealists-in-exile. Motherwell is well known as a lecturer and teacher and has taught at such colleges as Hunter college,

Smith College, and Harvard University. Although largely self-taught as a painter, he studied etching under Kurt Seligmann and engraving at Stanley William Hayter's Atelier 17. Presently Motherwell lives and works in Greenwich, Connecticut.

O'Hara, Frank. *Robert Motherwell.* New York, 1965.

Mount, William Sidney (1807–1868) Born in Setauket, Long Island, Mount spent most of his life in Stony Brook, Long Island. In 1824, he became an apprentice to his brother, a sign and ornamental painter in New York City. After 2 years, Mount entered the school of the National Academy of Design, of which he became a member in 1832. Between 1829 and 1836, he supported himself in New York by painting portraits. In 1837, Mount returned to Long Island to devote himself to painting the genre scenes that have established his artistic reputation. He died in Setauket in 1868.

Cowdrey, Bartlett and Hermann W. Williams. *William Sidney Mount.* New York, 1944.

Muybridge, Eadweard (1830–1904) Born Edward James Muggeridge in England, Muybridge sailed for the United States in 1852, drawn to California by news of the Gold Rush. In 1860, he returned to England but by 1867, he was back in San Francisco studying photography. In this same year, he organized an expedition to Yosemite Valley. In 1868, Muybridge was made director of photographic surveys for the federal government. In 1869, he invented one of the first efficient camera shutters. Requested by Leland Stanford, former Governor of California and president of the Central Pacific Railroad, to provide evidence that a horse trotting at top speed has all four feet off the ground at one time, Muybridge began this task in 1872. In 1873, he was commissioned to take photographs of the Modoc Indian War. In 1875, Muybridge was acquited of the murder of his wife's lover. He spent the next year in Central America. In 1877, he resumed his study of the locomotion of animals at Stanford's invitation. In 1880, he projected a motion picture on a screen for an audience, using a device he later called a "zoopraxiscope." In 1884, he began his experiments on the locomotion of humans and animals with Thomas Eakins at the University of Pennsylvania. In 1887, his book *Animal Locomotion* was published. In 1888, he met Thomas Edison and the two collaborated on the invention of an early version of the talking motion picture. In 1899, Muybridge's *Animals in Motion* was published, and in 1901, *Human Figure in Motion* appeared. In 1900, he returned to England, where he died in Kingston-on-Thames.

MacDonnell, Kevin. *Eadweard Muybridge: The Man Who Invented the Moving Picture.* Boston and Toronto, 1972.

Neutra, Richard (1892–1970) Born in Vienna, Neutra studied mechanics in Vienna, worked for a landscape architect, and collaborated with Erich Mendelsohn in designing the Berliner Tageblatt (then the tallest building in Berlin) before immigrating to the United States in 1923. After his arrival he worked as a draftsman for Holabird and Roche in Chicago and worked with Frank Lloyd Wright in Taliesin, Wisconsin. In 1925, he

moved to Los Angeles and in 1926 opened up his own practice, which he operated until his death in 1970. He taught architecture for a short time at the Academy of Modern Art in Los Angeles between 1928 and 1929. One of his earliest successes was the Lovell (Health) House in Los Angeles (1929), and he published many books including *Survival Through Design* (1954) and *World and Dwelling* (1962).

Heyer, Paul. *Architects on Architecture: New Directions in America.* London, 1967.

Nevelson, Louise (1899–) Born Louise Beliawsky in Kiev, Russia, Nevelson emigrated with her family to the United States in 1905 and settled in Maine. In 1920, she married Charles Nevelson and moved to New York. From 1929 to 1930, she studied at The Art Students League with Kenneth Hayes Miller and Kimon Nicolaides. In 1931, she went to Munich to study at the Hans Hofmann School of Art. In 1932, she served as an assistant to Diego Rivera. Nevelson briefly worked for the WPA Federal Art Project as a teacher at the Educational Alliance School of Art in New York City. In 1953, she began to make the black box sculpture for which she is noted. Nevelson lives and works in New York.

Glimcher, Arnold. *Louise Nevelson.* New York, 1972.

Newman, Barnett (1905–1970) Born in Manhattan, Newman began to attend The Art Students League in New York in 1922. From 1923 to 1927, he attended the City College of New York, where he took his B.A. degree. In 1929, he attended The Arts Students League again, where his teachers included John Sloan. Newman worked for his father's company, which manufactured men's clothes for a time. Between 1931 and 1939, Newman earned money by substitute teaching in New York high schools, since he could never pass the regular art teacher's exam. In 1933, he ran as the mayoralty candidate on the writers-artists ticket against Fiorello La Guardia. From 1939 to 1944, Newman stopped painting. In the summer of 1941, he studied ornithology at Cornell University. In 1948, he cofounded Subjects of the Artist: A New Art School with William Baziotes, Robert Motherwell, Mark Rothko, and David Hare. Newman taught at the Artists' Workshop in Emma Lake, Canada, in 1959 and at the University of Pennsylvania from 1962 to 1963. He died in New York in 1970.

Hess, Thomas B. *Barnett Newman.* New York, 1971.

Noguchi, Isamu (1904–) Born in Los Angeles, California, Noguchi spent much of his youth in Japan before returning to the United States in 1918 to attend school. After graduation from high school Noguchi was apprenticed to Gutzon Borglum in Stamford, Connecticut. Borglum told Noguchi that he would never be a sculptor, and so from 1922 to 1924, Noguchi attended Columbia University, where he studied medicine. In 1924, Noguchi began to attend the Leonardo da Vinci Art School in Greenwich Willage. In 1927, Noguchi won a Guggenheim Fellowship and went to study in Paris, where he worked as a stonecutter for Brancusi and attended evening classes at the Académie de la Grande Chaumière and the Colarossi School. In 1935, the sculptor began the first

of many successful collaborations with Martha Graham in designing theatrical sets for her dance company. In 1956, Noguchi designed the gardens for the UNESCO building in Paris. In 1968, he published *A Sculptor's World*. Noguchi now spends his time working in the United States, Italy, and Japan.

Gordon, John. *Isamu Noguchi*. New York, 1968.

Noland, Kenneth (1924–) Born in Asheville, North Carolina, Noland studied at Black Mountain College in North Carolina under Josef Albers and Ilya Bolotowsky from 1946 to 1948 and later with Ossip Zadkine in Paris from 1948 to 1949. From 1950 to 1952, Noland taught at the Institute of Contemporary Arts and The Catholic University of America, both in Washington, D.C. In the fall of 1967, Noland taught at Bennington College in Vermont. In the late 1950s, he began his "target" paintings, and in 1965, Noland began to use shaped canvases. In 1961, Noland moved to New York and presently lives in Shaftsbury, Vermont.

Kenneth Noland. New York, The Jewish Museum, 1965.

O'Keeffe, Georgia (1887–) Born near Sun Prairie, Wisconsin, O'Keeffe spent much of her youth on her family's farm. She decided to become an artist at the age of 10 and took private lessons at 11 and 12. From 1905 to 1906, O'Keeffe attended The Art Institute of Chicago, where she studied under John Vanderpoel, and from 1907 to 1908, The Art Students League, where she studied under William Merritt Chase. In 1908, she decided to give up painting and returned to Chicago, where she worked as a commercial artist until 1912. In 1912, she took a position as supervisor of public school art in Amarillo, Texas, and later held the post of head of the department of art at West Texas Normal College. In 1916, her first exhibition was held at 291. In 1924, she married Alfred Stieglitz. In 1917, O'Keeffe made her first trip to New Mexico, and in 1929, she began spending her summers there. In 1924, O'Keeffe made her first flower paintings. In 1953, she made her first trip to Europe. O'Keeffe now lives and works in Abiquiu, New Mexico.

Goodrich, Lloyd, and Doris Bry. *Georgia O'Keeffe*. New York, 1970.
O'Keeffe, Georgia. *Georgia O'Keeffe*. New York, 1976.

Oldenberg, Claes (1929–) Born in Stockholm, Sweden, Oldenberg was brought to the United States by his parents as an infant. The family lived in New York for a short time, than moved to Oslo, Norway, where they lived for 3 years before returning to the United States and settling in Chicago. From 1946 to 1950, Oldenberg attended Yale, where he majored in English literature and art. In 1948, he also attended the University of Chicago and in 1949 the University of Wisconsin. From 1950 to 1952, Oldenberg took classes at The Art Institute of Chicago while he worked as an apprentice reporter for the City News Bureau. In 1956, Oldenberg went to New York, where he worked at the Cooper Union Museum Library. From 1956 to 1958, he wrote a considerable amount of poetry but gave it up to concentrate on art. Among his publications are

Store Days (1968), *Notes in Hand* (1971), and *Object into Monument* (1971). Oldenberg now lives and works in New York.

Rose, Barbara. *Claes Oldenberg.* New York, 1970.

Olmsted, Frederick Law (1822–1903) Olmsted was born in Hartford, Connecticut, and he studied engineering at Yale University from 1837 to 1840. In 1844, he studied farming in Connecticut and New York. In 1850, he made a walking tour of Europe, studying foreign landscaping and architecture. In 1851, he consulted with Andrew Jackson Downing in Newburgh, New York. In 1857, Olmsted became the superintendent of Central Park in 1858, with Calvert Vaux, its chief architect. In 1865, he established a landscape architecture practice with Vaux, an arrangement that lasted until 1872. Olmsted's other designs include the landscaping of New York's Morningside and Riverside Parks, Brooklyn's Prospect Park, Boston's Arnold Arboretum, Chicago's South Park, Detroit's Belle Isle Park, and Montreal's Mount Royal Park. He also produced plans for thirteen college campuses and numerous private estates. Olmsted was one of the founders of the Metropolitan Museum of Art and the American Museum of Natural History, both in New York City. A member of many architectural, scientific, and benevolent organizations, Olmsted died in Massachusetts in 1903.

Barlow, Elizabeth. *Frederick Law Olmstead's New York.* New York, 1972.

Oppenheim, Dennis (1938–) Born in Mason City, Washington, Oppenheim received his B.A. from the California College of Arts and Crafts and his M.A. from Stanford University. Oppenheim has served as a visiting artist at Yale (1969), the Rhode Island College of Design (1970), and The Art institute of Chicago (1971–1972). He has been the recipient of a Guggenheim Fellowship (1971–1972) and a National Endowment for the Arts Grant for Sculpture (1974). Oppenheim now lives and works in New York City.

Sharp, Willoughby. "Dennis Oppenheim," *Studio,* vol. 182, November 1971.

O'Sullivan, Timothy (1840–1882) Born in New York City, O'Sullivan served as an apprentice to the photographer Mathew Brady in New York City. Soon after, he joined Alexander Gardner at the Brady National Photographic Art Gallery in Washington, D.C. During the Civil War, O'Sullivan was in the midst of the action, including the Battle of Gettysburg, taking photographs and running his portable darkroom. In 1867, 1868, and 1869, he accompanied Clarence King's expeditions to the area between the Rocky Mountains and the Sierra Nevadas. He returned briefly to Washington to select plates of his expedition for reports being prepared for Congress. By May of 1869, he was back with King in Salt Lake City for a survey of the Salt Lake area. In siting a possible canal route, the Darien Survey Expedition to the Isthmus of Darien in Panama hired O'Sullivan as its official photographer in 1870. Between 1871 and 1875, he was with the Wheeler Expedition in eastern Nevada and Arizona. In 1880, he was appointed official photographer for the United

States Treasury Department, only to resign 5 months later after contracting tuberculosis. O'Sullivan died on Staten Island, New York, in 1882.

Horan, James D. *Timothy O'Sullivan: America's Forgotten Photographer.* New York, 1966.

Peale, Charles Willson (1741–1827) Born in Queen Anne County, Maryland, Peale was the son of a poor school teacher and worked as a saddlemaker, cabinetmaker, and silversmith before studying painting with John Hesselius. In 1765, he visited Boston, met John Singleton Copley, and studied the paintings in John Smibert's old studio. From 1767 to 1769, he studied in Benjamin West's studio in London. He returned to Annapolis, worked briefly in Baltimore, and moved to Philadelphia, where he settled in 1778. In addition to his successful career as a painter, Peale pursued a wide range of interests during his long life, including the establishment of the nation's first natural history museum in Philadelphia in 1782 and the exhuming of a mastadon skeleton in Ulster County, New York. Father of a large family, Peale had several sons and daughters who became painters themselves, including Rembrandt, Raphaelle, and Titian Ramsay Peale. Not only did his natural history museum include mounted birds and animals but portraits of famous Americans as well. According to popular accounts, Peale died in Philadelphia from a chill caught while out courting a prospective new bride.

The Peale Family. Detroit, The Detroit Institute of Arts, 1967.
Sellers, Charles Coleman. *Charles Willson Peale.* New York, 1969.

Peale, James (1749–1831) Born in Chestertown, Maryland, James was the youngest brother of Charles Willson Peale. From his brother, James learned the crafts of saddlemaking and cabinetry before taking up painting after Charles returned from studying under Benjamin West in London. After the Revolutionary War, Charles and James worked in close association, with James specializing in portrait miniatures. After his eyesight began to fail, James painted still-lifes.

The Peale Family. Detroit, The Detroit Institute of Arts, 1967.

Peale, Raphaelle (1774–1825) Son of the painter Charles Willson Peale, Raphaelle Peale was born in Annapolis, Maryland, and raised in Philadelphia. He helped with his father's museum of natural history before traveling to Baltimore with his brother Rembrandt in 1796 to establish a gallery of portraits of distinguished Americans. Raphaelle painted portraits and after 1812 primarily still lifes (including his trompe l'oeil painting, *After the Bath,* 1823). In addition to painting, the artist also patented a preservative for ships' timbers, developed a successful plan for heating houses, and published his theories on the nature of astral bodies.

The Peale Family. Detroit, The Detroit Institute of Arts, 1967.

Peale, Rembrandt (1778–1860) Born in Bucks County, Pennsylvania, Rembrandt Peale was the son of the painter Charles Willson Peale. He as-

sisted his father in the excavation of a mastadon in Ulster County, New York, and like his father, studied painting with Benjamin West in London and also exhibited portraits at the Royal Academy. From 1796 to 1799, he lived in Baltimore, working with brother Raphaelle to establish a portrait gallery there. In 1800, he dropped his surname because of competition and confusion over the family dynasty of Peale painters. In 1805, he was one of the founding members of the Pennsylvania Academy of the Fine Arts. In 1808, he traveled to Paris to paint portraits for his father's museum including an equestrian portrait of Napolean. He also painted a portrait of Thomas Jefferson in 1805 and several portraits of George Washington. His most famous, *Porthole Portrait of Washington,* was sold to the United States government in 1830. In 1825, Peale succeeded John Trumbull as president of the American Academy of Fine Arts.

The Peale Family. Detroit, The Detroit Institute of Arts, 1967.

Peale, Sarah Miriam (1800–1885) Born in Philadelphia, Sarah Peale was the daughter of Charles Willson Peale's brother, James. Like her father and her sisters Maria, Anna, and Margaretta, Sarah specialized in painting still lifes. From 1820 to 1829, she had a studio in the Peale Museum in Baltimore, and she may have studied with her cousin Rembrandt. In 1847, she moved to St. Louis. In 1875, she returned to Philadelphia, where she died.

Born, Wolfgang. "The Female Peales: Their Art and Its Traditions," *American Collector,* August 1946.
The Peale Family. Detroit, The Detroit Institute of Arts, 1967.

Pearlstein, Philip (1924–) Born in Pittsburgh, Pennsylvania, Pearlstein received his B.F.A. from Carnegie Institute of Technology (now Carnegie-Mellon University) in 1949. Upon graduation Pearlstein moved to New York City, where he worked intermittently with Ladislav Sutner on an industrial trade catalogue from 1949 to 1957. In 1955, Pearlstein received his M.A. from the Institute of Fine Arts at New York University, where he wrote his master's thesis on Francis Picabia. In 1958, Pearlstein was the recipient of a Fulbright Grant for painting in Rome. He taught at Pratt Institute from 1959 to 1963 and has taught at Brooklyn College since 1963. In 1969, Pearlstein received a grant from the National Council of the Arts. He has published numerous articles in such periodicals as *Arts Magazine* and *Art News.* Pearlstein now lives in New York City.

Philip Pearlstein. Georgia, University of Georgia Museum of Art, 1970.

Pelham, Peter (1697–1751) Born in London, Pelham worked as engraver producing twenty-five mezzotint portraits between 1720 and 1726. In 1726, he emigrated with his wife and children to America, becoming the Colonies' first engraver of mezzotints. In Boston, he was an associate of John Smibert, painted a few portraits, as well as taught drawing, dancing, penmanship, and needlework. Pelham married three times, his last union in 1748 to the widowed mother of John Singleton Copley, who then came under the influence of his stepfather's work and interests. Pelham died in Boston in 1751.

Pepper, Beverly (1924–) Born in Brooklyn, Pepper studied painting at Pratt Institute, at The Art Students League of New York with Fernand Leger, and in Paris with André Lhote. Pepper began to sculpt in 1960 by carving up the trunks of dead trees that had fallen in her garden. She has lived in Rome, Italy, since 1951.

Beverly Pepper. New York, Marlborough-Gerson Gallery, Inc., 1969.

Peto, John Frederick (1854–1907) Born in Philadelphia, Pennsylvania, Peto studied at The Pennsylvania Academy of the Fine Arts in 1878 and exhibited there from 1879 to 1881 and 1885 to 1887. Peto moved to Island Heights, New Jersey, in 1889, where he supported himself by playing the coronet at revival meetings. Peto was associated with and influenced by William Harnett before 1880, and later many of his paintings were resigned and sold as the work of Harnett. Peto died at Island Heights on November 23, 1907, and his work remained virtually unknown until the 1940s.

John F. Peto. New York, The Brooklyn Museum Press, 1950.
Frankenstein, Alfred. *After the Hunt: William Harnett & Other American Still Life Painters 1870–1900.* Berkeley and Los Angeles, 1969

Pippin, Horace (1888–1946) Born in West Chester, Pennsylvania, Pippin, a self-taught artist, spent his childhood in Goshen, New York. From 1903 to 1917, Pippin worked at odd jobs in New York and New Jersey. Pippin served in the United States Army from 1917 to 1919 and was wounded in his right shoulder, which partially paralyzed his arm. In 1920, Pippin returned to West Chester and in 1931 produced his first oil painting, which was based on his war experiences. Pippin's work was discovered by Dr. Christian Brinton and N. C. Wyeth, and later the artist came under the patronage of Dr. Albert C. Barnes. Pippin died of a stroke at West Chester in 1946.

Rodman, Selden, and Carol Clearer. *Horace Pippin: The Artist as a Black American.* New York, 1972.

Pollock, Jackson (1912–1956) Born Paul Jackson Pollock in Cody, Wyoming, the artist spent his childhood in the West. In 1925, his family moved to Southern California. Pollock became interested in art through his brother Charles and attended the Manual Arts High School in Los Angeles but never received a high school diploma. In 1930, Pollock left Los Angeles and went to New York, where he studied at The Art Students League with Thomas Hart Benton from 1930 to 1933. He also studied briefly with John Sloan and Robert Laurent. Pollock worked on the WPA Federal Art Project, easel division, intermittently from 1935 to 1943. From 1944 to 1945, Pollock studied printmaking at Stanley William Hayter's Atelier 17. In 1945, Pollock moved to The Springs in Easthampton, New York, where he lived until the time of his death. Pollock died in an automobile accident in 1956.

O'Connor, Francis V. *Jackson Pollock.* New York, 1967.
Robertson, Bryan. *Jackson Pollock.* New York, 1960.

Poons, Larry (1937–) Born in Tokoyo, Japan, Poons was brought to the United States by his American parents in 1938. From 1955 to 1957, he

studied at the New England Conservatory of Music and in 1958 at the Boston Museum of Fine Arts School. From 1966 to 1970, he taught at The Art Students League of New York and from 1967 to 1972 was a visiting lecturer at the New York Studio School. Poons now lives in New York.

Tuchman, Phyllis. "An Interview with Larry Poons," *Artforum*, vol. 9, December 1970.

Porter, Fairfield (1907–1975) Born in Winnetka, Illinois, Porter was the son of an architect. He received his B.S. degree in art history from Harvard University in 1928. Although Porter studied at The Art Students League with Thomas Hart Benton and Boardman Robinson from 1928 to 1930, he claimed his greatest influences were the work of Edouard Vuillard and Willem de Kooning. In 1949, Porter settled in Southampton, Long Island. During the late 1950s and early 1960s, he served as an editorial associate for *Art News*. He was a ferquent contributor to such magazines as *Art in America, The Nation,* and *The Evergreen Review.* In 1959, Braziller Press published his monograph *Thomas Eakins.* Porter taught or served as a visiting artist at Yale University, The Skowhegan School of Painting and Sculpture, The Maryland Institute, and Amherst College. His brother is the renowned photographer Eliot Porter. Porter died of a heart attack in Southampton, Long Island, in 1975.

Cummings, P. "An Interview with Fairfield Porter," *American Artist,* vol. 39, April 1975.

Powers, Hiram (1805–1873) Born in Woodstock, Vermont, Powers went West with his parents, settling in Cincinnati, Ohio. At age 17, Powers's first job was in a clock and organ factory. In 1829, he began working at Dorfeuille's Western Museum in Cincinnati. Powers modeled wax figures for 5 years there. Powers accepted commissions to do busts of famous persons in Cincinnati, and in 1834, he moved to Washington, D.C., where he continued the same practice. In 1837, Powers left for Europe, stopping in Paris before moving on to Florence, where he was to live for the rest of his life. From his Florence studio, Powers produced numerous busts and full-size figures. His *Greek Slave* of 1834 made him the leading American Sculptor of his day. Powers died in Florence.

Crane, Sylvia. *White Silence: Greenough, Powers, and Crawford— American Sculptors in Nineteenth Century Italy.* Coral Gables, Fla., 1972.

Pratt, Matthew (1734–1805) Pratt, the son of a goldsmith, was born in Philadelphia. He was apprenticed to his uncle, James Claypoole, a limner and sign painter. From 1758 to 1764, Pratt was active as a portrait painter in Philadelphia, spending part of the time in New York. In 1764, he went to London and studied for 2½ years in Benajmin West's studio. While there, he painted *The American School* (1765), depicting West's studio. His stay in London was followed by a year and a half of painting portraits in Bristol. After his return to America in 1768, he spent most of his time in Philadelphia, except for a short trip to England and Ireland in 1770. Pratt was the first native American artist to study abroad and return home. He continued to paint portraits but found it necessary to supplement his income by teaching and painting decorative signs.

Although Pratt was active for 50 years, few pictures by him have been recorded. He died in Philadelphia.

Sawitsky, William. *Matthew Pratt.* New York, 1942.

Prendergast, Maurice (1859–1924) Born in St. John's, Newfoundland, Prendergast and his twin sister moved with their family to Boston in 1861. In 1873, Prendergast went to work for Loring and Waterhouse, a dry goods firm. In 1883, he earned his living by lettering show cards. In 1886, Prendergast made his first trip abroad, and in 1891, he returned to study in Paris at the Académie Julian and at the Colarossi School. In 1894, Prendergast returned to the United States and settled in Winchester, Massachusetts, which remained his chief residence until 1905, when he moved to Boston. In 1898, Prendergast made his third trip abroad and made subsequent trips in 1909, 1911, and 1914. In 1908, Prendergast exhibited at the Macbeth Gallery in New York with "the Eight," and later took part in the Armory Show of 1913. In 1914, Prendergast moved to a permanent address in New York City and that same year was elected president of the Association of American Painters. Prendergast died in New York in 1924.

Maurice Prendergast Art of Impulse and Color. Maryland, The University of Maryland, 1976.

Rhys, Hedley. *Maurice Prendergast.* Cambridge, Mass., 1960.

Quidor, John (1801–1881) Born in Tappan, New York, Quidor spent most of his life in and around New York City. He apprenticed there at an early age under the portrait painter John Wesley Jarvis. From 1823 to 1867, Quidor's career as a genre painter and illustrator of stories by Washington Irving was of limited success, although his illustrations were exhibited at the National Academy of Design. To earn a living, Quidor turned to painting signs and panels for fire engines. During the 1840s, he probably lived somewhere in the Midwest, though this has never been documented. From 1851 to 1868, Quidor lived in New York City. He retired to Jersey City in 1868 and died there in 1881.

Baur, John I. H. *John Quidor, 1801–1881.* New York, 1942.

Ramos, Mel (1935–) Born in Sacramento, California, Ramos attended San Jose State College from 1954 to 1955 and Sacramento State College from 1955 to 1958, where he received his A.B. and M.A. degrees. Ramos taught at Mira Loma High School in Sacramento from 1960 to 1966, taking time to travel throughout Europe in 1964. Ramos has also taught at California State College at Hayward (1966) and Arizona State University (1967). Ramos now lives and works in Oakland, California.

Tooker, Dan. "Mel Ramos," *Art International,* vol. 17, November 1973.

Rauschenberg, Robert (1925–) Born in Port Arthur, Texas, Rauschenberg served as a neuropsychiatric technician in the United States Navy from 1944 to 1946. He then studied at the Kansas City Art Institute and School of Design from 1946 to 1947, the Académie Julian in Paris in 1947, Black Mountain College, North Carolina, with Josef Albers from 1948 to 1949, and The Art Students League of New York from 1949 to

1951. Rauschenberg served as artist-in-residence at Black Mountain College in 1952 and traveled to Italy and North Africa before returning to New York in 1953. From 1955 to 1964, Rauschenberg periodically designed and executed stage sets and costumes for the Merce Cunningham Dance Company. Between 1955 and 1956, Rauschenberg, along with Jasper Johns, earned a living by doing free-lance window displays for Tiffany and Bonwit Teller. In 1962, Rauschenberg began extensive printmaking work. In 1964, he was awarded the Grand Prize for Painting at the Venice Biennale, and in 1976, a retrospective of his work was held at the National Collection of Fine Arts, Smithsonian Institution in Washington, D.C. Rauschenberg now divides his time between New York City and Captiva, Florida.

Forge, Andrew. *Rauschenberg*. New York, 1969.
Robert Rauschenberg. Washington, D.C., 1977.

Ray, Man (1890–1976) Born Emmanuel Radenski in Philadelphia, Pennsylvania, Man Ray grew up in New York City and spent most of his adult life in Paris. In 1912, he studied at the Ferrer Center in New York. Man Ray worked briefly as an advertising illustrator and was later apprenticed to an engraver. Along with Marcel Duchamp and Katherine S. Dreier, he founded the Société Anonyme in 1920. In 1921, Man Ray published *New York Dada*. His films include *Emak Bakia* (1926) and *L'Étoile de mer* (1928). In 1915, he took his first photographs and in 1917, his first rayographs. In 1963, he published an autobiography entitled *Self-Portrait*. Man Ray died in Paris.

Penrose, Roland. *Man Ray*. London, 1975.

Reinhardt, Ad (1913–1967) Born Adolph Frederick Reinhardt in Buffalo, New York, Reinhardt grew up in New York City, where he studied at Columbia University under Meyer Schapiro from 1931 to 1935. During 1936, he studied at the National Academy of Design and in that same year was hired by Burgoyne Diller for the WPA Federal Art Project, easel division, where he worked until 1941. In 1937, Reinhardt joined the Artists' Union, and he was a member of the American Abstract Artists from 1937 to 1947. From 1946 to 1950, he studied Oriental art and philosophy at New York University's Institute of Fine Arts. From 1944 to 1946, he served as a cartoonist and critic for the magazine *PM* and from 1954 to 1967 for *Art News*. From 1947 to 1967, Reinhardt taught at Brooklyn College in New York. Reinhardt also taught at Hunter College in New York, California School of Fine Arts in San Francisco, University of Wyoming in Laramie, Yale University, New York University, and Syracuse University. He made trips to Europe, the Middle East, and the Far East in 1952, 1953, 1958, and 1961. Reinhardt died in New York in 1967.

Rose, Barbara, ed. *Art As Art: The Selected Writings of Ad Reinhardt*. New York, 1975.

Remington, Frederick (1861–1909) Born in Canton, New York, Remington was almost entirely self-taught, studying only 1 year at the Yale Art School. When he was 19, he went West, working as a clerk in a general

store, then as a cowboy and ranch stockman. Remington remained in the West until 1886, sketching and painting life on the plains. When he returned to New York, Remington studied at The Art Students League until 1892, when he began a tour of Germany, Russia, and North Africa. Between 1897 and 1899, he made trips to Cuba to sketch scenes of the Spanish-American War. In addition to numerous oil paintings, Remington produced about fifteen bronze sculptures, illustrations for *Harper's Weekly* and *Outing,* and wrote several books. Remington received many honors during his lifetime including associate membership in the National Academy of Design. He died in Ridgefield, Connecticut.

McCracken, Harold. *Frederick Remington, Artist of the Old West.* Philadelphia and New York, 1947.

Revere, Paul (1735–1818) Revere spent his lifetime solely in Boston. He was trained in his father's goldsmith business, where he also learned to engrave on silver. In 1765, he began to do copper engravings, and his best-known plates are *The Repeal of the Stamp Act* (1766), *The Landing of the British Troops* (1768), and *The Boston Massacre* (1770). Revere was also a copper and silver worker, bell caster, political cartoonist, and watercolorist. He distinguished himself in the Revolutionary War as a patriot and courier for the Massachusetts Committee of Correspondence.

Richardson, Henry Hobson (1838–1886) Born near New Orleans, Louisiana, Richardson attended Harvard College and, after graduating in 1859, left for Paris to study at the École des Beaux-Arts. To support himself in Paris, he worked as a draftsman. In 1866, Richardson returned to New York and began his architectural career. In 1867, he formed a partnership with another architect, Emlyn Littel, but this only lasted a few months and Richardson then joined forces with Charles D. Gambrill, with whom he remained in partnership until 1878. Though his office was in New York, Richardson lived in Brookline, Massachusetts, and by 1878, he had adapted his home to a combination personal and professional space. He designed not only public, commercial, and business structures including Trinity Church in Boston, and the Marshall Field Warehouse in Chicago, but also city and country homes for the wealthy, such as the Watts Sherman House in Newport, Rhode Island. Richardson was awarded many honors during his lifetime, including election as a member of the Royal Institute of British Architects.

Hitchcock, Henry H. Jr. *The Architecture of Henry Hobson Richardson and His Times.* Hamden, Conn. 1961.

Riis, Jacob (1849–1914) Born in Ribe, Denmark, Riis worked as a carpenter before emigrating to the United States in 1870. Riis worked at odd jobs until 1877, when he began working as a reporter for the New York *Tribune.* Riis took up photography in 1877 and was one of the first photographers in America to use flashlight powder. In 1888, Riis joined the staff of the *New York Evening Sun* as a police reporter and worked in that capacity until 1899. Also in 1888, he founded a settlement house in the Mulberry Bend District of New York. In 1890, Riis

published *How the Other Half Lives,* a book which led to the first organized efforts to eliminate the worst aspects of tenement life. Riis subsequently published other books including *Children of the Poor* (1892), *Children of the Tenements* (1903), and an autobiography, *The Making of An American* (1901). Although Riis was a well-published journalist and photographer, his work was overlooked until 1947, when Alexander Alland rediscovered his prints by enlarging his original 4 × 5 inch glass negatives. Riis died at Barre, Massachusetts.

Alland, Alexander. *Jacob A. Riis—Photographer and Citizen.* New York, 1974.

Rimmer, William (1816–1879) Born in Liverpool, England, Rimmer was taken as a child to Nova Scotia and then Boston by his father who believed that he was the French Dauphin in exile, fleeing from the French Revolution. Rimmer's eccentric father and strange origins effected the artist deeply. His first work was a small gypsum sculpture of his father titled *Despair.* By 1840, Rimmer had worked at a number of jobs, including work as a lithographer and a typesetter in the Boston area. In 1845, he settled on the career of a cobbler, but studied medicine in his spare time. From 1855 to 1863, he was an unlicensed physician working in the village of East Milton. During this time, he attempted to teach himself to sculpt. His knowledge of anatomy resulted in offers to lecture on art anatomy, and from 1864 to 1866, he ran a school of drawing and modeling in Boston. From 1866 to 1870, he became the director of the School of Design for Women at Cooper Union in New York. Returning to Boston in 1870, Rimmer reopened his school, where he taught until 1876. For the 3 years prior to his death in 1879, Rimmer taught at the art school of the Boston Museum of Fine Arts. He died in his daughter's home in Boston.

Rimmer, William. *Elements of Design.* Boston, 1864.
Rimmer, William. *Art Anatomy.* Boston, 1877.
Bartlett, Truman H. *The Art Life of William Rimmer, Sculptor.* Boston, 1882.

Rivers, Larry (1923–) Born in the Bronx, New York, Rivers worked as a jazz saxophonist from 1940 to 1945. From 1942 to 1943, he served in the United States Army Air Corps. During 1944, Rivers studied musical composition at the Julliard School of Music in New York. Rivers began painting in Maine in 1945 and moved to New York in 1946, where he attended the Hans Hofmann School of Painting from 1947 to 1948. Late in 1948, Rivers began studying art under William Baziotes at New York University, where he graduated in 1941. Rivers made his first trip to Europe in 1950 and upon his return to New York devoted himself almost exclusively to painting. In 1951, Rivers began spending his summers in Southampton, Long Island, where he moved permanently in 1953. In 1957, he collaborated on some "painting poems" with Frank O'Hara, and in 1960, with Kenneth Koch. Rivers designed stage sets for a number of plays, including Igor Stravinsky's *Oedipus Rex* (1966). In 1964, Rivers served as artist-in-residence at the Slade School of Fine Art in London and traveled throughout Europe before returning to the United

States. Rivers now lives and works in New York City and Southampton, Long Island.

Hunter, Sam. *Larry Rivers.* New York, 1969

Rockburne, Dorothea (1934–) Born in Verdun, Canada, Rockburne received her B.A. from Black Mountain College in North Carolina. In 1970, Rockburne began teaching at the School of Visual Arts in New York. In 1972, she received a Guggenheim Fellowship. Rockburne now lives and works in New York.

Licht, Jennifer. "An Interview with Dorothea Rockburne," *Artforum,* vol. 10, March 1972.

Rogers, John (1829–1904) Rogers was born in Salem, Massachusetts, but spent his boyhood in Cincinnati, Ohio, Cambridge, Massachusetts, Walpole, New Hampshire, and Roxbury, Massachusetts. At 16, he was a clerk in a dry goods store in Boston and then a junior assistant to the water commissioner. Poor eyesight caused Rogers to abandon his future as a civil engineer, and he took a job in a machine shop, modeling clay in his spare time. By 1858, he decided to become a sculptor. In the same year, he went to Paris and Rome to study art, but returned within a year and took a drafting job in Chicago. This was short-lived, for his humorous genre works had appealed to so many that he decided to resume sculpting. In 1859, he moved to New York, opened a studio, and met with success that was to last for 35 years. In those years, he produced works which were to elect him to the National Academy of Design in 1863 and win him highest awards at the Columbian Exposition in 1893. In 1894, Rogers retired to New Canaan, Connecticut, where he died.

Wallace, David H. *John Rogers: The People's Sculptor.* Middleton, Conn., 1967.

Root, John Wellborn (1850–1892) Root was born in Lumpkin, Georgia. At the age of 14, he was taken to Liverpool, England, where his father was engaged on a special steamship mission for Jefferson Davis. While in England, Root studied architectural drawing and entered Oxford in 1868, remaining only a short time. After returning to America, Root studied engineering at New York City College. Root received architectural training under James Renwick and also worked for the architect James Snook of Brooklyn. In 1871, Root moved to Chicago and was employed as a draftsman for Carter, Drake, and Wight. Root became friends with Daniel Burnham, and in 1873, the two architects established a firm. Between the years 1880 and 1892, Burnham and Root were active in the Chicago building flurry. He died in Chicago while working on the plans for the Columbian Exposition.

Monroe, Harriet. *John Wellborn Root: A Study of His Life.* 1896.

Rothko, Mark (1903–1970) Born Marcus Rothkowitz in Dvinsk, Russia, Rothko and his family settled in Portland, Oregon in 1913. Rothko studied at Yale University from 1921 to 1923 and at The Art Students League

under Max Weber in 1925. From 1929 to 1952 Rothko taught at the Center Academy, Brooklyn Jewish Center in New York. In 1935, Rothko cofounded "the Ten." From 1936 to 1937, he worked on the WPA Federal Art Project, easel division in New York. In 1948, he cofounded Subjects of the Artists: A New Art School in New York, with William Baziotes, David Hare, Robert Motherwell, and Barnett Newman. From 1951 to 1954, Rothko taught at Brooklyn College in New York. In 1963, he was elected a member of the National Institute of Arts and Letters and in 1969 received an honorary doctor of fine arts degree from Yale University. Rothko committed suicide on February 25, 1970, in New York City. The Rothko Chapel was dedicated in Houston, Texas, in 1971.

Causey, Andrew. "Rothko Through His Paintings." *Studio International,* vol. 183, April 1972.

Ritchie, Andrew Carnduff. *Salute to Mark Rothko.* New Haven, 1971.

Rush, William (1756–1833) Born in Philadelphia, Pennsylvania, Rush was apprenticed to Edward Cutbush, a figurehead carver, around 1771. Rush served in the Revolutionary Army and after the war returned to Philadelphia, where he established a shop in which he carved the figureheads for United States ships. None of these ships' figureheads survive today. In 1794, Rush formed (with Charles Willson Peale among others) The Columbianum, an artists association which was established to protect and encourage the fine arts in the United States. In 1798, it ceased to function when members resigned because of a dispute over drawing from live models, a practice both Rush and Peale followed. In 1805, Rush was one of the founders of The Pennsylvania Academy of the Fine Arts. From 1811 until his death Rush exhibited in every annual Philadelphia Academy exhibition. About 1809, he completed his most famous work, *Water Nymph and Bittern,* a cast of which still stands in Philadelphia's Fairmont Park. Rush died in the city of his birth.

Marceau, Henri. *William Rush 1756–1833: The First Native American Sculptor.* Philadelphia, 1937.

Russell, Charles (1864–1926) Russell was born in St. Louis but lived all his life in and around Great Falls, Montana. He was a self-taught painter, sculptor, and writer. From 1886 until his death in 1926, Russell's sketches and paintings illustrated numerous books and magazines. As a sculptor, he created over one hundred bronzes. His book *Trails Plowed Under* recounts life on the Montana range.

McCracken, Harold. *The Charles M. Russell Book.* Garden City, N.Y., 1957.

Russell, Morgan (1886–1953) Born in New York City, Russell was the son of an architect. He studied architecture in New York from 1904 to 1905 before studying at The Art Students League from 1906 to 1908 under Robert Henri and James Earle Fraser. In 1908, Gertrude Vanderbilt Whitney became his patron, an arrangement which lasted until 1913. In 1909, Russell settled in Paris, where he remained until he returned to the United States in 1946. In 1912, he developed synchromism with Stanton

Macdonald-Wright in Paris. He exhibited in the Armory Show of 1913. Russell died in Broomall, Pennsylvania.

Agee, William C. "Synchromism and Color Principles in American Painting, 1910–1930." *Art in America*, vol. 53, October 1965.

Ryder, Albert Pinkham (1847–1917) Born in New Bedford, Massachusetts, Ryder's education ended with grammar school due to his poor eyesight, which was to trouble him all his life. In 1870, Ryder, along with his family, moved to New York City, where he was to reside for the rest of his life. Rejected for admission to the National Academy of Design, Ryder came under the influence of William Edgar Marshall, a portraitist and engraver. In the late 1870s, Ryder began his formal training at the National Academy and first exhibited there in 1873. In 1875, he exhibited with four other painters who had been rejected by the Academy. This was to lead to the organization of the Society of American Artists in 1877, to which Ryder subscribed and exhibited for the next 9 years. He spent a month in London in 1877, toured England with Daniel Cottier in 1882, and toured the Continent in 1882, 1887, and 1896. In 1880, Ryder's style of painting grew more imaginative. His art was patronized by only a few collectors, critics, and other artists; he exhibited infrequently; and he led an eccentric, unkempt life. After 1900, Ryder produced few works. Six of his paintings were shown in the Armory Show of 1913. In 1915, Ryder became ill and was cared for by friends, the Fitzpatricks, at their home in Long Island, New York, where he died in 1917.

Goodrich, Lloyd. *Albert P. Ryder*. New York, 1959.

Saarinen, Eero (1919–1961) Born in Kirkkonommi, Finland, the son of the architect Eliel Saarinen, Saarinen emigrated with his family to the United States in 1923. From 1930 to 1931 Saarinen studied sculpture at the Académie de la Grande Chaumière in Paris and received his B.F.A. in 1934 from Yale University's School of Architecture. From 1934 to 1936 Saarinen traveled throughout Europe. From 1930 to 1950 he worked in his father's architectural firm in Bloomfield Hills, Michigan. After his father's death in 1950, Saarinen became the principal partner in *Eero Saarinen and Associates* and remained so until his death. In 1940, Saarinen, in collaboration with Charles Eames, designed the molded plywood chair that won first prize in the Museum of Modern Art furniture competition and is now a classic. Eero Saarinen's best known works include the Jefferson National Expansion Memorial in St. Louis (1949–1964), the Trans World Airlines Terminal at Kennedy Airport in New York (1956–1962), and Dulles International Airport Terminal in Chantilly, Virginia (1958–1962). Saarinen died in Ann Arbor, Michigan.

Saarinen, Aline B., ed. *Eero Saarinen on His Work*. New Haven, 1968.
Temko, A. A. *Eero Saarinen*. London, 1962.

Saint-Gaudens, Augustus (1848–1907) Born in Dublin, Ireland, Saint-Gaudens was brought to New York by his parents when he was six months old. At the age of thirteen, he was apprenticed to a New York stone-cameo cutter. In 1864, he began attending drawing classes at

Cooper Union and later at the National Academy of Design. After three years, Saint-Gaudens left for Paris, where he studied drawing, first at the Petite École and in 1868 at the École des Beaux-Arts. He supported himself during this time by cutting cameos. In 1870 he was forced to leave Paris because of the Franco-Prussian War. He went to Rome, where he maintained a studio for three years, doing portrait work and cameo cutting. In 1873, he returned to New York for a brief stay, but was back in Rome in the same year, remaining until 1876. In 1876, he opened a studio in New York with David Maitland Armstrong and Erastus Dow Palmer. He exhibited at the Philadelphia Centennial Exhibition, did decorative painting for Trinity Church in Boston, and became acquainted with John La Farge and the architects Charles McKim, Stanford White, and Henry H. Richardson. During his lifetime, Saint-Gaudens established studios in New York, Rome, and Cornish, New Hampshire. His sculpture production included relief work for tombs, medallions of notable persons and events, and freestanding sculptural figures and memorials. In 1877, he helped to found the Society of American Artists, in 1893, the National Sculpture Society, and in 1904, the American Academy of Fine Arts in Rome. Saint-Gaudens was the recipient of numerous medals and honorary degrees, including election as a full academician to the National Academy of Design in 1890. Saint-Gaudens taught at The Art Students League of New York, acted as consultant to McKim, Mead, and White for the Boston Public Library construction, supervised sculptural decoration for the World's Columbian Exposition, and became advisor to the Park Planning Commission for the District of Columbia.

Augustus Saint-Gaudens: The Portrait Reliefs. Washington, D.C., 1969.
Cortissoz, Royal. *Augustus Saint-Gaudens.* New York, 1907.

Saint-Mémin, Charles B.J.F. (Balthazar Julien Fevret) du (1770–1852) Born in Dijon, France, Saint-Mémin fled with his family to Switzerland during the French Revolution and in 1793 came to America. In New York City he worked as a landscape and portrait painter beginning in 1796 and in 1798 moved to Burlington, New Jersey, and then to Philadelphia. From 1804 to 1809 Saint-Mémin worked in Baltimore, Annapolis, Washington, D.C., Richmond, and Charleston, specializing in profile portraits made with the aid of a physiognotrace. In 1810 he returned to France, but was back in New York City in 1812. In 1814 Saint-Mémin traveled again to France and remained in Dijon until his death.

Rice. *An Album of Saint-Mémin Portraits.*

Samaras, Lucas (1936–) Born in Kastoria, Greece, Samaras came to the United States in 1948 and settled in New Jersey with his parents. From 1955 to 1959 Samaras attended Rutgers University, where he studied with Allan Kaprow and met George Segal. From 1959 to 1962 Samaras attended Columbia University and studied art history under Meyer Schapiro. That same year he began to participate in "Happenings" at the Reuben Gallery and began to work in cloth dipped in plaster. In 1960 he made his last oil paintings and began making his first boxes. In 1964 Samaras created his first environmental work. In 1966 he

made his first photo-transformations. He taught at Brooklyn College from 1971 to 1972. Samaras now lives in New York City.

Levin, Kim. *Lucas Samaras.* New York, 1975.

Sargent, John Singer (1856–1925) Sargent was born in Florence, Italy, of American parents. His family traveled extensively throughout Europe during Sargent's childhood. In 1868 he studied with the German-American painter, Carl Welsch, and entered the Accademia delle Belle Arti of Florence in 1870. Trips to Dresden, Switzerland, Venice, and Normandy between 1871 and 1874 were followed by study at the École des Beaux-Arts in Paris and later in the studio of Carolus Duran. He first exhibited at the Salon in 1877, and the following year Sargent's works were shown for the first time in America by the Society of American Artists. Sargent worked in his Paris studio until 1885 and then moved to London, where his friends included Henry James, Robert Louis Stevenson, and Isabella Stewart Gardner. In 1887 and 1890, he visited America and during the second visit, he was commissioned to paint the murals for the Boston Public Library, a project he pursued intermittently until his death. Among the many honors he received were election as an academician to the National Academy of Design (1897). In addition, he decorated the rotunda of the Boston Museum of Fine Arts and painted the library murals at Harvard University. Sargent died in London.

Ormond, Richard. *John Singer Sargent Paintings, Drawings, Watercolors.* New York, 1970.

Segal, George (1924–) Born in New York City, Segal studied at Cooper Union from 1941 to 1942. From 1942 to 1946 Segal was a part-time student at Rutgers University in New Brunswick, New Jersey, and in 1947, he studied at Pratt Institute in New York City. In 1949 Segal received a B.S. in Art Education from New York University. From 1948 to 1958 he operated a chicken farm in Middlesex County, New Jersey, the site of several Happenings. When chicken farming was no longer profitable, Segal worked as a high school teacher from 1957 to 1964. In 1963, Segal received his M.F.A. from Rutgers University. In 1964, Segal began to devote himself entirely to sculpture. He now lives in North Brunswick, New Jersey.

Van der Marck, Jan. *George Segal.* New York, 1975.

Serra, Richard (1939–) Born in San Francisco, California, Serra received a B.A. from the University of California, Santa Barbara, and an M.F.A. from Yale University. In 1964 he was awarded a Fulbright Fellowship, and spent the year traveling in Italy. Since 1968 Serra has been involved with process art. He now lives and works in New York City.

Krauss, Rosalind. "Richard Serra: Sculpture Redrawn." *Artforum,* vol. 10, May 1972.

Shahn, Ben (1898–1969) Born in Kovno, Lithuania, Shahn emigrated with his family to the United States in 1906 and settled in Brooklyn. From 1911 to 1917, Shahn worked as a lithographer's apprentice while at-

tending high school at night. From 1919 to 1921 Shahn attended New York University and the City College of New York. In 1922 he studied at the National Academy of Design. Shahn traveled to Europe in 1925 and 1927. In 1929, he shared a studio in New York with photographer Walker Evans. Between 1931 and 1932 Shahn executed his Sacco-Vanzetti series. In 1933 he worked as an assistant to Diego Rivera on Rivera's mural *Man at the Crossroads* for Rockefeller Center. From 1933 to 1934 Shahn was enrolled in the Public Works Art Project of New York City. From 1935 to 1938 he worked as an artist, a photographer, and a designer for the Farm Security Administration. From 1943 until his death Shahn accepted commercial commissions from such corporations as CBS, Columbia Records, Time, and Harper's. From 1944 to 1946 he served as the director of the Graphic Arts Section of the CIO. During 1951 he taught at Black Mountain College and in 1956 was appointed Nortan Professor of Poetry at Harvard University. His publications include *The Shape of Content* (1957) and *Love and Joy About Letters* (1963). Shahn died in New York City on March 4, 1969.

Morse, John D., ed. *Ben Shahn.* New York, 1972.

Rodman, Selden. *Portrait of the Artist as an American: Ben Shahn, A Biography with Pictures.* New York, 1951.

Sheeler, Charles (1883–1965) Born in Philadelphia, Pennsylvania, Sheeler attended the Philadelphia Museum School of Industrial Art from 1900 to 1903. From 1903 to 1906 he attended The Pennsylvania Academy of the Fine Arts, where he studied with William Merritt Chase. Sheeler first visited Europe in 1904. In 1912 Sheeler began commercial photography assignments for Philadelphia architects by recording their projects on film. He exhibited six paintings in the Armory Show of 1913. In 1919, Sheeler moved to New York. In 1920 he collaborated with Paul Strand on the film *Manhatta.* Through the suggestion of Edward Steichen, Sheeler began free-lance photography for Condé Nast Publications and worked for such magazines as *Vogue* and *Vanity Fair.* In 1933 Sheeler moved to Ridgefield, Connecticut, and in 1944 made a final move to Irvington-on-Hudson, New York. From 1942 to 1945 Sheeler worked as photographer-in-residence for the Metropolitan Museum of Art. From 1946 to 1949 he served as artist-in-residence at the Phillips Academy in Andover, Massachusetts. In 1959 Sheeler was incapacitated by a stroke which rendered him unable to photograph or paint for the rest of his life. Sheeler died in Dobbs Ferry, New York, on May 7, 1965.

Friedman, Martin. *Charles Sheeler.* New York, 1975.

Shinn, Everett (1876–1953) Born in Woodstown, New Jersey, Shinn studied mechanical drawing at the Spring Garden Institute in Philadelphia from 1891 to 1893. From 1894 to 1895 he studied at The Pennsylvania Academy of the Fine Arts. In 1895 he joined George Luks and William Glackens as staff artist for the *Philadelphia Press.* In 1897 he moved to New York and began to work for the *New York World.* By 1900 Shinn was a well-known illustrator for *Harper's Weekly.* Shinn was invited to exhibit at the Armory Show of 1913 but refused or simply ignored the invitation. In 1917 Shinn began work as an art director for Sam Goldwyn

at Goldwyn Pictures, but he left this post in 1920 to take a similar position for Inspiration Pictures. In 1923 Shinn left his position at Inspiration Pictures to become art director for William Randolph Hearst's Cosmopolitan Pictures. In 1943 Shinn exhibited in the Brooklyn Museum's exhibition "The Eight." In 1943 he was made an academician, painter class, of the National Academy of Design. Shinn became a member of the American Academy of Arts and Letters in 1951. Shinn died in New York City on January 2, 1953.

DeShazo, Edith. *Everett Shinn, 1876–1953, A Figure in His Time.* New York, 1974.

Siskind, Aaron (1903–) Born in New York City. Siskind graduated from the City College of New York and earned a living by teaching English in New York City high schools. In 1932 he joined the New York Film and Photo League. In 1936 he helped to organize the Feature Group of the Photo League, along with photographers Morris Engel, Jack Manning, Harold Corsini, and others. Siskind stayed with the group for three years and helped to produce such photographic essays as "Portrait of a Tenement" and "Harlem Document." In 1939 he produced an independent photographic essay entitled "Most Crowded Block in the World." In 1951 Siskind began teaching at the Institute of Design in Chicago. In 1961 he became the head of the photography department of the Illinois Institute of Technology. In 1966 he received a Guggenheim Fellowship and spent most of his time photographing in and around Rome. In 1971 Siskind joined the faculty of the Rhode Island School of Design, where he continues to teach.

Aaron Siskind Photographer. New York, 1965.

Sloan, John (1871–1951) Born in Lock Haven, Pennsylvania, Sloan attended Central High School in Philadelphia with William Glackens and Albert C. Barnes. In 1888 Sloan left high school to take a job at a local booksellers shop, which also dealt in fine prints. He then taught himself etching by studying books. In 1890 Sloan had secured a position designing calenders and novelties and making etchings. This position led to Sloan becoming a free-lance artist in 1891. In 1892 he began work in the art department of the *Philadelphia Inquirer,* attended classes at The Pennsylvania Academy of the Fine Arts under Thomas Anshutz, and met Robert Henri. In 1895 Sloan left the *Inquirer* for the *Philadelphia Press.* His first serious oil paintings, done in 1896, were chiefly portraits, but by 1897 he had begun painting city scenes. In 1904 Sloan moved to New York. In 1908 he participated in the first exhibition of "The Eight." From 1912 to 1915 Sloan served as art editor for *The Masses.* Sloan exhibited in the Armory Show of 1913. In 1916 Sloan began teaching at The Art Students League of New York, where his students included Reginald Marsh and Adolph Gottlieb, and continued to do so, with several brief interruptions, until 1938. In 1918 Sloan became the president of the Society of Independent Artists, a position he held until 1944. In 1929 he was elected a member of the National Institute of Arts and Letters. From 1934 to 1939 Sloan worked for the WPA Federal Art Proj-

ect, easel division, in New York. In 1939 he published his book *Gist of Art*. Sloan died in Hanover, New Hampshire.

Scott, David. *John Sloan*. New York, 1975.

Smibert, John (1688–1751) Smibert was born in Scotland. After working as a house painter in Edinburgh, he moved to London, where he decorated coaches and copied old-master paintings for dealers. He studied at one of the first British art academies and then traveled to Italy where he studied independently. In 1728, Smibert came to America with Dean (later Bishop) George Berkeley, who persuaded him to join the faculty of a projected university to be established in Bermuda. The plan failed, and Smibert moved to Boston where he commemorated the experience in *The Bermuda Group* (1729), the first group portrait done in this country. Smibert received portrait commissions from Boston's leading families. In 1730, he opened a studio where he exhibited his copies of the old masters, casts from ancient sculpture, and his recent portraits of Bostonians. It was the first art exhibition to be held in America, and his studio helped introduce New England artists to the great European tradition. Smibert was also the architect of Fanueil Hall, Boston.

Smith, Captain Thomas (active 1680–1690) Little is known of Captain Thomas Smith. A sailor by profession, Smith came from Bermuda to New England about 1650 where he worked for a time as a portrait painter. A painting of Captain Thomas Smith (c. 1670) is believed to be a self-portrait.

Smith, David (1906–1965) Born in Decatur, Indiana, Smith moved with his family to Paulding, Ohio, in 1921. During 1923 Smith studied art by correspondence from the Cleveland School of Art. From 1924 to 1925 Smith studied at Ohio University in Athens, Ohio, before taking a job as an assembly-line worker in a Studebaker plant in South Bend, Indiana. In 1925 Smith moved to Washington, D.C., to work for the Morris Plan Bank and in 1926 moved to New York, taking a position in a branch of that bank. In 1926 he began taking evening courses at The Art Students League and studied under Richard Lahey, John Sloan, and Jan Matulka. In 1929 Smith bought Fox Farm near Bolton Landing, New York. In 1932 Smith created his first welded steel sculpture. In early 1934 Smith found Brooklyn Terminal Iron Works, a machinist shop on the waterfront, where he established a studio. In 1937 Smith joined the WPA Federal Art Project. In 1940 Smith moved permanently to Bolton Landing, where his house and home were thereafter known as Terminal Iron Works. From 1942 to 1944 he worked on a wartime job as a welder at the American Locomotive Company plant in Schenectady, New York. In 1950 and 1951 Smith won Guggenheim Fellowships. In 1961 he began work on his "Cubi" series. In 1962 Smith was invited by the Italian government to produce sculpture for the Fourth Festival of Two Worlds at Spoleto. Smith died on May 23, 1965, near Bennington, Vermont, in an automobile accident.

Gray, Cleve, ed. *David Smith by David Smith*. New York, 1968.
Krauss, Rosalind. *Terminal Iron Works: The Sculpture of David Smith*. Cambridge, Massachusetts, 1971.

Smithson, Robert (1938–1973) Born in Passaic, New Jersey, Smithson moved with his family to Clifton, New Jersey, in 1948. While still in high school, Smithson won a scholarship to The Art Students League and began evening studies there. In 1961 he visited Rome, and in 1963 he married Nancy Holt. In 1966 he was hired as a consultant to the engineering firm which was designing the Dallas-Fort Worth Regional Airport. He planned to create earthworks for the site, but the firm lost the contract and the works were not constructed. In 1970 he created *Spiral Jetty* and that same year produced a film on the work. Smithson died on July 20, 1973 in an airplane accident while inspecting the site for his *Amarillo Ramp* near Amarillo, Texas.

Ginsburg, Susan. *Robert Smithson: Drawings*. New York, 1974.
Smithson, Robert, and Gregoire Muller. "The Earth, Subject to Cataclysms, Is a Cruel Master." *Arts Magazine*, vol. 46, November 1971.

Sonnier, Keith (1941–) Born in Mamou, Louisiana, Sonnier graduated from the University of Southwestern Louisiana in 1963. After graduation he lived in France for one year. In 1966 Sonnier received his M.F.A. from Rutgers University. In 1969 Sonnier exhibited in the Whitney Museum's "Anti-Illusion" show, and by that year he was experimenting with neon tubing, string, latex, and glass. Sonnier has since expanded his art to an environmental scale which includes the use of video and sound equipment. In 1974 and 1975 Sonnier won consecutive Guggenheim Fellowships. Sonnier now lives in New York.

"Ray Thorburn Talks with Keith Sonnier." *Art International*, vol. 20, January-February 1976.

Southworth, Albert Sands (1811–1894) Southworth was born in West Fairlee, Vermont, and attended the Phillips Academy in Andover, Massachusetts. In 1840, after hearing Gourand lecture on daguerreotypy, he opened a daguerreotype studio in Cabotville (now Chicopee), Massachusetts, with Joseph Pennell as his partner. In 1841, Southworth moved to Boston and opened a new studio with Josiah Johnson Hawes as his partner. In 1849, the Gold Rush drew Southworth to California, where he mined, unsuccessfully, until 1851 when he returned to the firm. Ill health caused Southworth to leave the firm in 1861. He died in Charlestown, Massachusetts.

Sobieszek, R., and O. Appel. *The Spirit of Fact: The Daguerreotypes of Southworth and Hawes, 1843–1862*. Boston, 1976.

Soyer, Raphael (1899–) Raphael (and his twin brother, Moses) was born in Borisoglebsk, Russia. In 1913 his family emigrated to the United States and settled in New York. From 1914 to 1917 Soyer studied at The Cooper Union. From 1918 to 1922 he studied at the National Academy of Design. Soyer studied at The Art Students League briefly from 1920 to 1921 with Guy Pène du Bois and also in 1923 and 1926. In 1927 he began

exhibiting at the Whitney Studio Club. During the 1930s he worked for the WPA Federal Art Project in the Easel and Graphics Divisions. From 1933 to 1934 and from 1935 to 1942 Soyer taught at The Art Students League of New York. In 1945 he received a grant from the National Institute of Arts and Letters and was later elected a member in 1958. In 1949 he was elected an associate of the National Academy of Design and was made an academician in 1951. From 1957 to 1962 he taught at the New School for Social Research, and from 1965 to 1967 he taught at the National Academy of Design. Soyer has written three books: *Homage to Thomas Eakins, Etc.* (1961), *A Painter's Pilgrimage* (1962), and *Self-Revealment: A Memoir* (1967). He now lives in New York City.

Goodrich, Lloyd. *Raphael Soyer.* New York, 1972.

Spencer, Lily Martin (1822–1902) Born in Exeter, England, Spencer, the mother of eight children, emigrated to the United States with her family in 1830. The family settled briefly in New York and moved to Marietta, Ohio, in 1833. In 1841 she moved to Cincinnati and decided, after an exhibition of her work in that city, to pursue art as a career. In 1847 she exhibited eight paintings at the Western Art Union's opening. In 1848 she exhibited her first painting at the National Academy of Design. In 1849 the Western Art Union selected her painting *Life's Happy Hour* to be distributed to the subscribers of that year. That same year she moved to New York. In 1850 she was elected an honorary member of the National Academy of Design. In 1861 she exhibited her first paintings at the Boston Atheneum and The Pennsylvania Academy of the Fine Arts. Spencer died in New York City.

Bolton-Smith, Robin. *Lily Martin Spencer, 1822–1902, The Joys of Sentiment.* Washington, D.C., 1973.

Steichen, Edward (1879–1973) Born in Luxembourg, Steichen emigrated with his family to the United States in 1881. He was educated in Milwaukee, Wisconsin, where he studied art while working as a lithographer's apprentice. Steichen took his first photograph in 1896 and initially won recognition at the Philadelphia Salon of 1899. In 1900 he met Stieglitz, who bought three of his prints. Between 1901 and 1902 Steichen traveled throughout Europe. In 1901 Steichen was elected a member of the Link Ring and began his friendship with Rodin. In 1902 Steichen returned to New York, where he helped to found the Photo-Secession. In 1905 he founded, along with Stieglitz, the Little Galleries of the Photo-Secession. After returning to Europe in 1906, Steichen began sending works of contemporary art by Brancusi, Rodin, Picasso, and others to Stieglitz for exhibition. At the outbreak of World War I Steichen returned to the United States. In 1917 he volunteered for the U.S. Army and became the commander of the Photographic Division of Aerial Photography in the American Expeditionary Forces. After the war Steichen concentrated on photography and became the chief photographer for *Vogue* and *Vanity Fair*. In 1929 he organized, along with Edward Weston, the American section of the German exhibition "Film und Foto." During World War II Steichen served as commander of all navy combat photography. In 1947 Steichen became the director of the

department of photography at the Museum of Modern Art in New York, where he organized the exhibition "The Family of Man." (In 1962 he became director emeritus of that department.) In 1949 he published *Steichen the Photographer* with a text by his brother-in-law, the poet Carl Sandburg. In 1963 Steichen received the Medal of Freedom from President John F. Kennedy. Steichen died in West Redding, Connecticut.

Steichen the Photographer. New York, 1961.

Stella, Frank (1936–) Born in Malden, Massachusetts, Stella attended Phillips Academy in Andover from 1950 to 1954. In 1958 Stella graduated from Princeton University with an A.B. and that same year moved to New York. In 1961 Stella made his first trip to Europe where he married art historian Barbara Rose in London. In 1962 the couple returned to the United States. In 1963 Stella served as artist-in-residence at Dartmouth College for the summer session and then traveled to Iran in the fall. Stella presently lives and works in New York City.

Rubin, William S. *Frank Stella.* New York, 1970.

Stella, Joseph (1877–1946) Born in Muro Lucano, Italy, Stella emigrated to the United States in 1896. From 1896 to 1897 he studied medicine and pharmacology, but gave up these studies to devote himself to painting in 1897 and enrolled in The Art Students League of New York. From 1898 to 1900 he attended the New York School of Art. In 1909 Stella made his first trip back to Europe and returned to the United States in 1912, making other trips at later dates. He exhibited in the Armory Show of 1913. In 1920 he joined the Société Anonyme and exhibited in its exhibitions throughout the 1920s. In 1923 Stella became a United States citizen. From 1930 to 1934 he lived in Paris. In 1937 he worked for the WPA Federal Art Project, Easel Division, in New York. Stella died in Astoria, New York.

Baur, John I. H. *Joseph Stella.* New York, 1971.

Stieglitz, Alfred (1864–1946) Born in Hoboken, New Jersey, Stieglitz moved with his family to New York in 1871. From 1879 to 1881 he attended the College of the City of New York. In 1882 Stieglitz began studies in mechanical engineering at Berlin Polytechnic in Germany. From 1887 to 1890 he attended the University of Berlin. In 1890 he returned to New York to live and started a photoengraving business, which he ran until 1895. In 1891 he joined the Society of Amateur Photographers, which merged with the Camera Club of New York in 1897. In 1894 he became the first American elected to the Linked Ring. From 1897 to 1902 he edited *Camera Notes,* which he founded. In 1902 he formed the Photo-Secession and founded *Camera Work,* which he continued to publish until 1917. In 1905 Stieglitz, along with Edward Steichen, established the Little Galleries of the Photo-Secession at 291 Fifth Avenue, which remained open until 1917. In 1907 he was made an honorary member of the Royal Photographic Society. In 1924 Stieglitz married Georgia O'Keeffe and that same year received the Royal Photographic Society's Progress Medal. From 1925 to 1929 he ran Intimate Gallery and in 1929 opened another gallery called An American Place,

which he ran until his death in 1946. Stieglitz stopped photographing in 1937. He died in New York.

Bry, Doris. *Alfred Stieglitz: Photographer*. Boston, 1965.

Still, Clyfford (1904–) Born in Grandin, North Dakota, Still moved with his family to Spokane, Washington, shortly after his birth. In 1924 he made his first trip to New York but stayed only briefly. In 1933 he graduated from Spokane University, and from 1933 to 1941 taught at Washington State University, where he received his M.A. in 1935. From 1941 to 1943 he worked for the war industries in California. From 1943 to 1945 he taught at Richmond Professional Institute in Virginia. In 1945 Still moved to New York but returned to California in 1946 and taught at the California School of Fine Art in San Francisco until 1950. In 1950 he moved to New York City but made frequent trips to the West until 1961. From 1952 to 1953 he taught at Brooklyn College. Between 1952 and 1959 he had no public exhibitions of his work, but in 1959 was honored with a one-person retrospective at the Albright-Knox Art Gallery in Buffalo, New York. In 1961 Still moved to New Windsor, Maryland, where he presently lives and works.

Clyfford Still. San Francisco, 1976.

Stone, Sylvia (1928–) Born in Toronto, Canada, Stone attended Ontario College and studied art privately before moving to New York City in 1947. In 1948 and again from 1951 to 1953 she studied at The Art Students League under Vaclav Vytalcil. Until 1965 Stone worked primarily as a painter. She then began working with Plexiglas and acrylic to make painted wall reliefs. By 1967 she was exhibiting freestanding Plexiglas constructions. Stone has taught at Brooklyn College since 1960. She and her husband, the artist Al Held, divide their time between New York City and Boiceville, New York.

Sandler, Irving. "Sylvia Stone at Emmerich." *Art in America*, 1972.

Strand, Paul (1890–1976) Born in New York City, Strand first studied photography under Lewis W. Hine, who was then a science teacher at the Ethical Culture High School. After graduating from high school, Strand established himself as a commercial photographer. Around 1916 Strand took his first close-up photographs of machine forms. From 1918 to 1919 he worked as an X-ray technician (after being trained at the Mayo Clinic) for a U.S. Army hospital. In 1921 he collaborated with Charles Sheeler in making the film *Manhatta*. By 1922 Strand was supporting himself as a free-lance motion picture cameraman. From 1933 to 1934 he served as Chief of Photography and Cinematography for the Department of Fine Arts in the Secretariat of Education of Mexico. It was during this time that he photographed and supervised the production of the film *The Wave*. Upon his return from a trip to Russia in 1935, Strand made the documentary film *The Plow That Broke the Plains*. From 1937 to 1942 he served as the president of Frontier Films, a company which he established. From 1946 to 1947 he traveled in New England, gathering photographs for his book *Time in New England*. In 1950 he went to France to live and

began photographing countries in Europe. This resulted in several books on France (1957), Italy (1952), Hebrides (1954), and Egypt (1959). Strand died at Orgeval, France, on March 31, 1976.

Paul Strand. New York, 1971.

Stuart, Gilbert (1755–1828) Stuart, the son of a Scottish snuff grinder, was born in North Kingstown, Rhode Island. At fourteen, he studied under Cosmo Alexander, a Scottish artist, who took him to Edinburgh in 1772. Alexander died later that year and Stuart returned to America in 1773, where he painted portraits of Newport merchants and their families. In 1775, he went to London and after financial difficulties was taken in by Benjamin West, with whom he lived and worked for five years. In 1782, he opened his own studio. In 1787, to escape debts incurred by extravagant living, he fled to Ireland. In Dublin he had many commissions, but again in debt, he sailed to America in 1792. He settled first in New York, then the following year he opened a studio in Philadelphia, where he painted many prominent figures. In 1803, Stuart moved to Washington, D.C., and in 1805 he settled permanently in Boston. During his last years he suffered from poor health and financial difficulties. He died in Boston.

Gilbert Stuart, Portraitist of the Young Republic 1755–1828. Providence, Rhode Island, 1967.

Sullivan, Louis Henry (1856–1924) Sullivan was born in Boston. He entered the Massachusetts Institute of Technology at the age of sixteen, but left at the end of his first year. In 1873, Sullivan worked in Philadelphia as a draftsman for the office of Furness and Hewitt. In 1874, he left to study at the École des Beaux-Arts in Paris, remaining only a short time. Returning to the United States, Sullivan worked as a draftsman for various firms in Chicago from 1875 to 1879. In 1879 he joined the architectural office of Dankmar Adler in Chicago and two years later became a full partner. The partnership lasted until 1895. In 1893 Sullivan designed the Transportation Building at the Columbian Exposition. In his later years, Sullivan wrote articles to express his philosophy on architecture. In 1901 and 1902, "Kindergarten Chats," a series for the *Interstate Architect and Builder,* was published. "The Autobiography of an Idea" appeared in the *Journal of the American Institute of Architects* in 1922, and in that same year, Sullivan worked on the drawings for *A System of Architectural Ornament According With a Philosophy of Man's Powers.* Among his important buildings are the Wainwright Building in St. Louis, (1890–1891), the Guaranty Building in Buffalo (1894–1895), and the Carson-Pirie Scott Building in Chicago (1899–1904). Sullivan died in Chicago.

Bush-Brown, Albert. *Louis Sullivan.* New York, 1960.

Tanner, Henry O. (1859–1937) Born in Pittsburgh, Pennsylvania, Tanner moved with his family to Philadelphia in 1866. From 1880 to 1882 he studied at The Pennsylvania Academy of the Fine Arts under Thomas Eakins. In 1888 Tanner set up shop as a professional photographer in At-

lanta, Georgia. In 1890 Tanner taught drawing at Clark University in Atlanta, and in 1891 he went to Paris, where he studied at the Académie Julian. By 1894 Tanner was exhibiting in the Paris salons. In 1897 he visited Palestine and made a second trip to the Holy Lands in 1898. In 1902 Tanner returned to the United States, where he stayed until his return to Paris in 1904. In 1909 Tanner was elected an associate member of the National Academy of Design. When World War I broke out in 1914, Tanner was forced to flee France and go to England, but he later returned to France to work for the American Red Cross from 1917 to 1919. In 1923 Tanner was elected a full academician of the National Academy of Design. Tanner died in Paris.

Matthews, Marcia M. *Henry Ossawa Tanner, American Artist.* Chicago, 1969.

Tebow, Duncan Elliott (1945–) Born in Chicago, Illinois, Tebow received an A.A. in liberal arts from Montgomery Junior College in 1965 and a B.A. in art from the George Washington University in 1967. In 1969 he received a B.F.A. and M.F.A. from the school of art and architecture at Yale University. After working as a studio assistant to Al Held, Tebow taught part-time at Brooklyn College in 1970. He has also taught at Hood College in Frederick, Maryland, Northern Virginia Community College, and The Catholic University of America.

Thayer, Abbott (1849–1921) Born in Boston, Thayer grew up in New Hampshire. In 1867, he studied at the Brooklyn Academy of Design. He took a studio in New York until 1875 when he left for Paris to study first at the École des Beaux-Arts and later in the studio of Gérôme. He was elected academician to the National Academy of Design after being an associate in 1898. He was also the president of the Society of American Artists from 1879 to 1881. Thayer died in Monadnock, New Hampshire, in 1921.

Cortissoz, Royal. *Abbott H. Thayer.* New York, 1923.

Thornton, William (1759–1828) Thornton was born on the island of Tortola in the British West Indies (now the Virgin Islands). Educated in Scotland, Thornton received a degree in medicine from Aberdeen University in 1784. However, architecture and painting proved more interesting to him than medicine. After emigrating to the United States in 1787, Thornton designed the Library Company building in Philadelphia. Living in Philadelphia from 1788 to 1794, Thornton submitted a design for the Capitol in Washington. The design was accepted in 1793, and in 1794, Thornton settled in Washington to supervise the construction. In time, Thornton was replaced by Benjamin Latrobe, and many of Thornton's plans were redesigned. Thornton was appointed city commissioner until 1802 when he became commissioner of patents. He promoted the establishment of a national university in the nation's capital and designed the Octagon House in Washington (1800) and the Tudor Place in Georgetown (1815). He also took an active part in in the abolitionist movement. Thornton died in Washington, D.C.

Brown, G. *History of the U.S. Capitol.* Washington, 1900–1903.

Tobey, Mark (1890–1976) Born in Centerville, Wisconsin, Tobey moved with his family to Chicago in 1909, where he attended The Art Institute and also worked as a blueprint boy and letterer. In 1911 Tobey moved to New York, where he worked as a fashion illustrator and interior designer. In 1918 Tobey was converted to the Baha'i World Faith. In 1922 he moved to Seattle and taught drawing at the Cornish School of Allied Arts until 1929. In 1925 Tobey went to Europe, settling in Paris until his return to the United States in 1926. In 1934 Tobey spent a month in a Zen monastery in Kyoto, Japan, where he studied calligraphy and painting. Tobey produced his first "White Writings" in 1935 when he was living in Devonshire, England, and teaching at Dartington Hall School. During 1938 he worked for the WPA Federal Art Project, Easel Division, for six months. In 1939 Tobey returned to Seattle. In 1956 he received the Guggenheim International Award and was elected to the National Institute of Arts and Letters. Tobey settled in Basel, Switzerland, in 1960. That year he was elected a member of the American Academy of Arts and Sciences, but he declined the honor. In 1968 the French government honored him with the distinction of the position of Commandeur de l'Ordre des Arts et des Lettres. Tobey died in Basel on April 24, 1976.

Tobey. Switzerland, 1971.

Tomlin, Bradley Walker (1899–1953) Born in Syracuse, New York, Tomlin received a B.F.A. degree from Syracuse University in 1921. In 1921 he moved to New York City and by 1922 was designing covers for Condé Nast publications such as *House and Garden* and *Vogue*. In 1923 Tomlin visited Europe for a year, and he worked at the Académie Colarossi and the Académie de la Grande Chaumière before returning to New York. In 1925 he joined the Whitney Studio Club, where he exhibited regularly. Tomlin made another year-long visit to Europe in 1926. In 1933 he began teaching painting at Sarah Lawrence College in New York and continued to teach until 1941. In 1946 Tomlin executed his first totally abstract works. Tomlin died in New York.

Bradley Walker Tomlin, A Retrospective View. New York, 1975.

Trumbull, John (1756–1843) Born in Lebanon, Connecticut, Trumball, son of Jonathan Trumbull, governor of Connecticut, graduated from Harvard in 1773. From 1775 to 1777, Trumbull served in the colonial army as an aide to George Washington. In 1780, he left for France, then went to London, where he studied in the studio of Benjamin West. While in London, he was arrested in retaliation for the hanging of the British spy John Andre in America, and Trumbull was forced to leave England. He returned to 1784, studying in West's studio till 1789. During these five years, Trumbull worked on Revolutionary War scenes, portraits of Washington, and miniatures. From 1794 to 1804 he worked in England as secretary to John Jay, and as a commissioner of the Jay Treaty. In 1804, Trumbull returned to New York City where he had a studio until 1808, at which time he once again went to England. There he remained until 1816 when he came back to New York and began work on a commission to paint four large historical scenes for the Rotunda of the United States Capitol. Trumbull sold his collection of his own work to Yale College in

1831, making Yale the first American University to establish an art gallery. Trumbull also served as president of the American Academy of Fine Arts from 1817 to 1835. Trumbull died in New York City in 1843.

Sizer, Theodore. *The Works of Colonel John Trumbull, Artist of the American Revolution*. New Haven, 1967.

Twachtman, John Henry (1853–1902) Twachtman was born in Cincinnati, Ohio. At the age of fifteen, he enrolled in the Ohio Mechanics Institute evening school to study drawing. In 1871, he entered the McMiken School of Design in Cincinnati and came under the influence of Frank Duveneck. Together the two men returned to Munich in 1875, and Twachtman began study at the Royal Academy there. In 1877, he traveled to Venice with Duveneck and William Merritt Chase, and in 1878 returned to Cincinnati upon the death of his father. Later that year, Twachtman moved to New York, was admitted to the Society of American Artists and began a life-long friendship with J. Alden Weir. In 1879 he taught painting and drawing at the Cincinnati Women's Art Association and the next year joined the staff of Duveneck's art school in Florence. After his marriage to Martha Scudder in 1881, Twachtman and bride toured England, Holland, Belgium, Munich, and Venice, where he painted with Weir. A brief return to Cincinnati in 1882 was followed in 1883 by a two-year stay in Paris, where Twachtman studied at the Académie Julian and met Childe Hassam. In 1885 and 1886, Twachtman returned to the United States. In 1889, Twachtman began teaching at The Art Students League of New York, that same year doing illustrations for *Scribner's* until 1883. In 1884 he joined the teaching staff at Cooper Union in New York. Between 1884 and 1885, Twachtman traveled to Buffalo and Yellowstone Park to paint. In 1897, his friendships with other American impressionist painters resulted in the formation of "The Ten American Painters." In 1900, Twachtman began spending summers in Gloucester, Massachusetts, and it was there that he died suddenly in August, 1902.

Twachtman. Cincinnati, Ohio, 1966.

Tworkov, Jack (1900–) Born in Biala, Poland, Tworkov emigrated with his family to the United States in 1913. From 1920 to 1923 Tworkov studied at Columbia University, and from 1923 to 1925 he studied at the National Academy of Design. From 1925 to 1926 he studied at The Art Students League with Guy Pène du Bois and Boardman Robinson. In 1928 he became a United States citizen. He made a brief trip to Europe in 1933. In 1934 Tworkov worked for the U.S. Treasury Department Public Works of Art Project, and from 1935 to 1941 he worked in the WPA Federal Art Project, Easel Division, in New York. From 1942 to 1945 Tworkov worked as a tool designer in New York. Between 1948 and 1953 he shared adjoining studios with Willem de Kooning. From 1948 to 1955 he was a part-time drawing instructor at Queens College in New York, while teaching during the summers between 1948 and 1951 at the American University in Washington, D.C. From 1955 to 1958 Tworkov taught life drawing at Pratt Institute. In 1963 he won the Corcoran Gold Medal from the Corcoran Gallery of Art in Washington, D.C. From 1963 to 1969

Tworkov served as the Leffingwell Professor of Painting at Yale University. From 1970 to 1972 he was a visiting professor of painting at Cooper Union. In 1971 he was awarded a Guggenheim Fellowship. Tworkov now lives in New York.

Gula, Kasha Linville. "The Indian Summer of Jack Tworkov," *Art in America,* vol. 61, September 1973, pp. 62–69.
Tworkov, Jack. "Notes on My Painting," ibid.

Vanderlyn, John (1775–1852) Vanderlyn was born in Kingston, New York, to a family of painters. His career began auspiciously when Aaron Burr agreed to sponsor his art education: first a year's study in Philadelphia with Gilbert Stuart and then five years in Paris (1796–1801), where he was the first American to study at the French Academy. After returning home for two years, Vanderlyn again traveled to Europe, working in Rome and in Paris where he was awarded a gold medal by Napoleon for his painting of *Marius Amidst the Ruins of Carthage.* After the successes of his European stay, Vanderlyn's return to America in 1815 brought only disappointment and failure. A financial venture in which Vanderlyn operated a rotunda housing a panorama of the Gardens of Versailles ended in failure. In 1837, he was finally awarded a government commission to paint a mural for the Rotunda of the United States Capitol, but when it was finally unveiled, the mural was severely criticized. Vanderlyn died a pauper in Kingston, New York.

Schoonmaker, Marius. *John Vanderlyn, Artist 1775–1852.* Kingston, New York, 1950.

Vaux, Calvert (1824–1895) Vaux was born in London, England, where he studied architecture and worked for the architect L. N. Cottingham. In the 1850s, Vaux moved to New York and worked as a draftsman for Andrew Jackson Downing. As partners, Downing and Vaux established an office in Newburg-on-Hudson, but when Downing died in 1852, Vaux returned to New York City. There, Vaux worked for the landscape artist Frederick Law Olmstead, designing buildings for Central Park and Prospect Park in Brooklyn. Vaux also designed private villas for prominent New Yorkers. Until his death in 1892, Calvert Vaux was in partnership with Frederick C. Withers, their firm being responsible for the Jefferson Market Court and adjoining prison.

Vedder, Elihu (1836–1923) Vedder was born in New York City. After studying painting with Thompkins H. Matteson, a genre painter, Vedder traveled to Paris in 1856, where he studied under Picot. Upon his return to New York in 1861, Vedder found it difficult to obtain painting commissions because of the Civil War and supported himself by drawing comic valentines and sketching for *Vanity Fair.* In 1865 he returned to Europe and settled in Rome, and although he made trips to America, he maintained his permanent residence abroad until his death. His works included fifty black-and-white illustrations for an edition of the *Rubáiyát of Omar Khayyám* (1884), murals for the Walker Art Gallery at Bowdoin College in Maine, and five wall paintings and a

mosaic for the Library of Congress in Washington. He died on the Isle of Capri in 1923.

Soria, Regina. *Elihu Vedder American Visionary Artist in Rome (1836–1923).* New Jersey, 1970.

Venturi, Robert (1925–) Born in Philadelphia, Venturi received his B.A. from Princeton in 1947 and his M.F.A. in 1950. He worked for the architects Eero Saarinen and Louis Kahn before establishing his own architectural firm with William Short from 1961 to 1964, and then with John Rauch, with whom he continues to work under the firm name of Venturi and Rauch. From 1955 to 1963 Venturi taught at the University of Pennsylvania and from 1963 to 1967 at Yale University. In 1967 his book, *Complexities and Contradictions in Modern Architecture,* was published.

Stern, Robert. *New Directions in American Architecture.* New York, 1969.

Warhol, Andy (1928–) Born Andrew Warhola in Pittsburgh, Andy Warhol studied at the Carnegie Institute of Technology from 1945 to 1949. In 1949 he settled in New York and worked as a commercial artist from 1950 to 1960. In 1962 he began exhibiting, and in 1963 he began working as a filmmaker in addition to his printmaking and painting. Warhol lives in New York City.

Coplans, John. *Andy Warhol.* Greenwich, Connecticut, 1970.

Weber, Max (1881–1961) Born in Bialystok, Russia, Weber came to the United States in 1891 at the age of ten. In 1900 Weber graduated from Pratt Institute in New York, where he had studied under Arthur Wesley Dow. In 1905 Weber traveled to Paris, where he studied at the Académie Julian, the Académie Colarossi, and the Académie de la Grande Chaumière. In 1906 he discovered the work of Paul Cézanne at the Salon d'Automne. He studied with Henri Matisse in 1907 and met Picasso and became friends with Henri Rousseau. Upon his return to New York in 1909, Weber exhibited his paintings at "291." The following year he arranged a show there for Henri Rousseau. In 1911 Weber had his first one-man show at "291." In 1917 Weber moved to Long Island and began painting scenes inspired by his Jewish childhood in Russia. From 1920 to 1921, and from 1925 to 1927 he taught at the Art Students League of New York.

Goodrich, Lloyd. *Max Weber.* New York, 1949.

Weir, J. Alden (1852–1919) Born in West Point, New York, Julien Alden Weir began his art training at the age of eighteen at the National Academy of Design. In 1873 he left for Paris where he studied under Gérôme and then spent the years 1874–1876 traveling in Holland and Spain. Returning to New York in 1877, Weir helped found the Society of American Artists. Between 1880 and 1881 he toured Holland and Belgium before settling permanently in New York in 1883. In 1898 he was instrumental in the founding of the group "The Ten American Painters." Elected to both the National Institute of Arts and Letters and

the American Academy of Arts and Letters, Weir also received honorary degrees from Princeton and Yale. From 1915 to 1917 he served as president of the National Academy of Design. Weir died in New York City in 1919.

Young, Dorothy. *The Life and Letters of J. Alden Weir*. New Haven Connecticut, 1960.

Wesselmann, Tom (1931–) Born in Cincinnati, Ohio, Wesselman studied at Hirm College from 1949 to 1951 and received his B.A. in psychology from the University of Cincinnati in 1955. He attended Cooper Union in New York from 1956 to 1959. In 1961 Wesselmann began to paint his "Great American Nude" series. He presently lives in New York City.

Tom Wesselmann: Early Still Lifes, (1962–64). Balboa, California, 1970.

West, Benjamin (1738–1820) West was born to Quaker parents, in Springfield, Pennsylvania, on what is now the campus of Swarthmore College. He obtained instruction from William Williams, an English artist visiting Philadelphia. In 1757 West graduated from the University of Pennsylvania. In 1759 or 1760 a group of Philadelphia merchants funded West's journey to Italy, where he studied the old masters, making him the first native American to study abroad. In 1763, West moved permanently to London. His studio and art collection became a school for many American artists, among them Washington Allston, John Singleton Copley, Samuel Morse, Charles Willson Peale, Rembrant Peale, Matthew Pratt, Gilbert Stuart, and Thomas Sully. In 1772, he was appointed history painter to King George III. A charter member of the Royal Academy, West succeeded Sir Joshua Reynolds as its president in 1792. West held this position, with a one-year interruption, until his death. He was buried in St. Paul's Cathedral, London.

Evans, Grose. *Benjamin West and the Taste of His Times*. Carbondale, Illinois, 1959.

Weston, Edward (1886–1958) Weston saw his first exhibit of photographs at the Art Institute of Chicago when he was sixteen, and he insisted that his father buy him a camera. By 1905 he was in California going door-to-door taking photographs of families, marriages, funerals, and the like. In 1909 he married and in 1911 opened his own portrait studio in Tropico, California, specializing in children and using natural, rather than artificial, light. In 1922 he made his first architectural photos in Ohio, and in 1923 he set off for Mexico by steamer from New York. In 1925, after a brief visit to California he returned to Mexico with one of his four sons, Brett. He remained in Mexico for another two years. While there, he became friends with Diego Rivera and other Mexican muralists. In 1927 he returned to California and settled in Carmel. In 1932 Weston was cofounder with Willard Van Dyck, Imogen Cunningham, and others of "f/64," a group of photographers who promoted sharp-focus photography. They held their first exhibition at the De Young Museum in San Francisco. In 1937 Weston received a Guggenheim Fellowship (the first awarded to a photographer), and traveled to Death

Valley. From his travels he published a book of photographs, *California and the West*. In 1941 he published photographs illustrating Walt Whitman's *Leaves of Grass*. Crippled by Parkinson's disease in 1937, Weston was forced to give up photography, although his sons Brett and Cole continued to print his negatives. Weston died in California in 1958.

Newhall, Beaumont. *The Photographs of Edward Weston*. New York, 1946.

Whistler, James McNeill (1834–1903) Whistler was born in Lowell, Massachusetts. When he was nine years old, his father, Major George Washington Whistler, took the family to Russia for a period of six years. In 1851, Whistler entered West Point, but in 1854, he was expelled. He secured a job as draftsman and map engraver for the United States Coast Survey, but in 1855 his desire to study art took him to Paris. In 1858 Whistler's first portfolio of etchings was published. In 1859, Whistler settled in London, and though he continued to travel between London and Paris, he never returned to America. In 1877, slanderous remarks about Whistler's character and artistic ability by the art critic, John Ruskin, led to a court trial. Though Whistler won the case, he was left penniless because of the court cost. His book, *The Gentle Art of Making Enemies*, describes the lawsuit. Commissioned by the Fine Art Society of London, Whistler went to Venice from 1879 to 1880 to make a series of etchings. In 1894 he was involved in another lawsuit over Sir William Eden's refusal to pay for Whistler's portrait of Lady Eden, his wife. In 1898, Whistler was elected president of the International Society of Sculptors, Painters, and Gravers. During the years 1899–1901 he made painting trips to Holland, Ireland, and the Mediterranean. While out driving with Charles L. Freer in July of 1903, Whistler aggravated his heart ailment and died.

Stubbs, Burns A. *James McNeill Whistler*. Washington, D.C., 1950.

White, Clarence (1871–1925) From 1890 to 1906 White was head bookkeeper in a wholesale grocery firm in Newark, Ohio. In 1894 he began experimenting with photography and in 1898 exhibited his work at the Philadelphia Salon where he came to the attention of Alfred Stieglitz. In 1899 White was named an honorary member of the Camera Club of New York and that year exhibited in London, New York, and Boston. In 1901 he began illustrating popular novels with his photographs. In 1906 he was a founding member of the Photo-Secession. He moved to New York City, lectured at Columbia in 1907, and in 1910 established with the painter Max Weber, a summer school of photography at Seguinland, Maine. From 1908 to 1921 he was an instructor at the Brooklyn Institute of Art and Sciences. White died in Mexico City while accompanying his students on a tour.

White, Clarence H., Jr. *The Photography of Clarence H. White*. Lincoln, Nebraska, 1968.

White, Minor (1908–1976) Born in Minneapolis, Minnesota, White first intended to become a poet, and throughout his life continued to write blank verse to accompany his photographs. From 1938 to 1939 White

was a photographer for the WPA and then spent two years teaching photography at Portland's WPA center, where he had his first exhibition. In 1946 he joined the faculty of the California School of Fine Arts (now the San Francisco Art Institute). In 1952 he moved to New York, where he became a cofounder of *Aperture* magazine along with Ansel Adams, Dorothea Lange, and Nancy and Beaumont Newhall. White remained an editor of that magazine until the time of his death. He wrote extensively on photography, and in 1953 published his book *How to Read a Photograph*. In 1965, he joined the faculty of MIT as a member of the Department of Architecture, and was largely responsible for the establishment of the department of photography there. White died in Boston.

"White." *Camera,* vol. 51, January 1972, pp. 14–23.

Wood, Grant (1892–1942) Wood was born on a farm near Anamosa, Iowa. His first art instruction was through a course running serially in a magazine, *The Craftsman*. From 1910 to 1911 he attended the Minneapolis School of Design and Handicraft and Normal Art during the summer, and from 1911 to 1912 he took night art classes at the State University of Iowa. From 1913 to 1915, Wood attended classes periodically at The Art Institute of Chicago. In 1919 he taught high school art in Cedar Rapids, Iowa. In 1923 Wood traveled to Paris to study at the Académie Julian. Wood returned to Europe again in 1926 and in 1928 traveled to Munich, Germany, where he was particularly impressed with German and Flemish painting of the fifteenth and sixteenth centuries. In 1932 Wood helped found the Stone City Art Colony, Iowa, and in 1934 served as director of the WPA art project at the University of Iowa. He was a staff member of the University of Iowa in 1935. Wood died in Iowa City.

Garwood, Darrell. *Artist in Iowa: A Life of Grant Wood.* Greenwood, New Jersey, 1971.

Woodville, Richard Caton (1825–1855) Richard Caton Woodville was born and raised in Baltimore, Maryland, the son of a wealthy merchant. He attended the University of Maryland Medical School for a brief period, 1842–1843, before turning to genre painting in 1845. In that same year, Woodville left for Düsseldorf, where he studied painting for six years. While in Europe, Woodville sent many of his works back to America, where they were exhibited successfully at the American Art-Union. After 1851, Woodville lived primarily in Paris and London. He returned to Baltimore for a brief visit in 1854 but was called back to Europe because of his wife's illness. An accidental overdose of morphia claimed Woodville's life in 1855.

Grubar, Francis. *Richard Caton Woodville: An Early American Genre Painter.* Washington, D.C., 1967.

Wright, Frank Lloyd (1869–1959) Of Welsh descent, Wright was born in the village of Richland Center, Wisconsin, the son of a minister. As a child, Wright moved with his family to Weymouth, Massachusetts. In 1885 he enrolled at the University of Wisconsin, where he studied engi-

neering. After two years, he left school to seek work in Chicago as an architectural draftsman. His first position was in the firm of Lyman Silsbee. He then worked for the firm of Adler and Sullivan where he soon rose in the ranks of draftsman and was awarded commissions by Louis Sullivan. In 1893 Wright began his independent practice as an architect with his friend Cecil Corwin. From 1893 to 1906 he designed a number of private dwellings in the Chicago suburbs in his innovative "Prairie Style" (low-lying, projecting roofs, streamlined forms, Victorian decoration eliminated.) In addition to his residential projects, Wright designed Unity Temple, Oak Park (1905–1906) and the Larkin Building in Buffalo, New York (1904). In 1906 Wright visited Japan. In 1909 he traveled to Germany to work on drawings for a publication of his work there and then on to Fiesole, Italy. In 1911 he returned to Oak Park, Illinois, divorced his first wife, and moved to his family farm in Wisconsin. There he built a home called Taliesin (Welsh for "shining brow," the name of a sixth-century Welsh bard). Wright maintained a Chicago office. In August of 1914 Taliesin was destroyed by fire, and seven members of his household were killed. In the Fall of 1914 Wright was commissioned to design the Imperial Hotel in Tokyo. The structure, which was completed within seven years, survived the devastating Tokyo earthquake in 1923. In the twenties, Wright received a number of commissions for private residences in California (The Millard house, Pasadena, 1924). In 1924 Wright rebuilt Taliesin, and the following year the living quarters were again destroyed by fire. He again rebuilt and established a community of architect apprentices there, who followed him to Arizona to work on Taliesin West which was completed in 1938. Among his other projects were the E. J. Kaufman House ("Fallingwater"), built in Bear Run, Pennsylvania (1937), in which he used a dramatic cantilever design; The "Usonia Home," an economically priced house plan for moderate-income families; the "bern" home (1942), utilizing banked earth for one supporting wall; The Johnson Wax Administration building in Racine Wisconsin (1936–1939); and the Solomon R. Guggenheim Museum (1942–1962). Wright remained active until his death in Wisconsin in April 1959. Among his writings is *An Autobiography*, New York, 1932.

Scully, Vincent, Jr. *Frank Lloyd Wright.* New York, 1960.
Wright, O. Lloyd. *Frank Lloyd Wright, His Life, His Works, His Words.* New York, 1970.

Wyeth, Andrew Newell (1917–) Born in Chadds Ford, Pennsylvania, Wyeth was the son of the popular illustrator and painter, N. C. Wyeth. He studied art under his father and learned tempera painting from his brother-in-law Peter Hurd. In 1937 he had his first one-man show at the Macbeth Gallery in New York City. In 1944 he was named an academician of the National Academy of Design. In 1970 he had a one-man show at the Museum of Fine Arts in Boston and at the White House in Washington, D.C. In 1976 Wyeth was also given a one-man show at the Metropolitan Museum of Art in New York. Wyeth summers in Cushing, Maine, and winters in Chadds Ford.

Wyeth, Andrew and Richard Meryman. *Andrew Wyeth.* New York, 1968.

Youngerman, Jack (1926–) Born in Louisville, Kentucky, Younger-
man attended the University of North Carolina and the University of
Missouri. After World War II, Youngerman studied at the École des
Beaux-Arts in Paris, where he was introduced to constructivism. In
the fifties, Youngerman returned to New York City, where he presently
resides.

"Portrait—Youngerman." *Art in America*, 9–10, 1968.

Zox, Larry (1936–) Born Lawrence Ivan Zox in Des Moines, Iowa,
Larry Zox studied at the University of Oklahoma from 1955 to 1957, and
at Drake University from 1957 to 1958. In the summer of 1957 he studied
at the Des Moines Art Center with George Grosz and Louis Bouche. In
1961 he taught at Cornell University. In 1964 he was artist-in-residence
at Juniata College in Huntington, Pennsylvania. In 1967 he was guest
critic at Cornell and taught at the University of North Carolina. Zox re-
sides in New York City.

BIBLIOGRAPHY

The subject headings under which these books and exhibition catalogs are grouped are intended to suggest additional, more specialized areas of inquiry. Note that all monographs—books devoted to the work of one artist—are included with the artist's biography, not in this listing. Periodicals are not mentioned here either, and for these the student is referred to *The Art Index*, a guide to the many essays and reviews written in art journals.

THE AMERICAN AESTHETIC

Jewell, Edward Alden. *Have We an American Art?* New York: Longmans, 1939.

Lipman, Jean, ed. *What is American in American Art.* New York: McGraw-Hill, 1963.

McCoubrey, John W. *American Tradition in Painting.* New York: Braziller, 1963.

Owings, Nathaniel Alexander. *The American Aesthetic.* New York: Harper & Row, 1969.

Taylor, Joshua C. *America as Art*. Washington, D.C.: Smithsonian Institution, 1976.

ART SCHOOLS

Clark, Eliot. *History of the National Academy of Design*. New York: Columbia, 1954.

Landgren, Marchal E. *Years of Art: The Story of The Art Students League of New York*. New York: McBride, 1940.

Taylor, Joshua, and Lois Marie Fink. *Academy: The Academic Tradition in American Art*. Washington, D.C.: Smithsonian Institution, 1975.

Valentine, Lucia, and Alan Valentine. *The American Academy in Rome 1894–1969*. Charlottesville: University Press of Virginia, 1973.

BLACK ARTISTS AND ART

Bearden, Romare, and Harry Henderson. *Six Black Masters of American Art*. New York: Doubleday, 1972.

Dover, Cedric. *American Negro Art*. Greenwich, Connecticut: New York Graphic Society, 1960.

Fine, Elsa Honig. *The Afro-American Artist: A Search for Identity*. New York: Holt, 1973.

Lewis, Samella S., and Ruth G. Waddy, eds. *Black Artists on Art*. Ritchie, 1969.

Porter, James A. *Modern Negro Art*. New York: Dryden, 1943.

COLLECTORS

Lynes, Russell. *The Tastemakers*. New York: Grosset & Dunlap, 1954.

Miller, Lillian B. *Patrons and Patriotism: The Encouragement of the Fine Arts in the United States 1790–1860*. Chicago: University of Chicago Press, 1966.

Saarinen, Aline B. *The Proud Possessors: The Lives, Times, and Tastes of Some American Art Collectors*. New York: Random House, 1958.

Tomkins, Calvin. *Merchants and Masterpieces*. New York: Dutton, 1970.

CRITICISM

Greenberg, Clement. *Art and Culture: Critical Essays*. Boston: Beacon Press, 1961.

Kramer, Hilton. *The Age of the Avant-Garde*. New York: Farrar, Straus & Giroux, 1973.

Lippard, Lucy. *Changing: Essays in Art Criticism*. New York: Dutton, 1971.

McBride, Henry. *The Flow of Art: Essays and Criticism*. New York: Atheneum, 1975.

Rosenberg, Harold. *The Anxious Object*. New York: Horizon, 1964.

———. *Art Works and Packages*. New York: Horizon, 1969.

DOCUMENTS AND SOURCES

Kuh, Katharine. *The Artists' Voice; Talks with Seventeen Artists.* New York: Harper & Row, 1960.

McCoubrey, John W., ed. *American Art, 1700–1960: Sources and Documents.* Englewood Cliffs, New Jersey: Prentice-Hall, 1965.

Motherwell, Robert, and Ad Reinhardt, eds. *Modern Artists in America.* New York: Wittenborn, Schultz, 1951. Documentation by Bernard Karpel.

Rodman, Seldon. *Conversations with Artists.* New York: Capricorn, 1961.

Rose, Barbara, ed. *Readings in American Art Since 1900: A Documentary Survey.* New York: Praeger, 1968; rev. ed., 1975.

EIGHTEENTH AND NINETEENTH CENTURIES

Architecture

Andrews, Wayne. *Architecture, Ambition and Americans: A Social History of American Architecture.* New York: Harper, 1955; rev. ed., Free Press, 1964.

————. *Battle for Chicago.* New York: Harper & Row, 1946.

Burchard, John, and Albert Bush-Brown. *The Architecture of America.* Boston: Little, Brown, 1961.

Condit, Carl W. *The Chicago School of Architecture.* Chicago: University of Chicago Press, 1964.

Eberlein, Harold, and Cortland Hubbard. *American Georgian Architecture.* Bloomington: Indiana University Press, 1952.

Gifford, Don, ed. *The Literature of Architecture. The Evolution of Architectural Theory and Practice in Nineteenth Century America.* New York: Dutton, 1966.

Hamlin, Talbot. *Greek Revival Architecture in America.* New York: Oxford University Press, 1944.

Hitchcock, Henry-Russell. *The Architecture of H. H. Richardson and His Times.* New York: Museum of Modern Art, 1936.

Kimball, Fiske. *Domestic Architecture of the American Colonies and of the Early Republic.* New York: Scribner, 1922.

Morrison, Hugh. *Early American Architecture from the First Colonial Settlements to the National Period.* New York: Oxford University Press, 1952.

Mumford, Lewis, ed. *Roots of Contemporary American Architecture.* New York: Reinhold, 1952.

Scully, Vincent J., Jr. *The Shingle Style.* New Haven, Connecticut: Yale University Press, 1955.

General

Bancroft, Hubert Howe. *The Book of the Fair*, vol. I. New York: Bounty Books, 1894; reprint, Crown, 1972.

Classical America 1815–1845. Newark, New Jersey: Newark Museum, 1963.

Lynes, Russell. *The Art-Makers of Nineteenth Century America.* New York: Atheneum, 1970.

Mumford, Lewis. *The Brown Decades: A Study of the Arts in America 1865–1895*. Dover, 1966.

Novak, Barbara. *American Painting of the Nineteenth Century*. New York: Praeger, 1969.

Nineteenth Century America: Paintings and Sculpture. New York: Metropolitan Museum, 1970.

Wright, Louis B., George B. Tatum, John W. McCoubrey, and Robert C. Smith. *The Arts in America: The Colonial Period*. New York: Scribner, 1966.

Painting

Barker, Virgil. *American Painting, History and Interpretation*. New York: Macmillan, 1950.

Bizardel, Yvon. *American Painters in Paris*. New York: Macmillan, 1960.

Born, Wolfgang. *American Landscape Painting, An Interpretation*. New Haven, Connecticut: Yale University Press, 1948.

———. *Still Life Painting in America*. New York: Oxford University Press, 1947.

Boyle, Richard J. *American Impressionism*. Boston: New York Graphic Society, 1973.

Burroughs, Alan. *Limners and Likenesses: Three Centuries of American Painting*. Cambridge, Massachusetts: Harvard, 1936.

Curry, Larry. *The American West*. New York: Viking, 1972.

Evans, Grose. *Benjamin West and the Taste of His Times*. Carbondale: Southern Illinois University Press, 1959.

Ewers, John C. *Artists of the Old West*. Garden City, New York: Doubleday, 1973.

Frankenstein, Alfred. *After the Hunt: William Harnett and Other American Still Life Painters 1870–1900*. Berkeley: University of California Press, 1953; rev. ed., 1969.

Flexner, James T. *America's Old Masters*. New York: Viking, 1939.

———. *American Painting: First Flowers of Our Wilderness*. New York: Harcourt, Brace & World, 1968.

———. *Nineteenth Century American Painting*. New York: Putnam's, 1970.

———. *That Wilder Image: The Painting of America's Native School from Thomas Cole to Winslow Homer*. Boston: Little, Brown, 1962.

———. *The Light of Distant Skies: American Painting 1760–1835*. New York: Harcourt, Brace, 1954.

Gerdts, William, and Russell Burke. *American Still-Life Painting*. New York: Praeger, 197.

Hills, Patricia. *The Painters' America: Rural and Urban Life, 1818–1910*. New York: Praeger, 1974.

Hoopes, Donelson, F. *The American Impressionists*. New York: Watson-Guptil Publications, 1972.

Larkin, Oliver. *Samuel F. B. Morse and American Democratic Art*. Boston: Little, Brown, 1954.

McCracken, Harold. *Portrait of the Old West* (with a biographical checklist of Western artists). New York: McGraw-Hill, 1952.

Novak, Barbara. *American Painting of the Nineteenth Century*. New York: Praeger, 1969.

Richardson, Edgar P. *American Romantic Painting*. New York: Weyhe, 1944.

Soby, James Thrall, and Dorothy C. Miller. *Romantic Painting in America*. New York: Museum of Modern Art, 1943.

Sweet, Frederick A. *The Hudson River School and the Early Landscape Tradition*. Chicago: Art Institute, 1945.

Sculpture

Cikovsky, Nicolai, Jr., et al. *The White Marmorean Flock: Nineteenth Century American Women Neoclassical Sculptors*. Poughkeepsie, New York: Vassar College Art Gallery, 1972.

Crane, Sylvia E. *White Silence: Greenough, Powers and Crawford, American Sculptors in Nineteenth Century Italy*. Coral Gables, Florida: University of Miami Press, 1972.

Forbes, Harriette, M. *Gravestones of Early New England: And the Men Who Made Them, 1653–1806*. New York: DaCapo, 1967.

Gardner, Albert Ten Eyck. *American Sculpture, A Catalogue of the Collection of the Metropolitan Museum of Art*. New York: Metropolitan Museum, 1965.

Gardner, Albert Ten Eyck. *Yankee Stonecutters: The First American School of Sculpture, 1800–1850*. New York: Columbia, 1944.

Ludwig, Allan I. *Graven Images: New England Stonecarving and Its Symbols, 1650–1815*. Middleton, Connecticut: Wesleyan, 1966.

THE FEDERAL GOVERNMENT AND THE ARTS

McDonald, William F. *Federal Relief Administration and the Arts*. Columbus: Ohio State University Press, 1969.

Miller, Lillian B. *Patrons and Patriotism: The Encouragement of the Fine Arts in the United States, 1790–1860*. Chicago: University of Chicago Press, 1966.

Mondale, Joan Adams. *Politics in Art*. Minneapolis: Lerner, 1972.

O'Connor, Francis V. *Federal Support for the Visual Arts: The New Deal and Now*. Greenwich, Connecticut: New York Graphic Society, 1969.

————. ed. *The New Deal Art Projects: An Anthology of Memoirs*. Washington, D.C.: Smithsonian Institution, 1972.

————, ed. *Art for the Millions: Essays from the 1930's by Artists and Administrators of the Federal Art Project*. Boston: New York Graphic Society, 1973.

Purcell, Ralph. *Government and Art*. Washington, D.C.: Public Affairs Press, 1956.

FOLK ART AND CRAFTS

Bishop, Robert. *American Folk Sculpture*. New York: Dutton, 1974.

Christensen, Erwin O. *The Index of American Design*. New York: Macmillan, 1950.

Colby, Averil. *Quilting.* New York: Scribner, 1971.

Lipman, Jean, and Mary Black. *American Folk Painting.* New York: Crown, 1966.

Lipman, Jean. *American Folk Decoration.* New York: Oxford University Press, 1967.

Lipman, Jean, and Alice Winchester. *The Flowering of American Folk Art 1776–1876.* New York: Viking, 1974.

Safford, Carleton L., and Robert Bishop. *America's Quilts and Coverlets.* New York: Dutton, 1972.

GENERAL SURVEYS

Baigell, Matthew. *A History of American Painting.* New York: Praeger, 1971.

Craven, Wayne. *Sculpture in America.* New York: Crowell, 1968.

Dunlap, William. *A History of the Rise and Progress of the Arts of Design in the United States,* 3 vols., 1834; rev. and enl. ed., Dover, 1969.

Gerdts, William H. *The Great American Nude, A History in Art.* New York: Praeger, 1974.

Harris, Neil. *The Artist in American Society: The Formative Years, 1790–1860.* New York: Braziller, 1966; reprint, Simon and Schuster, 1970.

Larkin, Oliver W. *Art and Life in America.* New York: Holt, 1960.

McCabe, Cynthia. *The Golden Door: Artist-Immigrants of America, 1876–1976.* Washington, D.C.: Smithsonian Institution, 1976.

McLanathan, Richard. *The American Tradition in the Arts.* New York: Harcourt, Brace, & World, 1968.

McShine, Kynaston, ed. *The Natural Paradise, Painting in America 1800–1950.* New York: Museum of Modern Art, 1976.

Mendelowitz, Daniel M. *A History of American Art.* New York: Holt, 1970.

Richardson, Edgar P. *Painting in America: The Story of 450 Years.* New York: Crowell, 1956.

Taylor, Joshua. *America as Art.* Washington, D.C.: National Collection of Fine Arts, Smithsonian Institution, 1976.

Two Hundred Years of American Sculpture. New York: Whitney Museum of American Art, 1976.

GRAPHICS, DRAWING, WATERCOLOR

Baro, Gene. *Thirty Years of American Printmaking.* New York: Brooklyn Museum, 1976.

Craven, Thomas. *A Treasury of American Prints.* New York: Simon and Schuster, 1939.

Cummings, Paul. *American Drawings: The Twentieth Century.* New York: Viking, 1976.

Gardner, Albert TenEyck. *History of Watercolor Painting in America.* New York: Reinhold, 1966.

Middendorf, J. William, and Wendy J. Shadwell. *American Printmaking: The First 150 Years.* Washington, D.C.: Smithsonian Institution, 1969.

Stebbins, Theodore E., Jr. *American Master Drawings and Watercolors.* New York: Harper & Row, 1976.

INTERDISCIPLINARY STUDIES

Dorra, Henri. *The American Muse: A Story of American Painting, Poetry, and Prose.* New York: Viking, 1961.

Gruen, John. *The Party's Over Now: Reminiscences of the Fifties—New York's Artists, Writers, Musicians, and Their Friends.* New York: Viking, 1972.

Jones, Howard Mumford. *O Strange New World: American Culture, The Formative Years.* New York: Viking Compass, 1964.

Morgan, H. Wayne. *Unity and Culture, U.S. 1870–1900.* Baltimore: Penguin, 1971.

PHOTOGRAPHY

Gernsheim, Helmut, and Alison Gernsheim. *The History of Photography, 1685–1915.* New York: McGraw-Hill, 1969.

Green, Jonathan, ed. *Camera Work: A Critical Anthology.* New York: Aperture, 1973.

Naef, Weston, and James Wood. *Era of Exploration: The Rise of Landscape Photography in the American West, 1860–1885.* Boston: New York Graphic Society, 1974.

Newhall, Beaumont. *The Daguerreotype in America.* Greenwich, Connecticut: New York Graphic Society, 1961.

——. *The History of Photography.* Greenwich, Connecticut: New York Graphic Society, 1972.

Photography in America. New York: Whitney Museum of American Art, 1974.

Rinhart, Floyd, and Marion Rinhart. *American Daguerreian Art.* New York: Potter, 1967.

Scharf, Aaron. *Art and Photography.* Baltimore: Penguin, 1969.

TWENTIETH CENTURY

Architecture

Condit, Carl W. *American Building Art: The Twentieth Century.* New York: Oxford University Press, 1961.

Hitchcock, Henry-Russell, and Arthur Drexler. *Built in U.S.A.: Post-War Architecture.* New York: Museum of Modern Art, 1952.

Jacobs, Jane. *The Death and Life of Great American Cities.* New York: Random House, 1961.

Johnson, Philip. *Architecture, 1949–1964.* London: Thames and Hudson, 1966.

Scully, Vincent J., Jr. *American Architecture and Urbanism.* New York: Praeger, 1971.

Stern, Robert A. M. *New Directions in American Architecture.* New York: Braziller, 1969.

Tunnard, Christopher, and Henry Hope Reed. *American Skyline, The Growth and Form of Our Cities and Towns.* New York: Mentor, 1956.

Von Eckardt, Wolf. *A Place to Live: The Crisis of the Cities.* New York: Seymour Lawrence/Delacorte Press, 1967.

Alloway, Lawrence. *Topics in American Art Since 1945*. New York: Norton, 1975.

Ashton, Dore. *The Unknown Shore*. Boston: Little, Brown, 1962.

Avant-Garde Painting and Sculpture in America 1910–25. Wilmington, Delaware: Delaware Art Museum, 1975.

Baur, John I. H. *Revolution and Tradition in American Art*. Cambridge: Harvard, 1951, 1961.

Blesh, Rudi. *Modern Art U.S.A.: Men, Rebellion, Conquest, 1900–1956*. New York: Knopf, 1956.

Brown, Milton W. *The Story of the Armory Show*. New York: Joseph H. Hirshhorn Foundation, New York Graphic Society, 1963.

Davis, Douglas. *Art and the Future*. New York: Praeger, 1973.

Geldzahler, Henry, ed. *New York Painting and Sculpture: 1940–1970*. New York: Dutton, 1969.

Goodrich, Lloyd. *Pioneers of Modern Art in America: The Decade of the Armory Show, 1910–1920*.

Goodrich, Lloyd, and John I. H. Baur. *American Art of Our Century*. New York: Praeger, 1961.

Hunter, Sam. *Modern American Painting and Sculpture*. New York: Dell, 1959.

———. *U.S.A. Art Since 1945*. New York: Abrams, 1958.

———, and John Jacobus. *American Art of the Twentieth Century: Painting, Sculpture, and Architecture*. New York: Abrams, 1973.

Kirby, Michael. *Happenings*. New York: Dutton, 1965.

Kuh, Katharine. *Break-Up: The Core of Modern Art*. Greenwich, Connecticut: New York Graphic Society, 1965.

Lucie-Smith, Edward. *Late Modern, The Visual Arts Since 1945*. New York: Praeger, 1969.

Muller, Gregoire, and Gianfranco Gorgoni. *The New Avant-Garde: Issues for Art of the Seventies*. New York: Praeger, 1972.

Rose, Barbara. *American Art Since 1900: A Critical Survey*. New York: Praeger, 2d ed., 1975.

Tomkins, Calvin. *The Art Scene*. Viking, 1976.

Painting

Alloway, Lawrence. *The Shaped Canvas*. New York: Guggenheim Museum, 1964.

Ashton, Dore. *The New York School*. New York: Viking, 1973.

Baigell, Matthew. *The American Scene*. New York: Praeger, 1974.

Baur, John I. H. *The Eight: Robert Henri, John Sloan, William Glackens, Ernest Lawson, Maurice Prendergast, George Luks, Everett Shinn, Arthur Davies*. New York: Brooklyn Museum, 1943.

Brown, Milton W. *American Painting from the Armory Show to the Depression*. Princeton, New Jersey: Princeton University Press, 1955.

Geldzahler, Henry. New York.

Homer, William Inness. *Robert Henri and His Circle*. Ithaca, New York: Cornell University Press, 1969.

Lippard, Lucy. *Pop Art*. New York: Praeger, 1965.

Sandler, Irving. *The Triumph of American Painting, A History of Abstract Expressionism*. New York: Praeger, 1970.

Seitz, William C. *The Responsive Eye*. New York: Museum of Modern Art, 1964.

Tomkins, Calvin. *The Bride and the Bachelors*. New York: Viking, 1965.

Sculpture

Ashton, Dore. *Modern American Sculpture*. New York: Abrams, 1968.

Giedion-Welcker, Carola. *Contemporary Sculpture: An Evolution in Volume and Space*. New York: Wittenborn, 1955.

Ritchie, Andrew Carnduff. *Sculpture of the Twentieth Century*. New York: Simon and Schuster, 1952.

Seitz, William C. *The Art of Assemblage*. New York: Museum of Modern Art, 1964.

WOMEN ARTISTS

Collins, J. L. *Women Artists in America*. Chattanooga: University of Tennessee Press, 1973.

Gerdts, William. *Women Artists of America, 1707–1964*. Newark, New Jersey: Newark Museum, 1965.

Harris, Ann Sutherland, and Linda Nochlin. *Women Artists 1550–1950*. New York: Knopf, 1976.

Hess, Thomas B., and Elizabeth C. Baker., eds. *Art and Sexual Politics: Why Have There Been No Great Women Artists?* New York: Collier, 1971.

Hill, M. B. *Women: A Historical Survey of Works by Women Artists*. Raleigh: North Carolina Museum of Art, 1972.

Huber, Christine Jones. *The Pennsylvania Academy and Its Women, 1850–1920*. Philadelphia: Pennsylvania Academy of the Fine Arts, 1973.

Nemser, Cindy. *Art Talk: Conversations with Twelve Women Artists*. New York: Scribner, 1975.

Nineteenth Century American Women Artists. New York: Whitney Museum of American Art, Downtown Branch, 1976.

INDEX

429

433

434